Lady Rachel Russell

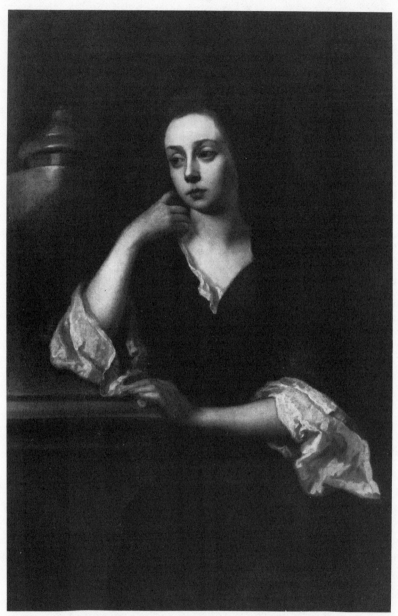

Lady Rachel Russell as a widow. By Sir Godfrey Kneller.

Lady Rachel Russell

•

"One of the Best of Women"

•

Lois G. Schwoerer

The Johns Hopkins University Press
Baltimore and London

©1988 The Johns Hopkins University Press
All rights reserved
Printed in the United States of America

The Johns Hopkins University Press, 701 West 40th Street, Baltimore,
Maryland 21211
The Johns Hopkins Press Ltd., London

The paper used in this publication meets the minimum requirements of American
National Standard for Information Sciences—Permanence of Paper for Printed
Library Materials, ANSI Z39.48-1984.

Frontispiece used with the kind permission of Lord Burnham of Hall Barn,
Beaconsfield.

Library of Congress Cataloging-in-Publication Data

Schwoerer, Lois G.
 Lady Rachel Russell, 1637-1723
 Bibliography: p.
 Includes index.
 1. Russell, Rachel, Lady, 1636-1723. 2. Great
Britain—Nobility—Biography. 3. Great Britain—
Politics and government—1660-1714. I. Title
DA447.R97S38 1988 941.06'092'4 [B] 87-45478
ISBN 0-8018-3515-1

To the memory of my foremothers—a business woman, a church woman, and a brave woman—with love and admiration.

Contents

Illustrations

Acknowledgments

It is a great pleasure to acknowledge the friendly and expert assistance I have received in researching and writing this book. Above all I am grateful to the Marquess and Marchioness of Tavistock and to the Trustees of the Bedford Estates for permission to use and quote from material at the Bedford Record Office, London, and for permission to reproduce portraits in the collection at Woburn Abbey. I thank also the Duke and Duchess of Devonshire and the Trustees of the Chatsworth Settlement for permission to use, quote from, and reproduce material at Chatsworth House. I acknowledge with appreciation the kind permission of the Duke of Rutland to visit Belvoir Castle and to use and quote from material in his archive there. I received expert and friendly assistance when I visited those archives: from Dorothy Stavely at Belvoir Castle, and from Peter Day and Michael Pearman at Chatsworth House. I am especially indebted to Marie P. G. Draper, Archivist at the Bedford Record Office, London. She gave unstintingly of her wide knowledge of the manuscript collection there, read chapters 3 and 4 of the book, and took a warm interest in the progress of the whole. She also put in my hands a recently recovered letter pertinent to the Rye House Plot found at Sandbeck Park, Rotherham, Yorkshire, and the Trustees of the Earl of Scarbrough's 1979 Settlement kindly gave me permission to use it.

The search for sources and scholarship regarding Lady Russell's French relations and her efforts to lay claim to property in France occasioned a trip to Paris. I thank Didier Coupaye, to whom I was introduced by Roger Lockyer, for facilitating my visit and for putting me in touch with French scholars. I am grateful to Bernard Barbiche, Solange Deyon, and Roger Zuber for generously sharing with me their knowledge of the de Ruvigny family. A search for information about Rachel Russell's English family lineage led me to the Hampshire Record Office, to Titchfield House (now in ruins), and to the general area where Stratton House once stood. I thank the staff at the Hampshire Record Office for their courtesies in sending me photocopied material. My knowledge of the Stratton estate and of seventeenth-century Hampshire politics was enhanced by Barry Shurlock, who wrote me at length about the one, and by Andrew Coleby, who shared his knowledge about the other. I appreciate the courtesy of John Orbell, Archivist at Barings Bank, in allowing me to use the papers of Lord Northbrook that are connected with

Thomas Baring's purchase of Stratton in 1801. Little information about the family of Richard Vaughan, earl of Carbery, whose son, Francis, was Lady Russell's first husband, has survived, but Major Francis Jones is master of what there is. He told me what I know about the prenuptial agreement that united Rachel and Francis. Basil Twigg made another search of the holdings at the Carmarthenshire Record Office to confirm that the original document is lost. I thank Susan Beckley of that Record Office for her assistance over several years.

Archivists at other county record offices treated my inquiries and requests for photocopies with unfailing courtesy. I thank the staffs at record offices in Buckinghamshire, Hertfordshire, Kent, and Northamptonshire. I am particularly indebted to Patricia Bell at the Bedfordshire County Record Office, who helped me to deal with the manorial records and estate papers from Lady Russell's Hampshire property. I am also indebted to the staff at the Public Record Office, in particular to D. Crook for searching several weeks of the Privy Council records for me. With the same sincerity I want to express my appreciation to M. A. Welch, Keeper of the Manuscripts at the University of Nottingham Library, and E. M. Coleman, at the Pepys Library, Magdalene College, Cambridge, for promptly sending me photocopied material. I thank also the staffs of the Victoria and Albert Museum, the Bodleian Library, and the Manuscript Room, Numismatic Room, Print Room, and Reading Room of the British Library. Isabel W. Kenrick, Historical Manuscript Commission, continued to help me, as she has done before, to identify and locate materials in English repositories.

Mary Robertson at the Henry E. Huntington Library expedited my requests for photocopies, for which I express my thanks. The staff at the Gelman Library, George Washington University, assisted this project by ordering material on interlibrary loan. As before, I owe a special debt of gratitude to the staff of the Folger Shakespeare Library for their friendship, warm interest, and expert assistance in matters great and small over many years.

It is a pleasure to thank fellow historians and scholars for their interest and advice. I am indebted to Esther Cope, Eveline Cruickshanks, K.H.D. Haley, Barbara J. Harris, David Hayton, Mark Kishlansky, Doreen Milne, Howard Nenner, J.G.A. Pocock, Paul Scherer, Gordon Schochet, Roy Shreiber, and Barbara Steadman, a graduate student at George Washington University. I thank especially Natia Krivatsky, Jean Miller, and Laetitia Yaendall. As always Barbara Taft read the entire manuscript, while Howard Nenner and Thomas A. Green read Chapter 6, and Barbara J. Harris, Elizabeth Hageman, and Gordon Schochet read the Introduction. If errors remain in this book, they are, of course, my own.

Portions of this book have drawn upon materials in three of my articles that have appeared in print or are forthcoming. "William, Lord Russell: The Making of a Martyr, 1683–1983" was published in the *Journal of British Studies* in 1985. "Seventeenth-Century English Women Engraved in Stone?" and "Women and the Glorious Revolution" appeared in *Albion*, the one in 1984, the other in 1986.

Many of the portraits in this book were selected with the assistance of Lavinia Wellicome, Curator, Woburn Abbey, to whom I express my thanks. They are reproduced, as indicated under each portrait, either by the kind permission of the Marquess of Tavistock and the Trustees of the Bedford Estates, or the Duke of Devonshire and the Trustees of the Chatsworth Settlement, or the Syndics of the Fitzwilliam Museum, or Sotheby's, or the National Portrait Gallery, or Lord Burham of Hall Barn, Beaconsfield. The letters are reproduced by the courtesy of the Duke of Devonshire and the Trustees of the Chatsworth Settlement. London Borough of Camden Local History Library permitted me to reproduce the pictures of Southampton House. The photograph of Belvoir Castle is courtesy of the Duke of Rutland.

I am deeply grateful to George Washington University for giving me a reduced teaching load in the spring semester of 1985 and for granting me a year-long sabbatical leave in 1985–86. I thank William R. Johnson, Chairman of the History Department, Clara M. Lovett, Dean of Columbian College, and Roderick French, Vice-President for Academic Affairs, for approving my request for leave. The Graduate School of Arts and Sciences generously provided a subvention in support of the publication of the book.

As wonderful as a word processor is, it took Carolyn Ann Hottle to bring this book to completion in a timely manner. I thank her for her skill and good humor. Finally, I express my appreciation to Carolyn I. Moser for the unusual care and interest she took in copyediting my manuscript.

Note on Dating,
Style, and Address

 Dates are given in Old Style, but with the year beginning on January 1. The Old Style calendar was ten days behind the New Style, which was used on the Continent.

With a few exceptions, punctuation, capitalization, and spelling have been modernized throughout.

The question of address and title in this book requires explanation (see *Titles and Forms of Address: A Guide to Correct Use* [London, 1978]). The subject of this book was the daughter of an earl, Thomas Wriothesley, fourth earl of Southampton, and from birth to first marriage her mode of address was Lady Rachel Wriothesley or Lady Rachel. She was not known as Lady Wriothesley or as Lady Rachel Southampton. In 1654 she married a man who occupied the same social rank as she, the Honorable Francis Vaughan, the eldest son and heir to an earl, Richard Vaughan, first earl of Carbery. His courtesy title was Lord Vaughan, and Rachel became Lady Rachel Vaughan or Lady Vaughan. Lord Vaughan died in 1667, and in 1669 she married the Honorable William Russell, a younger son of an earl, William Russell, the fifth earl of Bedford. The correct address for her husband was Mr. William Russell, but he appeared in the accounts of parliamentary debates in the early 1670s as simply "Mr. Russell." Since his social rank was beneath hers, she retained, as was customary, the title Lady Vaughan until, at the death of his elder brother in 1678, her husband became heir to the Bedford title and thus was raised to the same social rank as she. He took the courtesy title Lord Russell, and at the same time Rachel assumed the title Lady Rachel Russell or Lady Russell, a formula which showed that she was the daughter of an earl. William's courtesy title was no more than a courtesy; it had no standing in law. Russell died in 1683 before he inherited any other title. Although his name often appears as William, Lord Russell, that formula is not strictly speaking correct. After Lord Russell's death, the correct address for Lady Russell was Rachel, Lady Russell, to signify that she was a widow.

I have generally followed these changes in title for Lady Russell and her husband, but have avoided the formula signifying her widowhood, on the grounds that she herself never employed it. I have also freely

used the Russells' Christian names. There are several people in this story who bear those same names, but when the name "Rachel" or "William" appears, it always refers to the Russells unless otherwise indicated.

The names and titles of Lady Russell's sister, half-sister, and two daughters also underwent change. Her sister Elizabeth married the Honorable Edward Noel, heir of Baptist, third viscount Campden. Elizabeth died before Noel became earl of Gainsborough in 1682. Rachel's half-sister, also named Elizabeth, married first Joceline, eleventh earl of Northumberland, who died in 1670. In 1673 she married Ralph Montagu, who became earl of Montagu in 1689 and, after her death, duke of Montague in 1705.

Lady Russell's elder daughter, Rachel, married William Cavendish, known as Lord Cavendish until 1694 when he was made Marquess of Hartington. He became second duke of Devonshire in 1707. Her second daughter, Katherine, married John Manners, styled Lord Roos from 1679 to 1703, marquess of Granby from 1703 to 1711, and second duke of Rutland in 1711.

Introduction

"One of the best of women" was the way a contemporary described Lady Rachel Russell (1637–1723).[1] During her lifetime, Lady Russell enjoyed the respect and affection of both men and women. In 1773, fifty years after her death, the appearance of a portion of her letters revived admiring interest in her as the pious mourner of a martyr, her husband, Lord Russell. In the nineteenth century, the publication of more of her letters and several flattering biographies confirmed her reputation for religious piety and devotion to husband and family. In the late twentieth century, however, Lady Russell has virtually faded from view. This book, the first comprehensive and fully documented account of her life, aims to vivify her character and personality, to amplify nineteenth-century biographies, and to illuminate thereby aristocratic female culture in late-Stuart England.

I was first attracted to Lady Russell years ago by the remark of an eighteenth-century historian, Sir John Dalrymple. In concluding his account of the execution of Lady Russell's husband for high treason in 1683, Dalrymple wrote, "Lord and Lady Russell parted forever; he great in this last action of his life, but she greater."[2] This arresting remark, advancing a wife beyond her husband, appeared without further comment or explanation. Such a woman, I thought, merits attention. At about the same time I was reading Dalrymple, I had several conversations with the late Catherine Drinker Bowen, a prize-winning biographer. This vigorous, intelligent woman held biography in high regard and wrote about it as a "calling."[3] She talked about some of the challenges and rewards of working in the biographical mode, left me under no illusion about the difficulties involved, and encouraged me to hope that I would write a biography one day. But other projects claimed priority, and it was not until 1982 that I returned to Lady Russell. By then women's history was well established. The work of Natalie Davis, Joan Kelly, and Hilda Smith, among many others, opened up new questions for me and identified new materials for the study of women.[4] I am indebted to these historians. Had I written this biography earlier, it would have taken a different form.

Historians of women have shown little interest in biography, especially that of aristocratic ladies. Impatient with the "great man" theory of history, which excluded women, devoted to the effort to recover

women from all classes, and engaged in exploring new methodologies and materials, they have tended to dismiss studies of "women worthies"[5] as outdated. Yet, there are few serious biographies of late-Stuart women, except for queens;[6] until there are, women will remain as faceless as they always have been and our understanding of the past will remain incomplete and one-sided. Biography vivifies an individual as no other approach can. We need biographies of women to match those of men. Furthermore, the biographical mode may illuminate general questions about female experience even though sufficient material to write a biography almost never survives for a typical woman. Biography permits the historian to transcend the data provided by law, custom, and prescriptive literature (which was written mostly by men) and draw a more accurate picture of the actual experiences and attitudes of and towards women. The excuse that women in the late-Stuart period have not found biographers because of a dearth of material will probably prove to be ill-founded when English archives are systematically explored with the intention of discovering neglected or uncatalogued letters and papers.

A concept of historians of women's history which I have found useful and made my own is that of the "doubled vision," as Joan Kelly put it.[7] Kelly called on historians to keep one eye on men and the other on women, so that their perspective on the past would be all-encompassing. In keeping with that principle, this book has given more attention than might be expected to Rachel's husband. Treating Rachel and William together helps us to understand each of them better. The absence of Lord Russell's political papers, almost certainly destroyed at the time of his arrest, makes it impossible to undertake a full-scale treatment of him. However, in the context of Rachel's life one can take a closer look at his personality, political and religious views, and role as leader of the Country-Whig opposition in the House of Commons at the time of the Exclusion Crisis. By so doing, this study refines understanding of the principles and tactics of the Whigs. It also shows the subsidiary role that a woman might play in "high politics." Rachel was William's "informer," as she herself put it, and his counsellor during his parliamentary career. She took a central part in his trial and preparations for death, and played a major role in transforming him into a martyr and casting herself as mourner. Accordingly, two chapters of this book give extensive treatment to his political career, trial, and execution, events that were traumatic for Rachel.

Lady Rachel Russell's life was richer and more complex than the customary view of women of her era would suggest was possible. The traditional ideal confined women to the private sphere, made them subordinate to men as daughters, wives, and mothers, and stripped them of a public role.[8] But Rachel's class, personal qualities, and protracted

widowhood enabled her to circumvent some of the restraints imposed on all women in the period. A member of the English aristocracy by birth and marriage, she was also connected through her mother to the highest reaches of French Huguenot society. Her class gave her wealth, a passably good education, leisure, and opportunities for a self-indulgent social life when she was a young woman and for study, reflection, and writing later on, especially during her long widowhood. These advantages of class contributed to her sense of self-confidence and self-worth, while the men in her family who held high political office gave her access to the centers of political and religious power. Rachel's experience invites historians of women to consider more seriously the advantages of class and the effect they may have in freeing aristocratic women.[9]

Lady Russell's personality and character operated to the same end of enriching her life. Physically attractive, Rachel possessed a spirited temper, an independent spirit, and a voluble manner of speaking, reflecting her quick, sharp intelligence. At the same time she was a warm, loving, even sensuous woman, who cherished her friends and passionately adored her husband. She had personal courage, enduring nine pregnancies, witnessing the death of everyone in her immediate family except for her elder daughter, undergoing two operations for cataracts, and boldly confronting King Charles II during her husband's imprisonment and after his execution. Such a combination of traits won her a wide circle of friends among men as well as women. A less well-endowed woman would have been unable to profit from the opportunities that class opened up to her.

Lady Russell's long life falls into five distinct stages. The first— from her birth in 1637 through the death of her first husband, the Honorable Francis Vaughan, Lord Vaughan, in 1667—was a time scarred by personal illness and the death of many family members, when she led a life of self-indulgence, but began to develop an interest in politics and religion. The second phase lasted from her second marriage in 1669 to her husband's execution for treason in 1683, when she was forty-six years old. This marriage, which was based on romantic love, brought her fulfillment and children and, contrary to what is often written about the impact of marriage on a woman, widened her horizons, deepening her interest in politics, religion, and estate management. The third stage marked her entry upon a protracted widowhood of forty years, almost half her lifetime. The years from 1683 to 1688 were a time of intense grieving but purposeful activity in both the private and public spheres of life. Her mastery of her sorrow also provides insight into what is called "grief management" in the twentieth century.[10] The fourth phase, lasting from 1689 to about 1702, were years when the Glorious Revolution brought the reversal of William's attainder for treason and a renewal of

Rachel's social and political status and influence. Despite the onset of eye problems so serious as to require surgery, this was Lady Russell's "prime," the era in which she realized her full potentialities. As acknowledged head of her household, she supervised the education of her children, negotiated favorable marriage contracts for each of them, and supervised her financial and property interests, in these areas taking steps usually reserved to men. At the same time, as acknowledged Whig matriarch, a symbol of her martyred husband, and champion of his principles, she had a significant political role, exploiting the patronage system in church and state to advance the interests of family and friends and promote principles to which she adhered. During many of these years she occupied the emotional center of her family, always writing, reading, praying, grieving, and counselling others. Finally, the years from 1702 to 1723 were marked by slowly declining vigor and deepening introspection and reflection, although she continued to show interest in family, politics, religion, and property matters.

Rachel's life demonstrates that, contrary to contemporary writers' customary division of a woman's life into the three stages of maidenhood, wifehood, and widowhood, characterized in each instance by dependency and submissiveness, a woman's life may fall into successive phases of growth just as a man's does. Although some characteristics were constant throughout her life, Rachel grew in emotional strength, religious understanding, and political sagacity. She reached a prime, just as a successful man may do, but in her case the period of greatest effectiveness came later in life—when she was a widow in her fifties and sixties, after the years of childbearing and rearing of young children were past. Widowhood was emotionally devastating to Rachel, but unquestionably it strengthened her self-confidence and sense of independence. Her long widowhood provides data to study aristrocratic widows, a neglected subject.[11]

Throughout all the years of her adulthood and probably before, Rachel was obsessed with writing. She seemed to take an almost physical pleasure from the act of moving a pen or pencil across the page. Approximately four hundred and fifty of her letters and more than thirty of her essays survive; the probability is, as the eighteenth-century editor of her letters asserted, that she wrote "thousands" more letters during her long life. She probably also wrote more essays, which have been lost. Her voluminous correspondence was her most important instrument for expressing and insisting upon her views and for achieving and maintaining her role in both the private and public spheres.

Although her public and private roles violated conventional constraints, Lady Russell was not part of the small group of late-seventeenth-century women whom Hilda Smith has identified as the

"first feminists" because of their sensitivity to and resentment of the conventional attitude towards and restrictions on women in education, marriage, and public affairs.[12] Rachel did not protest against patriarchal institutions or try to change them. Rather she identified with and sought recognition from them, used the conventions of her society to advance her political and religious principles and the interests of herself, her children, and her male and female friends, and ignored or circumvented some of the restraints of gender. There were, of course, many things that Rachel could not do—vote, hold political office, win election to the House of Commons, attend a university, serve as a minister of the Anglican church. But, using her social position and personal contacts, the power of her pen, and the persuasiveness of her personality and intelligence, she was able to exercise *influence* in those areas. And in the private sector, as a widow, she fulfilled the role of head of household as a seventeenth-century English man would have done. Her attitudes and strategies are surely closer to the norm than those of "reason's disciples" and thus may illuminate more faithfully the life of aristocratic women in the era.

Rachel's life holds clues to the question of whether women react differently from men to ideas and larger events in society. The answer in her case seems to be that there is little difference for men and women of the same class. Intellectually, neither she nor her husband was a political theorist, but each subscribed to Whig political principles (including the right of resistance) and to religious ideas that were Anglican but were deeply influenced by Nonconformity. The difference between William and Rachel was over tactics. He was a reckless man, moved by chivalric ideals and a sense of responsibility to his class. She, who had always been close to the center of power through her father and other male relatives, was pragmatic and cautious, with an acute sense of the dangers inherent in political life. Had her judgment prevailed, Russell might have survived, as did other Whigs, including his best friend, William Cavendish. Rachel's concerns transcended domestic interests—she wrote of her love for her country and her religion—but possessed of a more finely tuned political instinct than her husband, she was willing to tailor her views and her actions to protect the interests of her family.

Lady Russell was unusual rather than unique among contemporary upper-class women. She shared a concern for politics with women such as Dorothy (Sidney) Spencer, countess of Sunderland; Katherine, countess of Ranelagh; and Elizabeth, viscountess Mordaunt. Like them she used her class, connections, and intelligence to create the power of influence and to use that influence in the patronage networks of church and state. She led a life of religious piety, as did multitudes of other aristocratic women, and like them wrote confessions and religious prayers and essays.[13] Indeed, the religiosity of such women invites

historians to see the Restoration as less cynical and areligious than is commonly assumed. As a widow Rachel mourned the death of her husband, as did many other women such as Ann, Lady Fanshawe,[14] although her grief is set apart by its intensity and duration. Like women such as Mrs. Elizabeth Howland or Anne, countess of Pembroke, Rachel was actively involved in the management of her property and estate. But few women undertook, as she did, to arrange marriage contracts for their children, carrying on the negotiations as an equal with the father in the opposite family. Thanks to her skill Rachel became the "founding mother" of the families of the present dukes of Devonshire and Rutland, and (with William Russell) of the present duke of Bedford. Her activities in these and other marriage negotiations reveal the role that a woman might play in this area, a role which has received little attention from historians. Like other contemporary women, such as Dorothy Osborne, the wife of Sir William Temple, Rachel formed a passionate attachment to her husband. The letters of both of these women provide tantalizing glimpses of that little explored subject of female sexuality.[15] The evidence is explicit that Rachel found great joy and fulfillment in marital relations and that the prudery of the nineteenth century was foreign to her nature. Whatever the similarities between Rachel and other contemporary women, she stands apart not just because each individual is distinct, but also because all the above-mentioned themes—politics, piety, property, and passion—and not just one or two as in the case of other women, are present in varying degrees in all the phases of her adult life.

The center of Rachel's life was always her family, household and a spreading network of kin and friends, both male and female. Her experiences illuminate aristocratic family life and add a female perspective to the picture of that life drawn so fully by Lawrence Stone.[16] As just mentioned, female sexuality in marriage finds some illumination from her example. Rachel's management of her London and Hampshire estates and of the marriage contracts of her children, and her exercise of influence over local church appointments, show a woman engaged in activities usually reserved to a man. Another striking feature of her family life was the strong ties between her and her sisters (her brothers died young). Those ties provided emotional support, underlay political connections, and facilitated the settlement of properties in which the women had an interest. Although the importance of affection between brothers and sisters has been remarked, sisterly relationships have not been much noticed. Rachel's experience invites attention to them. Rachel had other women friends, particularly Lady Shaftesbury, but women were rather shadowy figures in her personal life. She identified with men: the most powerful influence on her early development was her father, and her closest confidants in adulthood were men: her husband, her father-in-

law, clerics, and her French uncle and cousin. Her attitude and experience provide an early English example of a recently identified characteristic of Enlightenment domesticity: heterosocial friendships among kin and nonkin, based on the assumption of women's rationality and essential equality with men.[17] Rachel placed high value on these relationships, regarding friendship as the highest pleasure, next to marriage, that the world had to offer.

Furthermore, Lady Russell's relationship with her children not only reveals her personality and values but also gives rare insight into childhood in late-seventeenth-century England. She and her husband were loving and indulgent parents who took a deep interest in their children's antics, prattle, illnesses, and growth. Her letters provide glimpses of their children's toys, bedtime regimen, and early education, while the letters of the elder daughter, written when she was about six years old and preserved by a fond father, confirm the warm relationship. The presence of grandparents in late-seventeenth-century families was rare. The Russell children did have a paternal grandfather who wrote them, showered them with gifts, played with them, and, certainly in the case of his grandson, spoiled them. Later, Rachel, as a grandmother herself, displayed like warmth toward her grandchildren.

Another significant characteristic of Rachel's private life was her relationship with the families to which she was connected through her marriages and those of her sisters and children. Without abandoning her identification with her family of birth and the family she and Russell created, she established and maintained a lifelong loving relationship with these other families. The result was enhancement of her personal status in both private and public life. She also actively used her influence, when it became available after 1689, to promote the interest of members of this extended family network. The openly affectionate attachment to family which is often associated with the nineteenth-century English family is found well developed in Rachel's life.

The story of the publication of Rachel's letters and nineteenth-century biographies explains why she has been portrayed largely as a mourning wife and devoted mother. Her letters were published not to preserve her memory but to rescue the reputation of her husband. Indeed, when Lady Russell died in 1723, there was nothing to assure that her memory would long survive at all. Members of her close family who were still alive died shortly after she did—her elder daughter and last remaining child in 1725; her grandson, the third duke of Bedford, in 1732. There is no indication that either one had planned to perpetuate her memory by publishing her letters. It was left to her devoted steward, Thomas Sellwood, to transcribe her letters and to present them, in 1748, to her great-grandson, the fourth duke of Bedford.[18] But no further

steps were taken for twenty-five years. In 1773, a time when ideological disputes among court Whigs, opposition Whigs, and Tories were conducted with renewed sharpness, Sir John Dalrymple published the second volume of his *Memoirs of Great Britain and Ireland*, the first history of late-seventeenth-century England to be based upon French sources. He revealed that Russell had intrigued with emissaries from the French court (as had been charged in 1678) and that Algernon Sidney, another renowned Whig, had accepted money from Louis XIV. In commenting upon this evidence, Dalrymple expressed a sense of deep shock—as if, he said, he had "seen a son turn his back in the day of battle."[19] Russell's reputation was seriously threatened.[20] Immediately, materials appeared to rebut and explain away Dalrymple's charges and rehabilitate William. In the absence of William's own papers, the letters Rachel wrote between 1683 and her death in 1723 were published within three months.[21] The unsigned title page declared that Lady Russell's letters were about to be printed when Dalrymple's *Memoirs* appeared. It was decided, therefore, to preface the whole with an introduction "Vindicating the Character of Lord Russell Against Sir John Dalrymple."[22] Accordingly, the introduction to Rachel's letters barely mentions her. Rather, the anonymous author argued that Dalrymple's evidence was suspect and his interpretation misguided, and insisted that William was a martyr to Stuart tyranny. Rachel's letters, many of them encomia to her husband, reinforced the message. Her undoubted piety reflected well on her husband. Her deep distress over his death and repeated affirmations of her love of him implied that he was innocent, for no woman so good as she could have married a traitor to his country. The *Letters* enjoyed great popularity, going through seven more editions in London and two in Dublin by 1821, and laid the foundations for a view of Rachel which has prevailed ever since.

Other printed matter supported the portrait of Rachel as mourner and Russell as martyr. For example, in 1784, a playwright, William Hayley, dedicated a play titled *Lord Russell, A Tragedy*, to the duchess of Devonshire (a descendant of the Russells). He cited Rachel's letters as his inspiration and, confessing to "affectionate admiration" of William, declared that he had attempted to paint an exact picture of him. In fact, Hayley presented villains (James, duke of York, and King Charles II), and a hero and heroine, Lord and Lady Russell. William was "Heroic Russell, bright and genuine martyr of Liberty and Truth," who despised the doctrine of nonresistance because it "sinks the free-born sons of England / To the tame vassals of a Turkish despot." Rachel was a "lovely virtuous woman" who prostrated herself before the duke of York and the king of England to plead for her husband's life, and so affected the king

that he expressed his envy of Russell because of "Th' angelic tenderness of that chaste woman." Notwithstanding her devotion to her husband, her strength of character was such that she was able to master her emotions at their farewell.[23]

In 1784 a cleric and aspiring playwright, Thomas Stratford, penned a similar message. He depicted William in prison in chains (stage directions call for them to rattle), and subjected to torture. Stratford transformed Russell into a classical patriot and compared him to the ancient heroes who defended their country at Thermopylae. Rachel, torn apart by grief, threatens suicide, curses the Stuart kings as tyrants, and asks herself how she, a "free-born English woman" who enjoys "Heaven's equal charter," could have begged them to pardon her husband. In another scene, quite distracted, she pulls out her hair.[24] Stratford's play, of course, tells more about late-eighteenth-century political and intellectual concerns than it does about the Russells. The pertinent point is that it perpetuated the view of Rachel as nothing more than a pious, loving, and supportive wife.

It was not until 1819 that a biography of Rachel appeared. In that year the duke of Devonshire acceded to the request of unidentified "friends" and permitted the publication of many of the intimate letters Lady Russell had written to William in the 1670s, which the historian Mary Berry had sorted and annotated in 1815. Berry agreed to write a biographical sketch of Rachel to introduce the collection, which appeared under the title *Some Account Of The Life Of Rachael Wriothesley Lady Russell By The Editor of Madame Du Deffand's Letters Followed By A Series Of Letters From Lady Russell To Her Husband, William Lord Russell, From 1672 to 1682; Together With Some Miscellaneous Letters To and From Lady Russell.*[25] Berry was full of apologies for the subject and her work. Lady Russell's letters, she declared, were "devoid of every ornament of style." Their "merit must arise entirely from a previous knowledge of the character and habits of their writer." Her biographical essay she dismissed as no more than a "biographical notice" because of the paucity of facts and the insignificance of many of them.[26] But she admired Rachel as a "bright. . .example of female excellence" who sacrificed no feminine virtue and whose life might be a guide to other women.[27] Although aware of other dimensions to Rachel's life, Berry portrayed her largely as a devoted wife and mother. *Some Account* enjoyed immediate popularity and went through three editions by 1820. The biographical sketch, without the letters, was also well received and was reprinted in 1819, 1820, and 1844. Two more biographies, one heavily indebted to Berry's sketch, were published, one in 1832 and the other in 1847 or 1857.[28] In the meantime, the 1773 edition of Rachel's

letters continued to command an audience. Between 1801 and 1820 the sixth through the eighth editions appeared, while another edition appeared in the series The British Prose Writers.

Books and essays about William and biographies of Rachel continued to pour from the press in the early nineteenth century. The effect was to keep information about Rachel as well as her husband before the public. The effort to refurbish William's reputation was undertaken by Lord John Russell, who was just beginning his long political career as a reformer in the House of Commons and who also had literary ambitions. In 1819 he published a biography of his great-great-grandfather.[29] Although written with restraint, the study was an apologia for William. Lord John Russell concluded his book with several admiring comments about Rachel. He characterized her during her marriage to William as a woman of "amiable" character and described her conduct during her husband's trial and imprisonment as "sublime." He declared that her "most striking" feature was the esteem in which she was held by contemporaries and posterity without "any ambitious effort" on her part. "She showed herself in the appropriate character of a wife and a mother."[30]

Pictures also helped to reinforce and spread the positive view of Lord Russell as a victim of Stuart tyranny and of Rachel as his faithful helpmate. In 1825, John, the sixth duke of Bedford, commissioned Sir George Hayter (1792–1871) to paint a picture of William's trial, as a gesture, it was said, "to the fair fame of his illustrious ancestor." The huge canvas, said to be Hayter's *chef d'oeuvre*, depicted a crowded courtroom scene with Russell calm and dignified and Rachel looking anxiously at him. Shortly thereafter, the painting was rendered in an engraving by John Bromley.[31] It was regarded as such a treasure that Francis, the seventh duke, arranged for it to be included in the Paris Universal Exhibition in 1855.[32] Today it hangs in Woburn Abbey.

In the 1850s, as Lord John Russell's political career was reaching its climax, further attention was directed to Lord and Lady Russell. In 1853 Lord John Russell brought out a fourth edition of his biography of William and a new edition of all of Rachel's previously published letters as well as a few new ones. He made it clear in the preface that one reason for printing Rachel's letters was to counter the impression of William Russell given by Lord Macaulay in his recently published *History of England*. Lord John Russell maintained that Macaulay had not distinguished sharply enough between the aims of Shaftesbury and William; that William was opposed to any kind of active resistance; and that he had been "murdered" by the Stuart court "in order to establish arbitrary power, and destroy the liberties of England."[33] Again, the apparent assumption was that such a fine woman as Rachel, her worth displayed in her letters, would not have loved a traitor. The duke of Bedford sent

a copy of this book to François Guizot, the French Protestant historian and statesman, who was so beguiled by the "rare and charming" qualities of Lady Rachel, her devotion to her patriot husband, and the depth of their domestic happiness that he decided to write an account of their life as "an example" to his own irreligious age which, he said, cannot conceive of "passion, except unbounded."[34] Guizot's *L'Amour dans le mariage*, heavily indebted to Berry's essay, appeared in English in 1855, the very year it was printed in French, translated by John Martin (archivist to the Bedford family) at the request of the duke of Bedford, and dedicated to the duchess of Bedford. It captured an audience too, appearing in New York in 1864 under the title *Love in Marriage* and in London in 1883 as *The Devoted Life of Rachel Lady Russell*, both titles conveying accurately the tenor of the book and the view of Rachel. The book also influenced Catherine Pollock Manners, Lady Stepney, whose book, *Memoirs of Lady Russell and Lady Herbert*, published in 1898, was the last biography of Rachel to be written.

These nineteenth-century biographies were not wrong in presenting Rachel Russell as a pious woman devoted to husband and family. Rather, the portrait they drew is incomplete. The picture that they painted captured the imagination and sensibilities of nineteenth-century readers and assured that for a long time the reading public would know of and admire Lady Russell as a paragon of feminine virtue.[35] One purpose of this book is to enlarge that portrait to encompass the complexities in her personality, attitudes, and actions, and to show how a woman exploited the opportunities available to her to escape conventional restraints without condemning them. Rachel had many things in common with other women of her class, and her life may well provide fresh insight into the nature of female aristocratic culture.

I have been under no illusions about the challenges of writing a biography. Although some people regard it as a genre separate from "serious" history, I have not found prescriptions in handbooks about biography so very different from those which command the research and writing of intellectual and political history. Although psychoanalysis is sometimes recommended as preparation for the aspiring biographer, I have not submitted to it nor tried to become an instant expert in psychoanalytical theory. I do not disdain psychobiography,[36] but I have not attempted to practice it. Yet, I have found the approach of social learning theorists helpful,[37] and I have used some commonsense insights, which in the late twentieth century are part of the common wisdom, to help understand the nature of Lady Rachel's personality.

The record of Lady Russell's attitudes, actions, and experiences gives historians an opportunity to examine more fully the nature of aristocratic female culture in late-seventeenth-century England. From

that record Rachel herself emerges as a richer personality than earlier biographies painted, and the culture of upper-class women, whose class conferred advantages on them, is revealed in both the private and public spheres as more complex than is usually understood.

Lady Rachel Russell

• 1 •
Background
and Beginnings

Lady Rachel Russell was baptized Rachel Wriothesley on September 19, 1637, at the ancient parish church of St. Peter in the village of Titchfield in southern Hampshire.[1] She was the third child and second daughter of Thomas Wriothesley, the fourth earl of Southampton, and his French wife, Rachel Massüe de Ruvigny de la Maison Fort (see the illustrations). The parish church, which dates back to the late seventh century, had been in the patronage of the earls of Southampton since the mid-sixteenth century and was adorned by marks of their preeminence. In the chapel of St. Peter behind the baptismal font a massive mausoleum, commissioned by the second earl and erected in 1594, held the remains of Rachel's English ancestors—the first three earls of Southampton and their wives. On the south wall of the chapel a figure carved in white marble of a little girl, dressed in adult clothes with a ruff at her neck, memorialized Lady Mary Wriothesley, Rachel's aunt, who had died in 1615 at the age of four years. This physical setting gave abundant evidence of the aristocratic status of Rachel's English lineage.

Rachel's parents had been married for just over three years when she was born. Their wedding was celebrated not in England but at the most important Huguenot church near Paris, the Temple at Charenton, two leagues from the city on the banks of the Marne River.[2] The contrast with the parish church at Titchfield was striking. The temple had been built about 1623 on an estate formerly belonging to a minister of the government; the estate had been granted by the king to a group of Huguenots who had petitioned for a place of worship convenient to Paris, following the promulgation of the Edict of Nantes in 1598. The interior of the temple was described by John Evelyn, the diarist, who visited it in 1644, as a "fair and spacious room." The walls were decorated with instructive paintings of the Tables of the Law, the Lord's Prayer, and the Creed. The pulpit and communion table were enclosed in an area which also contained seats for the elders. The remainder of the congregation, which numbered about three thousand, sat on low stools.

All sang Psalms, and the children received rigorous training in cate-
chism. The temple symbolized Rachel's French Huguenot lineage just as
the setting of her baptism did her English heritage.[3]

Rachel's mother and father were a disparate pair in terms of per-
sonality, national origin, and family background. Southampton was
short, reserved, and "much inclined to melancholic."[4] Madame de la
Maison Fort was "somewhat taller" than the average Frenchwoman,
and of striking beauty with black hair, "excellent eyes," and a "sweet
and affable," even "merry," disposition.[5] Neither partner was young
when they married in 1634. At thirty-one, Madame de la Maison Fort
had been a widow for nine years; she had no surviving children from her
first marriage. For Southampton, five years her junior, it was a first mar-
riage. Madame de la Maison Fort came from a French family of noble
status, but one whose attainments and wealth were rather modest.
Southampton, on the other hand, was an English earl, whose great-
grandfather had established the family fortune and social and political
position in the sixteenth century. At the time of his marriage, however,
Rachel's father had no outstanding accomplishments of his own; they
were still to come. Moreover, Madame de la Maison Fort was a devout
Huguenot, whose male relatives were prominent leaders in the Huguenot
political and religious community, whereas Southampton was a member
of the Anglican church.

Thomas Wriothesley's ancestors had first come to public view in
the fifteenth century. At that time, they spelled their name Writh or
Wrythe. They advanced to some prominence as heralds in the newly
established College of Arms. Sir John Writh became third garter king-
of-arms in 1483 and served both Edward IV and Henry VII in diplo-
matic missions and court ceremonials. His two sons, Thomas and
William, also made their marks as heralds. As Thomas prospered he
abandoned the simple name of Writh and took on the aristocratic-
sounding name of Wriothesley, claiming descent from a family of that
name which had lived at the time of King John. His brother William fol-
lowed suit. It was this William's son, Thomas, the great-grandfather of
Rachel's father and the man whose given name he bore, who established
the family's landed wealth and tradition of political service.[6]

Educated at Cambridge University and trained in the law at
Gray's Inn, Rachel's great-great-grandfather, Thomas Wriothesley,
became an attorney in the Court of Common Pleas and a client of
Thomas Cromwell. As Cromwell's man, he took a prominent role in the
dissolution of the monasteries. Although he probably remained Catho-
lic,[7] he conducted himself in ways that pleased the king, and Henry
VIII rewarded him with land, offices, and titles. Thus, in 1537 Thomas
Wriothesley acquired the Abbey of Titchfield and nearly five thousand

acres of land connected with it. Titchfield, a Premonstratensian abbey, was located nine miles southeast of Southampton in Hampshire, close to Fareham and Portsmouth. It was notable for its great library of theological, classical, and humanistic works.[8] Thomas received many other manors, among them Micheldever and Stratton, two of the richest manors formerly belonging to Hyde Abbey. He also acquired property in London, a house and land along Holborn, and Bloomsbury manor, for which he paid £1,666.[9] These properties became significant in the story of Rachel Russell.

Almost immediately after acquiring Titchfield Abbey, Wriothesley undertook to transform it into a handsome house. By 1543 the reconstruction project was completed, John Leland, the antiquary, reporting that it was a "right stately house. . .having a goodly gate and a conduit casteled in the midle of the court of it."[10] No monarch visited Titchfield during the first earl's lifetime, as he had hoped would happen, but by the time the fourth earl brought his French bride to it in 1634, three monarchs—Edward VI, Elizabeth I, and Charles I—had stayed there. It was in this great house, located about a mile to the north of the village of Titchfield, that Rachel was probably born on September 14, 1637, and where she mostly lived until 1654.

Thomas Wriothesley received offices and titles as well as land. For example, he held the post of lord chancellor, and in 1544 King Henry VIII raised him to the peerage as Baron Wriothesley of Titchfield. In compliance with Henry's deathbed wish, King Edward VI made him first earl of Southampton in 1547. Although he suffered setbacks during the brief and politically volatile era of Edward VI, at the time of his death in 1550 the first earl had successfully established the social, economic, and public position of the Southampton family. Not until Rachel's father rose to high political office did another member equal the first earl in prestige and service.

The political and economic prospects of the Southampton family faltered under the second earl, Henry, a child of five when his father died. Raised in the Catholic faith, Henry remained Catholic when Elizabeth I became queen in 1558 and the state religion changed again. Married to a Catholic woman, Mary Browne, the daughter of Anthony Browne, first viscount Montagu, he translated his religious convictions into political intrigues, which landed him in the Tower in 1571 for two years and again in 1581.[11] His treasonable activities destroyed the public role of the family that his father had established.

The second earl also imperiled the financial position of the family by lavish spending on hospitality, house-building, and a retinue that numbered over a hundred. When he died in 1581, he left instructions in his will for erecting the great family mausoleum in the parish church of

St. Peter where Rachel was baptized. The plans were so extravagant that his executors found it necessary to modify them, but the final design executed by Gerard Johnson, a Flemish sculptor, was still magnificent— a two-tiered structure decorated with figures carved from marble and alabaster.[12]

Henry, the third earl of Southampton, rescued the family from the compromising situation created by his father by converting to Anglicanism. The conversion opened the way for him and his descendants once again to play a genuine role in England's political and social life. It also opened opportunities for them to be drawn to Puritan influences that were growing in the Anglican church. The earl's later political views and actions reflected his strong commitment to Puritan values. It was these values and views that Rachel's father inherited.

The third earl has won renown as a lover of literature and as a patron of writers, especially Shakespeare.[13] Southampton was also a bibliophile. About 1615 he purchased the library of William Crashaw, a distinguished Puritan divine and fellow of St. John's College.[14] These books, added to others that he had assembled, amounted to about two hundred rare manuscripts—sermons, homilies, works by early church fathers, and Scholastics—and some two thousand books.[15] Southampton intended to present the collection to St. John's College as the foundation of a library to be built there, a step carried out by his widow and Rachel's father in 1616 and 1635.[16] Thus, Rachel herself did not grow up in proximity to this magnificent library, but her father did. Surely the presence of such a collection influenced his intellectual development.

The third earl's political career was checkered. A handsome young man,[17] he attracted the attention of Queen Elizabeth I, only to forfeit her regard by having a love affair with one of her ladies-in-waiting, Elizabeth Vernon, whom he married in 1598. Following close upon this episode was his involvement in the Essex Rebellion in 1601, a far more serious matter. The uprising was a fiasco. Southampton was arrested, found guilty, and sentenced to die. But his life was spared, and he was imprisoned in the Tower until 1603, when King James VI of Scotland became King James I of England.[18] Recalling Essex's friendship, James released Southampton, restored his title with its former precedence, made him a Knight of the Garter, appointed him captain of the Isle of Wight, and bestowed on him the farm of the Sweet Wine Customs, which greatly enriched him. For years Southampton benefited from the favor of the king. For example, in February 1608 certain privileges regarding his Hampshire property were confirmed, such as freedom from interference by the sheriff and exemption from tallage,

aids, geld, and scot.[19] These privileges remained with the property when Rachel inherited it much later.

The third earl, however, never became an intimate of the king nor of the king's first minister, Robert Cecil, earl of Salisbury. Failing to win the office and status he coveted, he turned his restless spirit to the management of his estate. He took steps to enhance the value of his London properties and to facilitate their later expansion. In 1613 he began the practice of leasing plots for building in Bloomsbury, and in 1616 he bought part of the manor of St. Giles in the Fields, which extended the estate along Holborn. In 1617 the king agreed to extend the liberties of the earl's house in Holborn, now called Southampton House, down the east side of Chancery Lane.[20] These were properties that Rachel would also inherit.

After Salisbury's death in May 1612, Southampton played a larger political role, becoming a leader of the aristocratic Protestant faction at court. From 1619 to 1621 he angered the court because of his opposition to the pro-Spanish policy and the projected marriage of Prince Charles and the Spanish Infanta, and in March 1621 King James placed him in the custody of John Williams, dean of Westminster. Thanks to Williams' intervention with the king, Southampton won release by the end of August 1621.[21] But his royal pensions were suspended and, despite his efforts and those of friends, were not reinstated.[22]

By 1623 Southampton's relations with the king and with Buckingham and Prince Charles had improved, for the latter two had reversed themselves and now favored a war policy. When England and Holland signed a treaty in 1624 under which the English were to raise four regiments to serve under the Dutch in the Thirty Years War, Southampton took on the command of one of the regiments. He and his eldest son and heir, James, Lord Wriothesley, left for Holland in August 1624. Shortly thereafter both men were stricken with fever, and James succumbed. On the journey home with his son's body, the third earl died, probably of a heart attack, on November 10 at Bergen-op-zoom. That is how Thomas, the earl's second son and Rachel's father, was suddenly elevated at the age of sixteeen to the rank of fourth earl of Southampton.

Rachel's father, born in 1608 at Little Shelford in Cambridgeshire, inherited neither his father's good looks, impetuous nature, nor martial ardor. As a second son, Thomas Wriothesley had not expected to inherit his father's title and estates. And although he had had some experience in court ceremonials (at the age of eight he served as cupbearer at the investiture of Charles as Prince of Wales), he was discomfited by the new deference shown him as a peer of the realm.[23] But he was an in-

telligent young man. In 1625, when he was only seventeen years old, he discharged the social duties of his new status by entertaining King Charles I and his French bride, Henrietta Maria, at Titchfield. The queen enjoyed herself enough to stay on for five weeks and three days.[24] In the autumn of 1625 Thomas entered St. John's College, Cambridge, a center for Puritan thought, which would have reinforced his father's Puritan inclinations and his own sober nature. He impressed the president and seniors with his "fair and noble. . .demeanour," surely fulfilling his mother's hope that he would imitate his father in love of learning. In 1626, he left St. John's College without taking a degree.[25] His only youthful failing was enthusiasm for gambling and horse racing.

Rachel's mother, Rachel Massüe de Ruvigny de la Maison Fort, was the eldest daughter of Daniel de Massüe, seigneur de Ruvigny and seigneur de Rainval, and of Magdelaine de Pinot, the widow of Jean Pinot, seigneur de Fontaine. Descended from a bourgeois family of Abbeville, her immediate ancestors had achieved a place in French society and government, but not one of the first rank. Her grandfather was Antoine d'Ailly, seigneur de la Mairie and de Pierrepont, and in the early seventeenth century her father held the post of lieutenant-governor of the Bastille, serving under the governor of the Bastille, Maximilien de Béthune, the duc de Sully, a chief adviser to King Henry IV. A friendly relationship existed between the two families. The de Sullys were godparents to Rachel Massüe de Ruvigny and her brothers, including Henri, born probably in 1605, who became the first marquis de Ruvigny.[26] After Rachel Massüe de Ruvigny's mother died, her father married sometime between 1608 and 1611 Madelaine de Fontaine, dame de Caillemotte. When her father died in 1611, Rachel Massüe de Ruvigny and her brothers were left in the charge of their stepmother. The death of one brother left only Henri and Rachel, and they developed a closer sibling relationship than they might otherwise have done. When Rachel Massüe de Ruvigny de la Maison Fort married Southampton, Henri and her stepmother (who lived until 1636) accompanied her on her wedding trip to England. Her brother kept in touch with her, visiting at least once, three months before our Rachel was born, and remained a presence in the Southampton family.[27]

At the time Rachel Massüe de Ruvigny de la Maison Fort met Southampton in Paris in 1634, her brother's growing importance had elevated her position. A protégé of the duc de Sully, de Ruvigny became an officer in the French Guards and first made a name for himself at the siege of La Rochelle in 1627, when he fought *against* the Huguenot insurgents, his fellow religionists. Thanks to his personal bravery, the city fell to King Louis XIII, who, accompanied by Richelieu, entered it in triumph.[28] De Ruvigny continued to fight on the side of the king

against his fellow Huguenots, justifying his actions on the grounds that the latter should loyally serve France, but he nonetheless gained a reputation among the Huguenots for Protestant piety and conviction.[29] His high reputation in both Huguenot and court circles prepared the way for his later advancement. To anticipate, in 1653 Louis XIV appointed de Ruvigny to the post of lord deputy-general of Protestants in France—that is, to the position of chief spokesman for the interests and grievances of French Protestants at the royal court. After the Restoration of the Stuarts in 1660, Henri served as a special envoy and then in 1673 as ambassador from Louis XIV to the court of King Charles II. Thus, de Ruvigny came often to England, and a loving familial relationship developed between him and his son (also Henri) and Rachel and her family. Our Rachel dearly loved her "old uncle" and stayed in close touch with him as long as he lived. His son, the second marquis de Ruvigny, who fought with the prince of Orange in the Revolution of 1688–89 and became the first earl of Galway, continued this intimate connection until his death in 1720.

What were the circumstances that brought Rachel's parents together? For all his love of solitude and his dour disposition, Southampton was fond of horse racing and gambling, and that fondness was at the root of his meeting Madame de la Maison Fort. In March 1634 he lost money at the races at Newmarket. Full of remorse, he vowed to give up horses and gambling and, securing the usual three-year license to travel on the Continent, left for Paris to begin a kind of self-imposed penance.[30] He had, of course, entrée to French society. He had visited France earlier, and his father had been well known in French circles. In fact, his father had played host to the Huguenot leader, the duc de Sully, when he had come to England years before, in 1603.[31] But the duc de Sully, Madame de la Maison Fort's godfather, was not the one who brought the couple together. Rather, an English friend of Southampton's, Sir William St. Claire, introduced them to each other at a dinner party in Paris.[32]

From the moment of the dinner party, romantic love seems to have enveloped Madame de la Maison Fort and the earl of Southampton, and a whirlwind courtship ensued. Each was in a position to make an independent choice of spouse. As a widow, Madame de la Maison Fort could act freely; her closest relations were her stepmother and her brother. Objections from them to the union would have been unlikely, for marrying an English earl represented a great social advance for her. Southampton was also free to indulge his heart. Since his father was dead, there was no head of the family to whom he was obliged to defer and who might have pointed out certain disadvantages to his marrying this Frenchwoman. In July Southampton's traveling companion and

cousin, Henry Vernon, was back in England on "extraordinary business," which probably was to assist the earl to put his financial affairs in order so that he could marry. Perhaps Vernon looked into the private sales of timber from the New Forest, a part of Southampton's Hampshire estate. With the permission of King Charles I, such sales had been going on since May to help Southampton reduce his debts. Vernon returned to France at the end of July, and within three weeks Southampton and Madame de la Maison Fort were married. Southampton was back at Titchfield with his bride by August 24, 1634, ready to take on the pleasures and responsibilities of a family man.[33]

Rachel de la Maison Fort brought to the marriage highly desirable personal qualities: beauty, virtue, religious devotion, sweetness of disposition, and also high spirits. Rather incongruously, given her undoubted piety, Madame de la Maison Fort, as a young widow, took part in the worldly life of Paris and the court and enjoyed the attention of suitors. Tallemant des Réaux, the contemporary gossip who delighted in reporting lewd anecdotes, wrote incredulously that despite nine years of widowhood and many importunate suitors her reputation as a chaste woman remained intact. One suitor, Saint Prueill de Jussac en Angoumois, wooed her with great extravagance, arranging public games in her honor and one time bringing in twenty-four violin players to serenade her on the street.[34] Madame de la Maison Fort did not dissuade him from this nonsense, and he continued to present her with so many publicly displayed marks of his ardor that they became known as the "Saint Prueillades."

Madame de la Maison Fort must have astonished and bemused her suitors; it was said that she would interrupt a conversation with an admirer, retire for brief prayer and religious meditation, and then return to her suitor for further talk. For a woman to preserve her reputation in the licentious society of the court of Louis XIII and remain at the same time a part of that society took intelligence, common sense, religious conviction, and a love of that society. So successful was she in walking this fine line that Corneille dedicated to her his play *La Veuve*, printed in March 1634, the very month that Southampton arrived in Paris. Corneille used her as the model of a beautiful and virtuous widow, and described her in the dedicatory poem as a "charming original," a woman possessed of a "beautiful spirit in a beautiful body."[35] This rather unusual combination of personal characteristics—fun-loving worldliness, personal virtue, and seriousness of religious conviction—must have held special appeal to the rather sober-sided Southampton. The countess of Southampton's untimely death in 1640 meant that she had only a very limited influence on her children, but, nonetheless, some of these same traits may be discerned in her daughter Rachel.

Madame de la Maison Fort's beauty was much remarked in both France and England. In France she was known as "la belle et vertueuse Huguenotte." The famous portrait artist Van Dyck painted her portrait (reproduced in the illustrations), perhaps in 1636, a year before our Rachel was born, and in keeping with the contemporary fashion in portraiture, employed an allegorical motif, said to have been designed to underscore her beauty. Beauty, in the person of the countess of Southampton, reigns over the Universe from a seat in the clouds and triumphs over Death, symbolized by a skull on which she rests her foot. Van Dyck painted a strikingly handsome woman with lovely dark hair done in a chignon encircled with pearls, black eyes, and regular features, looking at the viewer confidently, even provocatively. He shows a well-proportioned figure, round, bare arms, and slender hands, highlighting the whole with a blue satin scarf draped decolletage over a white chemise. Several copies and versions of the portrait were made, but the original came into the possession of our Rachel, who may also have commissioned a version of it. She gave her second daughter, Katherine, an admittedly inferior copy of a portrait of her mother. The portraits are the only evidence of our Rachel's interest in perpetuating the memory of her mother.[36] One has only to compare the portraits of the countess and Rachel to see that Rachel inherited her beauty from her mother.

There were several reasons, beyond the custom of the time, for a member of the English aristocracy not to choose a foreign bride,[37] why a more calculating and politically ambitious man than Southampton would have stifled the urge to marry Rachel de la Maison Fort. Those reasons make the romantic attachment all the more compelling. First, as we have already seen, Rachel's family did not equal Southampton's in status or wealth. Second, for an English lord to marry a Frenchwoman so closely linked with the Huguenots was a rash step. For several years the influence of William Laud over King Charles I and in church affairs had grown. In 1633 Laud had won the post of archbishop of Canterbury. Already there was evidence of his determination to purify the Church of England of Puritan influences. Moreover, in 1625 King Charles I had married the French princess Henrietta Maria, and by 1634, in the wake of the assassination of the duke of Buckingham, she had achieved some influence over her husband and in court affairs. Devoutly Catholic, Henrietta Maria looked with entire disfavor on the Huguenots in her native land and distrusted the Puritans, their counterparts in England. In such circumstances, Southampton could not expect that his bride would enhance his opportunities for advancement at court, where the financial rewards that usually came with royal favor were great.

Third, Madame de la Maison Fort did not bring a large dowry. In view of Southampton's financial condition, he might have been ex-

pected to have searched for a wealthy heiress as a wife. The earl was certainly not poor, but he had faced severe financial problems in the 1620s. He was a minor at the death of his father in 1624 and so became a ward of the court. It cost his mother close to £3,000 to purchase his wardship and marriage, and she had to pay further sums to the duke of Buckingham, the king's favorite, who won the profits of the wardship and the management of the boy's education. Thomas's father's lucrative pensions were not transferred to him, despite the efforts of powerful persons. Moreover, Southampton had been obliged to pay off his father's debts and provide for his mother. The situation was serious enough for him to sell some properties in 1629, when he reached his majority and sued for his livery. In 1633 he was thinking of making further sales.[38] This is one reason why he felt so remorseful about losing money at the horse races and vowed to give up gambling.

The marriage contract that united Southampton and Madame de la Maison Fort has disappeared, so the exact terms are unknown.[39] But rumors spread from Paris that Rachel did not possess a great fortune. Initially, gossip placed her estate at 300,000 crowns, but later downgraded it to no more than 10,000 crowns.[40] Rumors apart, it is a fact that her first marriage in 1624 to Elysée de Beaujeu, sieur de la Maison Fort en Nivernais, was not a brilliant match. Beaujeu, a Huguenot, held a military post, probably under the duc de Sully. He died, perhaps a suicide, sometime before November 1625. A baby girl, Madeleine, was born posthumously and also died. In December 1626 Elysée's sister, Eleonard de Beaujeu, and her husband, Gédéon de Bois-des-Courts (also associated with the duc de Sully), sued Rachel in the Requêtes du Palais de Paris for 6,000 livres which had been made over to her for the benefit of her daughter.[41] The disposition of the case is unknown, but the suit holds interest for the slight clue it may provide about Madame de la Maison Fort's economic status. Six thousand livres to support a child is a respectable sum but does not suggest a great fortune.

Rumors about the dowry Southampton's French bride had brought him circulated in England too. There it was said that Southampton had got "little" from Madame de la Maison Fort. Further, the story went around that the earl "could have made a match in England that would have benefited his estate." It was said that Sir Thomas Thynne, thought to be the richest commoner in England, had tried to persuade Southampton to marry his daughter, who was learned in Greek and Latin, and whose marriage portion was £40,000. Thynne was so eager to link his children to the noble Southampton family that he also offered to settle £7,000 a year in land on his son and heir and marry him to the earl's sister, Elizabeth Wriothesley, without asking any portion at all from her.[42] Southampton turned down the proposal. Plainly, he gave up a

great deal in material terms when he married Rachel de Ruvigny de la Maison Fort.

Southampton brought his bride back to Titchfield and settled down to establish himself and raise a family. Although he must have realized that his marriage to a French Huguenot woman would not advance his interests, Southampton arranged to present his wife at court in the fall. The new countess, who was already pregnant, dazzled the assembly with her beauty.[43] The next year, in July, the earl made a gesture towards ingratiating himself with the king: he named his firstborn son Charles and laid on a christening party "with the most sumptuous pomp." The affair was attended by the French and Venetian ambassadors, and the king himself made a special trip to London to be present.[44] The birth of the boy was greeted with such joy that his death in November 1635 must have been a grievous blow; it also meant that a personal link with the king was broken. Other children came in rapid succession: Elizabeth in 1636, named after the earl's grandmother; our Rachel in September 1637, named after her mother; Henry in October 1638, named after the earl's father. For none of their baptisms was the king present.

During the years of Rachel's babyhood until 1640 her mother and father lived a retired life at Titchfield, her father devoting himself to repairing his fortune. He came into conflict with the government in so doing, with the result that he developed personal and economic grievances against the king. For example, the revival of the old Forest Laws, one of the quasi-legal steps the king took to raise money during the 1630s when he declined to call a parliament, fell with particular severity on Southampton's Hampshire estate. In October 1635 a Forest Court held at Winchester claimed for the king 2,236 acres of his land. It was said, with some exaggeration, that this action would "utterly ruin" Southampton. Charles later reduced the claim, but some of the earl's land remained under royal control, and in 1638–39 Southampton was still not free to cut timber on his estates without royal permission.[45]

Southampton encountered another difficulty with the court during a visit the king paid to Titchfield in September 1636. The king's officers threatened the earl's servants and tenants because the latter claimed exemption from the charges of carriage. Southampton, citing a grant of privileges by King James I to his father, petitioned for a review and confirmation of the grant.[46] The results of the review are unknown, but it was still another irritating incident in Southampton's relationship with the royal government.

The earl also faced disappointment in other business dealings. In March 1636, Southampton petitioned the king for permission to destroy houses on his Holborn property in London and erect tenements.

Although the king brought the petition to the council with his endorsement, saying that he "much respected Southampton," the council denied it. As had happened with the claim against his forest land, the council reversed itself and granted his petition, but not until two years later.[47] Finally, in 1639 the earl was rebuffed by the crown in his efforts to outfit a ship for colonizing the island of Mauritius. He had persuaded a group of investors to support his scheme and had found a ship for the purpose. But the East India Company objected on grounds of its monopoly, and the crown agreed, so the scheme came to nothing.[48]

On the other hand, Southampton did receive some marks of royal favor. In April 1636 the king made him a councillor for New England and in March 1638 granted him the island of Mauritius, which he renamed Charles Island.[49] In September 1636 and again for six weeks in the summer of 1637, just before Rachel was born, the king paid him the honor of visiting him to hunt in New Forest.[50] Also in 1637, Charles granted denization (that is to say, English citizenship) to his French wife. Denization was in Southampton's interest: it changed the countess's status at law, giving her the right to inherit land, claim guardianship over a ward holding land in tenure, and enjoy the privileges of the earl's title in a court of law.[51] And in 1640 the earl won permission to build a new town house on his Bloomsbury property to replace the house torn down in Holborn.[52]

But these favors were slim marks of royal regard, hardly enough to offset the disappointment and annoyance the earl had suffered in his business affairs. Moreover, Southampton had general reasons for disliking Charles's government. His Puritan inclinations and the influence of his devoutly Huguenot wife would have disposed him against the innovations in the Anglican church that Archbishop Laud was introducing. He objected not only to the notions of royal sovereignty held by Charles I and his friends but also to the rigorous administration in Ireland of the earl of Strafford. Thus, despite some overtures on both sides, Southampton did not become an intimate of Charles I during the 1630s when objections to the government were deepening. Indeed, the king's critics thought that he was hostile to the government and tried to win him to their side in the late 1630s.[53]

The year 1640, when national politics were entering a crisis stage, must have been a very unhappy one for little Rachel. When she was two and a half years old, on February 16, 1640, her mother died giving birth to a daughter, Magdalene, who survived. The loss of her mother occurred at a time in her life when, psychologists today tell us, it is especially difficult for a child to deal with such a blow. Then, three months after her mother's death, her father left his family to go up to London for the meetings of the Short Parliament. That parliament,

called by King Charles I in hopes of getting money to finance the war he was fighting against Scotland, lasted until May 4, with the earl in attendance at every session and voting not to give precedence to the king's request for supplies until grievances were discussed.[54] The Short Parliament marked Southampton's emergence from private life at Titchfield and the beginning of his ascent to national prominence. He became a leader of the House of Lords in the Long Parliament, from the fall of 1640 to 1642, and then a principal adviser to the king until Charles I's execution in 1649. In his frequent and prolonged absences, his four children were placed under the general care first of their grandmother, Elizabeth, dowager countess of Southampton, and later, when the earl married a second time in 1642, of their stepmother, Elizabeth Leigh (daughter of Francis Leigh, Lord Dunsmore, who became the earl of Chichester). These circumstances may have promoted the deep attachment that Rachel formed for her elder sister Elizabeth and the need for the approval of others that she later admitted.[55]

Southampton's political role during these years meant little to Rachel at the time. In the Long Parliament he developed a reputation as a man devoted to the public interest and won appointment to major committees.[56] In April 1641 Southampton broke with the king's critics over their use of a bill of attainder to remove the earl of Strafford,[57] and in January 1642, when the crisis had sharply escalated, he accepted the post of gentleman of the bedchamber and the office of privy councillor to the king. He chose Charles's side, according to his friend, Edward Hyde, earl of Clarendon, out of a sense of duty, a commitment to monarchy, and the conviction that the nobility would fall if the kingship did.[58]

From the spring of 1642 on, Southampton, although mindful of the king's weaknesses, loyally served Charles I. It was he, so it was said, who brought Charles a copy of the *Eikon Basilike* to comfort him.[59] Present at the trial of the king, Southampton was one of four lords who on January 26, 1649, offered to pledge their estates and lives on any terms if the army leaders would spare the king's life, restore his freedom, and preserve his title.[60] After the court condemned Charles to death, Southampton tried without success to visit him.[61] But he allegedly was successful in obtaining permission to watch by Charles's bier in the Banqueting Hall.[62] He and three other peers accompanied the king's body to Windsor to be buried. Stories of all these great events and Southampton's part in them must have been told after the earl's return to Titchfield in 1649, when Rachel was a young girl of twelve years. Years later, when she pleaded with King Charles II to spare the life of her husband, William Russell, she reminded him of how devoted her father had been in serving his father. She meant to call to the king's mind the memory of such events as these.

The Civil Wars touched young Rachel's life in several ways. Some events occurred so close to home that they fell within her ken and would have vivified for her the political affairs of the larger world. Soldiers on both sides were present in Hampshire. In 1643 the earl of Essex's army was garrisoned in the town of Titchfield, located about a mile from Titchfield Abbey, where Rachel lived. Battles took place not far from the abbey, at Portsmouth and West Meon. The estate suffered damage, for iron and wood were seized and soldiers were billeted there. She may have seen and surely would have heard stories of such activities.[63]

Still further, in November 1647, when Rachel was ten years old, King Charles I stopped at Titchfield. He had escaped from Hampton Court, intending perhaps to flee to France, but because of some mishap there was no ship waiting for him, and he made his way instead to Southampton's house. Finding there Elizabeth the dowager countess "with a small family," he stayed for two days before going on to Carisbrooke Castle on the Isle of Wight.[64] Rachel does not mention this episode, but a visit by the king of England must have created a moment of excitement and heightened her awareness of the outside world.

Furthermore, the war and the taxes imposed on royalists by the revolutionary government represented an economic setback to Rachel's family. Her father had to pay a fine of £6,466 to the government and £250 a year to the clergy in churches in which he served as a lay rector. The situation was serious enough for the earl to redraw leases to force his tenants to share the costs of the war, interest himself in agricultural practices to get more yield from his lands, and take out a mortgage on some of his Hampshire properties.[65]

The end of the war brought Southampton back to his family. Rachel, who specifically mentioned living with him at Titchfield, Stratton, and other manor houses from about 1651 to 1654, must have been aware of his continuing services to the Stuarts.[66] After the battle of Worcester in 1651 the earl offered Charles II a haven at Titchfield and a boat to escape to France. In the event, Charles left by another boat, but he was mindful that Southampton was the only person of his quality to risk danger by offering him aid.[67] In subsequent years Southampton deliberately avoided opportunities to become reconciled with Cromwell. Although not a member of the Sealed Knot, the small key group of royalists in England, the earl regularly sent money to the exiled king and kept in touch with Edward Hyde, who in the 1650s tried to orchestrate the political activities of the royalists at home and abroad. These were still further points in the story of Southampton's relationship with the Stuarts that Rachel would have wished to call to mind when she pleaded with Charles II to spare the life of her husband.

Another effect of the Civil Wars on Rachel may have been the

nature of her education. Mary Berry, her first biographer, conjectured that Rachel's formal education lacked rigor and thought this accountable to the dislocations of the 1640s.[68] The point is moot, because the bulk of Southampton's private and household papers have failed to survive, and there is no direct evidence about Rachel's formal education, as there is, for example, about that of her second husband, William Russell, and his brothers and sisters.[69] Nor does Rachel herself, in the two autobiographical fragments she wrote late in life, tell us anything about what she read as a child or the pattern of her day, as does, for example, Anne Lady Halkett, and other women who were her near contemporaries.[70] But a good deal may be deduced from indirect evidence and from what we know of Rachel as an adult.

It is reasonable to assume that a tutor, or more likely tutors, were in residence at Titchfield to instruct Rachel and her sisters. The Italian humanist tradition in which Rachel's father was reared would have demanded as much. Prescriptive literature about educating gentlewomen which appeared in quantity in early-seventeenth-century England reinforced such a requirement.[71] The presence over several generations of educated women in the Southampton family is equally pertinent. The first countess of Southampton, Jane Cheney, the daughter of William Cheney of Chesham Bois in Buckinghamshire, could read and write and possessed a 1532 edition of the works of Chaucer. She was the first owner of this important book, and, reflecting her pride in ownership, she inscribed the book in four places with "this ys Jane Southampton boke." In her will she left her daughters books of gold, set with diamonds and rubies, marked with the queen's writing.[72] The letters of Mary Browne, the second countess, reveal a highly literate woman with style and intelligence.[73] And the third countess of Southampton, Rachel's grandmother, was also a literate woman, who, as we have seen, donated the third earl's library to St. John's College and took an interest in her son's education.

Moreover, the earl of Southampton, although preoccupied with public responsibilities during the Civil Wars, would have provided his daughters with instruction suitable to their class and conformable with the Puritan tradition of Bible and devotional reading. A man reared in the humanist tradition, exposed to his father's great library, and married to a devout Huguenot woman could not have done otherwise. In a letter to Southampton, Henry Tubbe, a graduate of Cambridge and a visitor to Titchfield in 1648, painted a portrait of the high-minded atmosphere there, which he credited to Southampton. The "discipline and devotion" of the household were so "like ours at Cambridge" that he felt that he was at a college, while there was so much "gravity and state, but no pride at all" about the company that he sometimes imagined himself at

court.[74] He asked particularly to be remembered to the "young ladies"—that is, Rachel and her sisters. All this circumstantial evidence carries the strong presumption that a careful program of education was provided the girls in the family.

The curriculum Rachel and her sisters followed was probably one commonly offered to young gentlewomen. They would have been taught to read and write and to do sums. Rachel mastered a clear, legible handwriting (as did her sisters), learned to spell as well as any of her correspondents, and developed a marked talent for forthright, engaging expression. It was customary for a gentlewoman to learn needlework, and Rachel probably did, but in later life it was a pen, not a needle, that was constantly in her hand. She also probably received instruction in music—singing, dancing, perhaps playing an instrument. But Rachel did not mention music nor turn to it for comfort during the sorrows of her later life.

Latin and Greek were not normally a part of the curriculum for girls, and there is no evidence either that Rachel was taught them or that she undertook to learn them on her own, as did some contemporary women. Rachel may have studied poetry and serious literature, but she did not, apparently, develop an abiding interest in either one: in all her many letters she mentions but one poet, William Waller.[75] Like so many of her contemporaries, as an adult she enjoyed the London theater.[76] History may have been included in her studies, as her later interest in reading and taking notes on Roman history would suggest.[77]

French would have been an important part of Rachel's education. It is probable that she had a French tutor, as did earlier generations of Southampton children;[78] it is certain that she developed genuine skill in reading and writing French. Circumstances would have encouraged her interest in doing so. Her French mother, it may be reasonably supposed, sometimes spoke French to her when she was a baby. After her mother's death, the ties with her French uncle, Henri de Ruvigny, strengthened. In August 1641 Rachel and her two sisters, Elizabeth and Magdalene, became naturalized French citizens with a dispensation of the requirement of living in France. De Ruvigny, whose finances had greatly improved at about this time by reason of a royal pension and inheritance of some French property, took this step so that the girls could inherit his property, should he die without legitimate issue.[79] Rachel's brother, Henry, the heir to the Southampton title, was not included in these arrangements. The fact that Rachel held dual citizenship was without apparent importance until many years later, when she exploited that status to strengthen her claim to some de Ruvigny property in France.

Interest in the French language would also have been promoted by visits of the Southampton children to France during the 1640s. In 1643

Rachel's brother, Henry, was sent to France, perhaps to remove him from danger as the Civil War deepened. He died in Paris and was buried at the church at Charenton, where his mother had been baptized and his parents married.[80] Sometime between 1648 and 1651, Rachel herself visited France for an unknown number of months.[81] She almost certainly stayed with her uncle and his new wife, Marie Tallemant, whom he had married in 1647, at their home in the Faubourg St. Germain in Paris. Marie Tallemant, who came from a wealthy family of Protestant bankers, was the sister of Tallemant des Réaux, the famous gossip who wrote about Rachel de la Maison Fort. Marie Tallemant's relatives were to touch our Rachel's life later on.[82] What Rachel did and saw and her reactions to the visit are unknown. Her only surviving reference to the trip came sixty years later when she recalled that she had learned a card game, hoc marevin, in France.[83] But during this visit she would have met her cousin Henri, who was born on April 9, 1648. It was this child, nine years her junior, who would become the first earl of Galway and Rachel's closest friend in old age. Rachel's visit to France was not comparable to a "Grand Tour," which had become an integral part of the education of aristocratic boys,[84] but it would have introduced Rachel to her mother's family, church, and religion; confirmed ties with her uncle; broadened her mental horizons; and strengthened her command of the French language.

The principal substance of her education would have been religious works. She would have read the Bible and the *Book of Common Prayer* and studied catechisms, similar perhaps to the one prepared for her daughter, which she preserved.[85] Since Puritanism was an important part of her father's religion and had been reinforced by her Huguenot mother, perhaps Richard Baxter's *Sincere Convert* was among her books, as it was among William Russell's.[86] Whatever her reading, Rachel became well grounded in the Bible and religious teachings. Yet, according to her disarming confessions made later, religion was not the center of her life when she was young. She admitted that as a girl she was sometimes inattentive at private prayer and disinterested in attending public services. She confessed that she felt she had done well if she read a few lines in a pious book, and that even after a "sharp illness" when she was fifteen she continued to spend her time, as she put it, idly.[87] Rachel also lamented that she read carelessly, out of curiosity, and described herself as "not industrious to get knowledge" to glorify God.[88] Nonetheless, the groundwork for her later piety was laid in her youth.

If Rachel's formal education did indeed lack rigor, a reason equally as important as the dislocations of the Civil Wars was the absence of boys in the family. Had there been boys, their tutors almost certainly

would have instructed the girls as well, perhaps in much the same curriculum, as was the case in the Russell family.[89] But Rachel's two brothers, as we have seen, had died young—Charles at six months in November 1635 and Henry at five years in December 1643. So Rachel grew up in a decidedly female environment, composed of her sister Elizabeth, just fourteen months her senior; her younger sister Magdalene, who died in 1643; her grandmother, in her seventies in the 1640s and still living at Titchfield in 1651;[90] and her stepmother, Elizabeth Leigh, whom her father married in 1642. The new countess, her father's second wife, lived to 1654 and thus was the longest-term maternal presence in Rachel's life. Elizabeth was described as a "beautiful and worthy lady,"[91] but her influence on Rachel was not always praiseworthy. Late in life Rachel confessed that as a young girl she had been "ready to give ear to reports, and possibly malicious ones," and relay them to her stepmother "to please her," and admitted that throughout her life she indulged in gossip.[92] Rachel's remark repays reflection. It surely reveals a young girl growing into womanhood, confronting the often awkward relationship between stepdaughter and stepmother, and trying to ingratiate herself with her stepmother. The desire to please, to "seek the esteem of others," to be unwilling "to displease" people, as Rachel put it later, was one side of her personality.[93]

Elizabeth Leigh bore the earl of Southampton four daughters. Only one child, also named Elizabeth, born in 1646, lived to adulthood. Rachel's three other half-sisters were part of the family for varying lengths of time: Audrey, born in 1643 or 1644, lived until 1660; Penelope, born sometime after 1647, died in April 1649; and a second Penelope, whose birth date is also unknown, died in 1655. Thus, the only male presence in the family was her father, who was absent during the Civil War a good part of the time.

While such a female-dominated household may not have offered a favorable context for pursuing a rigorous educational program, Rachel may have developed a more independent, self-confident attitude than she otherwise would have done had she grown up with brothers whose very presence would have demonstrated that males always took precedence over females. The absence of brothers also provided circumstances in which abiding affection, or disaffection, might grow among the sisters. As it happened, the girls grew to love each other. Rachel was especially close to her sister Elizabeth, with whom she lived at Titchfield after the death of Rachel's first husband. She described her as a "delicious friend," whom she loved with too much passion, and whose "conversations and tender kindness" were precious to her.[94] Rachel was also fond of the younger Elizabeth, her half-sister, who lived nearby in London and with whom she exchanged regular visits. At her death Rachel wrote

that she had "ever loved her tenderly."[95] This sisterly affection not only enriched the personal lives of these three women, but also enlarged their political connections and made possible the extraordinarily harmonious division among them of their father's estate when he died in 1667.

The death of close family members and personal illness were features of Rachel's childhood. As we have seen, her mother died when she was two and a half years old, and when she was six, her younger brother, Henry, and her younger sister, Magdalene, both died within the year. Her half-sister Penelope died when Rachel was twelve years old. Rachel herself barely escaped death from pleurisy in 1652, when she was fifteen. As a young woman she was subject to "rheums," which tended to settle in her lungs.[96] It is impossible to gauge the impact of these experiences upon a child's mind and emotions, but it seems undeniable that they were of some importance in forming her views of God and of personal relationships.

Class and ancestry were critically important determinants in Rachel Russell's development as a woman. Her class was noble and privileged; her family was Anglo-French, which was almost unique in noble English circles. Her mother endowed her with beauty, high spirits, and Continental connections. Rachel's education, although not outstanding, probably fulfilled the important features of the humanist ideal and, in any case, rendered her perfectly literate. A visit to France would have broadened her intellectual horizons, strengthened her command of the French language, and reinforced ties with her mother's family. The great public events of the 1640s in which her father played such a prominent part touched her young life only indirectly, but surely induced in her a consciousness of public authority. Her father's religiosity found reflection in household piety, which laid the foundations for Rachel's own commitment to an Anglicanism that was deeply marked by respect for Puritanism. The death of her mother and of other family members, the remarriage of her father, and her own illnesses and those of others surely reinforced her consciousness of God's presence in man's affairs. Very early in her life, personal relationships were important to Rachel; she learned to love, to please, and to be loved. These features of her background and childhood help to explain her character in adulthood, her assumptions about religion and politics, and her independent spirit.

• 2 •
First Marriage, 1654–1667, to the Honorable Francis Vaughan

In October 1654, Rachel's formal education and childhood came to an end with her marriage to Francis Vaughan, styled Lord Vaughan, the heir to the second earl of Carbery. This arranged marriage, celebrated at Apscourt,[1] her father's estate in Surrey, lasted until March 1667, when Francis died of the plague. The union linked Rachel at the age of seventeen with a noble family whose social standing, cultural interests, political views, and tradition of active service in public affairs were comparable to those of her own family. Her name changed to Lady Rachel Vaughan.

Rachel's first marriage did not shower her with advantages. It is true that the two families occupied the same social rank, the fathers in each holding the rank of earl, and that the lineage of each was about equal. The Carbery family first came to view in the sixteenth century, at about the same time as the Southampton family, when John Vaughan established a seat at Golden Grove in Carmarthenshire, Wales. Vaughan, like Rachel's grandfather, served with the earl of Essex in his Irish campaign in 1599. Later he was comptroller of the household for Charles, Prince of Wales, and accompanied him on his trip to Spain in 1623. In 1628 he was created first earl of Carbery (in the Irish peerage). Richard, his eldest son, Rachel's father-in-law, was born about 1600. A member of Parliament for Carmarthenshire from 1624 to 1629, he inherited his father's title in 1634. In the Civil War, to the disappointment of parliamentary leaders, he became lieutenant-general of the king's forces in three Welsh counties, which won him the title of Baron Vaughan of Emlyn, Carmarthenshire, and the office of governor of Milford. His military career, however, was not a success. After being defeated in 1644 in a battle with the parliamentary army, the second earl of Carbery was so bitterly criticized as a coward that he resigned his command. Although heavily fined as a delinquent, Carbery, alone among royalists in South Wales, escaped sequestration, a favor accountable, it was said, to

his friendship with parliamentary generals. Such friendly connections deepened. In 1648 he opposed a royalist uprising in Wales, and that same year the second countess of Carbery, Frances Altham, a strong woman of great piety, so impressed Cromwell, who stopped at Golden Grove on a military campaign, that he later sent the earl some stags for his estate.[2] Carbery was, obviously, politically flexible, and it is a measure of Southampton's political moderation that he, who had been so entirely devoted to the royalist cause, should have been willing to ally his family with Carbery's.

On the other hand, the financial settlement that Southampton and Carbery arranged for Rachel and Francis was not outstanding. Forty-six manors and farms in Wales were placed in the hands of trustees, including Southampton's cousin Henry Vernon and his nephews Robert and Thomas Spencer, to pay the new couple £900 a year and to guarantee that same amount to Rachel as her portion, payable during her lifetime should Frank predecease her. The size of Rachel's dowry is unknown, but if it conformed to the average for daughters of peers between 1650 and 1674, the sum was £7,800.[3] Furthermore, the bridegroom, although heir to title and estate, was not an especially promising young man. Francis Vaughan was just past sixteen years of age, a little younger than Rachel, when they married; he was also younger than the average English nobleman at first marriage.[4] Frank, as he was called, had been tutored privately as a child by the Reverend Jeremy Taylor at Golden Grove, his development anxiously overseen by his parents. In letters of advice written in 1651, his father noted several weaknesses in his character, among them a "wandering carelessness of spirit," a tendency to criticize others, the habit of speaking out before considering his words, and a passionate nature which the earl feared would later become uncontrollable sexuality. On the other hand, Frank was blessed with quickness of spirit and ability to make sharp, perceptive observations.[5] Lord Vaughan, however, did not go to university, as his younger brother John did, a possibly significant fact given his father's intense interest in education and apparent intention that his heir would do so.[6] The little that is known of Frank's adult personality suggests immaturity: he offended his sister-in-law by a fondness for foul-smelling cheese and disappointed a correspondent by dilatoriness in correspondence.[7]

What Rachel thought of Frank is uncertain; she makes no direct comment about him in surviving memorabilia. But an anonymous correspondent, writing within a year of Rachel's marriage, remarked, apropos of a story about how Rachel's aunt had encouraged the attentions of a suitor, that Rachel "had not been so kind to Lord Vaughan."[8] Rachel herself, reflecting later upon arranged marriages, said that it was "accepting—not choosing—on both sides," probably a reflection on

her own experience.[9] She may have inadvertently revealed the nature of her relationship with Frank in 1695 when, in writing to her daughter Katherine to comfort her over some unhappiness, she recalled that when she was her exact age—that is, nineteen years old—she faced the same problems and dealt with them by not allowing unpleasant things to torment her for long. She counselled her daughter to believe that problems would pass with time and that temporal pleasures and pains were not worth too much trouble.[10] Moreover, what she recorded of her life as Vaughan's wife was not her happiness in him, but her travels from Wales to London and other places to visit her family. What she found to regret about these years when she reflected on them in old age was that she had trifled away her time and enjoyed the social diversions offered by London. Further, she confessed that she took little interest in the baby boy born to her in 1665, who died, the second child she had borne who died. She admitted that she wanted to regain her strength quickly following the birth, so that she might spend her time as before, with her "loved sisters."[11] She recorded Frank's death of the plague in March 1667 without comment. Clearly, these are not the recollections of a devoted wife and loving mother.

During her marriage to Vaughan, Rachel's principal residence was at Golden Grove in Wales, the main seat of the Carbery family. After 1660, when the earl became lord president of the Marches of Wales, she was also often at Ludlow Castle, in Shropshire, the lord president's official residence. But Rachel was not isolated in a cultural backwater, as one might think. Notwithstanding restrictions on the travel of royalists during the Interregnum, Rachel made frequent trips to visit her family. She was often in London, where she stayed with her father, and he visited Golden Grove for "some months" in 1656. The entire Carbery family was in London "on business" in 1657.[12] Rachel also traveled to Titchfield, the home of her sister Elizabeth, married in 1661 to Edward Noel, son of third viscount Campden, and to Petworth, the home of her half-sister Elizabeth, who married Joceline Percy, eleventh earl of Northumberland, in 1662. She went on holiday to Bath in the summer of 1661 with her second stepmother, Frances, and was at Bath again the summer of 1662 with her cousin Margaret Spencer and Margaret's husband, Anthony Ashley Cooper, later the first earl of Shaftesbury.[13] In all she records twenty-three visits to places outside of Wales. Such visits would have kept her in touch with a larger social, cultural, and political world.

The Carberys were cultivated people who respected the life of the mind and promoted the interests of creative intellectuals. The earl's enthusiasm for education, expressed in letters of advice to his son, goes far beyond a formulaic endorsement. As he put it, "A noble person of all

others has need of learning and therefore should contribute most time to it." If one may infer that Carbery practiced what he preached to Frank, then one may believe that he kept abreast of the law he had learned at Gray's Inn earlier, and that he took special pleasure in reading history, which he described as the "nobleman's best school." He three times recommended the works of Sir Francis Bacon to Francis, commending them especially for their style. Carbery, moreover, appreciated lively, intelligent conversation. He had developed an admiration for the wit of the Spanish, having visited Spain as a young man, and thought Spaniards the "best company in the world." He offered detailed advice on how to argue a point, conveying the impression of a man who has had experience in doing himself what he is talking about.[14]

Of first importance in his education, Carbery told his son, was to love God and to practice faithfully religious devotions and duties. He advised Frank to avoid sectarianism and ground his convictions upon study of the Bible. There is nothing rigidly doctrinaire about his advice, and discussions about religion were probably lively at Golden Grove. On the one hand, Carbery was tolerant of advanced Puritan ideas. A copy of the third edition of Milton's *Eikonoklastes* was sent to him, inscribed in a late-seventeenth-century hand, an extraordinary gift to a noble Englishman.[15] His son John flirted for a time with Quakerism and was arrested in 1664 for attending a Quaker conventicle at Mile End Green.[16] On the other hand, Carbery gave asylum to the Reverend Jeremy Taylor, who served the household as domestic chaplain and tutor of the children and would have provided a strong orthodox Anglican viewpoint. Taylor gratefully acknowledged that the earl allowed him free time from his duties to write. Among the books he wrote while at Golden Grove were his two most popular pieces of devotional literature, *Holy Living* (1650) and *Holy Dying* (1651), both dedicated to the earl of Carbery. One of the themes in his sermons and essays was the nature of ideal Christian marriage. He set out the duties of the partners and painted a picture of shared love in each other and their children.[17] Rachel's views about marriage seem to reflect the message of Taylor's sermons.

A further measure of the range of the earl's interests and tolerance of diverse views is his patronage. For example, he assisted such writers as James Howell, who dedicated his *Lexicon Tetraglotten* to him in 1658, and Rowland Watkin, who wrote poems in his honor published in 1662 under the title *Flamma sine Fumo*. He entertained John Taylor, the "Water Poet." William Nicholson dedicated his *Exposition of the Apostles' Creed* to the earl, and Samuel Butler, while serving as the earl's steward at Ludlow Castle during 1661, wrote the first part of *Hudibras*, the long satirical poem about Puritan leaders.[18]

Lady Vaughan could have met all of these people, but the only one she mentioned in later life was Jeremy Taylor. She certainly would have heard Taylor preach and otherwise have encountered him during the years they both were at Golden Grove (1654–57). They would have met again in London when he served as chaplain to her father in 1662.[19] She turned to Taylor's essays and prayers to help guide her devotional life, saying later that for years her prayers were drawn from his book *Holy Living*.[20]

Rachel's mother-in-law would also have enriched the Carberys' cultural life. Alice Egerton, daughter of the first earl of Bridgewater, became Carbery's third wife the summer of 1652.[21] Gifted musically, she had earlier taken part in several masques, as both dancer and singer, and had played the role of the Lady in the first performance of Milton's *Comus*, which took place at Ludlow Castle in 1634 to welcome her father as lord president of the Marches of Wales. Her music master, Henry Lawes, a friend of Milton's, had written the music for that performance. Lawes regarded Lady Alice as one of his most promising pupils, and in 1653 he dedicated his *Ayres and Dialogues* to her and her sister, referring to their excellence in "vocal music, wherein you were so absolute, that you gave life and honour to all I set and taught you."[22] It seems certain that as countess of Carbery, Alice would have continued her interest in music and likely that she invited her old music master, who had other friends in Wales, to visit Golden Grove.[23]

The countess's reputation for intelligence and interest in the arts preceded her to Wales. Katherine Philips, the poet, called "the Matchless Orinda," lived nearby and welcomed her with a poem. Philips admitted that the cultural life in the country was rather thin, but asked the countess to "receive this tribute of our shades from me." She went on to declare that Lady Egerton's talents "to these sad groves such a refreshment bring" that Wales will become the envy of cities.[24] Such praise may be thought to be overblown, but it still portrays a woman who had won recognition outside of her family and who would have insisted upon a cultivated environment wherever she lived.

Katherine Philips had other indirect ties with the Carberys. She and Henry Lawes knew each other, for he had been her music master and she wrote a poem in his honor.[25] Further, Philips put herself in touch with Jeremy Taylor, writing him for advice on reconciling friendship and Christianity. He responded in a lengthy essay, later published, in which he acknowledged Philips' query and complimented her on the strength of her ideas.[26] There is no evidence that he and Philips ever met or that Philips was invited to Golden Grove, but in view of the connections that had been established, both possibilities are likely.

John Vaughan, Rachel's brother-in-law, who was only fifteen

months younger than her husband, would have surely enlivened conversations at Golden Grove. Educated at Oxford (he matriculated at Christ Church in 1656), John developed an interest in poetry and wrote verse himself. Later he became one of Dryden's first patrons. Moreover, it was he who was captivated by Quakerism and, as already mentioned, was arrested at a Quaker meeting at Mile End Green in 1664. He courted Guilielma Maria Springett, whose mother married the republican Isaac Pennington, and who herself married William Penn in 1672. John Vaughan remained sympathetic to the Quakers until he succeeded to his father's title in 1686.[27] Interested also in mathematics, science, and navigation, John won admission to and eventually the presidency of the Royal Society. In 1667 he was prominent in the impeachment of the earl of Clarendon, because, it was said, of Clarendon's desire to curtail the powers of the Marches of Wales. In 1675 he was made governor of Jamaica and accused of administering the island with a brutal hand. His marriage in 1682 to Anne Savile, the only daughter of George Savile, who that year had been made the first marquess of Halifax, provided another familial link between Rachel and Halifax, who were already cousins by marriage, his mother being a Spencer. John Vaughan and Rachel must have become friends during the 1650s; they kept in touch with each other until Vaughan's death in 1713.[28]

It may be presumed that politics was a topic of conversation at Golden Grove. One letter has survived to suggest that Lady Vaughan probably took part in such talk. An unidentified correspondent, known only by the initials A.E., wrote to Rachel on January 20, 1660. Intimating that the correspondence was regular—"I must begin...where I ended in my last"—the writer provided a detailed account of General Monck's activities, the relations between London and Parliament, and the internal affairs of the House of Commons. He sent Rachel copies of political doggerel and of a letter the Speaker of the House of Commons allegedly concealed.[29] His remarks are of uncommon importance because they prove that prior to the Restoration Rachel possessed—or was thought to possess—a more than casual interest in public affairs and that a correspondent kept her rather well informed.

Although Lady Vaughan's recollections of these years at Golden Grove and Ludlow Castle do not mention cultural and intellectual activities, and although Rachel did not in later life show much interest in music or poetry, it is inconceivable that the interests of the Carberys made no impression upon her. Had she married into a different kind of family and spent the decade of her twenties vegetating in a remote country house, then her own intellectual self-confidence and interests might have failed to develop. As it was, the Carbery family provided a stimulating cultural and intellectual environment.

That Rachel fit easily into that environment is suggested by the fact that she endeared herself to her husband's family. Within a year of her marriage one Francis Williams, a friend of the Carbery family, paid her a fine compliment; he wrote that she proved that there was no charm so great as goodness, that he had observed this quality in her, and that all who knew her honored her for it.[30] Rachel shared her mother-in-law's interest in books, as Williams' efforts to supply the two women with them show.[31] Following Frank's death, Carbery wrote her a warm and sincere letter, assuring her of his love and affection, regretting her absence at Golden Grove, and affirming his obligations to her.[32] Throughout her long life, Rachel kept in touch with the Vaughans, including her father-in-law, her brother-in-law, John, and his wife, Anne Savile, and her two sisters-in-law, Frances and Althamiah. It need hardly be said that a woman does not always achieve such a position in her husband's family; that Rachel did suggests a personal attractiveness that appealed to diverse people. Rachel's affection for her husband's family did not weaken her identity with her own family. Rather, it revealed her emotional warmth, need for approval, and desire to create extended family connections, attitudes that remained with her throughout life.

Rachel's marriage introduced her to a family in which there were a number of men: husband, father-in-law, brother-in-law, male intellectuals, and probably other family friends. As we have seen, she also received letters from men. This male presence in her life was very different from her girlhood and adolescence. The evidence is too small to draw firm conclusions, but it seems to show that for the first time Rachel had male friends. Such contacts would also have helped to keep her in touch with a wider world and have prepared her for later heterosocial friendships.[33]

All during the years of her first marriage, as was the case during her childhood, Lady Vaughan confronted personal illness and the illness and death of people close to her. Three years after her marriage, in 1657, she was stricken with measles and three years later with smallpox, both dread diseases in the seventeenth century.[34] There is no indication that she was left pockmarked. Her successful recovery from these illnesses would have induced immunity and would explain why she later escaped infection when so many members of her family succumbed. Death struck people close to her. Her grandmother, in whose charge, it will be remembered, she had been placed as a little girl, died in 1654 and her first stepmother, Elizabeth Leigh, in 1656.[35] Two half-sisters died—the second Penelope in 1655 and Audrey in 1660. Rachel's first pregnancy in 1657 presumably ended in a miscarriage, and the two babies that she bore Francis Vaughan died—in 1659 and 1665.[36] Frank died in March

1667 and her father two months later. There was scarcely a year that Rachel was not either ill, pregnant, giving birth and suffering the trauma of infant death, or enduring the deaths of people near her. Even though she records rather than comments on these events, they must have influenced her attitudes, sharpening her awareness of the transitoriness of life and the power of God over each individual's fortunes. Taylor's *Holy Dying* assisted her then as it was to do later.

The Restoration brought office and wealth to the men in the Carbery and Southampton families, and thus gave Lady Vaughan entrée to high social and political circles in London and Wales. Her husband's political career was a modest one. Frank's father had predicted earlier that Frank would not be "easily enticed" out of private life into the public world, but he did undertake the duties usual to a person of his class.[37] Both he and his brother were elected to represent Carmarthenshire in the Cavalier Parliament, and he served on one important committee, that for the Corporation Bill.[38] He also took his place as a county leader, holding such posts as justice of the peace for Cardiganshire and Carmarthenshire from July 1660 to his death and serving as a member of the Council of the Marches of Wales under the presidency of his father. His interest in mining—he was involved with others in securing a license from the king to dig mines in certain areas and retain the profits for forty-one years[39]—may have revealed economic and intellectual venturesomeness.

Rachel's father, by contrast, held one of the most important posts in Charles II's government, that of lord treasurer, and received the Garter, the highest order of English knighthood. But Southampton was not an intimate of the new king, in large part because he found many things to criticize in Charles's private activities and public policies. First, he took offense at the king's mistresses, refusing to visit them and to allow Lady Castlemaine's name to appear in the treasury books,[40] despite the fact that Charles was known to regard as an "enemy" anyone who criticized his mistresses. Second, Southampton opposed the project of maintaining soldiers in peacetime who would be answerable to the king, and was only dissuaded from pointedly objecting to the king by Clarendon's promise that the number of soldiers would be kept to a minimum.[41] Third, the earl disagreed with the religious policy of the Anglican bishops and the king. He disliked the bishops' refusal to amend the church's government in order to conciliate Presbyterians.[42] Passionately anti-Catholic, he believed that both the king and the duke of York underestimated the danger from Rome. Accordingly, he joined with Clarendon in opposing Charles's bill for liberty of conscience, a step which so angered the king that he upbraided them both.[43] Finally, Southampton was deeply disappointed that Charles failed to follow his

advice to reduce his expenses. Exasperated with the king, Southampton reportedly declared that Charles should not have been allowed to return to England without conditions on his authority.[44]

For his part, Charles had little regard or affection for his treasurer. The earl's integrity and good intentions could not compensate for his frequent absences due to poor health or his failure to deal effectively with the debt of the government.[45] By 1664 some men were urging Charles II to replace Southampton, but either because of his respect for the earl's popularity or because of Clarendon's intervention, Charles refused. A contemporary aptly summed up the relationship when he wrote that when Southampton died, the court felt that it was "delivered of a great man, whom they did not much love, and who they knew did not love them."[46]

Whatever the view of the court, other people found much to admire in Southampton. He was regarded as personally incorruptible and commended for taking a fixed salary—of £8,000 a year—and refusing to sell treasury offices to his own profit. Clarendon, his good friend, thought him to be a "person of extraordinary parts," and Burnet concurred.[47] Southampton's nephew by marriage, Anthony Ashley Cooper, described him as "wise and worthy."[48] The two medals of him cast in 1664 were testimony to the social and political prominence that Southampton had achieved.[49] It was, of course, such views as these that Rachel hoped to recall when she appeared at her second husband's treason trial in 1683 and then prostrated herself before Charles II, begging for his life. Perhaps she did not fully appreciate that Charles had little love for her father and that her appeal must have suffered some diminution as a result.

Not only did Lady Vaughan's father hold high office during the Restoration, but he also was able to rebuild and expand his estate. Although the Cromwellian financial exactions represented a setback, they had not destroyed him financially, and in 1657 he reactivated the plans he had made in the early 1640s to build a mansion on his Bloomsbury property. In 1660 he spent over £5,000 finishing the house. He named it Southampton House-in-the-Fields, to distinguish it from the earlier Southampton House on Holborn. Over the next few years he furnished it lavishly, buying silver candlesticks, hangings, screens, silver serving dishes, linens, and paintings, including portraits of two of his deceased children, Henry and Magdalene. In 1662 he commissioned the portrait artist Sir Peter Lely to paint Rachel and paid him £20. The earl also purchased from Jeremy Taylor, now one of his chaplains, a great Bible for the chapel.[50] He greatly improved the setting of his mansion by tearing down the wooden tenements in the area and replacing them with brick houses which he rented. By doing so, his income was greatly aug-

mented, his London estate bringing in over £3,000 a year at his death.[51] A first-class suburban developer, the earl created a highly profitable, exceedingly attractive complex, which his daughter Rachel was to inherit. He also set an example in property management which Rachel could—and did—draw upon.

The political and social position of her male relatives involved Rachel in the lively social life of Restoration London. She had a little extra money of her own to spend, for, starting in 1660, her indulgent father provided her and her two sisters with an allowance of about £33 a year.[52] She enjoyed "all too well," she admitted later to her chagrin, the "esteemed diversions of the town"—walking in the park, visiting, plays, "etc." According to her account, she indulged in idleness at Tunbridge and Bath, and was "slothful" in her attention to spiritual duties in both Wales and London. She remembered regretfully that she had preferred attending Sunday services at some place other than her "dear" father's house, where the sermons were long and the ensuing discussions tedious.[53] In her old age, having lived for many years a life of piety, Rachel may have exaggerated these youthful follies, but it cannot be doubted that she indulged in the diversions usual to an aristocratic lady in the 1660s, and that at the time she enjoyed doing so.

The year 1667 was a traumatic one in Rachel's life. She lost her husband, who died of the plague at Ludlow Castle on March 2, 1667, and her father, who died on May 16 in London at Southampton House of kidney stones, an ailment that had plagued him all of his life. Rachel noted both events in her diary, but added about her father, "my good father died."[54] She would have witnessed her father's remarkable fortitude during the last days of his life. He suffered excruciating pain, made all the more agonizing by a new French treatment he had tried.[55] It is likely that Rachel would have known of her father's concern for the ill children of James, duke of York, and his inquiring about them the morning of his death.[56] Perhaps she hoped to evoke memory of such a thoughtful gesture when she pleaded in 1683 with the duke to urge his brother to spare the life of her husband. Rachel would probably have assisted her stepmother in making the arrangements for her father's elaborate funeral and certainly would have gone with her family to Titchfield for the burial on June 18.[57]

Thus, Rachel was left at the age of thirty a childless widow, with her father dead. Her father had been a greater influence on her than any other person up to that time. For her entire life, he had set an example of devotion to the Anglican church but sympathy for Dissenters, of high-minded living, and of service to one's country. From him, an observer remarked later on, Rachel had inherited her ideas about the church, the role of the Dissenters, and the "business of civil government."[58] South-

ampton had also given her what psychologists today say is of great importance in the development of a girl's self-confidence, the affection, approval, and even indulgence of a father. His influence may also have inclined Rachel to identify with men more than with women and throughout life to choose a male rather than a female for her closest confidant.

Living for thirteen years in the Carbery family as Frank Vaughan's wife also surely left a mark on Rachel. The religious, political, and cultural attitudes of the Carberys reinforced those already exemplified in her father and encouraged Rachel's intellectual development, which, had the family been differently inclined, might have atrophied. Her lack of fulfillment in this first marriage may also have inspired both a romantic notion of what married love might be and a realistic assessment of the chances of achieving it.

· 3 ·
Second Marriage,
1669, to the
Honorable William Russell

Rachel remained a widow for a little over two years. Then, on Tuesday, August 20, 1669, she married the Honorable William Russell, second son of the fifth earl of Bedford. The ceremony, celebrated at Titchfield, where she had been staying with her sister, Elizabeth, wife of the Honorable Edward Noel, must have been a splendid affair. The groom was resplendently attired in a suit of scarlet and silver brocade with a cherry-colored silk shirt, gold and silver braid, flounced garters made of silver lace, and a silver and gold sash. One hopes that the dress of the bride, about which no evidence has survived, was comparably gorgeous. It is a guess that the Reverend John Fitzwilliam, chaplain to Rachel's recently deceased father, and later Rachel's confidant, performed the ceremony.[1]

Rachel and William had fallen passionately in love with each other and married for love, just as both sets of their parents had done.[2] Within three months of Frank's death, in June 1667, gossip circulated that William had a "great desire" to win Rachel's hand.[3] Rachel, on her part, was already sufficiently attracted to William to seek her sister's help in unraveling the meaning of remarks made by his relations.[4] But the courtship was protracted. William was uncharacteristically bashful in Rachel's presence. His diffidence, as he himself explained, reflected passionate emotion, and it also may well have stemmed from self-consciousness over the fact that whereas Rachel was an exceedingly wealthy widow, he was, at that time, only a second son. Although his older brother Frank was sickly, William had no certain prospects of inheriting his family's wealth and title. He may also have felt that his father's financial reverses in 1665–66, which had led the earl to curtail family expenses sharply, strengthened the suspicion that he designed to marry Rachel for her money.[5]

Rachel apparently sought to advance the courtship by writing William and encouraging him with "expressions of love," as William put

it, and these gestures moved William to try to write her of his devotion. Drafts of letters, one with crossed-through words and insertions, survive to show how he struggled to do so. He began one draft by saying that he had intended to write "without being quickened thereunto by so great a favour and honour as a letter from your own hand," but that he was unable to express his happiness at "having a place in your memory."[6] In another draft he apologized for "the small haste" he had made in expressing his "thankfulness" for her "manyfold kindnesses and testimonies of affection." He explained that his failure to speak came from his fear that he could not express properly his "deep sense" of those "fore-mentioned favors, nor make known unto you but in part how much I am. . ." At this point William gave up, and the letter trails off, unfinished.[7] The letters, whether eventually dispatched or not, provide fascinating proof that a highly respectable, religiously inclined woman might take pointed initiatives in the courtship ritual. It is regrettable that Rachel's letters themselves are missing, for her "expressions of love" might well have illuminated the nature of female sexuality.

This bashful but ardent suitor had better luck in getting his thoughts about Rachel down on paper in 1668, when he wrote a lengthy letter to his mother, who was expecting to see Rachel. The letter offers a near-classic statement of romantic love. Russell was concerned that if his mother pressed his suit for him it would harden Rachel's announced determination not to remarry. He said that he would give anything for Rachel to know how much he loved her, but he feared that if he tried to tell her himself, he would be unable to speak, "so great an awe and reverence would then possess" him. He confessed that he led an "uneasy life," sauntering about town, thinking his day "excellently well spent" if "by chance" he saw her coach pass by. "What relief that gives me, it would move your compassion." William insisted that "it is not her fortune I look after. . .'tis her person and that alone I adore and admire, and had I the riches of the Indies they should be all dedicated to her." His love, he protested, had no base ends to it. He concluded that if he did not win Rachel, he would be "driven to despair" and would abandon the world so as not to be a "trouble" to his friends.[8] Rachel's acceptance of William spared him this fate.

If there was a romantic streak toward love in William, there was also one in Rachel, but for her it vied with a realistic assessment of marriage and of widowhood. In a letter to a female confidante, she remarked that "few" people find "felicity" in each other and that she saw no reason to expect it for herself.[9] She told the same correspondent, who apparently was one of several to offer advice, that her inclinations were far from fixed. Denying that by word or act she had ever given Russell reason to think otherwise, Rachel admitted that William's suit deserved

"all the civility I can give [it]." Heaping scorn on men who wooed her in an "extravagant" way—an attitude that must have made Russell's diffidence all the more charming in her eyes—Rachel declared that she still found her condition as widow a "very easy" one, and, displaying self-reliance and independence, asserted that she would not change it "unless I can think it wisest" to do so. Granting that widowhood had its vexations, she observed that "sure there is desperate hazard" in marriage. Even so, more than a hint of romance inheres in her view of married love. Writing that she "tremble[d] at a light inconstant haste," Rachel concluded, "If I love once, I shall do so ever."[10] Her attitude became a self-fulfilling prophecy.

That William, still unmarried at the age of thirty, should have felt such passion for Rachel is not difficult to understand. Her physical appearance, personality, and wealth attracted suitors. Although she was not the beauty among the Wriothesley girls—her half-sister Elizabeth was considered that—she was a handsome woman. A miniature bust and a waist-length portrait painted at about this time (both reproduced in the illustrations) show a woman with a markedly high forehead (a family trait noticeable in portraits of her mother, father, and half-sister), with light brown hair softly following the curve of her face, done in ringlets at the ears, and drawn up and back in a large chignon. The dark brown eyes are frank and open; the nose regular and a bit long; the mouth wide, and the lips full, somewhat puckered, and sensuous. She wears a string of pearls close about her throat and a bracelet of pearls and dark stones about the upper arm. The beginnings of a double chin and the round fullness of her arms and bosom suggest an ample figure and betray fondness for food. The portrait gives the impression of a woman taller than average for a woman, as her mother had been, and other evidence indicates that Rachel was about five feet seven inches in height.[11] An orange-colored gown decorated with pearls and a brooch sets off her face. Rachel is presented in the miniature and the portrait as an attractive young woman who possesses a sense of confidence and security that comes with wealth, social position, religious conviction, and the knowledge that one loves and is loved.

Not only was Rachel physically attractive, but she also had a lively, warm personality. From her French mother, it was said, she inherited vivaciousness and quickness of spirit, while her English father endowed her with "solidity" of judgment. This mixture of traits enabled Rachel to grasp quickly the heart of an issue and, at the same time, apply sound judgment to it. Her voluble manner of speaking suggested her mental agility. A contemporary remarked that Rachel's "thoughts furnish so fast for her in discourse that she [was] sometimes as it were choked with them, and can scarce fetch them all out."[12] Her articulate-

ness won praise from another observer, who said that he "never knew man nor woman speak better."[13] She expressed herself in writing with the same kind of fluency and ease that marked her speech. A sharp temper was a less attractive aspect of her vigorous personality; others noticed it, and later she confessed it. She even composed a short essay on anger in which she maintained that choler was as necessary as blood to a person, for without the one "we cannot live and without the other we should be as inactive as snails and oysters, drones."[14] Such a person might be expected to feel physical passion with special intensity, as Rachel apparently did.

At this time in her life, Rachel's high spirits found outlet in a lively social life. Displaying qualities observable in her mother when she had been a young widow in Parisian society, Rachel took part in London and court society after Frank's death, making it her business to be in London for part of each year. For the first year of her widowhood she lived with her stepmother at Southampton House and at Stratton. Although during this year Rachel must have observed the convention of dressing in black, she did not live in seclusion as some prescriptive advice to widows would have required, for, as we have seen, three months after Francis's death, William was courting her.[15] She spent the summer of 1668 with her sister Elizabeth at Titchfield, but for the winter of 1668–69 she and Elizabeth took a house together in Southampton Square.[16] London was recognized as a "marriage market,"[17] and it is legitimate to think that Rachel, whatever her reservations about a second marriage, spent the winter in London to survey that market. She clearly enjoyed herself in London, even as she had done in the early 1660s. In the one surviving letter from these years, she recounted with evident relish an episode in the courtship of an unidentified couple.[18] Writing that she will "personate" the lady, Rachel took pains to recreate in an amusing way a dialogue between the woman and her suitor, whom she rejected. Rachel reported that the man had taken the lady by the hand and after some silly questions had "said he had a favor to ask, but with so much disorder that she quickly suspecting said, he had made an ill choice to ask any favor, since she was never fortunate enough to do anybody a favor in all her life. . . . Some more short questions and answers past; though they (as perhaps to you) appeared long to her," and the lady disappeared in her coach. Letters followed, but the couple did not meet again "till upon the stairs coming to the coach; the dialogue would be too tedious, considering all I have said already," Rachel wrote gleefully, "but he concluded himself miserabler and she resolved in the case; so it rests, with a quiet night on both sides I believe."

She also included comments, some of them rather acid, about several of her own suitors. But Rachel was neither censorious nor judg-

mental of the behavior that she described; on the contrary, she was humorous, a bit arch, and certainly worldly wise. Had she been otherwise, it is unlikely that she would have found William Russell so attractive, for he was at this time very much a part of the morally relaxed society of Restoration England. Yet, Rachel did not herself participate in loose behavior nor stain her reputation for virtue and goodness. Just as was said of her mother, so it may be said of Rachel, that it took intelligence and restraint to maintain such a position in court society, and a love of that society to want to do so.

Finally, Rachel would have attracted suitors because of her wealth, which as a widow she could bestow on the person of her own choice; she did not even have a father to defer to. Her marriage contract with Francis Vaughan provided her with an annual income of £900, which, as we have seen, her father-in-law had confirmed at Frank's death. At her father's death, Rachel inherited one-third of his property, the whole estate having been divided equally among the three sisters, as Southampton's will instructed. The reason the estate was not shared with or bequeathed to Southampton's widow, Frances, was that their marriage settlement drawn up in May 1659 arranged that in exchange for having her property from her previous marriage solely at her disposal, Frances forfeited any dower in Southampton's estate and any part of it not specifically willed to her.[19] So, in July 1666 when Southampton drew up his will, he directed that his property be divided equally among his daughters, unless he should have a son by Frances, in which case the boy would receive the entire estate.[20] But the birth of any child was not assured, and reflecting confidence in and affection for his girls, as well as the desire to preserve his property in the hands of his own descendants, Southampton ordered that his daughters were to be regarded as tenants in common without respect to survivorship and that their husbands "shall not intermeddle" with the property they would inherit. Southampton left his wife (among other bequests) Southampton House in Bloomsbury and all its appurtenances to hold during her lifetime.

How the estate was to be valued and then divided the earl did not specify. That was worked out by the trustees in January 1668.[21] The trustees—Sir Orlando Bridgeman; Robert Leigh, their great-uncle; Sir Henry Vernon, their cousin; and Sir Philip Warwick, their father's former secretary at the Treasury—were men in whom Rachel and her sisters could feel complete confidence, but the fact that there was no haggling over the division of the property also testifies to the sisterly affection among them. At about the same time, on January 17, 1668, Rachel and her two sisters, clearly to avoid having one of them perform the act, authorized Thomas Corderoy, their father's receiver general, whom the earl had appointed in his will to manage his estate, to "draw on their

behalf the ball or lot...out of the bag" to determine which portion of their father's estate would go to which of them.[22] In further evidence of the cooperation between the three sisters, they agreed the next day with the trustees to levy a fine in Hilary term to raise money to pay off the debts of the estate and charged equally each sister's part of the estate.[23]

Testifying to increasing personal involvement in managing her own business affairs, Rachel herself wrote on the outer sheet of the statement she received that specified her share, "Valuation delivered to me by trustees 1668: the estate being valued and divided into 3 parts." She copied down the valuation of her share—£85,000.[24] Rachel received some manors in Hampshire, most importantly Micheldever and Stratton, whose rental income all together was about £1,000 a year. The manor house at Stratton, called Stratton House, was valued at nothing, for, as Rachel noted, half of it had burned down in 1668, but the goods in it were valued at £300.[25] She also inherited several pieces of property in Middlesex and London, including lands in St. Pancras, St. Martin's-in-the-Fields, Southampton House at Holborn, the manor and former hospital of St. Giles, and most importantly, the manor of Bloomsbury. The Bloomsbury property was bounded by Tottenham Court Road, what became Euston Road, Southampton Row, and New Oxford Street. It included two other separate parcels of land, one off Tottenham Court Road and the other across Euston Road. The general area of Bloomsbury bustled with activity from the market, cattle grazing in the fields, and 146 tenants who rented residential housing built in and around the square. The property brought in an annual income of over £2,000 annually.[26]

On the Bloomsbury estate, in the area called the Long Field, stood the now-completed mansion Rachel's father had been building for so many years. It was also called Southampton House, sometimes with the word "Bloomsbury" added to distinguish it from the Southampton House in Holborn. The house fronted on Southampton (now Bloomsbury) Square, with one side on Great Russell Street, which was cut through to connect the mansion and the square with Tottenham Court Road. Although the house was part of her inheritance, it did not immediately come to Rachel, for, as just noted, her stepmother, Frances, was given it to hold for her lifetime. Because of Lady Southampton's life interest, the house was valued at but £6,000. Owing to the luck of the draw, Rachel inherited what would become the most valuable portion of her father's huge holdings. Her beauty, personality, social position, and wealth made her one of the most desirable young widows in England.

What kind of man was it with whom Rachel fell in love and continued to adore until his death in 1683? He was a socially prominent, good-looking man, with a warm, exuberant personality. William's

family claimed a lineage as long as Rachel's, and his forebears, like hers, did not achieve real prominence until the sixteenth century. Then they rose in the service of the Tudor kings, winning office, land, and wealth. John Russell (1486?–1555) first came to the attention of King Henry VII because of his linguistic abilities. A story, which may well be true, relates that in 1506 Philip, archduke of Austria and king of Castile, and his bride, Joanna, were forced by bad weather to land at Weymouth in Dorset, where their local host, knowing of Russell's talent at languages, called upon him to serve as interpreter. Russell then accompanied the royal guests to London, where he was noticed by King Henry VII.[27] Thereafter he distinguished himself as diplomat and soldier, and at about the same time that his friend Thomas Wriothesley was made earl of Southampton, Russell in January 1550 became the first earl of Bedford. Born in Dorsetshire, he accumulated by grant, purchase, or exchange with the crown quantities of property in western England, including the tenth-century abbey of Tavistock in Devonshire, and also land in Cambridgeshire, especially the monastery of Thorney, and above all the Cistercian Abbey of Woburn in Bedfordshire. Like Southampton, Russell also won land in London: Covent Garden near Charing Cross on the Strand, with seven acres stretching out from it, called Long Acre, located in an area not far from Southampton's holdings.[28] The fourth earl of Bedford developed a residential square in Covent Garden, just as Rachel's father did later on his Bloomsbury estate. Rachel visited or lived in many of these properties after her marriage to William, especially Woburn Abbey, which became the principal seat of the Russell family in the 1620s, when William's grandfather settled there.

William's immediate ancestors, although active in politics, did not achieve the prominence that Rachel's forebears had. William's grandfather, Francis, the fourth earl of Bedford, was a sharp critic of Charles I's policies. Early in the reign he had subscribed to the Petition of Right, and in the Short Parliament he had opposed granting supply before redress of grievances, just as Southampton had done. In the Long Parliament the earl had briefly been a leader of the popular party in the House of Lords. But, again like Southampton, Bedford objected to the treatment Strafford received and to altering the government of the Anglican church, and at his death on May 9, 1641, he was seeking some way to effect a compromise between king and Parliament.[29] William's father, the fifth earl of Bedford, vacillated between the two sides in the Civil War. In 1643 he abandoned his post as general of the horse of the parliamentary army and as commander of Oliver Cromwell, a captain of one of his troops of horse, and joined Charles at Oxford. There he won a pardon from the king. But by the end of the year he returned to the parliamentary side, a step that surely moderated the fines on his prop-

erty. From then until the Restoration he took no part in politics, occupying himself with projects for draining the fens and with managing his estates and educating his growing family. When Charles II returned in 1660, Bedford emerged from retirement and appeared in the coronation service. It was not until 1671, however, that the king appointed him to a post, that of governor of Plymouth, and in 1673 made him joint commissioner for the office of earl marshal. Clearly, neither position was of an importance comparable to that of Rachel's father.[30] But the Bedford family was wealthy, respected, and of the same social order as Rachel's own. These facts notwithstanding, at the time of their marriage William was a second son and bore no title, being known simply as "Mr. Russell." Accordingly, as was customary, Rachel continued for many years to use her first husband's name because of its higher rank and signed letters and legal documents as Rachel Vaughan or Lady Vaughan. When Francis Russell died in 1678, William, now heir apparent to the Bedford title and property, was given the courtesy title of Lord Russell and advanced to the same social rank as Francis Vaughan had occupied. At that time Rachel changed her name to Rachel Russell or Lady Russell.

Besides being well connected, William was a handsome man, as multiple portraits confirm. He inherited his good looks from his mother, Anne Carr, as well as from his father (see the illustrations). Born on September 29, 1639, and almost exactly two years younger than Rachel, he stood about five feet ten inches tall and was rather heavy-set. His eyes were light brown, his nose strong and slightly bulbous, his mouth, like Rachel's, wide and sensuous. As he matured, his hair darkened to brown from the yellowish-brown of his youth.[31] William possessed a pleasing personality, a usually cheerful and smiling countenance, and a "generous and obliging temper." In public discourse, however, he was a man of so few words that it was a matter of comment. The fact is that William had a sound rather than a brilliant or creative intellect. A friend and admirer, Gilbert Burnet (who became the bishop of Salisbury), described him in maturity as "slow" but insisted that he had "true judgment when he considered things at his own leisure."[32] There is no reason to think that an assessment of William's intelligence when he was thirty years old would differ. Such deliberateness was in sharp contrast to Rachel's quickness of mind.

William's native abilities had been refined by a very good education that included a private tutor, a year at Cambridge, and several lengthy tours of the Continent. His tutor, the Reverend John Thornton, a Puritan with a degree from Trinity College, Cambridge, oversaw the early schooling of William and his elder brother, Francis, and in turn that of his four younger brothers and four sisters. Under Thornton's tute-

lage, William pursued a rigorous regimen of study based on humanist precepts and grounded in the Protestant religion. Among the books that formed the core of William's early study were the Bible (in Latin and English), a catechism, a Book of Common Prayer, and, reflecting Thornton's strong Nonconformist views, *Sincere Convert*, a book written by his friend Richard Baxter.[33] Respect for Nonconformity and abhorrence of Catholicism were central themes in the religious training his tutor provided. His father reinforced such themes not only by exhortation but also by practical example. Since 1639 the Russells had assisted French Huguenot refugees, allowing them to settle in large numbers in the fens near their Thorney estate, secured a license from the bishop to hold services, and paid a Nonconformist minister £40 a year.[34] In further proof of the sympathy with which William's father regarded Dissent, the earl gave the living of St. Paul's Covent Garden, a church endowed by *his* father, to Thomas Manton, one of Cromwell's chaplains, a "great name" among Presbyterians in London.[35]

When William was sixteen years old, in 1655, he spent a year at Cambridge University. He was admitted as a Fellow-Commoner at Trinity College and at matriculation was assigned to Magdalen.[36] The Cromwellian government, following the policy of the Stuarts in their endeavor to control the universities, had sought to transform the teaching of religion and the daily habits of academic life at both Oxford and Cambridge. Although their success was limited, Cambridge University was known during the 1650s as a "Puritan stronghold,"[37] so, at the least, William spent a year in an environment that favored Puritan assumptions and attitudes. More than that, Thornton had arranged for William and his brother to be placed in the special care of his good friend, the Reverend John Nidd, who shared his views. Nidd was a demanding taskmaster. In a letter to the earl about the boys' studies, he reported that they were making progress in logic and the classical Latin historians, which he had chosen to improve their command of the language and their knowledge of ancient affairs. He assured their father that they had won a reputation for being civil, studious, and eager for improvement.[38] It is certain that the religious precepts inculcated by Thornton received reinforcement during William's stay at Cambridge.

William's formal education came to an end with his departure from Cambridge. In view of his prominent role later on as a leader of the Whig party in the House of Commons, it is interesting to note that, in contrast to so many political leaders, William did not attend one of the Inns of Court nor take much interest in the law. Later, in a debate in 1677, he admitted that he seldom read statutes.[39]

William's general education was further developed by a lengthy tour of the Continent, lasting, with visits home, till 1665. He and his

brother Francis were accompanied by a French tutor, one M. de la Garde, and they traveled around France, Switzerland, Italy, and Austria. William's command of spoken French was undoubtedly secured by this experience; in 1665 he wrote French with ease.[40] This was a skill that William and Rachel shared and which must have enabled him later in life to converse readily with her French relatives.

During these years he moved in a circle of young people of like social standing who were traveling in Europe and were part of high society in London and other capitals. He corresponded with Henry Capel, whom he asked to convey his services to three different young women, wrote warmly to Sir John Reresby, and traveled with Philip Smythe, second viscount Strangford, who had a reputation as a drunk and libertine.[41] He also became good friends with William Cavendish, who was a year his junior and who later became the first duke of Devonshire. Cavendish had substantial cultural and artistic interests but was, like Russell, an exuberant spirit. For example, in 1669, when in Paris as a junior member of the English embassy under Ralph Montagu, Cavendish was involved in a ruckus with three French officers and was wounded. In the 1670s he transferred some of these high spirits to parliamentary affairs, as we shall see, but also led the life of a libertine. Russell remonstrated with him then and begged him to lead a "more Religious and Virtuous Course of Life." Cavendish reportedly tried to reform, but did not succeed.[42] None of these early friends of William showed any special promise, and none, with the exception of Cavendish, was intellectually inclined.

The diaries that William kept of his tour and the letters he wrote home show a young man taking great delight in innumerable sights and experiences and writing dutifully about them in an interesting but not deeply sensitive way. He viewed Roman antiquities with "great pleasure," inspected with equal enthusiasm the bones of a giant that stood fifteen feet tall, and examined manuscripts written over four hundred years before. He admired the bears at Berne, commented on Constance, "famous for the Council" held there,[43] and gave an excited account of seeing Christina, queen of Sweden, in Lyon, describing the dancing and bathing at night as a "very fine recreation."[44] These letters, some of them written before he was twenty, provide evidence of William's powers of observation and his ability to write in an engaging and coherent manner. They won fulsome praise from his pardonably proud tutor, who described the style of one as "free, masculine, coherent, exact," and of such power that "without flattery. . .the greatest masters of eloquence need not be ashamed to own it." Thornton's enthusiasm may have reflected gratified relief, for as he said, "formerly" William's mastery of the English language was "much defective."[45] But the letters are

undeniably well written. In the absence of Russell's political papers, they prove that William was capable of writing well and lend support to Rachel's insistence that William himself wrote his scaffold speech in 1683.

William's intellectual and cultural interests, although broad, seem to have been conventional and superficial. He became intrigued with his family's genealogy and asked that a pedigree be sent him. Perhaps he also developed an interest in astrology, as Thornton and his father feared when they received a request from him for the day and hour of his birth. Upon the earl's orders, Thornton sent him only the day of his birth, cautioning him that casting horoscopes was "vain, uncertain, and absolutely unlawful."[46] A drawing showing astronomical figures associated with the day of William's birth survives, but there is no evidence that William commissioned it.[47]

Renaissance art works, which he saw in quantity, did not particularly excite his wonder or move him to great praise. His comment on what was probably Titian's *Lady at her Toilet* ran thus: "a woman naked, combing of herself, made by Ticheon, and mightily esteemed of."[48] Nor did he show any interest in collecting art. The paintings he sent home were pictures of beautiful German women.[49] No more than Rachel did William have a deep appreciation of music. If he attended concerts during his trip, he did not mention them. He sent home scores for popular songs, accompanied by the observation that if "more gaysome" ones were desired, he could provide them.[50]

Evidence about his reading habits is sparse. From childhood he had access to a substantial library built about the collection of his ancestors, especially that of the third earl of Bedford and his wife—the intellectually inclined Lucy, countess of Bedford—and of his grandfather, the fourth earl, who left approximately two dozen volumes of religious writings, with the hope that his family would profit therefrom.[51] But William seems to have had few bookish inclinations. When abroad he asked only once that a book be sent to him—one by John Cleaveland, a writer of witty poems and essays. The request moved Thornton to express the hope that William's "main study" was in "books of more serious concernment," especially the Bible and books of religion.[52]

During these absences on the Continent William was not allowed to forget the religious and moral precepts of his boyhood. He received a steady stream of reminders from Thornton and his father of the importance of the Protestant religion in his daily life. In turn, the good reports that English visitors to France brought back of William's behavior[53] and his own disparaging remarks on various features of Catholicism that he observed would have gratified his tutor and family. So too would have

his reaction to a severe illness he suffered in Paris in March 1658 that "put him at death's door." He wrote that he prayed to God for health and for grace to use it in His service and to make good His cautionary visitation.[54] Nothing came of this vow immediately. In truth, it was not until his marriage to Rachel that William seems to have taken religion with genuine seriousness.

William was also a passionate, impetuous person, with a reckless streak. As a younger son, he had been obliged to think of what career he might follow, and his first choice was to become a soldier. He had what he described as an "inclination to the wars."[55] While William was abroad, his father encouraged this interest, arranging that a "special good suit of arms" be provided him, making an effort (unsuccessful in the event) to ship him a fine horse, and advising attention to exercises and "whatsoever" else was needed.[56] William's plan in December 1659 to join the Swedish army went awry, and other plans for a military career that seemed settled in January 1660 may have been postponed because of the likelihood of a Stuart Restoration.[57] Probably because the health of his elder brother continued to deteriorate and thus the expectation to grow that he would eventually be the Bedford heir, nothing came of his interest in the military.

His ebullient energies found other outlets. One was harmless, but expensive: an extravagant taste in fancy clothing. When he was twenty-one years old he ran up a bill of £183 for ribbons, fur-trimmed gloves, and plumes. He thought nothing of ordering four or five pairs of boots at a time and scolding his bootmaker for delays in delivery.[58] In 1665 alone his bills for clothing came to over £720. He liked silk cloth, sometimes striped, and ribbons to adorn it, and he showed a positive passion for gold and silver buttons, purchasing fourteen and a half dozen in October and November 1667 and another twenty and a half dozen in May 1669. He was fastidious about his clothing, having spots removed, older suits altered, and plumes, ribbons, and laces cleaned.[59] In preparation for his wedding, he ordered three suits with vests and waistcoats, adorned with gold and silver buttons, and his friend William Cavendish bought in April in Paris the "prettiest stuffs" he could find for two more coats and vests and lace for one of the vests.[60] Cavendish advised William that gold and silver were not being worn in the French capital, but that news did not affect William's plans for the outfit he wore at his wedding, which alone cost £150.[61] William was not, of course, unique among men of his class in Restoration England in his extravagance and fondness for elaborate dress. But it is clear from the haberdashery bills that have survived that he took full advantage of his position in the family as the favored older brother likely to succeed to the title, and that his younger brothers—George, Robert, James, and Edward—spent far less on clothing.[62]

Extravagance in clothing reflected, however, a more serious problem. To put it bluntly, Russell was a spendthrift in ways other than clothing, a man who squandered money and was reduced to borrowing from friends and family members and to pleading with his father to pay his debts. He was unable to live within an allowance of about £400 a year from 1659 to 1663 and £500 from 1663 to his marriage.[63] For example, in 1663 he owed £45 to his cousin Lord Brook; in 1664, excusing himself on the ground of his "small allowance," he borrowed £100 from a London alderman and £50 from his brother Edward.[64] Four years later, in March 1668, while he was staying at the Palais Royal in Paris, he wrote his father a rather frantic letter complaining about the high cost of everything and confessing that he had "run out of money insensibly." He had borrowed 1,500 livres from a Frenchman who was on his way to Woburn to collect the debt, and William implored his father to pay it.[65] That year William received £2,450 from his father, whereas his brother Edward was given £283.[66] Later in life, he confessed that he had never been able to "limit his bounty to his condition," but he insisted that he had never spent money in an "ill way."[67] Later still, after his death, when his son had run up an enormous gambling debt, Rachel used William's extravagant propensities and large debts to try to persuade her father-in-law to assist her in paying off his grandson's debt.[68]

The most serious reflection of William's exuberant nature was his involvement in several unsavory escapades. Although he had shown interest in a couple of women and was rumored to have been engaged to one, he had not married.[69] Sexual frustration, commitment to a chivalric ideal, and a vigorous spirit must explain his involvement in duels in July 1663 and in April 1664 (when he suffered a wound) and probably at other times as well. Letters to his father on the eve of these duels reveal a sweetness and considerateness in William's personality that would have endeared him to people who knew him well. Assuring his father that he was confident of his own courage, he admitted that lately he had been "unlucky in several things," and thus feared that he might die. But he insisted that "honour commanded" him to engage in the duel, that nothing could dissuade him from doing so, and that he did not fear death itself because his honor was involved. William thanked his father for his kindnesses and expressed the hope that he had not disappointed him. He asked the earl to remember him by paying his debts and by rewarding his friends, including his footman, whom he wished to leave £20 a year.[70] The letters are of uncommon importance in revealing the value system to which Russell adhered. The same kind of chivalric attitudes underlay other episodes later in his life, including his political activities.

William survived the duels, of course, and in 1665 engaged in another fracas of some kind that touched a woman in whom the duke of

York was also interested. The details of this incident are clouded, but apparently William and his uncle, Colonel John Russell, were rivals for the favor of Elizabeth Hamilton, to whom James, duke of York, was also attracted. A row occurred which was serious enough to land William and his uncle in the Tower for several days in 1665. They won release after an abject apology and payment of a fine.[71]

Notwithstanding such mindless, self-indulgent behavior, William did play a minor role in public affairs. His brother's ill health meant that William rather than Francis marched in the procession at Charles II's coronation, undertook a couple of local offices in Bedfordshire, and stood for election to the Convention Parliament in 1660. His family's borough of Tavistock in Devonshire returned him, but not without a contested election and a double return. He was inactive in the Convention, being appointed to only two committees, both touching his family's interests—the draining of the fens and the making of Covent Garden precinct into a parish. Although he did not visit Tavistock, some money was spent to advance his interests, and in another contested election, the borough returned him to the Cavalier Parliament.[72] Thus, William, whose name is so closely linked with Bedfordshire, represented a Devonshire borough for nineteen years. At an unknown date, but shortly after the election, he gathered himself to make a maiden speech, notable for its flowery language and conventional praise of the new king.[73] In 1663 William came to the general notice of the House in a way that did nothing for his reputation: members obliged him to promise neither to send nor receive a challenge from Robert Spencer, the second earl of Sunderland, who was trying to jilt William's cousin, Lady Anne Digby. In 1664 he was listed as a court dependent, possibly because of his close relationship with his uncle, the aforementioned Colonel John Russell.[74] Some change is discernible in William's activity in the House in 1667 and 1668, when he was courting Rachel. Either by coincidence or design, he apparently took a more serious interest in House affairs and won modest recognition. For example, he was appointed for the first time as a teller and was selected to present the king with an address—in this instance, one for the wearing of English manufactures. Even so, there was nothing in his early political experiences to forecast his eventual role as a leader of the Whig party in the House of Commons.

Such was the man whom Rachel married. Although she could not have admired every trait that he possessed, she fell in love with him, encouraged his suit, and gave her hand to him freely, as only a widow could do in seventeenth-century England.

Rachel and William's marriage was grounded in a property settlement as well as in passionate love. The marriage contract that united them was

contained in the usual form of conveyances by lease and release drawn up in June and July 1669 at a cost of £195. Two distinguished lawyers— the attorney general, Sir Geoffrey Palmer, and Sir Francis Pemberton (who would play a role in William's trial fourteen years later)—were called in to offer advice.[75] William's part in the settlement was spelled out first, in documents dated June 4 and 5, which ran to ten large parchment membranes. Four "parties" were involved. Those of the first part were the earl of Bedford and Francis, his eldest son and heir. Of the second part were Rachel's trustees, Edward Noel and Joceline Percy; her two brothers-in-law; and Sir Philip Warwick, her father's trusted colleague. William was the third party, and Rachel the fourth.[76] Displaying marked generosity, the earl of Bedford, having already paid William's outstanding debts, which ran to over a thousand pounds,[77] provided the couple with cash in the form of an allowance of £2,000 a year for William during his lifetime and, in the event of his death, the same amount for Rachel during her lifetime. This splendid sum was to be raised from the rents of several properties, most notably the Woburn estate in Bedfordshire and Thorney in Cambridgeshire. Further, the contract, reflecting the principles of the strict settlement, provided first for the male issue of the marriage and then identified a specific sum for female children. If one daughter resulted from the union, then £120 a year was to be paid for her maintenance until she reached the age of twelve. From twelve to eighteen years, or on her marriage, she was to receive £200 a year. Her dowry was fixed at £16,000, to be paid at eighteen years of age or the day of her marriage, whichever came first. If two daughters were born to Rachel and William, their maintenance was to be the same, but the dowry was set at £20,000, to be divided equally between them. These details are worth noting, for Rachel and William had one son and two daughters, and it is interesting to see the marriage settlements for these three children that Rachel, as a widow, was able to achieve.

Rachel's contribution to the marriage was set out in the July 27 and 28 instrument[78] and was far greater in value than William's. This dowry was, of course, Rachel's inheritance from her father, and thanks to some arrangements that she made in July with the trustees of her father's will, the property was debt-free.[79] Rachel's contribution provided the couple additional cash income, land, and houses. It included her London properties, most importantly the manor and hospital of St. Giles and the manor of Bloomsbury, which, as already noted, brought in an income of over £2,000 a year. Southampton House—which, it will be recalled, had been willed to Rachel's stepmother for her lifetime— was also part of the settlement, for, in anticipation of her marriage, Rachel had on March 27, 1669, purchased for £40,000 her stepmother's

life-interest in Southampton House.[80] This enormous price testifies to the grandeur of the mansion, possibly indicates that the furnishings were included, and presumably took into account that the dowager countess was relinquishing a very valuable piece of property in which she still had the prospect of future years' enjoyment. Although Rachel and William did not move into Southampton House until 1675, this purchase of her stepmother's life-interest meant that they had a luxurious London mansion ready to receive them when they wished to occupy it.

Rachel also brought to the marriage her Hampshire holdings, which, as we have seen, were worth about £1,000 a year, and included the hundred, manor, rectory, and advowson of Micheldever, which embraced the manors of East Stratton, West Stratton, Weston, and Abbots Worthy, and the advowsons of Abbots Worthy and Kings Worthy, totaling approximately 12,000 acres.[81] Also included was Stratton House, which Rachel and William used as their country retreat. All of this property was located about fifty miles southwest from London in central Hampshire in a narrow band stretching northeast from Winchester to Basingstoke.

Rachel's interests were carefully protected; she was clearly much better provided for than in her first marriage. First, as already mentioned, should William predecease her, she was to receive for life the same £2,000 per year allowance as granted him for life. Second, in settling a part of the premises in Hampshire—precisely which part is now impossible to determine—on William for his use for ninety-nine years, it was specified that the remainder was to go first to Rachel for life, then to the trustees to preserve the estate, and next to male offspring of Rachel and William. If there were no heirs, then the remainder was assigned to the earl of Bedford in fee. In view of future events, this was a fortuitous arrangement. Third, other parts of the Hampshire property were assigned to Rachel's use for life with the remainder first to her and William's children "as she should appoint." Fourth, and above all in importance, the Middlesex properties—that is, the manors in Bloomsbury and St. Giles—were placed in the hands of trustees "upon trust for such uses as [Rachel] shall direct." What this meant was that Rachel retained considerable legal authority over the London properties, and this explains her deep involvement in managing them after her marriage, as we shall see. Such an authority for women was not unique to Rachel; other contemporary women also possessed it. But it could not be exercised unless the appropriate legal arrangements were made.

Thus, the marriage settlement signed in the summer of 1669 made Rachel and William a very wealthy couple, providing them with an annual income of over £4,000, a country estate, and a London mansion. Their urban and rural properties continued to be developed for the four-

teen years of their marriage, with Rachel taking an active part in the process. They had expectations of even greater wealth to come, should William's elder brother predecease him, as seemed likely. Both Rachel and William achieved deep personal happiness in their private domestic life. Their marriage fulfilled the ideals of romantic love that informed their courtship. It is no wonder that later, when William became deeply involved in radical politics, a contemporary remarked that Russell "venture[d] as great a stake perhaps as any subject in England."[82]

· 4 ·
Domestic Life,
1669–1683

For fourteen years, from August 1669 to July 1683, Rachel and William enjoyed a rich[y fulfilling marriage relationship. Domestic matters, affectionate devotion to their children, and strong, passionate love united the couple. They also shared an interest in their property, religion, public affairs, and William's political career. Marriage changed both of them. William became, on the whole, a model husband and father, abandoning the profligate society of his youth, and Rachel no longer trifled away her time, as she accused herself of doing during her first marriage. The center of Rachel's life was her husband and children and her two households. In her devotion to them she fulfilled the contemporary ideal of womanhood, but, paradoxically, marriage widened rather than narrowed her horizons, heightening her religious sensibilities and promoting a new sense of personal responsibility for public issues. William's growing political role added an important dimension to her life as well as his, while Rachel's wealth and social position enabled her to circumvent some of the restrictions imposed on women. Domestic and public affairs were intertwined in the Russells' daily life, but the private sphere will be discussed first in this chapter and William's political career and Rachel's connection with politics in the next chapter.

Stratton House in Hampshire and, after 1675, Southampton House in London provided the physical setting of the Russells' domestic life. Stratton House held a special place in their affections. Rachel often referred to it as "sweet Stratton" and once expressed her delight that William liked it so much too.[1] A sympathetic twentieth-century visitor to the area around Micheldever, East Stratton, or Basingstoke has no trouble understanding why. The countryside is still green and gently rolling, with woods dotting the landscape, and the whole adorned by a high, vaulting sky. In 1730 estate surveyors expressed great admiration for the location of the Russell estate, praising the "clean champaign country"; the fertile soil, just right for growing corn and pasturing animals; and the woods, which preserved game and invited hunting.[2]

Stratton House was situated close to the main London–Winchester road, some seven and a half miles northeast of Winchester and about nine miles to the southwest of Basingstoke, but its privacy was assured by a license granted Rachel's father in 1664 to enclose the road running near the house that connected East Stratton to West Stratton.[3] No late-seventeenth-century descriptions or pictures of Stratton have survived, but contemporary comment and evidence from the eighteenth century permit one to reconstruct the appearance of the house and its setting at the time the Russells lived there. Although less large and formal than Titchfield or Woburn, Stratton was a substantial structure. Made of Portland stone, it stood three stories high and was adorned with fifteen bays across the front. At the center of the front expanse was an Ionic tetrastyle portico, with a perron of two flights on either side providing access to the main floor.[4] Inside there must have been many rooms, for eighteenth-century sales receipts and an inventory refer to servants' quarters on the ground floor, two "tapestry" rooms and a dining parlor on the first floor, and bedrooms with dressing rooms attached, and ten garrets, some with skylights, on other floors.[5] The interior must have been well appointed: we know that there were marble chimneys in the hall, carved ornaments in wood in several rooms, and carved work over two fireplaces in the billiard room, the latter almost certainly added by William, who, as a young man, had developed a passion for the game of billiards.[6]

The house was old when Rachel inherited it. She recalled living there as a young girl with her father from time to time, and it is probable that at least parts of it dated back to the sixteenth century.[7] The house had suffered a fire in 1667, and that it stood in need of repair is intimated by Rachel's concern about William's sleeping in their chamber in a time of heavy wind and her reference to "poor Stratton."[8] The Russells undertook renovations: the addition of a new room in 1676 and the replastering of the granary in 1680.[9] Two wings were also added, and it was said that William intended to rebuild the old middle part in a manner conformable to the additions.[10]

Stratton House stood on demesne land containing approximately 230 acres of parks, gardens, and woods.[11] The immediate environs of the house provided a handsome setting. William was responsible for laying out "orchards, gardens and avenues," creating groves and "wildernesses and other ornaments," and enlarging the deer park by tearing down part of the hamlet of Stratton.[12] In view of Rachel's lifelong love of walking and devotion to Stratton, she probably had something to do with the layout of the walks and gardens. Also on the demesne were "laundries, brewhouses, coach houses, stables for 60 horses, barns, . . . and [farm] offices" which William had built.[13] Two or three hundred

yards from the manor house was a small cottage with an oak-paneled room and a carved oak mantelpiece over the fireplace. Local tradition had it that after William's death Rachel lived there when she was at Stratton, and it became known as Lady Rachel's cottage.[14] It is doubtful that she lived in the cottage; more likely she sought solace there.

Green crops must have flourished at Stratton, for in the eighteenth century the kitchen garden kept four to eight men employed according to the season, and there is no reason to think that it was different in the seventeenth century.[15] During Rachel's and William's lifetimes cabbage was grown in a special garden, corn and hay were harvested, and pear trees enjoyed success. William developed a proprietary interest in the pears, reporting in 1674 to Thornton that the quality of his fruit was as good as any in the London market.[16] Reflecting this interest, Rachel wrote him in 1681 in detail about laying up the pears, explaining how the varieties were to be distinguished.[17] Orange trees were grown in cases (so that they could be moved indoors in cold weather) in the early eighteenth century, and perhaps also in the late seventeenth century, as they were at Woburn Abbey.[18] If William followed the practice of his father, which is not an unreasonable assumption, cherries and apricots were also grown.[19] Animals abounded: a bull, sheep, cows, chickens, horses, hunting dogs, at least one pet dog, and hawks.[20] William took a direct interest in his horses, arranging through Thornton for their sale and for their transportation from Woburn Abbey to Stratton.[21]

The whole estate contained close to 12,000 acres and was one of the largest in Hampshire.[22] The day-to-day operation would have been in the hands of a steward, who from 1675 (if not earlier) to 1683 was a man named Watkins.[23] But because his account books have failed to survive, it is not possible to reconstruct directly the details of estate management. Yet, as we have seen, the Hampshire property was privileged; because King James I confirmed in 1608 certain rights to Rachel's grandfather, the estate was free from interference by the sheriff and exempt from, among other things, pleas and tallage.[24] Further, the sale of timber was an important source of income,[25] as it had been earlier for Rachel's father. There were woods that bore such names as Black Wood Forest, Thorny Down Wood, and Micheldever Wood where larch, hazel, and especially oak trees flourished. In 1730 close to fifteen hundred oak trees were counted. The estate was farmed according to the traditional pattern of three or four large holdings in each tithing farmed in common. Pasture and cow downs were also used in common, with each tenant allowed to pasture only a specified number of animals.[26] A 1677 survey shows that approximately one hundred individuals held land—eighty male and twenty female. The tenure varied with the parcel

of land, so a person might possess both freehold and leasehold land. The estate comprised approximately twenty-seven freeholds, thirty-one lease-holds, and twenty-four copyholds. Among the individuals who held freeholds were Robert Bristow, Simon Kinching, and Sir Robert Worsley, whom Rachel later consulted about the appointment of a curate.[27] Among leaseholders were Thomas Perrey, Stephen Archer, and Widow Thorpe; and among copyholders, Dorothy Bradley, Stephen Claverly, and Richard Collyear. Old traditions lingered; the herriot of "best beast" was specified in the survey.

The steward, perhaps at Russell's instruction, exercised exemplary care in facilitating the resolution of the tenants' problems. The special survey of copyholders made in 1677 provided a record of the holdings in that year and the basis for showing the fifty-six changes made in leases over the next fifty years as they came due or people died or some special arrangement was made to transfer property. Further, a court of record was held every three weeks to handle cases between tenants on the manor. Courts leet were a yearly occurrence, as were courts baron, except for an intermission of a few years in the early eighteenth century. Rachel ordered the reinstitution of the courts baron in 1712.[28] It is unlikely that William involved himself in any of the details of the manorial courts, but presumably he used them to transact business. For example, in 1680 he signed an agreement with the tenants on the manor of East Stratton for enclosing the north and south downs there, probably to increase the yield from the land.[29] The regular visits he made to Stratton on estate affairs suggest that he maintained a supervisory interest.

Other features of the Hampshire estate may have enriched the lives of the Russells and their tenants. A nearby old Roman villa and a Roman road from Sherborne St. John to Winchester which passed near Stratton may have enhanced interest in an ancient past. The market or fair that was held in the area may have provided a local outlet for some of the produce grown on the estate.[30] Several chapels and churches (some still in use today) provided opportunity for worship. The estate held the patronage of the vicarage of Micheldever and the rectories of Kings Worthy, Abbots Worthy, and Stratton. William's increasing the stipends of the appointed clerics suggests sympathetic attention to this responsibility, an attention which Rachel conscientiously continued after her husband's death.[31] The Russells may have worshipped at the chapel at East Stratton, located close to their mansion, on days when for some reason it was inconvenient to use their private chapel. Rachel's cousin, Henri de Ruvigny, Jr., was buried there, his body being carried from Stratton House along a path still called Coffon Walk.[32] At other times, perhaps on festival days, it is reasonable to think that they

attended services at churches with which their names are connected. A placard in St. Mary's of Micheldever lists Rachel as a patroness in 1688 and 1721, and for "many years" the money from a bond to help the poor of the parish of Micheldever was put in Rachel's hands.[33] To the Church of our Lady at Stratton she presented a "curious silver cup" in 1703.[34] And in the East Stratton church a stained glass window, installed in 1889, was dedicated to the memory of Lord and Lady Russell.

Further, the ties of friendship and acquaintanceship in the local community must have been important to the Russells. Rachel had known the area since her youth, and she introduced William to it. William fitted readily into the community, for by 1675 he held a trust for James Stansby, a member of a family who had long lived in Micheldever. Probably the Stansbys were occasional guests at Stratton House, along with the family of Robert Bristow, one of the freeholders on the Russells' estate. Bristow's son, also Robert, became a director of the Bank of England. Among other prominent county neighbors was the family of Benjamin Whitaker, who was connected by marriage with the Coopers and the Manners. Rachel's second daughter was to marry the heir to the Manners' fortune and title. Probably the Russells' closest friend in Hampshire was Charles Paulet, sixth marquess of Winchester, later the duke of Bolton, who became William's local political patron. He owned property that adjoined the Russells' estate, and he and his family were surely guests at Stratton House from time to time.[35] Although direct evidence is sparse, county connections must have been strong, for they underlay William's remarkable success in winning the parliamentary election for the county in both February and September 1679.

In Rachel's view the life she and William led at Stratton was idyllic. During these years their physical relationship was apparently intense and fulfilling; their children were babies or beguiling little ones. Rachel's memory of her happiness at Stratton was so poignant as to be excruciatingly painful to her after William's death.

Rachel and William lived a portion of each year in London. Although, as we have seen, Southampton House in Bloomsbury was a part of Rachel's dowry, she and William did not live in it immediately. Rather, for "about" the first two years of their marriage they lived with Lord Bedford either at Woburn Abbey or at Bedford House on the Strand in London. In June 1670 they purchased from Rachel's cousin, Spencer, a house located on the northwestern corner of Southampton Square and Great Russell Street. Apparently it needed some work, for they did not move in until November 1671.[36] Next door lived Sir Thomas Chicheley, a relative of the first earl of Shaftesbury, and on friendly enough terms with the Russells to figure in several property transactions.[37] In March 1675 Rachel and William sold the house to Sir

William Jones, the attorney general, for £5,500 with an annual rent charge of £10.[38] By that time they had already moved into Southampton House, which then became their principal London residence and remained so for Rachel after William's death.

Southampton House, as eighteenth- and nineteenth-century prints show and contemporary comments confirm, was a large building, occupying the entire north side of Southampton Square (see the illustrations).[39] As we have seen, it cost Rachel's father over £5,000 to complete it at the time of the Restoration. Constructed of brick, the house was built around a courtyard in the shape of a U. The building hugged the ground, for the central arm of the U was only three stories high and the two side arms only two stories, and was thought by some critics to be too low.[40] Leading up to the main entrance was a single flight of stairs that narrowed in the middle only to widen out again at the doorway. Inside, a great hall welcomed visitors to the first floor, where there were eighteen rooms in all, including a chapel, a banquet hall and smaller dining rooms, two or three drawing rooms where Rachel probably wrote some of her letters, and the master bedroom and dressing room. Twenty-four rooms—the nursery, bedrooms, storage rooms, retiring rooms—were on the second floor. The servants' quarters and thirty-two rooms for running the house—the kitchen, scullery, laundry, drying rooms, and so on—were on the ground floor. The interior furnishings, for which Rachel's father paid over £2,000 a few years before his death, included expensive hangings, gilded and silver candlesticks, screens, pictures, and linens.[41] It is not known whether these things were included in the purchase price Rachel paid her stepmother, but if they were not, it is a reasonable assumption that the Russells replaced them with objects of like beauty and value.

At the back of the house were stables, buildings for the grooms and coachmen, and gardens. Thus, one could leave by the back without being readily seen, a point of significance in the story of William Russell's arrest. The area around the house was enclosed by a brick wall, with a handsomely carved iron gate placed in the wall directly opposite the front entrance. The Russells' London house symbolized for them, as it had for Rachel's father, their social and political status. It was the grandest by far of the mansions on the square and a focal point of life there. As William's political role grew, it became the scene of political meetings.

Rachel would have exercised only the most general supervision of the household servants at both houses. A housekeeper, whose name for these years is lost, would have handled the details of household management. Thus, Lady Vaughan's time was freed for her to pursue other activities. The glimpses we have of her dealing with servants show her

to have been a kind, generous, and sympathetic mistress. For example, she confessed reluctance to give her maid an absolute command to do something she did not wish to do. "You know I am ill at putting people to inconvenience," she wrote to William.[42] She was concerned that the woman nursing William's ill brother not think that she disliked her.[43] In 1681 she wrote from London to William at Stratton asking him to tell a servant that if she wished, Rachel would arrange for her child to be touched for the evil by the king.[44] Such was her sense of consideration, although she must have found the purpose repugnant. Yet, Rachel recognized the reality of thievery by servants and presumably took the kind of precautions she advised her sister-in-law to follow when her porter was missing.[45]

Rachel and William shared an interest in decorating their houses. In 1675 William wrote in some anxiety about the reshaping of the outside steps at Southampton House. He complained that the new stairs had turned out to be too narrow for "so great a house," but concluded that it was too late to make a change.[46] Rachel and William exchanged instructions with each other about fabrics. He asked her to be sure to get some room measurements at Stratton and to send up the "red damask" to be matched.[47] She asked him to buy "stuff" for her closet at Stratton and told him that she had decided that cane was the best material to be used in so small a room.[48] Rachel was willing to leave to William a decision about some picture frames, assuring him that she would "like anything better" that he did.[49] They furnished their table with silver-trimmed glass, for everyday use, and gold plate, reserved for meals at Southampton House only. They bought still other gold pieces, Rachel ordering an unidentified object from the queen's goldsmith.[50] Rachel did not regard these matters as her responsibility alone; rather, she and William took a seemingly near-equal interest in their homes.

Management of their property also occupied the Russells. First, the implications of their marriage contract required ongoing attention. During the month the contract was being drawn up and continuing into 1670, Rachel entered into an agreement with the earl of Bedford and William to buy back mortgages that she had taken during her widowhood on some of her properties. Altogether £4,705 was spent to effect these transfers.[51] Two years later Pemberton, who had advised the parties about their marriage contract, attended "several meetings" and gave advice relative to the "business of the Lady Vaughan and several of his Lordship's settlements."[52] In 1682 Rachel named new trustees to replace those named in the 1669 marriage settlement who had died.[53] Second, William in seven transactions between 1672 and 1682 added small parcels of land to the Hampshire property, as, for example, a coppice called Biddlewood in East Stratton, or twenty-four luggs of land in

Middlefield, also in East Stratton.[54] Altogether Russell purchased 141 luggs of land. Third, the couple used their land to raise money. They entered into agreements in 1671 and 1673 that involved a portion of their holdings in Hampshire and London, the effect of which was to bring in a rent of £800 a year. In April 1682 William and Rachel sold forty-three messuages in St. Giles to William's father for the whopping sum of £8,000, paid to William. The transaction may be entirely innocent of political significance, but it should not go unremarked that in 1683 William was accused of intending to raise £10,000 to send to fellow Scottish conspirators, a charge that, as we will see, greatly agitated Rachel, who took steps to track down its origins. This property transaction is the only known evidence to survive that suggests that Russell had taken a preliminary step towards sending the money.[55]

Fourth, Rachel took an interest in helping her brother-in-law settle the estate of her sister, Elizabeth, who died in March 1680. The earl of Shaftesbury had told Rachel that Lord Noel had mismanaged things by returning to Titchfield before the property was settled. Rachel took the initiative in getting word to Lord Noel about this and in telling him to send some papers by a safe messenger immediately and to be sure to keep attested copies.[56] Her letter is a well-thought-out and clear statement about the transaction, testifying to her familiarity with such legal proceedings. After William's death, as we will see, she again took steps to arrange her sister's property affairs so as to fulfill her wishes. Fifth, Rachel also corresponded with her first father-in-law, the earl of Carbery, respecting business matters. In 1680 Carbery wrote to Rachel, rather than to anyone else, about a problem that had arisen with regard apparently to the properties whose rent paid Rachel's annual allowance of £900.[57]

Finally, and above all in importance, Rachel became deeply involved in the development of her London properties. It will be recalled that the marriage settlement specified that the trustees should manage those properties "for such uses as [Rachel] shall direct." In effect, Rachel, with the help of trustees and lawyers, continued the practice begun by her father of leasing plots of land on the Bloomsbury manor and thereby developing the neighborhood of the square and adjacent streets. The first such lease that she signed was dated June 2, 1669; between then and William's death on July 23, 1683, Rachel signed fifty-four leases, dispatching seventeen of them on one apparently active day, March 2, 1670.[58]

The largest sale was to Rachel's half-sister Elizabeth and Elizabeth's second husband, Ralph Montagu, who in 1675 paid £2,601 for seven acres located west of Long Field, on the present site of the British Museum. The Russells placed several restrictions on the de-

velopment of the property, specifying, for example, that no road could be made across the field nor any building erected beyond the northern brick wall and stipulating that the house itself must be fit for a nobleman, with a courtyard in the front and offices and stables in the rear.[59] It took at least six months of negotiations to work out all the details, a process suggesting the careful attention the Russells gave to the development of the square.[60]

In these different ways, then, Rachel gained experience in managing property, business matters, and household affairs. That experience would prove to be invaluable later when she was widowed and faced such responsibilities on her own.

There was little reason for Rachel and William to become bored with either one of their major residences. Immediately following their marriage they fell into a pattern, common to aristocratic families, of shifting their household from London to the country and back again, interspersing these moves with visits to friends and relatives, especially Rachel's sisters and William's family at Woburn Abbey (see the illustrations). These moves and visits Rachel noted in her diary, along with births, deaths, illnesses, and so on, as if to indicate the importance to her of the domestic space she occupied. Her record of the four or five months following her marriage—what might be called their honeymoon—illustrates the point: "Some days at Beaulieu, came back by Titchfield, and so by Stratton to Bedford House for 2 or 4 weeks and then to Woburn for rest of summer, except one week at Quikswood. Came back, went with Lord Bedford to Bedford House for all the winter, except some days with my sister Noel, when she lay in at Titchfield, went and came by Stratton."[61] From 1670 to William's death in July 1683 Rachel made approximately sixty-four trips, or an average of about five a year. These visits to family and friends, sometimes without William, his deepening involvement in politics from 1673, and estate business kept the couple apart for some days each year. To these separations we owe Rachel's love letters to her husband.

Rachel was deeply in love with William, and all during their marriage she continued to woo him, even as she had done during their courtship. The romantic attitude that she expressed before her marriage informed her view of their relationship afterwards. She had declared, it will be remembered, that once she loved, she would love forever, and she seems to have been determined to fulfill that ideal. Her vigorous, lively, sensuous nature, suggested by portraits and confirmed by contemporary comment, found fulfillment in a passionate attachment to William. Her letters provide a glimpse of a pious woman's abounding pleasure in the married state.

Rachel poured out her love, passion, and concern for William's

well-being in the letters she wrote him. "I will not endeavor to tell you what I suffer by being parted from you," Rachel wrote on May 16, 1672, in the first of her letters to William that has survived. Four months later in September when she would have known herself to be pregnant—she miscarried in October—she wrote apparently just to tell her husband of the "real and perfect happiness" she enjoyed and of how she treasured the "new marks" she received each day of his love. "My best life," she continued, "you that know so well how to love and oblige, make my felicity entire, by believing my heart possessed with all the gratitude, honour, and passionate affection to your person, any creature is capable of." In 1675 Rachel started her letter with the lament that "the few hours we have been parted seem too many to me, to let this first postnight pass, without giving my dear man a little talk." In 1679, after ten years of living together, she wrote of her passionate longing for William's return, saying that she loved him more than her own life and was "entirely his." In 1680 she regretted her inability to express how big her heart was with "a passionate return of love and gratitude." During the fateful autumn of 1682, when William engaged in conversations that were to be judged treasonable, Rachel reaffirmed her conjugal passion. Writing as a woman forty-five years old, and married for thirteen years, she declared, "I know as certainly as I live, that I have been for twelve [*sic*] years, as passionate a lover as ever woman was, and hope to be so one twelve years more; happy still, and entirely yours."[62] Rachel's many allusions to sexual fulfillment show how foreign to her nature was the prudery associated with Englishwomen in the nineteenth century. The genuine passion that Rachel felt would have needed no reinforcement from a cleric's admonitions, but it is nonetheless true that the love relationship which she enjoyed with William fulfilled the ideal expressed by the cleric Jeremy Taylor, whom Rachel had known years before at Golden Grove and whose works continued to appear in print.

Writing to William was in itself a kind of act of love. Rachel wrote to keep in touch with her husband and to nourish their relationship, to report on their children, to send instructions about domestic matters, and to supply him with gossip and news of political and public events. Writing to William also gave a purpose to her day and, in a way, endowed her with importance. She wrote, moreover, because she liked to write. Rachel seemed to derive a kind of physical pleasure from writing. Later in life, when an eye operation restricted the use of her eyes, she said that she took little pleasure in sending letters when she could not "write them with my own hand."[63] The remark of a male contemporary, that he loved nothing better than to sit "passing the pen from side to side of the paper," might well apply to her.[64] She admitted ruefully one time that she intended *not* to write, but had no power to stop herself.[65]

William recognized the pleasure she took in writing. In her first letter Rachel acknowledged this, saying, "I am very sure, my dearest Mr. Russell meant to oblige me extremely when he enjoined me to scribble to him by the post, as knowing he could not do a kinder thing than to let me see he designed not to think me impertinent in it."[66] With that encouragement, she felt free to write as often as she wished, which was almost every day that they were apart. Thus, these love letters, it is important to note, reinforced in Rachel the *habit* of composition, a habit that was to dominate her days after 1683.

Writing to her husband was for Rachel the "delight of the morning and the support of the day." In the absence of her "dearest blessing," "the pleasing moments" of her day were "either to read something from [him] or be writing something to [him]." The act of writing a letter brought William close to her. "I love to be busied in either speaking of him or to him," she confessed. "I would fain be telling my heart more things—any thing to be in a kind of talk with him." "I am so well pleased," she wrote, "to be alone and scribbling." Feeling that she should have a pretense for her frequent communications, often written within hours of William's departure, she decided that the "best" one was "that [what] I wrote yesterday should miscarry." She took especial pleasure in writing when she knew William would be home soon. "It is so much pleasure to me to write to you, when I shall see you so soon after, that I cannot deny myself the entertainment. My head will lie the easier on my pillow, where I am just going to lay it down, as soon as I have scribbled this side of paper."[67]

None of the surviving letters to William is a practiced essay; rather they were written in the midst of a busy domestic life (see the letter reproduced in the illustrations). Sometimes the room where she was writing was so full of people that she could not "tell what I say." Sometimes people impatiently hastened her to finish the note so that they might all go out or have "an egg." One time Rachel broke off a letter explaining that "boiled oysters call, so, my story must rest." On a couple of occasions she wrote when she was visiting Diana, Lady Alington, William's sister. Sometimes she wrote in the nursery with the children running in and out. One time she reported that she retired to her "little dressing room" to avoid the "next room" which was full of people "at cards."[68] Reflecting confidence and security in William's love, Rachel wrote sometimes on a scrap of paper, with a poor pen, apologizing ruefully for it: "You may guess by my writing what pains I take to do it." She was sensitive to the pell-mell quality of her letters and asked to be excused for what she termed their "nonsense" and "ill rhetoric." "What reputation [in] writing this may give me, the chamber being full of ladies, I know not," she began one letter in 1675.[69]

Whatever the circumstances under which she was writing and whatever tools she used, her handwriting was clear, free, and forceful, showing her intelligence and ease in expression, the same qualities that we have seen characterized her earlier letters and her pattern of speech. She had the ability in one and the same letter to write of her love for William in terms that seem to spring from her heart, to report succinctly political and social gossip and events, and to vivify domestic incidents so effectively that they still leap to the mind's eye. Yet she sometimes expressed diffidence about her ability to put into words the deep love she bore William. "It is not my talent," she complained to William after several sentences of well-expressed sentiments. She confessed to using some words that William himself had employed, saying, "If I could have found one [expression] more fit to speak the passion of my soul, I should send it you with joy; but I submit with great content to imitate [you]."[70] She was too modest by far. Her letters are fresh, warm, humorous, vivid, passionate, and spontaneous, superior to the few from William that have survived and the equal of or better than those of like nature written by her female contemporaries. Rachel's love letters to William compare favorably with those written by Dorothy Osborne to William Temple.[71]

Rachel wrote her letters herself, without employing an amanuensis, and that permitted an intimacy and freedom of expression that otherwise would have been impossible. Her letters are laced with familiar terms of endearment—"my dearest," "my dearest heart," "my dearest life," "my best life."[72] Yet she also employed conventional modes of address, referring to "Mr. Russell" or "Lord Russell." She did not use his given name.

The few letters from William to Rachel that have survived match hers as testimonials of love, passion, and interest in a variety of domestic and public affairs.[73] In 1675 William subscribed himself, "absolutely and entirely hers and only hers, William Russell."[74] Four years later when he was attending a political meeting, he stole away from a "great many gentlemen" to write Rachel that he was thinking of her and longed to see her more than she could imagine. "[I] want the chariot and my dearest dear in it," he declared.[75] Again, in autumn of 1681, when he was in London to raise bail for the earl of Shaftesbury, William, in a letter dated November 26 (see the illustrations) and written two days after his previous one, assured Rachel that he was hastening to "go to my dearest dear's embraces which, upon my word, I value now as much as I did ten, eleven, and twelve years ago." And in an inappropriate comparison, perhaps written in jest—for he sometimes teased his wife—he continued the thought that Rachel's embraces were of more value "than any the town can afford, now that you are out of it."[76]

During the fourteen years of their marriage, Rachel bore William four children, three of whom lived to adulthood. She had one genuine miscarriage in the autumn of 1672, and one she suspected in June 1674.[77] Clearly, she was not so fertile as her mother had been, and it seems likely, in view of Rachel's desire for children, the passion she and William felt for each other, and the spacing between the children (which was not extended by breast feeding, for she employed a wet nurse), that she experienced difficulty in conceiving.[78] The point draws reinforcement from her references to "drinking the waters," a common treatment in the seventeenth century for gynecological problems.[79] In any case, her first child with William, a daughter, was born at their "own house in Southampton buildings" on December 13, 1671.[80] The next day, the Reverend John Fitzwilliam, formerly chaplain to Rachel's father, now chaplain to the bishop of Winchester, and Rachel's sometime correspondent, officiated at the baptism. The baby was named Anne in honor of William's mother and of his little sister who had died as a child.[81] The Russell grandparents spent £238 for gifts for the ceremony, including a deep silver basin engraved with the Bedford coat of arms and a quantity of fine lace embroidered with gold, silver, and pearls.[82] But within four months the child died and was buried at Chenies on April 23, 1672. Although Rachel later recorded the baby's death by simply writing "my oldest girl...died some months after,"[83] it must have been a shock to her at the age of thirty-four that the fourth child she had brought into the world (counting the children with Francis Vaughan) had died so soon after birth.

Another girl, who was named Rachel, arrived safely on Saturday, January 17, 1674, born also at the Russells' first house on Southampton Square.[84] She grew up to become the duchess of Devonshire. A second girl, baptized Katherine and called "Kate," was born at the mansion, Southampton House, on August 23, 1676. She became the duchess of Rutland. Finally, on November 1, 1680 Rachel gave birth to a boy, also at Southampton House. It was a "day of great exaltation" for the Bedford family, for the arrival of a male child meant that the family title would be carried on.[85] Happiness over the arrival of a son must have been enlarged by the fact that Rachel was now forty-three years old, and the likelihood of further safe pregnancies and of healthy babies was diminishing with each year. And, in fact, this was her last pregnancy. The next day the baby was baptized Wriothesley, thereby preserving Rachel's maiden name in the Russell family for all succeeding generations.[86]

Rachel left only a few comments about her pregnancies and none about the experience of childbirth. She complained in August 1680, when she was about seven months pregnant with Wriothesley, that the

heat incommoded her, and she asked twice for a cleric's prayers that God would assist her in her approaching confinement.[87] There is no evidence that she encountered major problems in giving birth. There is no evidence either about who attended her, whether a midwife or male midwife. It is a matter of interest that later, in 1711, when her daughter, Katherine, faced obstetrical problems, Rachel wrote frantically to the well-known physician Dr. Hans Sloane, a friend and tenant in the Bloomsbury estate, to send the best doctor he could find.[88] In any case, it is reasonable to assume that when Rachel gave birth, one or both of her sisters (until the first Elizabeth died in March 1680) and maybe one or more of her sisters-in-law were present. She records that she was with her two sisters at their confinements.[89]

Rachel and William's attitude towards their children was one of deep affection and loving indulgence. Of course, neither one had the responsibility for the daily care of the children; there were nursemaids and servants for that, and the Russells followed the conventional practice of using a wet nurse. Indeed, little Rachel was sent to Titchfield to visit her aunt when she was six months old and again at fourteen months. And little Rachel and her sister were away from their parents in September 1679.[90] But Rachel enjoyed being with the children; it was her "best entertainment" when William was away. She visited them in the nursery, sometimes ate dinner with them, took them for walks to the farmhouse when at Stratton and to visit their cousins in London, observed them at play (specifically referring to the girls a-lacing), helped them to write notes to their father, and tucked them in bed.[91] She almost always had something to report to William about them.

Rachel filled her letters with accounts of the children's conversation, the condition of their health, and their activities, thereby providing rare insight into late-seventeenth-century English childhood. There is a timelessness about her account of how little Rachel, aged one, grew so impatient for breakfast that "nothing would do without the help of a piece of bread and butter." Equally beguiling are her references to the baby's "pretty new tricks" and to her pleasant disposition in the evening when she was undressed and ready for bed. Later, Rachel recreated for William the antics of Rachel, aged three, telling how she "prattled a long story; . . . She says, papa has sent for her to Wobee [that is Woburn Abbey], and then she gallops and says she has been there, and a great deal more; . . . She will send no duty; she is positive in it." In letters, she brought vividly to view the picture of a ten-month-old boy greeting her as she alighted from her coach, following her about calling "Papa," the only word he knew, she explained, so she was not "disobliged by the little fellow." Or again, she conveyed the image of the prancing about of a two-year-old boy, describing him "as mad, winking at me, and striking

with his drumstick whatever comes to his reach." Wriothesley was into everything, burning his fingers one time in his eagerness to sample the sack-posset. At another time, Rachel ended her letter with just a couple of words about the children—"Boy is asleep, girls singing abed"— conveying with great effectiveness an intimate picture of the nursery. William was not spared the details of the children's medical treatment when they were ill, including accounts of their vomits and bowel movements.[92] All these details were included certainly because Rachel believed that her husband wanted to know about them.

Further to enliven her letters to William, Rachel enclosed notes from their eldest child, which William preserved, a mute testimony to his fondness for his children. From the time she was five years old, little Rachel aped her mother in writing notes to her father. Rachel recreated the scene of the child following her into her chamber, observing her take up pen and paper, and asking what she was going to do. "I told her I was going to write to her papa." "So will I," said she, "and while you write, I will think what I have to say; And truly, before I could write one word, she came and told me she had done; so I set down her words; and she is hard at the business." Little Rachel took her writing seriously: once she was near tears with the effort; once she fussed at her mother for thinking that someone had helped her. One letter reproduced here illustrates the warmth of her love for and confidence in her father. "Dear papa," the letter begins, "I hope you will stay at Woburn but a little while. I should be glad to see you with me again. I believe you think of me as much as I can think of you. My duty to you, R Russell."[93]

No letters from Kate have survived, but Rachel said that she "takes her journey often to papa" and also that she dreamed of him. William responded to this affection, writing in an undated fragment, "Pray tell Miss [Rachel] I love her better then she loves me I believe, for all her kind expression in writing, which I thank her heartily for, as well as Miss Kate for her dreaming of me."[94] William loved the children. As he said later when he was awaiting execution, his son's illness affected him more than his own condition.[95]

Rachel's and William's health during their fourteen-year marriage seems to have been good. Aside from horseback-riding accidents, William suffered from only a few "indispositions"—in 1673, twice in 1675, and again in 1678. In 1675, he wrote an amusing account of a visit to a doctor for treatment of one of those illnesses. The unidentified physician was apparently baffled by William's complaint. "After humming two or three times," William recounted, "[he] concluded I was not fit to do anything at present but take my pills sometimes, which was all I had for my guinea." But from mid-October to mid-December 1677 William was so sick with a severe "rheum," which brought pains in his legs,

shortness of breath, heavy sweating, and fainting fits, that he was sure that he was going to die, and others were not confident to the contrary. Also, in 1680, when his involvement in politics had become frenzied, he had a series of nosebleeds.[96]

Rachel's health was better than it had been during her youth. She was ill with a sore throat in the late summer of 1674 and with a "great cold" in July 1678.[97] She was "tormented" by frequent "strong" headaches, but the only serious illness she recorded was some kind of infection involving vomiting and a sore mouth in November 1676, three months after the birth of Kate in August. The nature of the "distemper" is unknown, but Rachel was so gravely ill that a special doctor was called in for consultation. He gave her "much satisfaction" by candidly discussing his diagnosis and prognosis. In conformity with her thoughtful nature, she insisted that Bedford not be told of her illness until she was better.[98]

As she had done with the family of her first marriage, Rachel established a warm and loving relationship with the Bedford family. Without weakening ties with her sisters, Rachel established ties with William's siblings, especially two of his brothers, Edward and James, and his sisters, Diana and Margaret. Significantly, Rachel and her father-in-law rather than her mother-in-law became close. Three or four years after her marriage, Bedford wrote Rachel that the "greatest part of satisfaction I have in this world. . . is the seeing of you and my son happy in one another." He sent her a "heartful of kindness."[99] His pleasure in his grandchildren, expressed in gifts and letters, must have pleased Rachel. Confident of her affection, in March 1683 the earl sent Rachel his portrait as a gift.[100] Later, Rachel described the Bedford family as the "easiest to converse or live with that ever I have known or could observe" and declared that she was "entirely dedicated to it."[101] Early in her marriage the foundations were laid for Rachel to become Bedford's favorite child and to succeed him at his death in 1700 as the head of the family.

Rachel and William's private life was less intellectual and cultured than that of either Rachel's father or the earl of Carbery, her first father-in-law. William was not an intellectual, and as husband and father he set the tone of their life together. Marriage did not dull his high spirits. He remained a sensuous person of great exuberance, who enjoyed all kinds of physical activity. Like most well-to-do country gentlemen, he kept hawks and dogs, loved horses, hunted, and rode for pleasure, undeterred by accidents (one of which occurred in January 1674, and another in July 1682, which was serious enough for Rachel to note in her diary).[102] Rachel apparently did not share her husband's love of sport and riding, but she did enjoy walking outdoors.

All during his life, as late as 1681, William indulged in horseplay with family members, a harmless but perhaps irritating habit to the family members on whom this boisterousness was inflicted.[103] He was also evidently something of a tease, even with Rachel, a habit which seems to have pained her. Further, he remained extravagant in his expenditures, requiring an advance from time to time on the £2,000 yearly allowance that his father had settled on him at the time of his marriage. At his death his debts were large enough to be a burden for some time to Rachel.[104]

Both William and Rachel enjoyed eating. They peppered their letters with references to food that they had particularly liked and perhaps spiced their conversation with accounts of such treats. For example, Rachel wrote of drinking white wine and beer, mixed "my uncle's way, with nutmeg and sugar," and of eating "pudding with the girls and . . . porridge and partridge" with her sister. She reminded William not to forget to send the larks and broke off one letter because "boiled oysters call."[105] All these prosaic matters of mutual interest and concern show from another perspective the relaxed, comfortable, warm, and intimate relationship that they had.

As before his marriage, William continued to be heedless of the consequences of his actions. In September 1671, when Rachel was six months pregnant with their first child, William recklessly undertook to avenge the honor of her half-sister, Elizabeth Percy, countess of Northumberland, whose husband had recently died. During a visit to Althorp (the Sunderlands' country seat), Henry Savile, younger brother of George Savile and thus an indirect relation of Rachel's, had invaded Elizabeth's bedroom at one o'clock in the morning to declare his love for her. Astonished and frightened, Elizabeth rang for a maid and then leaped out of bed to the bedroom of another lady. The next morning the assembled company expressed such indignation at these shenanigans that Savile rode away posthaste to London, and from there, it was thought, to France. William and some others pursued him, and William alone, it was said, followed him to France. He won the admiration of some people for this.[106] There is no evidence revealing how Rachel herself regarded the episode. Such exuberance of spirit would have made daily domestic life a lively affair. Rachel clearly enjoyed the excitement her husband provided. She wrote him one time, "All I see either are or appear duller to me than when you are here." And again, nine years later in 1681, she observed, "As often as you are absent, we are taught by experience, who gives life to this house and family; but we dodge on in a dull way [without you], as well as we can."[107] If she missed the intellectual milieu that her father created at Southampton House and Titchfield or that her first father-in-law, the earl of Carbery, developed at Golden Grove, she did not say so.

There was, however, a softer side to William's temperament. A tender and loving man, he kept in touch his entire life with John Thornton, his old tutor, and revealed in letters to him the generosity of his spirit. He was much saddened by some accident that had befallen his brother's child and deeply alarmed by a report about his sister's indisposition. He told Thornton how he had comforted Rachel, who had cried over the news, by telling her that he was confident that Diana's illness was the effect of some "melancholy vapour" that would pass.[108] His apparent interest in the details of his children's health and his response to their childish letters speak to the same quality in him. Rachel wrote later that William was a true "partner in all [her] joys and griefs."[109]

Rachel described her married life as one of "great and true happiness made up of love and quiet at home, abroad friendships and innocent diversions."[110] The "diversions" mentioned in letters to William when he was away were probably no different from the ones she enjoyed when they were together. They included shopping with her sisters or sister-in-law, Diana, Lady Alington; visiting and receiving friends and relatives, especially her half-sister Elizabeth, married since 1673 to Ralph Montagu and living nearby; and playing a variety of card games, such as backgammon, ombre, and beast, sometimes for money.[111] Rachel does not mention attending the theater, as she had done before her marriage to William, but it seems a reasonable guess that they both enjoyed this popular entertainment when they were in London. If this assumption is correct, then it is clear that the Russells' sympathy for Dissent did not include the proscriptions that Nonconformists placed, at least in theory, on card playing and theater going. It cannot be said that Rachel was a political hostess or that she created a salon of intellectuals of any kind. But men from the highest reaches of government and politics and their wives were among her circle of friends, and the conversations that she reported inevitably included politics.

It seems virtually certain that the "quiet at home" did not include wide reading. William's reading habits did not, so far as can be determined, change very much from those established in his youth. After marriage he showed some interest in astronomy, once ordering two copies of a book on that subject, one in Latin, one in English.[112] Plainly, the order shows that he kept up an ability to read Latin, in which he had been so well schooled as a youngster and prodded as a young man by his tutor to continue. He also read religious tracts, Rachel referring one time in 1682 to an unidentified book that had made William "in love with heaven."[113] While he seldom read statutes, he read newssheets and current polemical political tracts. Rachel herself was an avid reader of domestic newspapers, referring specifically to the *Gazette*, the *Mercury*, and French "prints."[114] According to an observer, the daily news and the "politics of Europe" were the staple of Russell's conversation,[115]

and Rachel's volubility virtually assures that she would want to talk about what she was reading. Rachel infrequently mentioned the Bible and devotional literature, but it cannot be doubted that she regularly read such material. In the absence of household accounts, which might have shown expenditures for books, one has to conclude from the available evidence that reading serious literature was not important to William nor to Rachel at this period of her life.

But Rachel was serious about religion, and almost certainly because of her influence, William became more devout after their marriage. Sympathy for Nonconformity, established in their youth, continued to inform both their attitudes. William, in particular, developed a sharply anticlerical view of the Anglican church and an obsessional hatred for Roman Catholicism which was reinforced by his fear that the Anglican church was becoming infected with popery. But apparently, the thought of breaking with Anglicanism was never seriously considered. Because of the absence of William's papers and the paucity of the letters that have survived, it is impossible to say how Russell expressed his religion within the domestic sphere. There is no evidence of lengthy sermons and high-minded discourse following them, as was the case in Rachel's father's household, but prayers were regularly said twice a day.[116] In 1679 Russell appointed as his chaplain the Reverend Samuel Johnson, a radical preacher and pamphleteer devoted to the principles of Nonconformity, toleration, and limited monarchy. Johnson, who became "warmly attached" to Russell, felt that his chaplaincy "proved to their mutual satisfaction." He influenced and/or reinforced William's views, especially on the question of the right of resistance, to which, as we will see, Russell adhered during his imprisonment in 1683, despite efforts to convince him otherwise.[117] Vigorous in personality, intransigent in principle, and courageous in the face of persecution, Johnson would have raised the level of intellectual conversation in the household. Lady Russell must have approved of his views. She kept him on as her chaplain after William's death and assisted him in other ways. In 1689 Johnson dedicated his tract *Remarks upon Dr. Sherlock's Book* (written originally in 1683), to the Russells' son, and when his works were printed in 1710, the title page bore the words *The Works of the Late Reverend Mr. Samuel Johnson, Sometime Chaplain to The Right Honourable William Lord Russell*. It seems unlikely that either the dedication or the reference to Johnson's serving Russell as chaplain would have appeared had Johnson thought that Lady Russell would object.

Rachel's sympathy for Nonconformity was surely strengthened by her French uncle, Henri de Ruvigny. De Ruvigny visited England frequently: on three short missions between 1660 and 1665, in 1667, in

1671, from November 1673 through June 1676, in 1678, and in 1681. He often saw the Russells.[118] One probable consequence of his influence was that Lord Bedford allowed a nonconformist Huguenot congregation to settle on his estate at Thorney (where French Protestants had found refuge since 1652) and, perhaps at the instigation of Rachel and her uncle, granted them special privileges. Services in the parish church, which was under Bedford's sole jurisdiction, were conducted alternately in French and English, and parish records were kept in both languages. The congregation numbered over one hundred individuals in the mid-1670s.[119]

Rachel's great happiness in her husband's love and in her children, as they arrived, heightened her sense of God's presence and love. She was deeply grateful for these blessings and thanked God regularly for them. But perhaps because illness and death had been ever-present in her early years, Rachel was fearful that her happiness might not last and anxious that she and William prepare themselves for life's tribulations and for death. In 1672 she wrote a letter to William that had the character of a prayer and, in view of future events, of a prophecy. "What have I to ask," she wrote, "but a continuance (if God see fit) of these present enjoyments? if not, a submission, without murmur, to his most wise dispensations and unerring providence; He knows best when we have had enough here; what I most earnestly beg from his mercy is, that we both live so as, which ever goes first, the other may not sorrow as for one of whom they have no hope." She went on to say that they should live in the confidence that God would support them in whatever "trial he will inflict." Excusing herself for dwelling on such a topic, she explained that it came from "her opinion" that if prepared, "we can with greater tranquillity enjoy the present"; and when death comes, "it will be for the better, I trust, through the merits of Christ." Daily prayer would prepare them to face death without fear and thus to live life with "light hearts."[120] But she begged God to spare her and William the "sharpest trials" and to dispose their minds and hearts to submit to His will.[121]

Rachel's reaction to the death of her sister, Elizabeth Noel, in March 1680 was prophetic of her reaction to William's death later on. Reflecting the intensity of the sibling affection the two women had had for each other, Rachel felt that she had lost her dearest friend and wrote William despairingly that he was the only friend she had in the world. So uncontrolled was her grief that she feared God might "try [her] with greater crosses."[122] Rachel felt that she should possess "a resigned will" in the face of earthly sorrows and a "strong belief" that the expectation of eternal bliss with God made earthly afflictions inconsequential. But she was not able to achieve such an attitude; her passionate nature rebelled against it.

During the fourteen years that Rachel and William were married, only a few instances of discord seem to have marred their relationship. In old age Rachel blamed herself for failing to bear quietly William's "infirmities" and for "provoking" him by her "impatience."[123] We know of specific instances of tension between the couple only indirectly from oblique references in Rachel's letters. The references themselves reveal Rachel's nature. She was strong-minded and independent enough to tell William when he had done or said something that caused her pain, but she buried her distress in expressions of affection and did not permit the disharmony to become destructive. Throughout her marriage she bound William to her by unfailing devotion.

The first minor disequilibrium found reflection in a letter of August 23, 1675. Rachel wrote that she loved to be talking with him, "though he does abuse poor me sometimes." Her remark suggests that William teased her sometimes about some aspect of her behavior or attitude. She went on to complain that William had "vexed" her "bravely" over a letter that she had received from Jack Vaughan (her brother-in-law, it will be recalled, from her previous marriage). She saw that William had opened the letter, but in confused language she explained away the incident and rushed on to say, "Oh, my best life, how long I think it since we were together!"[124] Another minor disharmony seems to have occurred the next year. On September 15, 1676, a month after the birth of Kate, Rachel remarked that although she had no greater pleasure than in writing to William, she had not indulged herself in doing so "because I do not know 'tis one to you." Her letter, she explained, was simply to convey some necessary news. Again, in 1681, Rachel, while assuring William that she would have no true pleasure until she saw him again, added that she would forebear telling him "how I take your abusing me about my perfections. You should leave those things to your brother to say, when occasion serves." Again the implication is that her husband teased her. On still another occasion in 1681, while acknowledging her joy over William's expressions of love, Rachel noted that his letter contained "some alloys possibly. . . but I defer that matter till Friday." Finally, Rachel rather ruefully confessed to feeling that William's interest in politics had taken precedence over everything else. Writing on October 20, 1681, about arrangements to rejoin her husband in London, Rachel asked him to reply the next day, "if you can think of anything but parliamentary affairs."[125] Such hints of marital discord are very minor matters in an intimate relationship; what they show is Rachel's determination not to allow the disharmony to grow.

But there were, apparently, two rather serious disagreements. One occurred in March 1681 and concerned William's role in the upcoming Oxford Parliament. It will be discussed in the next chapter. The

details of the other episode are opaque and fragmentary, but seem to reflect Rachel's suspicions that William was indulging in a sexual excursion. To place this incident in perspective, one needs to recall that William had a reputation as a womanizer before he and Rachel married and that Rachel would certainly have known about that. A handful of hints in her letters intimate that she was a little anxious about his faithfulness after they married. Her repeated expressions of thanks for the marks of his passion may well have reflected her relief on that matter. For example, in May 1672 Rachel wrote William about a visit that two ladies had paid her at their new house on Southampton Square. Referring to them as Mrs. Laton and her "she friend, not yours, at least not your best (I praise God)," she reported that the two women had inspected the house and that William's former friend "praised it, and seems to like it, as well as you have done her."[126] The remark about his previous relationship with this unidentified woman, however gently made, was still pointed and suggests some insecurity.

A tasteless letter that Rachel received the next month from Colonel John Russell, William's uncle (the man who was involved with William in the episode in 1665 that landed them in the Tower), may have threatened her confidence in her husband. After discussing details regarding the diplomatic negotiations respecting the Third Dutch War, the colonel reported that the Dutch will offer England cautionary towns and "Dutch women to every governour since the females of our own country will not be persuaded which, I am sure, Mr. Russell believes not." Not content with that, John Russell continued his coarse remarks in a postscript in which he asked Rachel to tell William that he had a letter for him "which shall be his shame and to all his scandalous companions, for women are honest to a fault."[127] There is no record of what Rachel made of this, but one may imagine her distress at the intimations of William's loose sexual behavior.

Two years later, in 1675, gossip circulated that William was a rival for the favors of Lady Jane Norwich, the wife of Henry Howard, earl of Norwich, and that William, George Villiers, the second duke of Buckingham, and James, duke of Monmouth, were involved in several compromising situations. The matter was made all the more awkward by the interest that the king, so it was said, had in the woman.[128] Whether or not the rumor had any basis in fact is unknown, nor is it known whether or not such a rumor reached Rachel's ears. There is no reference to it in the Russell papers. If it were true, however, it added one more reason why both Buckingham and Charles II might dislike William Russell. And, true or not, if the rumor reached Rachel's ears, it obviously would have distressed her.

What may have been the most serious disagreement developed at

an unspecified moment, probably in the spring of 1680, when Rachel was at Titchfield and William in London. In an undated letter written on a Friday, Rachel complained of William's "most tedious absence," expressed anxious concern over the state of his health, and stated her suspicions that he was delaying his return. She threatened that she would "either stay here till Monday or march to London to see how 'tis with you. For 'tis not public affairs I find hinders now."[129] If it was not public affairs that kept William in London, what was it? What would make Rachel declare, in language of unaccustomed firmness in her correspondence with her husband, that she would "march" to London? Why should she use such strong words, even though she buried them in a text that was otherwise loving? No other letters on the matter have survived, so it is not possible to discover the reason for Rachel's disquiet. It may have been concern for William's health; it may have been wifely outrage over suspicions of marital infidelity. Whatever it was, it did not last long. In the summer of 1680, Rachel, now pregnant, wrote William, who was at Stratton, "My dearest heart, flesh and blood cannot have a truer and greater sense of their happiness than your poor but honest wife has." Carried away by emotion, Rachel expressed the hope that William might continue to enjoy Stratton for fifty more years and that she might be by his side during that time. But she added a curious comment that supports the hypothesis that in the spring she had suspected him of infidelity. Following the expressed hope that she might be by his side, she wrote, "Unless you wish other at any time; then I think I could willingly leave all in the world, knowing you would take care of our brats."[130]

The marital discord, whatever its nature, was really unimportant in the relationship between Rachel and William. In the final analysis, they enjoyed near-perfect marital harmony, based on love and passion for each other, devotion to their children, common concerns about their household and property, and mutual interest in religion and politics. When Rachel reflected on her private life with William after his death, she asserted that she had lived with him "in the highest pitch of the world's felicity" and declared that when he died she had lost an "inestimable treasure."[131]

· 5 ·
Politics, 1673–1683

The center of Rachel's life during the years of her second marriage was, as we have seen, her husband, her children, and other domestic relationships. But as William's political career grew from 1673 to 1681 so too did Rachel's interest in politics. Opportunities for her to participate indirectly in public affairs multiplied. Through her contacts with well-placed people, Rachel kept Russell informed of political developments when he was out of town. She endeavored to comfort, advise, warn, and restrain him. Moreover, she provided a social link to people in public life whom he had not known before his marriage. Among the men with whom he was associated in politics were Rachel's relations: Shaftesbury, the founder and tactician of the Whig party; Montagu, the English ambassador to France; and de Ruvigny, Jr., emissary from the court of Louis XIV. Russell's career and Rachel's connection with it illuminate the public dimension of family culture, highlight the limitations in political opportunities for a woman, and illustrate the dangers of opposing the government in late-Stuart England.

Rachel's view of her role in politics was ambiguous. On the one hand, she saw herself in largely conventional terms. She had no personal political ambitions, as did Sarah Churchill.[1] Nor did she complain in writing about women's exclusion from politics, as did a few women during her lifetime. The attitude of Margaret Cavendish, the duchess of Newcastle, who bitterly denounced the political system and declared that it had imposed a "slavery" on women, found no parallel in Rachel's writing.[2] Rachel accepted without comment that according to custom (rather than law) she could not vote, hold public office, nor sit in the House of Commons. She was apparently unaware that during her lifetime more men than ever before were voting and, with the expansion of the national bureaucracy, holding administrative office.[3]

On the other hand, Rachel's attitude and activities included unconventional elements. As we have seen, her interest in politics and public affairs was well established long before her marriage to William. She admitted to being so "curious in seeking into the secret causes of events" as to fear herself at fault.[4] Like some other aristocratic ladies who were connected with the highest reaches of government through the men in

their families, Rachel simply assumed that she had a right to know what was going on in politics. She felt that the opinions and recommendations she proffered were worth listening to. She believed that her husband's political career and her part in supporting it furthered religious and political ideals that she favored. No more than William did she write about political ideas, but his actions and her apparent approval of them implicitly reveal the ideals of both. When she feared for William's safety, she forthrightly attempted to influence him.

William's career in the House of Commons falls into two major parts: his movement from obscurity in 1673 to importance in 1678, when the Popish Plot broke, and his ascent to eminence from 1678 to 1680, when he was described as the "governing man" in the House.[5] Throughout this public career he conducted himself in a rash and impetuous manner, boldly attacking the king's ministers and policies, aligning himself with the Country opposition in the House of Commons, and serving from about 1677 to 1681 in the Commons as the earl of Shaftesbury's most trusted ally as the Whig party emerged. His major contribution to politics was to champion fearlessly certain political and religious principles and to inspire men to follow his lead. In effect he transferred to politics the aristocratic, chivalric attitude that had informed his private life. After King Charles II dissolved Parliament in 1681, Russell became involved in conspiracies against the government. His career ended in 1683 when he was executed as a traitor, an event that brought wrenching change to Rachel's life.

Rachel's active interest in public issues grew in tandem with her husband's political career. Her first contribution may have been to encourage him to take a serious interest in public affairs, as she was accustomed to having male family members hold high office, and political service was expected of men in his social and economic rank. Also, Rachel was known to have imbibed her father's views, among them criticism of Charles II and his court as corrupt, immoral, extravagant, sympathetic to Catholicism, and inclined to favor absolutism. It is reasonable to think that she was alarmed by public events that appeared to confirm that assessment. Her long-term interest in politics, her later pride in William's success and recognition, and her confession that at some periods in her life she was greedy for honor support such a hypothesis.[6]

At the time of his marriage to Rachel in 1669 Russell was, as we have seen, a nonentity in House affairs, and so he remained in 1670.[7] Two years later his role had changed enough for Rachel to include domestic and foreign news in her letters to him.[8] And during the next year, 1673, he emerged from obscurity when he was named with others to discuss House business with the lord chancellor, the earl of Shaftesbury, and was appointed teller on the nay side in a vote on a bill to incapacitate

Dissenters from sitting in the House of Commons.[9] Two acute political observers—Sir William Temple and King Charles II—singled him out as a member of a group in the House of Commons that was especially alarmed over the Third Dutch War and the condition of Protestantism in Europe.[10] On October 31, 1673, for the first time in his life, he opened a major debate.

New, aggressive, and sometimes secret policies in finance, religion, and foreign affairs, which had marked Charles II's government since 1670, fostered apprehension throughout the country that the court favored France, Catholicism, and absolute rule.[11] The conversion to Catholicism of James, duke of York, and his second marriage to an Italian Catholic princess, Mary of Modena, along with an increase in the numbers of Catholics at Whitehall and in London gave concrete evidence of the increasing influence of Catholics. Unless some miracle of biology or statecraft occurred to enable Charles to produce legitimate offspring, the Catholic duke would someday inherit the throne. One may be assured that William and Rachel regarded that possibility with horror.

Furthermore, several controversial actions taken by king and court during the long intermission of Parliament from the spring of 1671 to February 1673 were suggestive of absolutism. One was the Stop at the Exchequer on January 20, 1672, which brought money into the government without recourse to Parliament and ruined some bankers and investors. Even more controversial was the Declaration of Indulgence issued on March 15, 1672, which granted some religious toleration to Dissenters and Catholics and reopened the sensitive question of the king's power to suspend and/or dispense with the law. Billeting, the use of martial law, and the very presence of soldiers, raised before and during the war with Holland, potentially threatened law, parliamentary government, and morality. Beginning in the spring of 1673 a propaganda campaign of pamphlets and tracts, mounted by the Dutch, depicted these and other policies as injurious to English liberties and to Protestantism everywhere.[12] These issues animated William's opposition to the government in the first phase of his career.

Russell's speech of October 31, 1673, opening debate in Grand Committee on the government's request for money to continue the Third Dutch War, marked his first public expression of opposition to the government. Despite William's confessed inarticulateness, his speech was effective. "The business of the day is 'Money,' " he began, and continued by saying that he "would rather be thought to mean well and speak ill than to betray the trust of his country." Money given to fight against Holland endangered the nation and Protestantism. Expressing himself in rash terms, Russell hinted that the king's ministers had "betrayed their trust" and urged the House to tell the king so plainly, as

earlier parliaments had done, by refusing to grant any supply at all.[13] Although Russell's proposal failed and more moderate views prevailed, this speech launched his career.

It is not known whether he discussed the substance of his remarks with Rachel, but she may have contributed to forming the views that he expressed. It is known that in the previous year she had followed the news of the naval battles and reported it to William. She revealed sophistication and depth of knowledge in suggesting treachery on the part of the French.[14] Furthermore, knowledgeable men, such as Colonel John Russell, William's uncle, had written *her* in detail in June 1672 about the war and prospects for peace with Holland.[15] And news that Louis XIV regarded the war as a "Catholic war" to crush Protestant Holland, obtained probably through Rachel's Huguenot relatives, may have contributed to Russell's decision to speak out.[16]

Over the next four months, until the end of February 1674, when Charles II prorogued Parliament for over a year, William emerged as an emphatic supporter of the opposition. During this time Rachel gave birth, on January 17, to the girl named Rachel, and it is likely that her time and thoughts were otherwise occupied. There is no evidence of her reaction to her husband's continued criticism of the government. Once more, on January 12, Russell took the initiative, introducing the idea that the king's ministers should be brought to account. Again, his speech was effective. Exempting Charles from blame, he urged the House to discover "the authors of our misfortunes, the ill ministers about the king." Reinforced by senior members, on January 14, William vigorously supported a motion to remove George Villiers, the duke of Buckingham. Again he employed inflammatory language, declaring that a "knot of persons" close to Buckingham "who have neither morality nor Christianity," had "turn[ed] our Saviour and Parliaments into ridicule and contrive[d] prorogations."[17] As a result of the debate, the House prepared addresses for the removal of Buckingham and of John Maitland, the duke of Lauderdale. From the very beginning of his career, William was fearless in attacking men who held high office.

Russell also joined others in criticizing the government's handling of the army. In a debate on February 7 he inferred that "CABAL-Interest" had "set up an army to establish their interest," and concluded his speech with an ominous and intemperate remark: "This government, with a standing army, can never be safe; we cannot be secure in this House, and some of us may have our heads taken off."[18] At the end of the debate, members voted to declare that continuing any forces other than the militia was a "great grievance" and voted to petition the king to disband all troops that had been raised since January 1, 1663.[19]

In 1675 Rachel resumed her self-appointed role of keeping her

husband informed about public affairs when he was out of London. In February when he was at Stratton, she sent him copies of the *Gazette* and the *Mercury*. Assuring William that she had "asked everyone I see for news," she reported rumors about candidates for the position of chief justice, and relayed a gossipy account about the jealousy at court between the duke of York and Henry Savile, which, in view of the episode four years before involving Savile and Rachel's sister, must have delighted Russell. Intelligence about the court's interest in seeing a naval report prepared by the Dutch admiral, De Ruyter, and the progress of French arms reached William through Rachel's letters at the time he was preparing for the new session of Parliament, which opened in mid-April 1675.[20] Printed sources supplied some of Rachel's news. People with access to the inner circles of government also provided her with information. They included Lord William Alington, her brother-in-law, M.P. for Cambridge; the earl of Bedford; Francis Charlton; the Honorable Conyers Darcy, her stepmother's husband; her half-sister Elizabeth and her husband, Ralph Montagu; Lady Shaftesbury and Shaftesbury himself; Spencer; and Colonel John Russell, William's uncle.

Only a few letters from William to Rachel during the years from 1673 to 1683 have survived, although Rachel's references to others prove that he wrote often.[21] In one letter, written from London on Tuesday, August 10, 1675, Russell reported that he had discussed with Henri de Ruvigny, Rachel's French uncle, the fall of Crequi. This confirms that the two men enjoyed a friendly relationship at the time. He filled his letter with other public news: a rising among the Bretons in Normandy, a disturbance among French weavers in Moorefields, and the feeling among "knowing people" that Parliament would not meet until February. He confided his interpretation of events, the court's response to French reverses, and the significance of the fall of Crequi. Apologizing for the shortness of this lengthy letter, he said he had several more stories to tell her which slipped his mind.[22] This single letter suggests the regularity with which William and Rachel corresponded on public affairs and testifies to his confidence in her interest and judgment in politics.

No comment from Rachel about William's role in either the spring or fall parliamentary session has survived. But the record makes clear that he continued to oppose the government at every turn, resisting a motion for customary thanks for the king's opening speech, serving on a committee to draw up reasons why Lauderdale should be removed, and calling for the impeachment of Thomas Osborne, earl of Danby, the lord treasurer and the third minister whose dismissal he had demanded.[23] Moreover, in October 1675 he took part in a stratagem to obstruct the king's business by igniting anxiety over standing armies and English

soldiers serving in the French army in ways that revealed his willingness to use unfounded rumor in the service of political tactics.[24] By the time the king prorogued Parliament on November 22 for fifteen months, William had further increased his visibility and identified himself strongly with extremists in the Country party.[25] A friend of the court expressed the hope that before Parliament reconvened, Russell's two brothers-in-law (Lord Alington, his sister's husband, and Edward Noel, Rachel's sister's husband), "might do some good with him."[26] That did not happen.

Another influence Rachel had on William's political career was to introduce him to the earl of Shaftesbury, a critic of the government since 1673, who became the organizer and tactician of the Country opposition and then the Whig party. Russell and Shaftesbury were so far apart in age, temperament, and political attainment and status that they probably would not have established so much as an acquaintanceship had it not been for the connection through Rachel. In 1677 Russell was a man of thirty-eight, a large, active, genial, unbookish person of still modest attainments, whereas Shaftesbury, in his mid-fifties, was a short, slight person, whose health had never been robust and who carried a permanent drainage tube in his abdomen, left there following a spectacular operation in 1668 for a hydatid cyst on the liver.[27] Whereas Russell had held no office beyond minor local ones in Bedfordshire and Hampshire,[28] Shaftesbury had occupied some of the highest posts in the nation—under-treasurer, president of the Council of Trade, chancellor of the Exchequer, and lord chancellor. Highly intelligent, a skilled orator, ambitious to exercise power, and willing to use almost any political means to attain his ends, Shaftesbury was also deeply committed to certain political and religious attitudes. He favored limited monarchy and toleration for Dissenters; and expressed hatred of Catholicism and arbitrary government, devotion to the rule of law, fear of standing armies, and respect for the landed, well-to-do classes. Russell, as we know from his actions and speeches, shared these views.

Rachel enjoyed a warm relationship with Lord and Lady Shaftesbury, and close ties bound the two families. Their estates lay near one another in Hampshire. Marriage linked them: in 1655 the then Anthony Ashley Cooper married as his third wife Margaret Spencer, Rachel's cousin.[29] Shaftesbury owed his start in Restoration politics to Southampton, who, as treasurer, used his influence to win him appointment as chancellor of the Exchequer and under-treasurer.[30]

Rachel and her cousin Margaret, ten years her senior, were good friends. Both women were intelligent, thoughtful, interested in politics, and sincerely religious.[31] Rachel and Margaret spent part of the summer of 1662 together at Bath, where the earl joined them.[32] In 1675,

1676, 1677, and 1679 Margaret either called on, dined with, or played cards with Rachel. One time she stayed for three weeks with her.[33] When Wriothesley was born in 1680, Margaret stood as godmother.[34] The two women comforted each other in the trials that their husbands brought to their lives, as in 1681 at the time of the Oxford Parliament, when Margaret was desperately afraid that Shaftesbury would be arrested, or after William Russell's execution, when Margaret was the only woman that Rachel invited to be with her.[35] In September 1683 Lady Shaftesbury addressed Rachel in a poignant letter of sympathy as "my best and dearest friend."[36] In a later letter Margaret subscribed herself as "unimaginably passionately affectionately yours."[37]

Rachel had still other contacts with the Shaftesbury household. Margaret's brother, Robert Spencer, was a source of news of public affairs, as was Francis Charlton, Shaftesbury's one-legged cousin.[38] Rachel met John Hoskins, Shaftesbury's solicitor and probably his kinsman, at Shaftesbury's house and formed such a good impression of his abilities that after William's death she asked him to advise her on legal and business matters.[39] Further, it is likely that Rachel was acquainted with John Locke, who was not only Shaftesbury's physician, adviser, and intellectual companion, but also was physician and traveling companion to her half-sister Elizabeth Percy, countess of Northumberland.[40] Whether Russell met Locke in these familial circumstances is unknown. Since William was not a man of ideas, a friendship between them is unlikely. No letters between them have survived. Yet they must have seen each other more often than the one specific record of an intended meeting in August 1680 would suggest.[41]

There are no surviving comments from either Russell or Shaftesbury about the other. But it is obvious that Shaftesbury was the dominant figure in the relationship. Shaftesbury would have respected William for his energy, fearlessness, selflessness, growing popularity, and willingness to accept direction from him. Russell's noble family, familial and kinship connections, wealth, expections of inheriting a title and even greater wealth, and reputation, since his marriage to Rachel, for honesty, morality, and religion were all extremely useful to Shaftesbury. Russell would have admired the older man for his experience, past offices, bold leadership, and ideals.

The relationship between Shaftesbury and Russell deepened, and when Parliament reconvened in 1677, William had become one of Shaftesbury's most trusted and dependable allies in the House of Commons. From the time of the Popish Plot, which broke in the autumn of 1678, and the ensuing Exclusion Crisis, which lasted until the dissolution of the Oxford Parliament in March 1681, Russell was Shaftesbury's "point man" in the Lower House. The role placed him on the extreme

edge of issues and in the spotlight and was fraught with potential hazard.

During the short parliamentary session from mid-February to mid-April 1677, when Russell was absent on estate business, Rachel intensified her efforts to keep her husband informed. She wrote in April that she had tried to gather news because she wanted to "entertain your dear self the better by this letter; . . . for all my ends and designs in this world are to be as useful and acceptable to my Mr. Russell as I can."[42] She traveled about London with her sister Diana, Lady Alington, and talked with Lord Alington (who gave her a copy of Charles's message to the House of April 11), Sir Hugh Cholmondeley, and her cousin Spencer. Thus fortified, she wrote her husband a lucid, sophisticated, and comprehensive account of the results of a debate in the House of Commons, the attitude of the Lords, and the view of the court towards the proceedings. She also copied Charles's speech for William.[43] Still further, Rachel made herself visible for the first time by dining with Shaftesbury in the Tower.[44] Her visit was, in effect, a political act, and a bold one.

This visit to Shaftesbury is the only evidence available from 1677 to suggest that Rachel approved of his views and thus of the part Russell played in the Commons in forwarding them. Shaftesbury, along with three other peers, was sent to the Tower on February 17. The circumstances were as follows. On February 15, the day Parliament opened, Shaftesbury and three other peers in the House of Lords caused Russell and others in the Commons to introduce the proposition that the parliament was dissolved. The move was a sharp rebuff of the king, who, in opening Parliament and asking for supply, had promised to do everything consistent with "Christian Prudence" to preserve the Protestant religion as established by the Church of England and to secure property and liberty.[45] In both Houses the main argument was that ancient laws, dating back to the fourteenth century, required Parliament to meet at least once a year; the prorogation had lasted fifteen months, and hence the body was dissolved.[46] Such an argument threatened a prerogative of the crown to call and dissolve Parliament at its pleasure.

While Russell did not contribute to the substance of the debate, he helped to sharpen the issue. Admitting that "he was no great reader of Statutes and therefore is no competent judge of those mentioned," he moved an address to the king that Parliament was dissolved, so that the issue could be settled.[47] The proposal had no success in either House, in part because members were disinclined to give up their seats.[48] In the Commons, support was lacking to bring the question to a vote, which made more visible the few men, Russell among them, who promoted the issue. The four peers were sent to the Tower on February 17 for their part in the action, and Shaftesbury stayed there for almost a year. Loy-

ally Russell on February 20 sought permission, as was required, to visit Shaftesbury but was turned down, thereby making Rachel's subsequent visit all the more prominent.[49]

William's social status was enhanced with the death of his elder brother in January 1678. William assumed the courtesy title of Lord Russell and the position of heir to the Bedford title and fortune. Now that his rank equalled that of her first husband, Rachel adopted his name and was known henceforth as Lady Russell or Rachel Russell.

Lord Russell's new status facilitated his moving into a position of genuine consequence in English politics when Parliament reconvened in January 1678 after a prorogation of eight months. In February and March he and opposition peers engaged in secret conversations with emissaries from France. In the autumn, he exploited the Popish Plot for partisan purposes. As before, Russell's actions and language were rash and fraught with personal risk; they alarmed Rachel, who sought to restrain him. But the steps he took served the principles of the parliamentary opposition, inspired less brave M.P.'s, and won William their admiration.

Rachel also influenced William's career by introducing him to her French uncle, Henri de Ruvigny, Sr., and her cousin, Henri, Jr. Between 1667 and 1676 her uncle served as an envoy from Louis XIV. De Ruvigny and Rachel had always been fond of each other, and he saw the Russells often. De Ruvigny, who was in his seventies and held a high place as spokesman for French Protestants in Louis XIV's government, was respected for his "eminent administrative powers and great dexterity." Under a "very plain exterior," he used both candor and finesse.[50] It is unlikely that de Ruvigny and Lord Russell would have established a relationship at all had it not been for the connection through Rachel. De Ruvigny and Russell, however, became friends. In 1673 Henri may have confided to William (who in turn told Rachel) that he had approached Shaftesbury with a view to bribing him to support the interests of France.[51] If this story is true, the Russells knew firsthand that the French government had contrived to bribe M.P.'s to achieve a policy congenial to their interests. Apparently they did not object, for the intimacy with de Ruvigny remained intact.

De Ruvigny, Jr., a man of thirty years in 1678, was also an intimate of the Russells. In part because of that, Louis XIV sent him to London armed with money to see how the mutual interests of the parliamentary opposition and the French government might be served.[52] The French court entrusted the task to young de Ruvigny rather than to his father because they felt that the latter was too old to undertake it. The younger de Ruvigny had already had experience under his father's guidance in influencing members of the English Parliament. The French

counted on Russell to introduce Henri "into a great commerce with the malcontented members of Parliament." They were also prepared "by the means of Will Russell" and others to pay Whigs for their help.[53]

In February and March 1678 Lord Russell and Denzil, Lord Holles, met with de Ruvigny. It was not the first time that French emissaries and members of the parliamentary opposition had met for an exchange of news, views, and, often, bribe money.[54] But this was the first time that Russell had taken part in such an encounter.

William was willing to engage in these secret conversations, the discovery of which could have ruined his political career, and Rachel apparently approved because of the apprehension and confusion generated by Charles II's domestic and foreign policies in 1677 and 1678. On the surface at least, a diplomatic revolution conceived by Danby had changed England's foreign policy from pro-French to pro-Dutch.[55] Charles would propose peace terms to France and Holland and, if they were rejected, ally himself with Holland. The policy required an army, Danby said, which would enable Charles to "speak boldly" to Parliament asking for a liberal supply in exchange for disbanding the soldiers. This new approach was sealed by the marriage in the fall of 1677 of Princess Mary, the duke of York's elder Protestant daughter, to her cousin, William, prince of Orange, Louis XIV's inveterate foe. Louis XIV rejected Charles's peace proposals, tried to sow dissension among the allies and between Holland and England, promoted the idea in England that an army threatened the liberties of the people, and prepared to bribe members of Parliament not to fund an army for war against France.[56] Faced with Louis's rebuff, Charles in the fall of 1677 recalled English troops serving in France, thereby making good his threat to assist Holland.

The question observers asked was, Do these public steps reflect a genuine change in policy? Or are they a pretense enabling Charles, with the connivance of Louis XIV, to raise men and demand money, and when accomplished, to arrange a peace with France and use his troops to destroy parliamentary liberties and Protestantism? Many people, Russell among them, sincerely feared the latter. Charles had put his critics in an awkward position by ostensibly embracing an anti-French foreign policy just as they had urged him to do. They were reluctant to support that policy with men and money because they distrusted the king. One way to resolve their dilemma was to discover the real intentions of Charles and Louis. Such was the purpose of Russell's meeting with de Ruvigny, Jr.

Apparently well prepared for the meetings, perhaps through briefings by Shaftesbury,[57] Russell forcefully stated his suspicions that a secret treaty existed between Charles and Louis. He indignantly turned

aside de Ruvigny's suggestion that France should bribe M.P.'s to secure their vote against giving money for war with France, saying that he "should be very sorry to have any commerce with people capable of being gained by money." But he took de Ruvigny's suggestion of bribing M.P.'s to mean that there was no secret treaty between England and France. Acknowledging the difficulties in bringing along the House, Russell said that he and his friends would "work underhand" against increasing money for war against France and would add such disagreeable conditions to the grant already made that Charles would prefer peace to accepting them. He affirmed that he and his friends wanted only the dissolution of Parliament. Assuring de Ruvigny that such were Shaftesbury's sentiments, Russell said that he would "engage" Shaftesbury in the affair but speak to no one else about it. William suggested that de Ruvigny and Shaftesbury meet "one of these days" at Southampton House.[58] Always on the side of extreme measures, Russell asserted that he was resolved to attack Danby, the duke of York, and "all the Catholics."[59]

Following this meeting in March, Russell and Holles, joined by Buckingham and Shaftesbury, met at the beginning of April with the French ambassador, Paul Barrillon, marquis de Branges.[60] Expressing renewed anxiety over Charles's intentions, they suggested that Louis should ask Charles point-blank whether he intended peace or war. Russell reasoned that the question would not cause war, if war were not already planned, and it would prove that Louis had no secret agreement with Charles to use a sham war to destroy English liberties. Barrillon believed that this proposal aimed either to force a war between England and France, thereby protecting Parliament from the army, or to win assurance of Louis's protection should a domestic crisis develop between Charles and his critics. Should these conversations be revealed they clearly would embarrass the English participants.

Rachel certainly knew of these meetings, and it is likely that she approved of them. Her half-sister, Elizabeth, wrote to tell her that de Ruvigny was coming and to assure her that his mission would not harm William.[61] Moreover, an urgent letter Rachel wrote to William a year later, in February 1679, suggests that she approved of her husband's contacts. In the letter she said that she needed to see William "to discourse something of that affair that my uncle was on Sunday so long with me about. It is urged, and Your Lordship is thought a necessary person to advise about it."[62] If Rachel had disapproved of William's conversations with her French cousin in 1678, it seems unlikely that a year later she would have allowed herself to be drawn into a lengthy discussion with her French uncle on a matter that she veils in oblique language. Further, her note implies that she herself was willing to promote William's discussions with the French even after the potentially damag-

ing episode in the Commons over the de Ruvigny meetings, to be dis-
cussed. To do that suggests a boldness that matches William's, notwith-
standing her deepening concern for his safety. Finally, the warm familial
relationship with the de Ruvigny family continued, another indication
that Lady Russell did not disapprove of the meetings.

The conversations testify to the central place William had as-
sumed in the opposition in the Commons. Barrillon acknowledged this
role, referring to Russell and "his cabal."[63] The talks show that William
was able, whether by instruction or his own resources, to effectively
carry on delicate conversations. Moreover, they illustrate still again his
bold courage. It was obviously a risky business for anyone to engage in
conversations with representatives of a foreign power which they pub-
licly decried, the more so for a rapidly emerging leader of the opposition
in the House of Commons. Finally, they testify to Russell's moral
strength. Not only did he express abhorrence of the idea of accepting
money from the French; he resolutely refused to accept money. There is
no evidence either that he distributed bribe money to fellow Whigs.[64]

If the participants thought that these talks would be kept secret,
they were mistaken. Montagu wrote Danby as early as January 1, 1678,
all he knew of the de Ruvigny mission and later offered advice to Charles
through Danby on how to handle it. He specifically mentioned that
Russell, the contact person, was expected to introduce de Ruvigny
to opposition members.[65] His report, of course, was a duty of his post,
but a contemporary believed that Montagu also wanted to "libel"
Russell in revenge for Russell's opposing Montagu's marriage to Lady
Northumberland, Rachel's sister.[66] The news of de Ruvigny's mission
and Russell's part in it spread rapidly enough to reach the ears of at least
one court supporter by January 14, and if it went that far, one may be
sure it went farther still.[67]

In the meantime, Russell and his colleagues in the House of Com-
mons faced the problem of holding rank-and-file members of the op-
position to the strategy discussed with the French without revealing
that strategy. The difficulties they encountered reveal that the Country
party was not especially well organized at this time. For example, on
March 14 Sir Gilbert Gerrard urged the House to ask Charles for an
immediate declaration of war on France, his purpose being to assure that
the army would be rapidly employed away from England. But at the
instigation of Shaftesbury and certainly with prior planning,[68] Russell
was quick to derail the motion by raising the specter of a Catholic men-
ace. Russell moved that the House "set the saddle on the right horse" by
going into a committee of the whole to "consider of the sad and deplora-
ble condition we are in, and the apprehensions we are under of popery,
and a standing army; and...of some way to save ourselves from

ruin."[69] His tactic was successful. Others expressed concern about saddling the right horse too, and the House, despite objections, galloped off to a lengthy debate that took them far afield from the idea of declaring war on France, with the result that Gerrard's motion failed.[70]

Lady Russell followed the Commons debates carefully and with mounting anxiety for the safety of her husband. During one of them in March 1678, she had a note delivered to William while the House was in session. She had heard of his intentions from her sister-in-law Diana, who had overheard William discussing his plans with Lord Alington. Rachel understood that William intended to "take notice of the business (you know what I mean) in the House." "This alarms me, and I do earnestly beg of you to tell me truly if you have or mean to do it." Unabashed in offering her judgment, Rachel warned, "If you do, I am most assured you will repent it." Suggesting that she had raised such a question with him before, she wrote, "I beg *once more* [italics supplied] to know the truth." Rachel concluded with a special appeal to William's obligation to her. She said, "If I have any interest, I use it to beg your silence in this case, at least today."[71] The note is of uncommon importance. Her use of the phrase "once more" suggests that Rachel had importuned her husband to tell her what his plans were more than once. It indicates that in this instance he had not confided in her, and that she had refused to be silenced. It also shows that Rachel believed that she possessed information indicating that William would repent the move he planned. But unless William moderated even stronger motions than the ones he offered, the advice from his wife went unheeded. Yet it must have made some impression on him, for he preserved the note.

In subsequent weeks Russell continued to be in the forefront of the attack on the government. On May 7, 1678, probably at the instigation of Shaftesbury,[72] Russell promoted a resolution for the removal of the king's counsellors. Blaming the king's advisers for waiting so long to assist the enemies of France and asserting that the nation could expect no improvement so long as they remained in office, he seconded the motion to name Lauderdale in the address and also probably supported another resolution which named Danby.[73] The king was genuinely outraged at these steps,[74] and once more Russell had aligned himself with the opposition in an action especially offensive to the court. It is a reasonable presumption that Lady Russell did not endorse these moves.

In the autumn the political situation changed dramatically. The Popish Plot was revealed by the king at the opening session of Parliament on October 21, 1678. That revelation confirmed the parliamentary opposition in its worst fears. Some people, Russell among them, sincerely believed in the reality of the plot.[75] What Rachel thought is unknown. Others, especially Shaftesbury, were skeptical about the

genuineness of the plot, but saw it as a political weapon to be used against the government. However viewed, the Popish Plot became a cause célèbre and the justification over the next three years for the campaign to exclude the duke of York from the succession.

Lord Russell cooperated with Shaftesbury in the latter's efforts to exploit the Popish Plot in the service of removing the duke of York from the succession to the throne.[76] On November 1 Shaftesbury led the Lords in agreeing with the Commons that a "damnable plot" existed and on November 2 introduced a motion that the duke of York should be removed from the king's "Councils and publick affaires."[77] Coordinating strategy, Russell, two days later, introduced the same motion in more extreme form, asking that the duke be removed from the king's presence as well as his council.[78] In an "unusually able speech" using language close to that of Shaftesbury, William asserted that "all our dangers proceeded from the duke of York, who is perverted to popery, and from him only." Softening this audacious attack, he insisted that he had great respect for the duke, but declared that his virtues "did but enhance our dangers." Although enthusiastic support existed for the motion,[79] a majority of M.P.'s were reluctant to proceed. Their reluctance revealed fissures in the ranks of the opposition and also the effectiveness of Charles's response to the motion: on November 9 in a formal ceremony in the House of Lords the king promised to do all Parliament might ask to protect the Protestant religion so long as the "right of succession" and the "descent of the Crown in the true line" were preserved.[80] The House declined to take action on Russell's motion.[81] But his motion again demonstrated his willingness to advocate an extreme course of action. His courage and conviction won him the admiration of the House.

In late November 1678 rumor reached the duke of York that Charles II's bastard son, the duke of Monmouth, had held "cabals" with Russell and "others of that gang" and talked of putting Monmouth forward as successor to the throne.[82] Whether the rumor was true or not, it could not have endeared William to James. If Lady Russell heard of these meetings, she left no record of them.

William's prestige in the House was so high that he escaped severe damage when in December 1678 his meetings with de Ruvigny were revealed in the political cross fire between Danby and Montagu.[83] In the course of the dispute Danby unveiled letters written by Montagu in January about the de Ruvigny mission. His purpose was to demonstrate that the parliamentary opposition was in league with France. But his ploy boomeranged. Russell, the only one named in the letters, was not above using a duplicitous remark to protect himself. Appealing to the House, he said, "I defy any man alive to charge me with any dealings

with the French. My actions here have given sufficient testimony to the contrary."[84] His remark, however, was unnecessary, for fellow M.P.'s rushed to exculpate him. Among them was Montagu himself, who insisted that he and his wife looked upon the de Ruvigny mission as a joke because they knew that the French could get nothing out of Russell.[85] The prevailing opinion was that the letters had been produced by the court "with some design against" Russell, and that William was "most remarkable in his affections to the good of the Nation." Members decided not to enter the letters in the House journal lest they draw a "dark paraphrase upon this noble Lord's actions." Thus, Russell escaped what could have been a devastating blow to his political career. The outcome of this episode might have been different. A remark by one member suggests misgivings in some members' minds. Colonel Titus said, "All we here very well understand Lord Russell's character. But how after ages may understand it, I know not."[86]

William and Rachel do not seem to have blamed Montagu for this episode. Perhaps they reasoned that he was fulfilling his responsibilities as ambassador in reporting the de Ruvigny mission and accepted his assertion that he and his wife laughed at the thought that France would benefit from a meeting with William. The Russells apparently dismissed the rumor that Montagu had sought revenge for Russell's opposing his marriage. Russell probably applauded Montagu for helping to achieve Danby's downfall. There was certainly no rupture between the two families. Rachel even expressed sympathy for Montagu when she reported on January 4, 1679, that he had been summoned before the council to "see his cabinets opened." "The poor man," she wrote, "is delivered out of a peck of troubles, one may perceive."[87]

Within a fortnight of the revelations of the Danby-Montagu correspondence, on December 30, 1678, Charles II prorogued Parliament, and he dissolved it on January 30, 1679. A long-standing goal of the opposition had been achieved. The ensuing election of a new parliament and then the mounting excitement over Exclusion sealed until the eighteenth century further interest in Russell's involvement with the French emissaries.

The parliamentary elections that took place in January and February of 1679 testify to William's newly elevated political status. There was no thought that Russell should stand for Tavistock in Devon, the borough he had represented for eighteen years.[88] He was nominated as knight of the shire for Bedfordshire and Hampshire and was returned for both counties, an unusual honor.

William and his associates worked hard to win this election. He visited both counties, spent considerable money for feasting and enter-

taining, and almost certainly saw to it that campaign pamphlets and tracts were distributed.[89] Whether or not William presented a speech before the electors, a device that became a feature of elections in 1681,[90] is unknown, but in view of his verbal inaptitude it seems unlikely. Russell may have used underhanded methods to forward his chances in attempting to discredit his opponent in Bedfordshire. It was claimed by Thomas, Lord Bruce (eldest son of the earl of Ailesbury, the lord-lieutenant of the county), that before the "pretended plot" broke, Bedfordshire gentlemen had pledged their support to Bruce. But Lord Russell's "party," at Russell's "instigation," circulated a rumor that Bruce's father did not believe in the plot. Bruce blamed his defeat on this malicious gossip.[91] The earl of Ailesbury was also furious at the "ill offices done him in the county."[92] Whatever his means, Russell was a great success. He won handsomely in Bedfordshire, by five hundred voices, it was said.[93] Much to the relief of the Bedfordshire men—who, Rachel reported, were "ready to break their hearts" had the decision been different—William chose to represent Bedfordshire rather than Hampshire.[94]

Rachel attached great importance to the election. During William's absence, she made a concerted effort to collect election news for him, "coast[ing] the town," as she put it, making a "dozen visits" (including one at Whitehall), asking questions, dining at Shaftesbury's house, and often dropping by Montagu House for the express purpose of uncovering political news.[95] The news she garnered kept William abreast of events that he could not otherwise have known in a timely way. For example, Rachel told him of Lord Ailesbury's reaction to his son's defeat in Bedfordshire, of the Bedfordshire gentlemen's anguish that he might not represent them, and of the status of other candidates. She relayed the remark that Charles made upon learning that Shaftesbury had written his followers not to choose fanatics. In his amusing way the king said that "he had not heard so much good of [him] a great while."

Rachel also provided William with sympathy, support, and encouragement. She comforted him with the thought that "the enjoyments at sweet Stratton, will recompense all." Referring to how difficult his situation would likely be "in town and country" because of some unidentified problem, she wrote, "My love, I am in pain, . . . because I am sure you must have a great deal." When Russell received accolades of praise from fellow political leaders, Rachel reported all that they said, remarking that "my heart thinks abundantly more is due to my man." Her letters about the elections show strikingly how small a part she played in the process and how deeply interested she was.

William's success on the hustings elevated his reputation with Shaftesbury and other opposition leaders. Russell had become so much

a part of the inner circle of opposition leaders that portions of a letter from William to Rachel were read aloud to Shaftesbury's dinner guests. Shaftesbury jocularly said to William Sacheverell that Russell was the "greater man," for Sacheverell was "but one knight, and Lord Russell would be two." Sacheverell rejoined that "if it were in his power [Russell] should be a hundred." Indicating his high opinion of Russell, Shaftesbury marked him "thrice worthy" in lists he made of parliamentary members he could trust.[96]

Lady Russell was undoubtedly with Lord Russell in London during the spring parliamentary session from mid-March to mid-May 1679, for no letters have survived from these months. Thus, there is no indication of her reaction to the steps he took in the House. One move provides an example of Russell's willingness to separate himself from Shaftesbury. The Commons faced the question of how to deal with Danby, who stood charged of treason because of the revelations in his correspondence with Montagu. Shaftesbury wanted to disable Danby by expedients short of an attainder.[97] The Lower House wanted to attaint Danby, in part to underscore their right to punish a minister, and Russell, remaining silent in the debates, went along with them. With Whig party stalwarts he was appointed on March 27 to the committee on the bill for summoning Danby to surrender himself or face attainder.[98] The upshot of subsequent maneuvering in both Houses was victory for the Commons' bill and the imprisonment of Danby in the Tower. The episode illustrates that Shaftesbury lacked firm control over the forces of the opposition.

Another step Russell took during this session marked a watershed in his career. On April 27, deeply alarmed by news that the French intended to bring the duke of York back to England by force, members of the House opened the issue of how to protect the Protestant religion in the reign of the present king and "his successors."[99] In this debate Russell made the most powerful speech of his career.[100] Charging the House with "but trifling hitherto," Russell declared that "if we do not something relating to the succession, we must resolve when we have a prince of the popish religion to be papists, or burn." "And I will do neither," he said defiantly. He vigorously denied that his ownership of abbey lands had promoted his anti-Catholicism. Stressing his scorn for Catholicism and also revealing a capacity for coarse humor, he went on, "I despise such a ridiculous and nonsensical religion—A piece of wafer, broken betwixt a priest's fingers, to be our Saviour! And what becomes of it when eaten, and taken down, you know." Expressing hope that the present House would "neither be bribed, corrupted, nor cajoled, nor feasted into the giving up the grand concerns of our religion and property," he moved for the appointment of a committee to draw up a bill "to secure our religion and properties in case of a popish successor." Im-

plied in the speech was a preference for limiting the power of the king rather than excluding York from the succession,[101] but Russell's speech was critically important in the movement towards the first Exclusion Bill.

Russell's speech almost certainly had a dual purpose. It served also to reassure the House that he had not been co-opted by the king, for just a week before, on April 20, 1679, he had accepted a summons from Charles to become a member of the newly constituted thirty-member Privy Council.[102] It was the first administrative office of any consequence that he had held. His appointment testifies to the position he had achieved. This body was the brainchild of Sir William Temple, and one of its purposes was to bring in members of the opposition and involve them in the work of government. The king's announcement of the new appointments had provoked skepticism and scorn in the Lower House.[103] Further, on April 22, rumor circulated that Russell would be appointed governor of Portsmouth.[104] William may well have designed his forceful speech on April 27 to blunt the suspicion that preferment would silence him.

The result of William's motion on April 27 was a resolution, passed unanimously, that the duke of York's religion and the expectation of his accession have encouraged conspiracies of papists against the king and Protestantism. Russell was selected to carry the resolution to the House of Lords for their concurrence. That same day the House instructed the committee of safety it had appointed a month before to draw up an "Abstract of such Matters as Concern the duke of York" respecting the plot.[105]

The report of this committee on May 11 provided the context within which the first Exclusion Bill was introduced. Russell, who was not a member of the committee, inflated the evidence it presented of York's correspondence with popish leaders. William cited still another letter "of a more desperate style and matter of any of the rest."[106] He did not, however, reveal his position on limitations or exclusion, and the fact that he was not named to the committee to draw up the first Exclusion Bill suggests that his views were still ambivalent.[107] On exclusion, as on a number of other issues, the Whigs were not a monolithic body, as has sometimes been suggested.

Russell had to make a decision on exclusion on May 21, when the House divided on the second reading of the Exclusion Bill. As a prominent member of the House, he could not absent himself to avoid the vote, as many members did. He voted for exclusion.[108] In electing exclusion over limitations, he took a position different from that of his best friend, Cavendish, and became closer than ever to Shaftesbury. He explained later in his scaffold speech that he chose exclusion because he believed that limitations smacked of republicanism. From this date on, excluding

York from the line of succession to the throne became the central goal of Russell's political activities. The matter was not put to the test in May 1679, for on the twenty-seventh the king prorogued Parliament.

In the absence of Parliament, the Privy Council offered Whigs the only institutional forum within which to exert pressure on the king. Russell stayed a member for almost exactly nine months, until the end of January 1680, drawing upon himself the still deeper enmity of the king. He deliberately identified himself with Shaftesbury, who was made lord president, and, alone among councillors, followed Shaftesbury's lead in promoting the idea of exclusion. As Shaftesbury became increasingly isolated, so too was Russell.[109] Russell irritated Charles. On June 6, when the council was discussing the rising of the Covenanters in Scotland, Russell expressed wonder that the trouble had not occurred sooner, "since His Majesty had thought fit to retain incendiaries near his person, and in his very Council." His meaning was that Lauderdale was to blame for provoking the revolt by his cruel rule. When Lauderdale made a move to leave the meeting, the king, in an oblique slap at Russell, said, "No, no, sit down my Lord. This is not a place for addresses."[110] And in a direct slap, Charles refused to dismiss his minister.[111] A month later, on July 10, Russell, Shaftesbury, and "two or three more" responded "with the greatest rage in the world" to Charles's announced decision to dissolve Parliament and summon another one for October 7. That summer Charles remarked to a friend that he would soon be parted from "Russell and his party."[112]

The parliamentary elections in September underscored anew Russell's standing in the country and Rachel's active interest. Despite the king's efforts through Lord Ailesbury to defeat him, William won reelection in Bedfordshire.[113] And, once again testifying to his great popularity, Russell also won reelection in Hampshire. There, the marquess of Winchester, allegedly without William's knowledge, proposed him when the freeholders met about the election. "Although at a great distance," he defeated Edward Noel, his brother-in-law. Word of William's success reached Southampton House while Russell was "campaigning" in Bedfordshire and Rachel opened the letter addressed to William, "curiosity inviting me," she confessed. The Hampshire election preceded that in Bedfordshire, and Rachel, believing that once elected, William could not be elected twice, wrote, "I know not how you are to behave yourself." She sought advice from her brother-in-law, Lord Alington, who reported that William could stand in Bedfordshire and would have a fortnight after the House convened to decline one of the elections. Alington predicted that if Russell declined in Hampshire, then Noel would win.[114]

Russell again declined Hampshire, and Noel was then elected. It

may have been that Winchester proposed William as part of a "deep stratagem": Russell would decline to serve, a by-election would be necessary, and a second Whig would be elected, a result which could not be assured on the day of the first poll.[115] If the stratagem in Hampshire had indeed been executed without Russell's knowledge, Rachel was among the first to see the complications for her husband.

But Parliament did not meet in the fall. On October 14 Charles dismissed Shaftesbury as lord president of the Privy Council and on October 17 prorogued Parliament to January 26, 1680.[116] Russell was again outraged, but his protests and those of others were turned aside, and rumors circulated that Russell and his friends Cavendish and Capel would resign.[117] The last meeting of the council that Russell attended was on November 7, 1679,[118] but matters did not reach a climax until January. On January 26, the day Parliament was to have met, Charles formally prorogued it; and four days later—urged on by Shaftesbury[119]—Russell, Cavendish, and two others resigned from the Privy Council in a body. Observers described the episode as "unprecedented," "remarkable," and ominous.[120] Charles openly displayed his delight in seeing these men go, granting them permission to withdraw "with all my heart." Privately he expressed contempt for them.[121]

The next ten months of 1680 were difficult ones in the Russells' private and public life. Tension between the king and his critics continued to escalate, with mutual suspicions deepening—of a government coup on the one hand, of an uprising on the other. Lady Russell's personal life was somewhat disordered. The death of her sister, Elizabeth, in March filled her with sadness. The unexplained disharmony between her and William in June surely did likewise. Moreover, she was pregnant with her last child for much of the time, giving birth to a son on November 1, 1680.

Yet, Rachel increased her efforts to serve as her husband's "informer." Declaring her intention to "suck the honey from all that will be communicative," she enlarged her sources to include a privy councillor (unidentified); a "black coat" (meaning a cleric); Henry Sidney; Sir Thomas Cheeke, son-in-law of Philip Sydney, earl of Leicester; Lady Inchiquin, a lady-in-waiting to the princess of Orange; and perhaps Lady Harvey, Montagu's sister, who was deeply involved in politics. The result was that Rachel conveyed news that few people could have known about at the time. For example, she reported that the lord mayor of London had examined some men charged in the Prentices Plot; that the council intended to discuss the imminent reappearance of Monmouth, who, "great talk" had it, intended to raise a regiment; that there were rumors of a "new plot" involving Monmouth and Shaftesbury; that "most" people were predicting that following the meeting of the council

in June the king would convene Parliament.[122] Of possible importance in reinforcing Russell's belief in the validity of the evidence that William Bedloe (Titus Oates's accomplice) had presented in the Popish Plot was Rachel's report that Bedloe, dying of fever, had declared on his deathbed to Sir Francis North that all he had told was true.[123] Finally, she hinted in a letter that she had advised William to seek an accommodation with the duke of York. "I hear," she wrote in June, "you had the opportunity of making your court handsomely at Bagshot"—where James was staying —and she went on to observe rather ruefully, "if you had had the grace to have taken the good fortune offered."[124] It is no wonder that by autumn of 1680 Rachel regarded the times as "crazy" and offered the prayer that God would preserve her and William from the "sharpest trials."[125]

Such cautionary sentiments at no time made an impression on William. Although his activities are clouded, he continued to meet with radical Whig leaders. In April rumor had it that Russell, Shaftesbury, Cavendish, and Monmouth were meeting in "cabails" at a different house each night to lay "their heads together to oppose [the king's] interest . . . in Parliament or elsewhere."[126] In May when the king suffered another illness, they reportedly met to discuss contingency plans in case of his death, Shaftesbury telling the group that many eminent men in London had said that if Charles died and if he, Monmouth, and Russell would assist them, they would rise in revolt to prevent York from succeeding to the throne.[127] In public William was appearing openly, indeed provocatively, with radical Whigs. With Monmouth he attended a splendid dinner held in London in May where one toast was "The confusion of all pretending Popish successors!"[128] It could not have been just coincidence that much to Bedford's indignation the king pointedly declined an invitation to dine early the next month.[129] Russell also signed a paper entitled "Reasons whereupon the duke of York may most strongly be reputed and suspected to be a Papist," the basis for presenting James as a recusant to the Middlesex Grand Jury.[130] Russell appeared with others in the Court of Requests on June 21 and again on June 30 to enter the information.[131] Their effort failed, but it identified Russell with extremists. In July an observer described him as "a blind follower" of Shaftesbury, and as "great a Commonwealth man as Algernon Sidney."[132]

Rachel could not have been ignorant of the public events with which Russell was associated, but whether she knew of the private meetings of the "cabails" is unknown. She does not mention these episodes in her letters, but one would not expect her to refer to them; she was too astute for that. However, anxiety over William's safety threads through her letters, possibly reflecting knowledge of her husband's clandestine affairs.

Throughout the parliamentary session lasting from October 21, 1680, to January 18, 1681, others deliberately tried to inflate concern about James's succession by linking the duke to the Popish Plot. To that end, Thomas Dangerfield (a man with a criminal record who since 1679 had testified as needed about aspects of the Popish Plot) appeared in the House on October 26 and swore that James had tried to hire him to kill the king. It was within this context that Russell on October 26 delivered a speech that prepared the way for the second Exclusion Bill. With his usual rhetorical extravagance, Russell declared that "this Parliament must either destroy Popery, or they will destroy us; there is no middle way to be taken, no mincing the matter." His motion, that the House consider means to secure the government and religion, and "provide against a popish succession," passed unanimously.[133]

William was in the forefront of the tactical maneuvering that underlay the second Exclusion Bill.[134] He kept the issue before the House even while it debated other issues and then, on November 2, the day after the birth of his son, took a direct initiative which resulted in a resolution to bring in a bill to disable the duke from inheriting the throne of England.[135] William was the first man appointed to the committee to draw up the bill, which meant that he served as chairman, if usual practice was followed. So well prepared was the committee, which included many seasoned Whig leaders, that only two days later William presented the second Exclusion Bill for a first reading.[136]

On November 6 Tories tried to derail the bill by arguing that it did not name a successor to James. The tactic aimed to divide the Whigs, who were far from united on a successor, and to embarrass them by charging that failure to name a successor implied an intention to set up a commonwealth.[137] But the House finally agreed to instruct the committee to add a proviso to the bill that exclusion extended only to the duke.[138] The proviso that Russell brought back from the committee on November 8 read ambiguously that "the Crown shall descend to such person, during the life of the duke of York, as should inherit the same, in case the duke were dead."[139] The language preserved the right of Princess Mary but did not specify her by name, nor did it deny the claims of others.

Three days later, on November 11, the Commons passed the bill without a division and deputed Russell to carry it to the Lords.[140] The House's sense of urgency, well illustrated by their requiring the clerks to stay up all night to engross the bill,[141] was frustrated, for when Russell reached the Upper House that day, it had adjourned. For four days Shaftesbury and others engaged in complex negotiations to assure the success of the bill. On the fifteenth, William could contain his impatience no longer. Somehow he got the bill in his hands, and although

"many" M.P.'s wanted to delay still longer, Russell's "impetuous temper and exceeding ardour...hurried him with such violence that he run away with it." Seeing him depart, a "great crowd" of members followed him. In the crowd were the lord mayor of London and the aldermen who were M.P.'s, their presence underlining the support of the City for exclusion.[142] When the bill was delivered to the peers about 11:00 A.M., men from the Commons "gave a mighty shout" and were answered by some peers with a "very great acclamation."[143]

The defeat of the bill, accountable to the superior rhetoric of Halifax and the presence of the king throughout the long debate, which lasted until 10:00 P.M.,[144] was a severe disappointment to Russell. So distraught was William that his language matched his impetuous action. He said that if his father had voted against exclusion, he would "have thought him an enemy to the king and kingdom" and concluded, "I hope that if I may not live a Protestant, I shall die a Protestant."[145] Such language was suggestive of violence, as was that of some other M.P.'s, and it is possible that at about this time Russell, along with Monmouth, Lord Grey of Werk, and others, heard Shaftesbury recommend insurrection.[146]

At about this time Russell adopted an extreme position on the issue of the duke of York. He felt that James should be tried—and executed—as a traitor for his alleged activities in the Popish Plot. This solution, shared by "some others equally violent," went beyond even Shaftesbury, who, reasoning that the king would never let his brother be brought to the block, was content with exclusion and exile. But Russell argued that while York would not return in the earl's lifetime, "we who are younger" had reason to fear that he would "take revenge" on them.[147] At the time of his arrest and trial Russell disavowed any thought of using violence against the king and his brother and brought in witnesses to testify to his character. Whig historians are agreed that he was incapable of violence, but, as we have seen, Russell had indulged in violence in his youth and chosen the army as a career. This idea of how to solve the problem of York really is not incompatible with his personality.

News that William held this view circulated widely enough for Barrillon to report it to Louis XIV.[148] So it almost certainly was known to Charles and James and would not have endeared Russell to either of them. It may be that the memory of this idea was in Charles's mind when he rejected Rachel's pleas for her husband's life with the remark that if he did not have Russell's head, Russell would have his.

For the rest of the parliamentary session William and other Whig leaders contrived to keep exclusion alive while doing everything possible to embarrass the government. One tactic was to charge royal ministers with promoting popery. From November 13 to January 7, 1681,

Russell participated in attacks on four crown officers: Sir George Jeffreys, then recorder for London; Sir Francis North, lord chief justice of the Court of Common Pleas; Sir William Scroggs, lord chief justice of the King's Bench; and Laurence Hyde, a lord of the Treasury, and York's brother-in-law.[149]

These men—Jeffreys, North, Scroggs, and Hyde—were all powerful individuals who remained in the king's favor. Some of them would play a part in Russell's treason trial two and a half years later. None could be expected to forget that Russell was prominent among the Whigs in the Commons who were determined to remove them. Russell, however, remained silent when Halifax, Rachel's kinsman, came under fire.[150] Perhaps Halifax's gratitude that Russell had no part in the resolution calling for his dismissal helps explain his sympathy towards Russell at the time of William's trial.

A further tactic, aimed partly at refueling consciousness of the Popish Plot, was to bring to trial the five Catholic peers, including the aged William Howard, viscount Stafford, charged with complicity in the plot. On December 7, fifty-four peers, William's father among them, returned a verdict of guilty against Stafford.[151] As was usual in the case of a peer convicted of treason, Charles commuted the barbarous sentence of hanging, drawing, and quartering to simple beheading, a step that moved the sheriffs of London to appeal to the House of Commons for a ruling. The grounds of the appeal were the apprehension that if the king could commute the form of the execution, he might be able to pardon the victim. Only after a couple of lawyers discounted this possibility did the Lower House agree to the commutation of the sentence.[152] These points are pertinent to Russell because rumor had it that he had objected to commuting the sentence.[153] The story gained credence, and when Charles commuted the same sentence on behalf of William in 1683, he adverted to it. Assuming its accuracy, one must explain, as admirers of Russell have done, that surely the reason for William's objection was not bloodthirstiness, but rather the constitutional issue which had brought the London sheriffs to the House in the first place.

Later in December, William and other Whig leaders turned to negotiating with the king to win him over to exclusion. Gossip circulated that during the Christmas recess, they and Charles reached a deal,[154] whereby in return for the exclusion of the duke, the Whig leadership would bring Parliament to grant the king ample supplies and the power (such as Henry VIII had held) to appoint his own successor. The advantages to Charles would be financial security and power over his successor, thereby making all claimants dependent upon him. Whig leaders

would win offices; Russell, for example, would be named governor of Portsmouth, a post earlier connected with his name. Shaftesbury disavowed these negotiations, once again illustrating Russell's independence and the absence of ironclad control over the Whigs. But the deal with the king collapsed. Charles prorogued the session on January 10 amid bitter exchanges with the Whig leaders. On the eighteenth he dissolved Parliament and summoned a new one to meet at Oxford on March 21, 1681.

This session of Parliament marked the apogee of Russell's political career. He was regarded as the "governing man" in the Commons. He addressed the House more often, rising sixteen times, and apparently spoke more effectively. For the first time in his life his speeches won praise. Indeed, it was said that only he and a handful of other former members could command the attention of the House.[155] His high standing also won him more committee assignments than ever before. A physical manifestation of his overwork and emotional strain during the session was indifferent health and nosebleeds.[156]

His contribution to the opposition was to move members along in face of doubts, indeed of retreat sometimes. He was always out in front on the issues, recommending an extreme tactic and showing no fear in his criticism of individuals at the highest reaches of government. His seeming willingness to sacrifice for his religion and government everything a man might hold dear—a devoted wife, a loving family, and great wealth and position—made him an inspiration to others. His steadfast adherence to certain political and religious principles further enhanced his reputation.

Although Russell left no theoretical statement, as did his associate Algernon Sidney, his speeches and actions reveal his views, and his scaffold speech reaffirmed many of them. Russell wanted to restrict decisively the prerogative powers of kingship and shift authority to Parliament in such areas as foreign policy, appointing and dismissing royal ministers, standing armies, and calling and dismissing parliaments. He wanted Parliament—that is, men of substance—to exercise power. William believed in the right of resistance, a position implied in his parliamentary career and in the conspiratorial conversations with which he admitted a connection and reaffirmed when he was imprisoned. He was no republican or commonwealthman, whatever the suspicions of some contemporaries. William expressed dismay when Slingsby Bethell, an acknowledged republican, was elected sheriff of London in 1680.[157] His decision to support exclusion over limitations, as already noted, rested on his conviction that limitations would leave the monarchy without sufficient powers. The French ambassador distinguished Russell from the republican Sidney, saying that William wanted

a king whom he would choose and a monarchy he would fashion.[158] Still, if Russell's ideas on government had prevailed, a very different kingship from that of Charles II would have resulted.

The energizing force in Russell's politics was his irrational hatred of Catholicism and dislike of High Church Anglicanism. The strong influence of Nonconformity and perhaps the fear (as his enemies charged and he denied) that a Catholic king would mean the return of monastic lands and the impoverishment of his family explain his attitude. The exclusion of York from the succession to the crown became a cause célèbre in Russell's life.

The recognition that Russell received in Parliament was matched by praise heaped on him by people outside. His enormous success in the elections testified to his widespread popularity; if the late seventeenth century had had approval ratings, Russell's would surely have stood very high on the scale. Personal letters, private toasts, and expressions of admiration over the preceding two years conveyed the same message. At least one printed tract singled him out for comment, calling him the "Tribune of the People," a title which, interestingly enough, Shaftesbury had applied to himself in the autumn of 1679.[159] So firm became his reputation as a champion of Nonconformity that in 1680 William Bates, a Presbyterian minister, dedicated a book to him, citing his efforts to achieve "union among all that agree in the substantial parts of doctrine." Bates heaped praise on William for his "excellent virtues," "inflexible integrity and courageous wisdom."[160] The publication of the book further identified Russell with the Dissenting community. But clearly his popularity extended beyond that; Burnet said that he "never knew any man to have so entire a credit in the nation" as William.[161]

Russell's popularity in Parliament and country served him well in the elections to the Oxford Parliament in early 1681. As before, Lady Russell kept him informed about election news.[162] He won again in Bedfordshire, but this time the Hampshire gentlemen made no effort to have him represent them.

Lady Russell's anxiety mounted during these months over the dangers she felt William was courting. The result was a major quarrel between the two of them. The night before Russell left to attend the Oxford Parliament on March 18, they quarreled from seven in the evening till nine the next morning. The next day Rachel wrote him contritely: "I hope my dearest did not [mis]interpret any action of mine. . . . I am certain I had sufficient punishment for the ill conduct I used, of the short time then left us to spend together, without so terrible an addition. . . . I was really sorry I could not scribble as you told me you designed I should. . . [for] I might have prevailed for the laying by a smart word or so, which will now pass current, unless you will oblige a

wife, after eleven years, by making such a sacrifice to her now and then, upon occasion offered."[163] In her voluble way Rachel probably urged her husband to follow a certain course of action at the upcoming Parliament and met with his refusal. The letter demonstrates the strength of Rachel's convictions and concern for her husband's welfare and her unabashed boldness in haranguing him.

Lady Russell followed the news of the Oxford Parliament closely, reading the king's speech in print before William had seen it, and reporting the rumor (which she dismissed as groundless) that Shaftesbury had been impeached. Her concern for Russell continued. She wrote him anxiously, "Look to your pockets; a printed paper says you will have fine papers put into them, and then witnesses to swear."[164] Rachel's remark must have referred to the efforts of the government to entrap its Whig opponents by planting incriminating papers on them.[165]

Nothing untoward happened at the parliamentary session. Charles, who had entered into another agreement with Louis XIV for money in return for dissolving Parliament and not summoning another one, gave his Whig opponents little time to set out their predictable agenda. The first few days after the opening of the session on March 21 were enlivened by the discovery of an alleged plot by Edward Fitzharris and some sharp exchanges about it. Russell was appointed to the committee to draw up the impeachment against him.[166] On the twenty-sixth, the House turned to the central issue on the minds of all members, exclusion, and Russell seconded the bill proposed to eliminate the duke of York from the succession. The arguments and words he used sounded familiar. William recalled how long he had been of the opinion that "nothing but excluding the duke. . .can secure us." "Should he come to the Crown, his power will be more. . . .Every day we see the sad consequences of his power." Nothing else but exclusion would secure the nation. For the first time he justified his position on the grounds of his obligation to the county he served. After thorough debate, a resolution passed to bring in the third Exclusion Bill.[167] It was read a first time on Monday, March 28, and ordered read a second time the next day. But before further business could transpire, Black Rod knocked at the door summoning members to attend the king. Charles, arrayed in his robes of state, dissolved the Parliament.

The dissolution of the Oxford Parliament deprived William and his Whig colleagues of a legitimate forum in which to press for exclusion and for changes in the ministry and in domestic and foreign policies. The new circumstances were exceedingly dangerous to anyone who infringed the law and defied the court. Lord Russell was indiscreet in public and private actions. What we know of Lady Russell shows her profound apprehension for his safety.

Briefly, the story of political developments from 1681 to 1683 is this.[168] King Charles, with the enthusiastic cooperation of some Anglicans and Tories, continued an uncompromising campaign to remove his political enemies. His technique was to use the law to bring them to trial and to employ *quo warranto* procedures to gain control of local government and, through that, control of the House of Commons, should he ever decide to call another Parliament. The high-water mark of the government's campaign was its success in 1682–83 in achieving control over London by forcing the City to forfeit its charter and by the election of a Tory mayor and of Tory sheriffs, who would control the selection of juries. The court sought to depict itself as the champion of law and stability, whose policies would avert another Civil War.

In the face of Charles's resurgent control and renewed popularity, Whig leaders sought to preserve the integrity of their party and embarrass the court, and schemed about how to achieve their political goals using nonparliamentary and even violent means. Russell did not retire to Stratton, as his first biography declares,[169] but, rather, took a part in such activities. The role he played invariably aligned him with the radical wing of the Whig party. In May and June 1681 he and a great many people—including Shaftesbury, Lord Howard of Escrick, and Grey— were present at the trial of Edward Fitzharris.[170] William probably had a special interest in the proceedings because during the Oxford Parliament he had served on the committee charged with drawing up articles of impeachment against Fitzharris. At that time the House of Commons had tried to use Fitzharris to further their interests. The court regarded Fitzharris as potentially embarrassing and wanted him convicted, and thus the trial was seen as a test of strength between the court and the Whigs. In the event, Charles won, and the government used Fitzharris's testimony as grounds for arresting Lord Howard.[171] William was singled out for notice as being present and, thus, marked again as a person opposed to the government. The results of the trial might well have warned a more cautious man.

The next month, July 1681, Russell further irritated the court by meeting with the prince of Orange. The prince was visiting the king for the purpose, it was said, of reconciling him with his critics so that England would be in a position to aid the Netherlands in its ongoing struggle with France. With Charles's permission the prince had come to London, where Whigs, including Essex, Sir William Jones (the lawyer), and Russell, had approached him and arranged a meeting at Southampton House.[172] William's father was present and left an account of what he himself said. Painting a picture of the nation's "most dismal condition" and expressing the idea that the prince's "interest and ours is the same," Bedford asserted that "a popish king must destroy

England." Implying support for helping Holland against France, he declared that England could "never be settled, great, nor considerable, but by being head of the Protestant party."[173]

Unfortunately, the earl did not report the remarks of either Russell or the prince, but an anonymous letter to William dated August 3 referred to the conversation. The writer noticed that there was much "contentment" to be derived from the "plainness" in Orange's views on international and domestic issues. But he felt that the prince would "not do us any good," because Charles's ministers had convinced him of the merits of the court's opposition to exclusion.[174] The comment is significant; if the prince opposed exclusion, he could not have won Russell's approval. Negotiations between Orange and the Whigs came to nothing. The prince declined an invitation to dine with the sheriffs of London, which would have identified him with the Whigs. Instead, he returned to Oxford, as Charles commanded him to do.

The record of this encounter between William and the prince of Orange sheds little light on whom Russell favored as a successor to James. It does not rule out the prince of Orange, even though the talks were disappointing. Lady Russell's care in preserving the account implies that she regarded the interview as significant and, thus, that William did too. The attentions paid her by the prince's emissary after Russell's death, her friendship with Princess Mary, and the honors given the Bedford family after the Glorious Revolution suggest a commitment. Yet, William continued to be a friend of Monmouth and to be seen in public with him.

In the autumn of 1681 William continued to be involved in political contests with the court. In September he was among a small group of men who "conjured" up opposition to Sir John Moore, the court-supported candidate for the position of lord mayor of London. These intransigent Whigs opposed Moore for many reasons, among them their concern about York's succession to the throne, for the lord mayor of London would play an important role in proclaiming the new king. The Whigs figured that if the king died soon, it would be essential to have a lord mayor sympathetic to their interests.[175] In the event, Moore was elected, his election marking another setback for the Whigs.

Furthermore, Russell became more closely identified with Shaftesbury. The earl had been jailed in early July on a charge of treason, and on July 8 a grand jury, with Russell and other Whig luminaries in attendance, had refused Shaftesbury *habeas corpus* on grounds that the Tower was outside their jurisdiction. This ruling forced the earl to wait until the Court of King's Bench began its autumn term in mid-October to take further legal action.[176] Faced with an imprisonment of several months, Shaftesbury attempted in September 1681 to arrange a

deal with Charles for his release.[177] William was in London at about this time and may have consulted with Shaftesbury and his friends about the strategy. Since it failed, perhaps arrangements were then made that William should serve on the Middlesex grand jury. The Westminster panel—the list of names of men from which the grand jury would be chosen—was announced on October 1 by the radical London sheriffs, and it contained Russell's name.[178]

In mid-October Francis Charlton wrote William to urge him to return to London immediately for private business as well as for Shaftesbury's trial.[179] Russell was back in London by October 20 and surely in court on the twenty-fourth when Shaftesbury petitioned for an immediate trial or release on bail. The court's ruling—that bail would be granted before the last day of term if there had been no prosecution—moved the government to decide to present evidence against Shaftesbury to a grand jury a month later, on November 24.[180]

These events deepened Rachel's concern for William's safety. In September she referred to "our enemies and illwishers," and in October when Russell was in London attending the hearings about Shaftesbury's release, she wrote him anxiously, praying God to "direct" his consultations and saying, "My dearest dear, you guess my mind. A word to the wise. I never longed more earnestly to be with you." Her remark suggests that she placed value on being present when Russell engaged in delicate political affairs. As the day drew near for the government to present evidence against Shaftesbury, her alarm intensified. On November 22, Lady Russell cautioned Russell in these words, "One remembrance more, my best life: be wise as a serpent, harmless as a dove."[181] Her anxiety found further expression two days later when she wrote to Spencer to chastise him for failing to send her news and to express the wish that she were in London.[182]

Russell was not chosen a member of the Middlesex grand jury, but he almost certainly appeared at the proceedings against Shaftesbury when the grand jury brought in a verdict of *Ignoramus*, that is, refused to find a case against him. When Shaftesbury petitioned for release on November 28 in the Court of King's Bench, Russell and others put up £1,500 to meet the required bail. The size of his contribution testified to his commitment to the earl.[183]

On November 26 when William wrote Rachel of his intention to stand bail for Shaftesbury, he remarked that some of Rachel's friends thought that the "fair man" was "troubled" by the *Ignoramus* ruling. The "fair man" was almost certainly Monmouth, and his "trouble" may indicate alarm at what steps Shaftesbury might propose once he was released. This letter offers a frank and full accounting of political events

and provides further specific evidence that William not only kept Rachel informed but also confided in her.[184]

Russell apparently did little in the public sphere in 1682, but his known actions linked him still with radical Whigs. In July he was at Tunbridge Wells with a group of Nonconformist ministers and London citizens known for their vehement opposition to the government. They circulated printed tracts attacking the government. Among the papers was *The Rights of the City*, which was read aloud by a gentleman identified as William's servant.[185] It excoriated the Tory lord mayor of London, Sir John Moore, for his alleged "misbehaviour" in the election of the City's sheriffs and warned him that Parliament, whenever it met, would call him to account.

In September 1682 Russell was again visible, this time as one of many Whigs who joined the duke of Monmouth on his progress through northwest England.[186] Monmouth attracted large crowds, played the role of prince, and touched for the king's evil. Charles was incensed and ordered the duke arrested for causing a riot in Chester. Monmouth submitted a *habeas corpus* and was released on bail, which was raised by Russell and other Whigs, who put up £2,000 apiece.[187] William's support of Monmouth was, of course, known to the court.

Finally, in the autumn of 1682 and the winter and spring of 1683, Russell engaged in secret conversations with Whig leaders who were considering the use of force to achieve their ends. The talks were either outright treason or close to it, and that William was present at some of them is indisputable. He himself admitted as much, and testimony to that effect comes from multiple sources.[188] Whether Lady Russell was aware of everything that her husband was doing is doubtful, but she may have known of meetings that were held at Southampton House. And she noted in her diary William's meeting with Colonel John Rumsey.[189] Talk about the use of violence was not new, as we have seen. None of the plans was executed, and in angry frustration and to save his life, Shaftesbury fled England for Holland, where he died in January 1683.[190] In his place, it was said, a Council of Six, of whom Lord Russell was one, continued in the spring of 1683 to engage in conspiratorial conversations, but took no action. In the meantime, in March and again in May, reports of desperate plots against the king, involving Sidney and others, reached the government.[191] At the end of May, a man identifying himself as privy to the plans of conspirators wrote Sir Robert Townsend an urgent letter begging him to persuade the government to take precautions to protect the king's life. He declared that the plan was to seize the king and the duke and to issue a declaration showing how the government had violated England's religion, laws, and liberties. The writer warned that

in every county and in all corporations there were men ready to "break out into a rebellion."[192] In June one of the conspirators, Josiah Keeling, confessed all he knew to the government. William Russell and other Whig leaders were arrested and charged with treason. Within six weeks, Russell was dead, executed by Charles II's government as a traitor.

· 6 ·
Trial and Execution
of Lord Russell, July 1683

On June 26, 1683, two years and three months after the Oxford Parliament was dissolved, William Russell was arrested and sent to the Tower on suspicion of conspiring with other Whig leaders in schemes to raise rebellion by seizing the king's guards. On July 13 he was tried at the Old Bailey and found guilty of treason. On July 21 he was executed in Lincoln's Inn Fields. Lady Russell played an important role in these terrible events. Although she could have turned over to others the tasks she performed in her husband's behalf, she did not do so. Instead, using private and political contacts and personal appeals to the king and duke and calling upon the memory of her father's service to the royal family, she did everything she could, and assisted the efforts of others, to help prepare William for his trial and afterwards to save his life.

Russell's trial and conviction play a role in English history and historiography that transcends the personal trauma that they represented to Rachel and William. Whig partisans and historians have charged that the court concocted what became generally known as the Rye House Plot, bribed the witnesses, and led them to implicate aristocratic Whig leaders so as to complete the destruction of the party. Russell's scaffold speech was the first printed piece to advance the notion that the government was guilty of his judicial murder.[1] That assessment became gospel thereafter in Whig political quarters. It underlay not only article 11 of the Bill of Rights (which held that jurors in treason trials ought to be freeholders), but also the reversal of Russell's attainder after the Glorious Revolution, the elevation of his father to a dukedom in 1694, and the Treason Trials Act of 1696. It was echoed in later Whig histories. Thus, for example, Rapin-Thoyras thought that Russell's death was "the most crying injustice, ever known in *England*." Charles James Fox concluded that Russell died not for his crimes, but for his virtues, and opined that when his memory ceased to be the object of "respect and veneration" then "English liberty will be fast approaching its final consummation." In a couple of sentences Macaulay expressed his conviction that Russell

knew nothing of plans for assassinating the king and that he had commit-
ted no offense that fell under the law of treason.[2] In a variety of ways
and for many reasons—personal, emotional, familial, and political—
Russell was made into a martyr who suffered at the hands of a tyrannical
government, and so he has remained until today. No modern historian
has studied Russell's trial closely, and only a few have raised doubts
about the validity of such judgments.[3]

Therefore it is essential to an understanding of both William and
Rachel to try to reach a dispassionate judgment on whether or not
Charles II's government was responsible for Russell's judicial murder.
The basic question to be answered is, Did the government violate the
laws of treason and criminal trial procedures, as such laws existed in
1683? To do so one must bear in mind those laws, the substance of the
charge, the treatment Russell received in prison and in court, the evidence
against him and how it was gathered, the status of jurors and witnesses,
and Russell's defense and the opportunities he had for preparing it.

Russell's arrest came two weeks after the existence of a con-
spiracy to murder Charles II and his brother James was revealed to the
government. On June 12, 1683, Josiah Keeling, a London oilman and a
"most perverse fanatic," who was overcome by guilt, remorse, and fear
that someone might identify *him* as involved in discussions to that end,
informed the government of what he knew.[4] Alerted by Keeling's
brother, Russell's Whig associates brought William word of Keeling's
confession and at the same time urged him to give a signal for revolt.
Russell declined to do so on grounds that "it was better some private
men should suffer than the public be precipitated."[5] This answer fore-
stalled any uprising, and many of the principals fled England or went
into hiding, one, Sir Thomas Armstrong, seeking haven in Southampton
House.[6] A privy councillor was bewildered over how they could have
been forewarned.[7]

During the next fortnight other informers and men they accused
turned state's evidence, plea-bargained with the Privy Council to save
their own skins, and implicated in the conspiracies aristocratic leaders
of the Whig party, including Russell; Essex; Lord Grey of Werk;
William Howard, baron Howard of Escrick; and Algernon Sidney.
Keeling and his brother, John, who was brought in to testify, were
the first to name Russell when they deposed on June 15 that they had
been told that Russell had said that he "would use all his interest to
accomplish the. . .design of killing the king and the duke of York."[8] Ten
days later, on June 25, Colonel John Rumsey, the nephew of a former
major-general under Cromwell and himself a soldier in Cromwell's
armies who had become a client of Shaftesbury's, claimed under exami-
nation by secretary of state Sir Leoline Jenkins that in October or

November 1682 Shaftesbury had planned an insurrection. Responding to Jenkins' question about what persons of quality were to command in the uprising, Rumsey said that he had heard Russell named.[9] In a further undated confession, probably taken on the same day, Rumsey declared that Shaftesbury had sent him on November 2 to the house of Thomas Shepherd, a wine merchant and a probable relation of one of Shaftesbury's gentlemen servants,[10] to meet Russell, Monmouth, Grey, Armstrong, and Ferguson to tell them that it was high time they came to a resolution about an uprising. Their answer was that their man in the west (John Trenchard) had said that things were not yet ready and that the rebellion should be postponed. Rumsey also deposed that he was told that Russell, Essex, Sidney, John Hampden, Robert West, and Robert Ferguson were in touch with people in Scotland and had committed themselves to raise £10,000 to buy arms in Holland. The plan was to begin the rebellion in Scotland and follow with uprisings in London and Taunton. Lord Howard, Rumsey said, was at first privy to the scheme, but later was left out because of his habit of indiscreet talk.[11]

This story was enough to move the Privy Council on June 25 to post a messenger to Russell's house in Southampton Square to prevent him from going out. Spying the guard, William dispatched Rachel to take counsel among unidentified "friends" about what he should do. Russell accepted their reading that to escape (which seemed feasible, since the back of Southampton House was left unguarded, perhaps on purpose to permit him to do just that) would "give the court too great an advantage" because it would "look like a confessing of guilt." This advice, reached after disagreement, apparently took into account that William (who later said that he had forgotten his encounter with Rumsey at Shepherd's house) was confident that there was no credible evidence against him.[12] Notwithstanding Russell's confidence, it is certain beyond doubt that by the end of the day, William's political papers had been destroyed. Otherwise, they surely would have been confiscated and used by the government, or, if they had been hidden so securely that government agents were unable to find them, Rachel would have preserved them as mementos of her beloved husband, as she did every scrap of paper his hands had touched. They have disappeared without a trace.

What Rachel thought of the advice not to flee is uncertain. She may have favored flight, for in his scaffold speech Russell wrote that he had been "much pressed" to flee, and later Rachel was troubled by the thought that if "greater persuasions had been used" William might have escaped.[13]

The next day, June 26, Russell was arrested and taken before the Privy Council.[14] The king, who participated actively in the interrogation, told Russell that he was not suspected of plotting to murder him,

but of being involved in schemes to raise an insurrection against the government. Russell appeared in "very great confusion," denied all knowledge of plans to raise a body of men in the west, and "refused to answer particular questions," but he did not deny knowledge of a general plot of rebellion.[15] Not surprisingly, he was sent to the Tower under heavy guard. A privy councillor thought that Russell's situation was "very dangerous," his behavior before the king "very foolish," and his future prospects harder "than he may imagine."[16] But Russell apparently had no doubts about his prospects. He told a servant as he entered the Tower that he would not come out alive, and Rachel, so she said later, concurred with this assessment.[17] William's remark may, of course, be interpreted two ways, either as a comment on a despotic government or as a recognition of the strength of the case against himself.

At least two of Russell's friends shared his reading of the seriousness of his condition and offered to help him. Lord Essex, who was himself under suspicion, decided not to flee lest that action strengthen the evidence against William. And Monmouth, who was in hiding to avoid arrest, a warrant for which was issued on June 28, offered to return to assist Russell with his defense. But William replied to the duke that it would be no advantage for his friends to die with him and declined the offer.[18]

The government continued to receive evidence linking Russell with a plot to raise an insurrection against the government. Between June 15 and July 11 a total of eleven witnesses incriminated Russell in depositions made before the Privy Council.[19] In addition to Keeling and Rumsey, men who named Russell included Colonel Thomas Walcot, a former lieutenant to Edmund Ludlow and one of Shaftesbury's confidantes; Thomas Shepherd, the wine merchant mentioned by Rumsey; and Lord Howard. Of them Howard's deposition was the fullest, most detailed, and most damaging. From the moment of his arrest, when he was found cowering in a chimney, Howard had announced himself eager to do whatever was needful to save his own life.[20] His confession, which was centrally important in convicting Russell and Algernon Sidney, achieved that aim.

The interrogations of these persons were conducted by members of the Privy Council, often with the king himself and the duke of York in attendance. The available evidence shows that they were carried out in a fair manner, without browbeating or bribes.[21] In contrast to procedures used a century before, prisoners were not brought before the council in chains nor threatened with or subjected to torture. One privy councillor, writing privately, asserted that at the beginning of the investigations King Charles ordered that "all possible fairness" be used. No leading questions were to be asked that might prompt the prisoner to

accuse anyone.[22] A friend of Russell's, Dr. Gilbert Burnet, confirmed this description, adding that the king insisted that witnesses must say all at once what they knew, to avoid "growing evidence," as Charles put it. The king "valued himself much" upon these methods, Burnet said.[23]

Nonetheless, it must be recognized that these witnesses were themselves prisoners, that they were engaged in plea-bargaining to save their own skins, and that they had not as yet won a pardon. It is legitimate to think, therefore, that, although under oath, they might well have been inclined to tell the council what they felt would best help themselves. At the same time, outright lies, without any substance in truth, would not serve either. The status of a plea-bargainer does not entirely discredit the testimony given, but it should weaken it. However, the practice of giving immunity to an accused person in return for evidence against others, called "turning king's evidence" in seventeenth-century England, was an old one, dating back to the Middle Ages and widely practiced since. The prevailing opinion then, contested by only one legal writer during the Restoration, was that no one better than an accomplice in crime could reveal the dimensions of that crime. Not until the eighteenth century was it decided that the evidence supplied by plea-bargainers must be corroborated.[24] So it is not surprising that at his trial William sought in vain to discredit such witnesses and discount their evidence. It would have been a surprise had he succeeded.

The general reaction of the court to the informations belies the charge that it concocted a story about plots to murder the king and the duke and to raise rebellion and set about to discover witnesses who would confess such schemes. As the revelations multiplied, the court displayed deep alarm, engaged in frenzied activity, and announced its determination to proceed only in ways according to law. The king hastened back to London from Windsor and appeared at Whitehall with a guard of 200 soldiers.[25] The Privy Council, frequently attended by Charles and the duke of York, met long hours almost every day. Charles, observers said, and the council, members declared, were genuinely persuaded that a conspiracy to murder the king and the duke had existed.[26] The lord keeper was so industrious that he neglected other legal business. For several weeks, nothing else got done at the highest reaches of the government.[27] Special attention was focused on London, the former Whig stronghold; the lord mayor was asked to send a delegation to the king to report what had been done to disarm the disaffected in the City and to receive further assignments.[28] Numerous instructions went out to local officials in all parts of the country to keep a strict watch on all ports, bridges, and passes, and on all creeks in Surrey; to hunt down and arrest persons named by the informers and to investigate suspicious persons, especially those moving to and from Scotland, Ireland, or the

western counties; to send the government information about Richard Cromwell; to put the militia in readiness; to search for arms; and to disarm all disaffected persons.[29] Specific instructions were to proceed in these tasks "according to law" or in a manner "agreeable to law."[30] In searching for arms, local officials were told to avoid confiscating weapons such as fowling pieces or decorative swords that could not be used in an insurrection, and to dispose of the arms according to law. "The King's rule," explained the secretary of state, "is that this search be made with as little appearance as may be of military force."[31]

The treatment accorded Russell during the three weeks between his arrest and trial (on July 13) was considerate. The picture of him shackled in irons in a damp cell, as a late-eighteenth-century dramatist would have it, is without foundation.[32] In response to Lady Russell's petitions, which she cast in the most respectful and conciliatory terms, the government granted William an additional room in the Tower so that he might have greater privacy and a change of air, and permitted Rachel, William's father, his brothers and sisters, and his steward to visit as often as they wished "at convenient hours."[33]

More importantly, on July 3 the government agreed to allow Russell to consult four lawyers and a solicitor named by Rachel. Thus William, who was untrained in law, had the benefit of legal advice from Henry Pollexfen and Sir John Holt, both prominent, experienced, and highly regarded.[34] To be allowed to consult with counsel was, indeed, a favor, and it was noticed at his trial as a procedure "which hath not been known granted to any under [such] circumstances."[35] Russell's lawyers actively assisted him. They recommended in writing that William should ask for a written indictment and challenge jurymen on grounds that they did not possess a freehold, and they supplied ideas for Russell to use in examining witnesses and composing his speech to be given before the court. As it happened—for Russell was, of course, kept under guard—his lawyers' papers titled "Advice to Lord Russell about his trial" were seized and sent to the council.[36] Thus the government had prior information about Russell's defense strategy, including his intention to challenge the jurors on grounds of absence of freehold status. Such a challenge had not been entered before in a London trial.

Counsel must also have told William that he would be tried upon one of two laws governing treason, 13 Charles 2, c. 1, or 25 Edward 3, for William copied out the first in its entirety and wrote up the substance of the other. Further, counsel must have introduced him to Sir Edward Coke's interpretation of the law, for he also copied out verbatim portions of "Cook's" *Institutes*. He made careful notes on what points to argue, depending upon the law he was tried upon, on how to examine and attempt to discredit witnesses, and on what to say in his speech to the

jury. Such marginalia on his notes as "I may urge," "As to Rumsey I may observe," and "Something of this kind may be said" prove how carefully he prepared his defense.[37]

Finally, Russell's lawyers advised him against telling the whole truth, on grounds that a full accounting of his actions would bring him within a charge of misprision of treason. Misprision of treason was the crime of concealing a treason, of failing to report it to the authorities, and it carried the penalties of life imprisonment and forfeiture of goods. Those penalties were certainly to be avoided if a person could hope to be found innocent. The fears of his counsel were well founded, for if Russell *had* given a full accounting of his actions, he would certainly have been convicted of concealing treason; indeed, in his scaffold speech he admitted that he was guilty of a "bare misprision" for talk about "making some stirs."[38] But it may be that the real reason his counsel recommended that he not tell the whole truth was because they feared, given the very fine line in law between misprision of treason and treason, that if he testified fully, he might prove himself guilty of treason. In fact, in cases in 1662 and 1663 a judge had sharpened the definition of misprision of treason by ruling that a person was guilty of misprision of treason if he listened to conversation about a design against the king and, although disapproving, failed to report it. But he was guilty of treason if he came into the same company again, listened to such a design, said nothing, even disapproved, but yet concealed that knowledge.[39] King's counsel, Sir Francis North, in notes he made on Russell's scaffold speech, thought that the admissions therein alone were evidence of treason, not just misprision of treason.[40]

Still other advantages were allowed Russell prior to the trial. At the order of Chief Justice Pemberton, a list of the panel of jurors from which the jury for his trial would be selected was sent to him, the court's officer handing it to William's servant, who, in turn, gave it to Rachel.[41] As we shall see, confusion over this jury panel delayed the preliminaries at William's trial. Still further, a committee from the council, including Sir Robert Sawyer and Sir Heneage Finch, who were to conduct the prosecution, interviewed William on June 28, over a fortnight before his trial, and possibly again on July 9.[42] The questions covered meetings at Shepherd's house, talk about a rising in the west, plans for seizing the guards, and Russell's contacts with the Scots. Burnet recalled that although Russell answered his interrogators civilly, he said that he was preparing for his trial and expected there to answer everything they could ask.[43] The record of William's responses shows that he denied all knowledge of plans for an uprising or seizing the guards. He admitted to going to Shepherd's house "divers times" and to accompanying the duke of Monmouth there, but declined to say who else was present. He

denied knowledge of a plot with the Scots but, still irrepressibly bold, declared that he had heard "general discourses of many distressed people, ministers and others of the Scottish nation that were fled and that it were great charity to relieve them."[44] Such a remark must have irritated his examiners, who were in a position to recall Russell's performance at the Privy Council in 1679 over Lauderdale's handling of conditions in Scotland. As will be seen, there were discrepancies between his responses in the Tower and his remarks at his trial.

William, Rachel, and his friends took the interrogatories seriously. They were especially concerned about the question of his dealings with the Scots to plan rebellion, and Rachel asked Burnet to try to discover who had raised it. It is possible that she feared that the government would discover that she and William had raised £8,000 in a property transaction in 1682 and suspect that that money was related to the £10,000 Russell allegedly promised the Scots.[45] Burnet wrote, however, that the charge was a *ballon d'essai* to trap Russell.[46]

At his trial, William maintained that he had no idea of the charges against him and that he had heard only some general questions from his interrogators.[47] If that were indeed true, his lawyers were grievously at fault in not alerting him to the significance of the interview. In effect, the questions were in the nature of an unwritten indictment, a substitute for a written indictment which was denied prisoners accused of treason at that time. The prosecution insisted at the trial that those questions were designed not only to elicit information but also to indicate to Russell what he might expect at his trial.[48]

Rachel assisted William in still other ways. She kept him informed of what was happening and wrote him notes, sending at least one enclosed in a cold chicken.[49] She acted as the intermediary between Russell and his lawyers and with his friends. For example, William Harbord, who had been secretary to Essex when he was lord lieutenant of Ireland, wrote Rachel to offer his services upon hearing of William's arrest, and Dr. Gilbert Burnet did likewise.[50] Rachel arranged for Burnet to stay with William during his confinement and make a journal of everything that Russell did and said during his last days. She was in touch with Sir Robert Atkyns, the lawyer; with Hugh Speke, a radical Whig member of the Green Ribbon Club, who copied some material for her use; and with other unidentified persons who presented their "thoughts" about the trial.[51] Lady Russell heartily approved one scheme that they devised, which was for her to appear in court to take notes for her husband. She eagerly wrote William about the idea: "Your friends, believing I can do you some service at the trial, I am extremely willing to try. My resolution will hold out. Pray let yours; but it may be the Court will not let me. However do you let me try."[52] The purpose in

making Lady Russell visible in this unprecedented way was to remind the court, the king, and the public of the well-known marital felicity the Russells enjoyed and, equally important, of the services Rachel's father had rendered to both Charles I and Charles II. It took courage for an aristocratic lady to put herself forward in public in this unprecedented way, and Rachel's "extreme willingness" to do so is a measure of her strength of character and devotion to William. It also testifies to the high regard in which his friends held her.

Still further, with the help of Rachel, family members, and friends, eleven witnesses were secured to testify for William. This may have taken some persuading, for, naturally, not all people who were approached were willing to come forward for an accused traitor. Philip Stanhope, the second earl of Chesterfield, sought the advice of Charles II when asked to speak in William's favor. Charles said that while he wanted Russell to have "as fair a trial as was possible," he thought that making "encomiums. . .would do him no good," and that it would "look ill" for a privy councillor to appear on behalf of an accused traitor. So Chesterfield begged off.[53] Men who were willing to stand as witnesses included Russell's best friend, Cavendish; several clerics, among them Burnet and Fitzwilliam; a peer; and family friends and relations such as Rachel's cousin Spencer. An effort was also made to assemble evidence, but only to establish the contradictions in and hence the unreliability of Howard's testimony; this was the only substantive point offered by witnesses at the trial. No record has survived of efforts by Rachel or others to collect any other kind of evidence to assist Russell, as for example to prove that he was not in London on particular days, as he was to claim at the trial. The absence of such evidence weighs strongly against the presumption of his innocence.

William's trial took place in the Old Bailey on Friday, July 13. It began at nine o'clock in the morning, and in keeping with common practice not to adjourn criminal trials overnight, it lasted until five in the afternoon, when a guilty verdict was brought in.[54] The trial provoked such great public interest that guards and trained bands were posted about the city and at the gates of Old Bailey.[55] Although it was a showery day with a fierce storm at about 4:00 P.M., the crowd inside was so large that William's counsel (called in to argue a point of law) could find no place to sit.[56] Russell's popularity, his social status as heir to a great title and fortune, his former role as leader of the opposition in the House of Commons, and the usual interest in attending criminal trials must account for the crowd. There is no evidence that William's friends tried to bring out a large number of people.

Members of William's family were there to lend him psychological support—his sisters and his servants for certain and probably his

brothers. It is a guess that his aging father and mother did not attend. His closest friend, Cavendish, and other friends such as Dr. Burnet and Spencer were also in the court to testify to his good character. Lady Russell was present from the very beginning of the trial, sitting next to her husband, ready to come forward upon signal if the court permitted her to do so.[57] Her presence was noted; when one John Tisard tried to speak to her, he was turned out of court.[58] Unfortunately she left no notes about the day, but a later comment confirms the high pitch of anxiety that one would expect her to have felt, especially in view of her conviction that William was doomed.[59]

The presiding judge was Lord Chief Justice Francis Pemberton, who had frequently provided legal advice to the Bedford family, including Lord and Lady Russell.[60] Pemberton was even-handed, patient, even gentle, in dealing with Russell. Declaring at the outset that the king designed that Russell should have as "fair a trial as ever any noble person had," he conscientiously carried out his responsibility of assuring that the law was strictly observed and that Russell understood what he was expected to do.[61]

Seven judges assisted Pemberton, including the lord chief baron of the Exchequer, Sir William Montagu; Sir Creswell Levinz and Sir Job Charlton, both judges of the Court of Common Pleas; and Sir Francis Wythens, a justice of the Court of King's Bench. Sir George Treby, recorder of London, and the two City sheriffs, Sir Dudley North and Sir Peter Rich, were also present.

Attorney general Sir Robert Sawyer, solicitor general Sir Heneage Finch, and king's serjeant Sir George Jeffreys managed the prosecution, assisted by king's counsel, Sir Francis North. They, too, were fair in the sense that the evidence their witnesses presented followed the lines of the questions put to William in the Tower.[62] Moreover, there were only two instances of what may be described as verbal abuse. Sawyer, exasperated with Russell's repeated assertions that he was being used "hard," expostulated, "Do not say so; the king does not deal hardly with you; but. . .you would have dealt more hardly with the king: you would not have given the king an hour's notice for saving his life."[63] Jeffreys, who was otherwise restrained (in contrast to his demeanor at other trials), interjected gratuitously that there was not so much evidence against Lord Stafford as there was against Russell.[64] None of these lawyers had had a friendly personal relationship with Russell in the past but, rather, had been on opposite sides of the issues debated in the House of Commons. Indeed, Russell, it will be recalled, had been prominently associated with the effort in 1680 to remove Jeffreys and North. It was a formidable array of legal expertise for Russell to face alone, as he repeatedly said, without counsel in court,

except to argue a point of law. But all persons charged with treason confronted that condition until the Treason Trials Act of 1696; it was not a situation unique to William.

The charge against Russell set out in the written indictment was that he had conspired the "death of the king's majesty" by scheming to raise insurrection, specifically to seize the king's guards and, thus, in law, to kill the king. The overt acts said to prove the charge were his meetings with other men on November 2, 1682, and at other times both before and after that date to discuss and plot their plans. William was not, as Charles had told him in their first interview, charged with plotting to murder the king physically, and both Sawyer and Pemberton specifically distinguished the plots to murder Charles and the one to raise an insurrection against the king's government.[65] The indictment rested, as Russell found out during the trial, on 25 Edward 3, the nation's basic law governing treason. That statute defined treason as, among other things, compassing or imagining the death of the king, or levying war against the king. Subsequent treason laws passed in profusion during the Reformation, treason cases, and judicial rulings about the definition of treason and the procedures to be followed in criminal trials left the meaning of treason law open to interpretation in 1683. An issue at the heart of Russell's case was this: if the facts proved a man guilty of conspiring to raise rebellion, but no rebellion followed, was that person guilty of treason according to the statute?

The preliminaries to the proceedings showed how well Russell had learned his law lessons. Immediately upon the reading of the indictment, he insisted upon raising several legal technicalities, the effect of which was to divert the attention of the court and delay the proceedings. First, as his counsel had instructed, he asked for a written copy of the indictment, complained that he did not know what to answer to, and requested a postponement of a day. He also maintained that a prisoner was "never" arraigned and tried on the same day. But the fact is that a written indictment was not at that time allowed persons charged with treason, and the failure to provide one for Russell was a routine, rather than a special, hardship. Further, the prosecution scored in telling the court that the questions put to William in prison were designed in part as a favor to him that he might know what he would be asked in court, that he had been allowed advice of counsel to prepare his defense, and that he had had seven days' notice of his trial. Russell's first request for a postponement was denied, Pemberton pointing out what was true, namely, that arraignment and trial on the same day in cases of treason were common practice.

Second, Russell asked for a copy of the panel of the jury, declaring that he required it to frame his exceptions. Pemberton, with obvious

surprise, said that he had ordered it delivered to Russell. He explained that the list contained sixty to eighty names because in treason cases the defendant may enter thirty-five challenges. An officer of the court and William's servant were called. Arriving after some time, the one declared that he had given the jury panel to the other, who insisted that he had handed it to Lady Russell. Thereupon, William admitted that he *had* received a paper with names on it, but asserted that he did not know what they meant. Russell must surely have contrived this misunderstanding, else his lawyers were guilty of gross mismanagement. They would have known the purport of the list of names, and as Jeffreys pointed out, Russell could have requested a jury panel if he had not received one.[66] But raising the issue in court delayed the proceedings and gave Russell another opportunity to request that the trial be postponed. This second request won the endorsement of Pemberton, but the prosecution dissented; and since their approval was required, as Pemberton explained, a postponement was again denied.

Third, to reinforce his request for a postponement, Russell said that he had a witness who had not yet arrived and would be unable to reach London before nightfall. Sawyer expressed doubt that there *was* a witness whose arrival was delayed.[67] Russell made no attempt to rebut the rejoinder. He did not name the witness, explain the delay, or otherwise raise the point again. The identity of this mystery witness remains a mystery. He was not mentioned thereafter by William or Rachel, who surely would have moved heaven and earth to get a person to London who might have helped William. William had three weeks to bring in witnesses and was able to produce eleven of them in time for the trial. It is a reasonable conclusion that his allusion to a witness who had not yet arrived was really a tactic to win a delay of the trial.

Fourth, Russell asked for, and was allowed, the use of pen, ink, and paper as well as the papers he had prepared for his defense. He also asked if he might have someone to take notes to "help his memory." Pemberton said that any of his servants would be permitted to do that, specifying "servants" to prevent his using legal counsel. But William responded, "My wife is here, my lord, to do it."[68] The court was clearly startled by this clever theatrical gesture, devised, as we have seen, by William's friends. Pemberton blurted out, "If my lady please to give herself the trouble," and Sawyer chimed in, saying that Russell could have two people to write for him, if he wished.[69] Lady Russell stepped forward and seated herself, presumably at a small table, to handle William's papers and take notes for him.[70] The defense was thus successful in its plan to play on the sympathies of the court. Lady Russell was a symbol for all to see of Russell's happy marriage and family life. She evoked memory of her father's services to both Charles I and

Charles II and of his reputation for moral rectitude, a reputation which was embodied in her. Her role in the trial remains a unique episode in the annals of British legal history, and she became the focus in the nineteenth century of a painting of the trial by Sir George Hayter.

The selection of the jury followed next in the proceedings, and immediately Russell challenged the first man called, querying whether he was a forty-shilling freeholder and arguing that the law required of jurors such status. This was a point, it will be recalled, that William's lawyers had suggested that he make. As accepted procedure required, Pemberton granted Russell's request that his legal counsel argue the law on the matter and summoned Pollexfen, Holt, and Ward to do so.

Pollexfen and his colleagues presented a weak case in terms of prevailing law, and under close questioning, Pollexfen had to admit that the laws he was citing did not apply to cases of treason. He was met with a rebuke from Pemberton: "Unless treason, you do not speak *ad idem.*"[71] All seven judges, whom modern scholars now feel cannot be regarded as legal incompetents, concurred that the defense plea was inadmissible. By contrast, the prosecution, which had had time to prepare an answer to the point, was notably effective in rebutting the defense plea that jurors in a treason trial should be freeholders. They cited overriding statutory law and common law principle, argued that such a challenge had not been entered before, and explained the reason—namely, there were very few freeholders in London because most of the urban property belonged to the nobility and corporations. As Jeffreys stressed,[72] if such a requirement existed, treason could be committed in the City, and there would be no way to try it. Their points were well taken because the fact was that although the principle that jurors must be freeholders (to prevent a poor man from being influenced) was generally accepted, the law on whether a juror must be a freeholder in a treason case tried in a city, especially London, was unclear.[73] In fact, it was not until the Bill of Rights was passed in the fall of 1689 that the principle that jurors in trials for high treason be freeholders became law. Clearly the court violated no law in disallowing Russell's plea.

In an effort to reassure Russell, Pemberton insisted that he would not suffer, because the persons impaneled were men of "quality and substance."[74] The occupational status of the jury finally selected, after Russell, exercising his right, had made thirty-one challenges, would confirm that contention. Although the jurors did not, of course, share William's noble status, the foreman, John Martin, was a milliner with an establishment on the Old Exchange, and among the other jurors were an apothecary, four merchants, a haberdasher, a tobacconist, and a linen draper. The apothecary had a yearly income of between three and four hundred pounds, and one merchant was said to be worth between five

and six thousand pounds.[75] In other words, the jurymen were of the urban middle class, with incomes far exceeding 40 shillings, and not from the dregs of society, as was intimated. Yet, Russell's jury was not composed of esquires, gentlemen, baronets, or knights, as were all other juries in treason trials from 1678 to 1684.[76] The status of the jurors was one basis for the reversal of Russell's attainder in 1689.

These preliminaries settled, the prosecution, as was customary, went first to present evidence and argue law to prove Russell guilty as charged. The government's lawyers did not scruple to exploit the coincidence of Essex's suicide the morning of Russell's trial. In opening remarks summarizing and elaborating upon the indictment, Sir Francis North made an opportunity to let the court know about the incident, and later Serjeant Jeffreys and a witness, Lord Howard, adverted to it.[77] Contemporaries differed on the impact of this news on the jury,[78] but the implication that Essex preferred death to revelations of his guilt could not have helped Russell. Although the prosecution did not underline the event, the crown lawyers were surely aware of what they were doing in alluding to it. Rachel believed that the announcement was what persuaded the jury of William's guilt.[79]

The prosecution presented three witnesses—Colonel John Rumsey, Thomas Shepherd, the wine merchant, and William, Lord Howard of Escrick. Colonel Rumsey was sworn first.[80] Soft-spoken and seemingly reluctant, he told the court under questioning all that he had earlier told the Privy Council. He deposed that Shaftesbury had sent him to Shepherd's house, where a company, including Russell, the duke of Monmouth, Lord Grey of Werk, Armstrong, and Ferguson, were to meet to discuss what they proposed to do about a rising in Taunton. Rumsey asserted that Russell was in the room when he arrived and that the answer he received was that things were not yet ready, but that Russell agreed to the uprising. He said that there was some talk about a declaration to set out grievances and justify the uprising, but told the court that he was not certain about the details. He maintained that "all the company," Russell included, had discussed a plan to surprise the guards and that several of them—Monmouth, Grey, and Armstrong— had gone to inspect the condition of the guards.

Pemberton allowed Russell to ask questions of each witness in turn, rather than waiting until all had testified, and upon William's direct query whether he, Russell, had given an answer to any message about a rising, Rumsey said positively that he had and that he gave his consent to the plan. Russell rejoined that it was "the greatest accident in the world" that he had been at Shepherd's that night, that he came to taste wine, and that he heard no discourse about an insurrection. Rumsey's testimony was damaging, as were Russell's comments, for William ex-

cused his admitted presence at Shepherd's on grounds of a coincidence that brought him there just to taste wine and simply denied what Rumsey said without offering contrary evidence or closely questioning the witness.

Shepherd, the wine merchant, was sworn next, and he, too, like Rumsey, had to be prodded to speak up loudly. He testified that the conspirators met twice at his house and that Russell was present when the talk centered on seizing the guards. Excusing himself on grounds that he was in and out of the room fetching wine, sugar, and nutmeg for the group, Shepherd confessed that he could not be sure if William was there when the group discussed a paper, in the form of a declaration, setting out the grievances of the nation and justifying rebellion. Further, in the ensuing "cross-examination," Shepherd admitted that he could not be certain of the dates of the meetings nor even if William were present at one or two meetings, although he thought two. Russell rejoined that he "was in the country" at the time of the meetings, but he made no effort at any point during the trial to prove his whereabouts in late October and early November. Russell also pointed out that Rumsey had mentioned only one meeting, an assertion which prompted Rumsey to admit that he could not remember whether there was one meeting or two at Shepherd's house. The confusion over how many times Russell met with the conspirators at Shepherd's could have been turned to William's decided advantage. He insisted in court that he had been at Shepherd's only once, although it will be recalled that in the Tower he admitted to going there "divers times." But Russell did not press this point during the exchange with Shepherd.

Lord Howard was the third witness, and like Rumsey and Shepherd he began his testimony in such a soft voice that the jury could not hear him. Howard explained himself as overcome with emotion because of the news of Lord Essex's death—which, of course, had the effect of reminding the jury of North's allusion to that event. The question he was asked to address was what he knew of plans for an insurrection that were laid before Shaftesbury left England and were continued thereafter. In a long, rambling exposé of events from early fall 1682 through spring 1683, he deposed that although there had been earlier discussions about an uprising, the election of the London sheriffs reawakened interest, and Shaftesbury and others laid plans for men supplied with horses that were "kept in the most secret and blind stables they could [find]" to "possess. . .the gates [of the City]. . .and Whitehall by beating the guards." Howard said that Shaftesbury was angry at both Russell and Monmouth for obstructing these plans on grounds that their contacts in the country were not ready to mount a concurrent insurrection. Howard, professing a commitment to an uprising but unwilling to go forward unless the plot

was well laid and Monmouth and Russell involved in it, undertook to reconcile Monmouth, Russell, and Shaftesbury and proposed that he arrange a meeting between them. So he went to Monmouth, who said that he thought Shaftesbury was "mad," and that he and Russell had told him "from the beginning" that there was nothing to be done "in the country at that time." Nevertheless, Monmouth agreed to see Shaftesbury. A meeting was arranged, but Shaftesbury, fearing discovery, postponed it, and Howard said he "supposed" Monmouth would have told Russell of this postponement. Continuing his narrative, Howard recounted that the plan to murder the king at the Rye House was disavowed by Monmouth and failed, and that an alternative scheme to dispatch Charles on November 17, the anniversary of Queen Elizabeth's accession to the throne, was postponed. After these disappointments, Shaftesbury fled to Holland. Thereupon, six men—Russell, Monmouth, Essex, the younger Hampden, Algernon Sidney, and Howard—fearing that it was unsafe to make a retreat because so many people knew of the scheme, formed a cabal in mid-January 1683 to coordinate future plans. They met twice for that purpose, once at Hampden's house and once at Russell's, Howard continued, where they discussed the problems of men, money, military strategy, and their relationship with Scottish dissidents, and agreed to send Aaron Smith to Scotland to settle affairs there. Under questioning, Howard insisted that Russell was present at these meetings, and that while no note was taken, the plans "went without contradiction" and that he understood that "all there gave their consent." When asked what Russell had said, Howard responded, "Every one knows my lord Russell is a person of great judgment, and not very lavish in discourse."

Pemberton then invited Russell to ask Howard questions. Russell's initial response was that Howard's testimony was hearsay, a point that he had made earlier, interrupting Howard's narrative to introduce it. Pemberton, who had promised him then that he would not allow hearsay evidence to be used against him, now distinguished what Howard had said based on his own knowledge from what he had heard. He insisted upon that distinction when Sawyer pointedly queried it.[81] In two other instances in the trial, Pemberton disallowed hearsay evidence, rulings which testify to his concern for fairness.[82] In fact, the admissibility of hearsay evidence had only begun to be doubted in the late seventeenth century. Reservations about it had appeared in three trials before 1683, and Russell's trial itself is regarded by one legal historian as advancing that concept. Yet, even in the early eighteenth century, some legal minds continued to believe that hearsay could be employed as background to or reinforcement of direct evidence.[83] It is impossible to know whether or not the jurymen were able to discount in their minds

the portions of Howard's rambling narrative that did not touch Russell, and William was justified in complaining that he was charged with a crime that had been "intricated and intermixed with the treasons and horrid practices and speeches of other people."[84]

Pemberton remained at pains to direct William's attention to the part of Howard's testimony that hurt him, so that, as Pemberton put it, "you may consider of it, if you will ask any questions." Twice he underscored Howard's statement that a cabal of six men had met to discuss plans for an insurrection. Russell's response was that the six men did meet often to discuss public affairs and to listen to Howard, who was so fluent in discourse, talk about them. But he maintained that they had no "formed design."[85]

Howard's testimony and Russell's rebuttal were damaging to William's case. He and Howard were both sons of noble families who, by Russell's own admission, met often with others to discuss politics. It was Howard's word against Russell's as to what was said at those meetings, and Russell had no evidence to present to prove that the encounters were innocent.

Other witnesses were ready to be brought forward, crown lawyers said, but when Pemberton disallowed the testimony of one of them (West) because it was hearsay, the prosecution decided to call no others and rested its case.[86]

It was now time for Russell to present his formal defense. To assist him, Pemberton laid out again, as he put it, the "things that [were] material" in the case, and that "press[ed]" him.[87] Although Russell, with aristocratic insouciance, had seemed inattentive during the time the prosecution presented its case,[88] he roused himself and responded with care. First, he appealed to the sympathy of the court, portraying himself as an unready speaker, untrained in the law, and bereft of counsel, standing alone before the king's lawyers, who "took all advantages... improving and heightening things against" him. Such an appeal echoed his repeated asides throughout the trial that he was being used hard. Second, he sought, as he had done earlier, to discredit Rumsey's testimony because it was that of a plea-bargainer. Third, William maintained that his acts, even if proved, did not constitute treason according to the law. Arguing that two witnesses to an act were needed to convict a man of treason, Russell insisted that Rumsey's testimony was not corroborated by Shepherd, who had admitted that he was in and out of the room. Continuing, he claimed that even if Rumsey's testimony were true, it could not be used against him, because the statute of 13 Charles 2 specified that prosecution must fall within six lunary months, and it was nine months since the meeting. Still further, he asserted that even if the facts were proved against him, they did not amount to treason according to 25

Edward 3. This argument rested upon a distinction between compassing to levy war against the king, said not to be treason unless accompanied by an overt act, and compassing or imagining the death or murder of the king, treason without an overt act. Thus, it could be said that admitting the facts against him, they amounted only to a conspiracy to levy war, which without an overt act was not treason. Russell asked to be told on what law he was being tried. Sawyer immediately answered that the prosecution rested its case on 25 Edward 3 and contradicted Russell's interpretation of that law. Implicitly acknowledging the idea of the king's two bodies, the one human and the other symbolic of political power, he asserted that to design to raise forces against the king was tantamount to compassing the king's death and thus treason within that act. Russell countered by asking that these legal matters be argued by his counsel.

But this the court denied. Pemberton was adamant in ruling that Russell must admit that he had consulted with Rumsey and Howard, as they had testified, before counsel could be allowed to argue whether or not that was treason. He said, "To hear. . .counsel concerning this fact, that we cannot do, it was never done, nor will be done. If your lordship doubts whether this fact is treason or not, and desire your counsel may be heard to that, I will do it." This ruling conformed to accepted legal procedure at that time, as the prosecution and one of the judges affirmed.[89] But Russell, following the advice of his counsel, who feared, as we have seen, that he would convict himself surely of misprision of treason and perhaps of treason itself, refused to admit outright the fact. Yet, the legal points that Russell raised did draw comments from the prosecution lawyers in their summary statements, while Russell had neither the legal expertise nor the opportunity to present a contrary reading.

Pemberton continued to encourage William to present a defense. He urged him to ask questions and to call witnesses to disprove the testimony of the prosecution's witnesses, telling him flatly that if he could not "contradict [the crown's witnesses] by testimony, [their testimony] will be taken to be a proof." Russell's first response was to say that he could prove that he was out of town when one of the meetings was held and that the dates of the meetings were uncertain. But since he admitted that he had come to Shepherd's house with Monmouth to taste wine, and in any case did not bring forward a witness to prove that he was out of town, that line of argument did not advance his defense. Second, he disputed with Rumsey over which one of them was at Shepherd's first, claiming that Rumsey preceded him and discussed the plans for insurrection before he got there, an account which Rumsey emphatically denied.

Third, William sought to discredit Howard's testimony on grounds that he must have concocted it very recently, because earlier he

had protested to several people that he knew of no plot that Russell could have been involved in. To that end he turned to witnesses to reinforce his claim. It should be noted that witnesses for the defense in treason trials at this time gave their testimony without being sworn. Not until the Treason Trials Act of 1696 were witnesses for the defense placed under oath; before then, they were simply told to tell the truth out of fear of God. A legal historian, quoting contemporary sources, believes that their testimony was given the same weight as if it were under oath, but it is worth noting that the French ambassador did not think so.[90] Be that as it may, three witnesses—Lord Anglesey; Mr. Howard, a relation of Lord Howard; and Dr. Burnet—confirmed Russell's point by recounting interviews with Howard in which he had told them that he knew nothing of a plot, and especially nothing of Russell's connection with any plot. This testimony carried weight with the jury, and the foreman interjected a request that Lord Howard answer. Howard readily admitted to having made such remarks, saying that he had sought to protect himself and his friends and that, in his conversation with William's father, he had meant only to reassure him. At that time, he insisted, he had not intended to be in the position he now found himself. He also asserted that he distinguished closely the two plots (one to murder the king, the other to raise an insurrection) so that he could honestly say that neither Monmouth nor Russell had any part in the design to murder Charles. It was a logical and reasonable explanation which the prosecution underscored in their summary statements.

Finally, Russell called eight more witnesses to testify to his good character. Distinguished clergymen, Dr. John Tillotson and Dr. Thomas Coxe; a nobleman, the duke of Somerset, who was related to Russell by marriage; and personal friends such as Cavendish and Spencer, who could be said to know the defendant intimately, declared that Russell's moral character and virtue were such that he could not possibly be guilty of the crimes of which he was charged. Some of these encomia were fervently stated, but, of course, they did not address the specific charges against Russell, and as Charles II had predicted, such testimony did not do him much good.

Russell's concluding speech to the court was not a strong one. He protested that he was a loyal subject who detested rebellion and favored redress of grievances only in a parliamentary way.[91] He said that it was "unlikely" that he would try to raise an insurrection and that, even if he were inclined to do so, "by all the observation I made in the country, there was no tendency to it." What other "hot headed" men may have done was another thing. "A rebellion," he said, "cannot be made now as it has been in former times; we have few great men." Such remarks would seem to indicate that he had thought quite seriously about the pos-

sibility of an uprising and had even gone so far as to make "observations" about the feasibility of it. Russell placed himself in the hands of the jury, expressing the hope that the "heats and animosities" among them would "not so bias" them that they would convict an innocent man. Disparaging the integrity of the jurors may not have recommended William to them. Russell closed his speech with a call to heaven and earth to witness that he never "had a design against the king's life," that he was innocent, and that nothing at all had been proved against him. Since he was not charged with participating in a design against the king's life, this protestation may not have carried weight with the jury.

Finch and Jeffreys summed up the case for the prosecution. First, the crown lawyers reviewed the evidence against Russell and sought to discredit his responses. For example, they ridiculed the idea that it was an accident that Russell found himself at Shepherd's house on the night of the conspirators' meeting, having gone there for the purpose of tasting wine. Finch made a telling point that Russell had admitted coming and going with Monmouth, and that Monmouth would not have allowed a person unconcerned in the affair to have accompanied him.[92] In like terms, Finch dismissed the idea that the six men said to make up the cabal met, as Russell admitted they did, just to listen to Howard comment on public events. Second, Finch undertook to answer the objection that Russell, a man of honor and integrity, could not have conspired treason. He said that Russell's reputation was a strong point in his favor, but that William had been puffed up by the popularity he enjoyed with the crowd and fallen prey to the temptation of pride and ambition.

Third, the prosecution addressed the legal objections that Russell had wanted his counsel to debate. Their remarks suggest that had such a debate somehow occurred, Russell would not have fared well. Jeffreys contended that in a treason trial two witnesses to the same *act* were not required, only two witnesses to the same *treason*, a point illustrated by the trial of Lord Stafford.[93] Modern legal historians confirm this reading of the law, their studies showing that it was not until the Treason Trials Act of 1696 that the principle of requiring two witnesses to the same act in a treason trial was established.[94] Moreover, Finch emphatically denied Russell's reading of the law of 13 Charles 2 and 25 Edward 3, saying that it was "plainly otherwise."[95] He quoted the text of 13 Charles 2 to show that the clause requiring prosecution of a person charged with a criminal offense to take place within six months of the crime did not apply to treason. Most importantly, he commented *in extenso*, citing cases and rulings on 25 Edward 3, in elaboration of the point that Sawyer had broached, namely that by that statute a conspiracy to levy war was an overt act testifying to compassing and imagining the death of the king and was therefore treason. Finch declared that Russell

had no part in the plan to assassinate the king but, rather, that he with others planned an insurrection which would bring the king within their power until he consented to certain changes, and that was treason. A legal historian concurs with this reading of the law.[96] These were the lines of argument that Russell's counsel did not want to undertake to debate.

As throughout the trial, Pemberton was even-handed in addressing the jury. Although he justified the admission of plea-bargainers' evidence, saying that no one better than they could know what were the secret designs against the king, he carefully distinguished William's case from that of other persons charged with conspiracy, underlining that William's crime was *not* to consult to murder the king in person but to contrive rebellion to seize the king's guards. If proved, that act, he maintained, was tantamount in law to a design against the king's life, and treason.[97] In notes that she made later, Rachel recorded that Judge Wythens spoke to the jury after Pemberton had completed his summing up. Wythens said twice that the jury "should notice that an intent of seizing the guards was the same thing as killing the king." Rachel declared that his remarks failed to appear in published accounts of the trial.[98]

The jury deliberated a little over one hour. One juror had written out the proceedings in shorthand and read his account to the jury.[99] At four o'clock the jury brought in a verdict of guilty of high treason. No evidence survives of the immediate reaction of Lord and Lady Russell to the verdict, but if their demeanor over the next week is any indication, they responded with quiet dignity.

The immediate public reaction divided along partisan lines. Russell's defense declared his innocence and laid the foundation for the subsequent claim that the government had concocted the charge to destroy its enemies. "Every creature," Evelyn declared, "deplored Essex and Russell, especially the last as being. . .drawn in on pretence only of endeavouring to rescue the king" from evil counsellors, Anglicanism from popery, and the "nation from arbitrary government."[100] On the other hand, friends of the court and also dispassionate observers thought that the trial had been fair. One said that Russell had made a very weak and inconsequential defense, and another, that the evidence against him was "full" and "most plain."[101] A third remarked that Russell's defense was simply to call people to give an account of his life "to make it unlikely" that he would contrive so horrible a design, while a fourth declared that the "evidence [was] so full and plain that imprudence itself cannot gainsay it."[102] The astute French ambassador reported that Russell had not defended himself well, but that public sentiment about his guilt was divided along partisan lines.[103] And so it has remained today.

Was the government guilty in Russell's case of violating the laws of treason and criminal trial procedures, as such laws existed in 1683? The answer must be no. As we have seen, treatment accorded William in the days after his arrest and prior to his trial was fair, even generous. He was allowed to have larger living quarters in the Tower, to receive visits from his wife and family, to consult with distinguished legal counsel, to enjoy the presence of a cleric, and to have the benefit of advice from his former political associates in preparing his defense. The procedures at his trial that he criticized as "hard" were, in fact, legal. No defendant in a treason trial was allowed a written copy of the indictment nor counsel to advise him during the trial except on a point of law. Freehold status of jurors in a treason trial was not required by law until the Treason Trials Act of 1696. There was no requirement that there be two witnesses to the same act of treason, just to the same treason. The evidence of plea-bargainers was routinely admitted, even as it is today, and corroboration by another witness was not mandated until the eighteenth century. The presiding judge conducted the proceedings in an even-handed manner, with strict attention to the law and with care to see that Russell understood the law and what was expected of him.

Was Russell really guilty, as charged? The evidence is certain that he had discussed the raising of an insurrection. He himself admitted as much after the trial. The advice of his lawyers not to tell the whole truth and his willingness to follow that advice weigh heavily against his innocence. His counsel obviously lacked confidence that the law would be on Russell's side. Russell was unable to present any evidence or witnesses to shake the testimony of the several witnesses for the prosecution. His reckless nature, his impatience, his earlier interest in the military, his fervently held belief that England was moving towards an absolute government that would destroy the nation's laws and return it to Catholicism, help explain why he would have allowed himself to be drawn into wild schemes in the first place. To discuss such plans more than once and fail to report them to the authorities was clearly treason according to treason law in 1683.

The next day Russell was returned to the bar to hear the sentence pronounced against him. Perhaps at the direction of his legal advisers, he asked to have the indictment read once more and interrupted the recital to renew his contention that he was not guilty under 25 Edward 3 because to levy war against the king was not to compass his death. But the plea was denied, and Sir George Treby, the recorder of London, pronounced the usual horrible sentence for treason—to be hanged, drawn, and quartered.

Lord and Lady Russell responded to his conviction in ways that dis-

played their strong characters. Rachel threw herself into frenzied but purposeful activity to try to win for William a pardon or at least a reprieve and, failing that, to assist him in writing his scaffold speech and preparing for death. Through it all she did not weep nor urge Russell to plea-bargain or to change his views so as to gain the king's favor. Dignified and restrained in William's presence, passionate in petitioning the king and the duke, Rachel showed strength of character and intelligence, winning Burnet's increased respect and admiration and heightening William's love and gratitude. William, who had been moved to Newgate Prison to await execution, professed to have no confidence in the success of her endeavors, but he cooperated in every project that she undertook, wisely recognizing that after his death she would take comfort in knowing that she had left no stone unturned. He spent the week saying his farewells to family members and friends, preparing himself through prayer, reading, and conversation with Burnet and other clergymen for death, reaffirming his commitment to the idea of the right to resist in the face of efforts by Anglican clergymen to dissuade him, and writing out his scaffold speech. Burnet stayed with him and, at Rachel's request, kept a journal of all he said and did during these last days.[104]

The first step that Rachel and others took was to bombard the king, who alone held the power of pardon, with petitions; at the same time they appealed to the duke of York to move Charles to compassion for William. Two days after the sentencing, Rachel put William's petition in the hands of the secretary of state, beseeching him to give it to Charles, and declaring that William stood ready to provide still further evidence of his submission. In the petition William humbly begged Charles's mercy and pardon, disavowed any design against the king's life, but admitted listening to conversations and failing to "decline them" as he might have done, offered to live in exile wherever the king should appoint, and promised never to "meddle" in England's affairs, unless the king should wish him to do so.[105] The next day the earl of Bedford put his pleas before the king. The earl, who had apparently been denied an audience, begged Charles to pardon his son, declaring in affecting terms that he would rather live on bread and water than to lose William. It was also rumored that Bedford offered Charles £50,000 and the duchess of Portsmouth £100,000 to intervene with Charles on behalf of William. Charles declined any such overtures.[106]

Rachel, using the good offices of Arthur Annesley, earl of Anglesey, also placed a petition in the king's hands. She too pleaded with Charles to spare William's life, describing herself and her children as helpless and promising that henceforth her husband would show so much obedience and submission to the king and royal family as to outweigh his past acts.[107] At the same time, Lady Katherine Ranelagh,

whom Lady Russell had consulted, advised her to contrive to see the king in person, to beg if not for Russell's life, then a reprieve.[108] Accordingly, on the afternoon of July 16, Rachel wrote another petition to Charles, asking only for a reprieve of several days, a thing "so commonly granted," she said, that she was confident Charles could not deny it. She sought to strengthen her plea by begging him to remember her father's devoted service to his father and to himself, but Charles, as we have seen, had no special fondness for Rachel's father, and that appeal was not likely to impress him. Rachel also succeeded, despite reports that the king was avoiding her because he feared that he "could not deny" her, in winning a personal interview with Charles.[109] Lady Russell left no account of that meeting, except to refer to herself as importunate, but eighteenth-century historians described, without citing sources, a passionate interview in which Rachel threw herself weeping at the king's feet and implored him to grant her request. Charles was said to have responded that Russell, had it been in his power, would not have granted him six hours.[110]

Also on July 16 Rachel delivered to the duchess of York a petition from William addressed to the duke. Lady Ranelagh had advised that William's address to the duke should be in the form of a petition and counselled that the "sooner it is presented the better."[111] Russell had difficulty composing this statement to the man against whom he had fought for so long. He predicted that his letter would be circulated after his death as evidence of his submission. But he swallowed his pride, wrote that he had never entertained any personal animus towards York, and begged him to assist his case with the king.[112] Rachel followed this with the most "passionate letter to the duke that ever he read," reported a contemporary, but it was to no avail.[113] If the duke remembered Rachel's father's kindness to him sixteen years before, he did not allow that memory to influence his judgment respecting William. James was adamant that Russell should die. His attitude was not unreasonable in view of the evidence against William and the past history of relations between the two men, which included, it should be remembered, William's idea that York be tried, condemned, and executed for his alleged activities in the Popish Plot. Furthermore, it could not have helped the appeals for clemency that Russell's guard had informed the king that he had overheard William say that his sufferings were "but the procreation of the Popish Plot and that if he were pardoned the papists would assassinate him." The remark incensed Charles and would have angered even more the duke of York.[114]

Russell's friends and political associates also tried to soften the king's heart. Someone representing "that party who looked upon [Russell] as their head" used Fitzwilliam to get a message to Rachel to

meet him at the office of the secretary of state, there to pledge that the party would desist in criticizing the government if Russell were pardoned.[115] The proposal was thought likely to carry weight with the king, but if Charles did hear about it, it too fell on deaf ears. Moreover, unidentified friends also offered Charles large sums of money, upwards of £50,000, in return for a pardon for William, but Charles refused, as he had refused Bedford's bribe.[116]

In addition, Rachel's French relatives tried to use their influence at the highest reaches of the French government. Her cousin, de Ruvigny, begged Louis XIV to urge Charles II to pardon Russell, and her old uncle won permission to come to England to plead with Charles and to be with Rachel. Barrillon showed Charles de Ruvigny's letter on July 19 and probably presented some guarded expressions from Louis XIV favoring mercy, but was met with a rebuff. Charles said that he would not prevent de Ruvigny from coming to London, but that Russell would be dead before he arrived. The king also remarked that he was sure that Louis would not advise him to pardon someone who would have given him no quarter.[117]

These efforts were not without hope of success, for people about the king were divided on whether or not to pardon or reprieve Russell. On the one hand, George Legge, baron of Dartmouth, sought to persuade Charles to pardon William on grounds that he would otherwise antagonize the powerful Bedford family and that he owed something to Southampton's daughter and her children. The king dismissed such advice, reportedly replying, "All that is true, but it is as true, that if I do not take his life, he will soon have mine."[118] Laurence Hyde, earl of Rochester, described as "very affectionate and helpful," undertook at Lady Ranelagh's urging to persuade Charles to grant William a month's reprieve. He also discussed the issue with the duke of York.[119] Halifax, Rachel's relative, displayed a "very compassionate concern" for William, and his help was acknowledged by both Lord and Lady Russell.[120] As a note in his hand testifies, Halifax believed in William's moral innocence and was persuaded that Russell never intended to use force to redress grievances.[121]

On the other hand, Robert Spencer, the earl of Sunderland, Russell's relative, adopted a very severe attitude towards the conspirators in general and, possibly because of his dislike for Halifax, who was promoting Russell's interests, did nothing to save William.[122] The duke of York was, as we have seen, adamant that Russell must suffer the penalty of death. The king, it was said, might have succumbed to the importunities for leniency that he received on all sides had it not been for his unwillingness to break with his brother.[123] Yet Charles at no point showed a really conciliatory spirit. He had long ago formed an unfavora-

ble opinion of Russell; he genuinely believed in the reality of plots against his life; his iterated comments that if he did not have Russell's head, Russell would have his, seem close to the mark of his true feelings.

Although Charles was unmoved by pleas for a pardon or a reprieve, he was not brutal. On July 19 he commuted the dreadful sentence the law imposed on traitors to simply beheading and, dismissing York's suggestion that the execution take place in Southampton Square in front of Russell's home,[124] ordered a scaffold to be erected in Lincoln's Inn Fields. The king chose Lincoln's Inn Fields, as the warrant to the London sheriffs put it, "for certain considerations and in respect that [Russell] is the eldest son of a peer."[125] The nature of the site would have facilitated crowd control and distinguished Russell, the son of a peer, from three other convicted traitors, all commoners, who died the day before at Tyburn. Further, on the twenty-first the king ordered that after the execution William's body be handed over to Rachel or other relations for a private burial, thereby assuring that Russell's head would not be displayed, as were those of the three other condemned traitors.[126] And, as we shall see, he did not claim Russell's personal estate, which normally would have been forfeited.

William cooperated fully in every effort to secure a pardon, saying, however, that he did so to indulge Rachel, not because he had confidence in the outcome. But he resisted a scheme proposed by his good friend Cavendish whereby the two men, who were of similar height, would change clothes and Cavendish would take his place while he escaped from prison.[127] Flight would have been taken as an admission of guilt. Had he fled, he would have strengthened the king's hand and sacrificed his own role as martyr.

Throughout his imprisonment, Russell conducted himself with a dignity fully matching that of Rachel. His mind was much sharpened and his spiritual understanding clarified by impending death, and his serene demeanor and wise and sometimes humorous comments, which Burnet reported in copious detail, were the stuff of which martyrs are made. William was surely aware that this would be the case. Dr. Burnet's account and William's scaffold speech were gifts to Russell's wife, family, and political associates. They were designed not only to comfort them, but also to help keep the broken Whig party together, justify his role in politics, and lay the foundations for the idea that the government had contrived the charge of a plot against it to destroy its enemies and that Russell was a victim, a martyr, to Stuart despotism.

Russell's conversations with Burnet ranged widely, touching such topics as the "state of Hungary and the affairs of Europe." William was also at pains to identify himself with his radical friends, perhaps to send a message that he still adhered to the principles that had united them. He

"spoke often and with great kindness" of John Hampden the younger, and commended Essex for his great concern for the public good.[128] He reviewed aspects of his trial, suggesting that the jury was packed to assure his conviction and blaming Pemberton for crediting Howard's testimony.[129]

William also spent a good portion of his time examining the condition of his soul and reaffirming his devotion to Protestant Christianity. He read the Bible and Richard Baxter's *Dying Thoughts*, which John Hampden brought him as a gift from the author. He ran over the defects in his life, among which he placed failing to take the sacrament often. An extravagant streak he admitted, but he maintained that he had long ago decided not to change his style of life when he came into his inheritance but to devote his fortune to doing good. He professed a clear conscience about all he had done in public life, except for listening to some "indecent discourses" and, as he admitted, being pleased with them.[130] Withal, he concluded that his sins had been mostly those of omission. Russell was able to forgive all of his enemies, he said, except for Howard, for whom he had never possessed high regard and whom he now heartily detested. He turned to Burnet for guidance on this point and took comfort from the fifteenth Psalm, where verses 3 and 5 excoriated a person who "backbiteth" and "taketh up a reproach against his neighbor" and accepts a "reward against the innocent." William drew solace also from two sermons that Burnet preached to him and Rachel on the morning before he died. In one of them, on the text of Psalm 23:4, the good divine came close to comparing Russell to Jesus Christ and actually said that he was a martyr to the true religion.[131] Thus fortified by his religion and by a kind of aristocratic chivalric code, he was able, he assured Burnet, to regard the coming execution as no more than a moment of personal exhibition and passing pain that would introduce him into life everlasting. He remarked that he had been more troubled by his son's illness some months before than by his own impending death.[132]

His exuberant nature, of course, might have expressed itself in a very different attitude. Although he was outwardly composed, some physical symptoms betrayed his nervous tension. During his imprisonment a rash broke out all over his body, and he reported himself as suffering from "heat in the blood," a sense of fullness, and a susceptibility to fever. The day before the execution, he had two nosebleeds, just as had happened earlier during the Exclusion Crisis debates. With a characteristic effort at humor, he dismissed them with a laugh, saying that he should not need to be bled, for that would be done tomorrow. Had he lived, he said, he would have had to undertake a course of physic to restore his health, and he remarked how ironic it would have been if

Rachel's schemes for his release had enjoyed success, only to have him sicken and die within a short time.[133] Such symptoms as these, surely psychosomatic, reveal William's emotional tension and suggest the effort it cost him to preserve an outwardly calm and serene manner.

William spent much time composing his scaffold speech. According to Burnet, Russell decided to prepare the statement himself, a step that reflected sensitivity to the political uses of the printed word, an awareness he had shown earlier.[134] William took care to choose words that expressed "exactly. . .his conscience" and discussed portions of the text with Rachel and Burnet. He asked Burnet to provide "heads" that he might address and to suggest their order, because he was "unaccustomed to draw such papers." Burnet insisted that apart from ordering the topics, suggesting that Russell clear himself of the charge of suborning witnesses in the Popish Plot trials, and persuading him not to comment on slavery, he gave William no substantive guidance and that the ideas and language of the speech were Russell's. Rachel was also emphatic in averring that William wrote the speech himself.[135] Since, as we have seen, Russell had displayed a talent for expository writing as a young man, these claims may be taken at face value. And, even if he had received assistance with the speech, the ideas in it were those that William wanted to leave behind as testimonial of his views.

Printed as *The Speech of the Late Lord Russel To the Sheriffs: Together with the Paper deliver'd by him to them, at the Place of Execution, on July 21, 1683*, the scaffold speech is the only extended statement of Russell's beliefs that has survived.[136] In it he affirmed in print views already discussed that were implicit in his speeches and actions. First, in the original draft of his speech, William categorically asserted his belief in the right of resistance, a position that his chaplain, the Reverend Samuel Johnson, had successfully reinforced against the efforts of Burnet and the Reverend John Tillotson to persuade him to disavow.[137] Russell went so far as to say to Tillotson that unless the right of resistance was acknowledged in England, the English government was no different from a "Turkish constitution."[138] Belief in the right to resist, obviously, justified the actions with which he had been charged and if made public in writing would have strengthened the charge against him. In the original draft of his speech, written in his hand and preserved in the Bedford Record Office, London, Russell, while acknowledging that Burnet and Tillotson had argued otherwise, declared emphatically that a "free nation. . .might defend both their religion and liberties when they are invaded and taken from them though under pretence and colour of law."[139] The concept was bold and such language a sharp indictment of the court, which regarded the idea of the right to resist as seditious. Significantly, Russell used the word "invaded" with

respect to the nation's "religion and liberties," even as he had done in conversation with Tillotson. The same language had appeared in 1675 in *Letter from a Person of Quality to His Friend in the Country,* a tract closely associated with Shaftesbury. It may be regarded as a part of the code language radical Whigs used to signify the tyranny of Charles II's government.[140] In employing it William apparently intended to signal to the Whigs his continuing commitment to principles they had shared.

But this paragraph, with its especially damaging concept and language, did not appear in the printed version of the speech. In the manuscript copy at the Bedford Record Office, London, someone has underlined the paragraph in pencil; the paragraph in the manuscript copy at Chatsworth is inked out.[141] The story of what had happened is this. Burnet and Tillotson construed conversations that each had had with William to mean that he was willing to disavow the principle of right of resistance. Thinking that such a disavowal would move the king to pardon him, Tillotson, at Burnet's urging, took the information to Halifax, who conveyed it to Charles. The king was impressed. But when Tillotson returned for further confirmation of his view, Russell said that he had been misunderstood, that he did believe in the right to resist. Thus, Tillotson found himself in an awkward position. Endeavoring to exculpate himself with King Charles, Tillotson wrote a letter to Russell dated July 20, in which he set out the errors of such a doctrine. After studying the letter, Russell concluded that his views of English laws and government differed from those of Burnet and Tillotson and refused to change the words in his speech; he would have to lie to do so, he said. But he added that "whatever his opinion might be in cases of extremity, he was against those ways and ever thought a parliamentary course was the proper remedy for all the distempers of a nation."[142] The night before he died he assured Tillotson that he had always believed that Parliament should be the instrument to redress grievances, yet he added that "it was once in their power to have overturned the Government,"[143] a remark which implied that he had been party to schemes that involved force to overturn the government. Russell, however, would not change the language of his paragraph on resistance. Tillotson therefore urged Burnet to prevail upon Russell to "dash out" the entire paragraph, and in the end Russell agreed to the compromise. Thereby he preserved his intellectual integrity on the issue, as a letter from Burnet to Bishop Henry Compton dated July 30 confirmed. Burnet declared that Anglican divines had tried to persuade Russell to disavow resistance, but that he persisted in the belief.[144] Why, then, did he agree to omit the words in his printed speech? Almost certainly because he did not want to antagonize the court towards his wife and family.

Tillotson expressed considerable anxiety after Russell's execution

over the possibility that he had offended Rachel by importuning her husband to change his mind on resistance. His anxiety is of importance, suggesting as it does that Rachel adhered to the doctrine of resistance herself. It took a couple of letters and several months before Lady Russell forgave him.[145] Thereafter, Tillotson and Rachel became close friends, and, as we shall see, they mutually supported each other after the Revolution of 1689.

A second major point in the *Speech* concerned William's religious views. Russell portrayed himself as a devout Protestant and a member of the Anglican church who could not accept "all the heights" of that communion and who called on all true Protestants to lay aside their differences and unite "against the common enemy," popery. His position on comprehension versus toleration is not made crystal clear, but the implication of his calling upon Protestants to unite is that he favored comprehension. What *is* clear is his violent dislike of Catholicism. He excoriated popery, as he had done in the House of Commons, describing it as an "idolatrous and bloody" religion. He explained that he felt himself bound in his "station" to do all he could against it, even though he expected to suffer thereby. Recalling his role in the Popish Plot and Exclusion, Russell intimated that a vengeful government had brought upon him his "present sufferings." Asserting that he had sincerely believed that there was a Catholic conspiracy against the nation, he declared that popery remained a danger and that many Protestants (meaning Anglican clerics) continued to advance it. Russell warned that the nation had "just reason to fear the worst" and expressed pessimism for the future, because of the boundless impiety and profaneness that prevailed.

Third, Russell maintained that he had always believed that England's government was "one of the best in the world." He implicitly denied any connection with republican notions, explaining, as we have seen, that he had supported the idea of exclusion because a popish successor threatened England's religion, law, and government. Limitations, he felt, would have altered the government by removing the prerogative powers of a king. Russell believed that the result would be "perpetual jealousies."

A fourth theme in the *Speech* was a "true and clear account" of his part in the conspiracies. William admitted that on the advice of his lawyers, who feared he might convict himself of misprision of treason, he had not been candid at his trial. But, in fact, his written account was far from a clear and full account. On the one hand he said that he knew of no plot against the king, and on the other admitted to participating in conspiratorial conversations at Shaftesbury's house and at Shepherd's tavern. He confessed that he had not gone to the tavern just to taste wine,

as he had said at his trial. But he insisted that, along with the duke of Monmouth, he had opposed violent action, such as seizing the guards. He dismissed such conversations as just talk "about making some stirs." He admitted that there had been "discourse" at Shepherd's about the "feasibleness" of "securing, or seizing the guards," and even that "several times by accident, in general discourse elsewhere" he had "heard it mentioned as a thing might easily be done." But he insisted that he had abhorred the idea because, if successful, it would result in a massacre. Russell conceded, however, that he was guilty of misprision of treason. As we have seen, according to the law of treason, as it stood in 1683, if he had admitted so much at his trial, he would have been convicted of treason by his own account.

Fifth, Russell sought to exculpate himself further by saying that he would not accuse others to save himself and by arguing that clever, articulate crown lawyers had stretched the evidence to make "constructive treason" and convicted him "by forms and subtleties of law." This was judicial murder, the worst kind of killing. He was an innocent man, who wanted only to protect his beloved nation from popery and absolutism. Russell said that he forgave everyone connected with his "murder"—lawyers, judges, and especially the jurors. Significantly, he did not mention the absence of freeholders among the jurors, a point his lawyers had argued at his trial and which would be revived in 1689. William begged his friends not to revenge his death, saying that he would "offer up" his life "with so much more joy" if he could feel that the spilling of innocent blood would end with his own. Russell's speech was a powerful political statement which, as we shall see, deeply offended the court.

Lady Russell was closely associated with her husband's speech. As already mentioned, William consulted her about portions of it. In view of her strong personality and the close relationship the Russells enjoyed, the final version undoubtedly represented her views and had her warm endorsement. Presumably to make certain that the paper should not fail to be printed, she and William wrote out, between them, five "original" copies which he signed the night before his execution.[146] The fact that the first edition of the speech bore the words "Printed...by Direction of the Lady Russell" further supports this point. It is inconceivable that a person of her quick intelligence and political sophistication would have allowed herself to be connected with a printed document of which she disapproved. Her insistence after the execution that the paper faithfully reflected Russell's views does likewise.

William's political associates undoubtedly assisted in the project of the speech. The duke of York had no doubt that Russell's "factious

friends" had published it.[147] Some unidentified person among them must have contacted the printer John Darby, a man described as a "true asserter of English liberties," delivered the manuscript to him the night before the execution, and seen to it that the tract was on sale in the streets "within an hour" of William's death.[148]

During these days, when she was not engaged in projects to rescue William, Rachel was with him in prison, helping him with his speech, talking, and eating with him. She followed Burnet's account of her husband's last days with avid interest, and, in keeping with her energetic nature, corrected it in one or two particulars to portray William in the best possible light. The account found favor with her, and she told Burnet firmly that she was prepared to swear to its accuracy.[149] Burnet formed a very high opinion of Lady Russell for her demeanor and actions this week, commending her for having acted "so noble a part" and declaring that she had earned a "great" reputation on her own. Thereafter, Burnet and Rachel remained close friends.[150]

On July 19 Russell wrote a letter to Charles II and gave it to Lady Russell to deliver after his death. He took great pains with the language to avoid offending the king. Thus, he declined to subscribe himself as a "loyal" subject, as inappropriate to a condemned traitor, and to include the thought that he had been devoted to the king's service, since he had resigned from the council. He begged the king's pardon, confessed more than he had in public, and declared that he forgave everyone connected with his trial. Barrillon could not imagine why Russell wrote this letter. The real reason lies in his appeal to the king to spare his wife and children the king's displeasure. In effect, he was laying the groundwork on which Lady Russell would build to recover a position for herself and their children.[151] Burnet suggested to Rachel that she get a copy to the king before William's death in hopes of moving him to pardon or reprieve Russell. Colonel Russell, William's uncle, did that, but again Charles was unmoved.

On Friday, July 20, the day before his execution, Russell said his farewells to friends, family, and Rachel, comporting himself in so composed a manner that everyone was filled with admiration. For example, when his brother James (the one with whom he had earlier engaged in boisterous horseplay) came for a last visit, William jokingly suggested that they should change places, saying to him, "Come, shall we change our clothes." To another visitor he said pleasantly, "You ever find me out in a new place." He saw his three children in the morning and again in the evening, but his last words to them have not been preserved. Rachel ate dinner with him. During the meal William took her by the hand and said, without any discomposure, "This flesh you now feel will soon be cold."[152] Their conversation was cheerful on several topics, especially

about their two daughters. During the meal a note addressed to Rachel was delivered; it laid out a new project to reprieve William, but he ridiculed and dismissed it. At about ten o'clock Rachel left him. Russell kissed her four or five times, and they parted silently without tears.[153] It must have taken enormous self-control on the part of both, but especially Rachel, to part so quietly. Later, she blessed God for enabling her to master her emotions so as not to increase William's suffering.[154]

William remarked to Burnet that now that he had said goodbye to Rachel the bitterness of death was behind him. Testifying to his deep love for his wife, he spoke at length of her, declaring that she had been the greatest blessing in his life. He described her as combining birth, fortune, great religion, and great kindness to him. He had been afraid earlier that she would not be able to bear their parting, and he was filled with admiration at the restraint she showed. Showing his understanding of her nature, he expressed concern that after his death, when the whirlwind of her activities to save him were over, the "quickness of her spirit would act too powerfully within her." This was a prophetic judgment.

Russell slept well from one to four o'clock the night before his execution, and upon awakening even fell asleep while his servant was laying out his clothes. He prayed with Burnet and Tillotson, sent word of his love to Rachel, and said a last farewell to Cavendish, who was waiting for him outside Newgate. Burnet and Tillotson accompanied him in his own coach, which was heavily guarded by trained bands marching on both sides and behind it, undoubtedly to forestall any attempt at a rescue, which in fact Cavendish had at one time proposed.[155] It was a special favor for William to drive to the scene of execution in his own coach.[156] As they drove along, William sang Psalm 119 and acknowledged the presence of several people whom he recognized on the street. He showed his emotion only once, when he looked towards Southampton House, where Rachel and his three children must have been keeping a vigil.

The little party reached Lincoln's Inn Fields, where already assembled were a large number of people and ten companies of the king's guards drawn up around the scaffold and a troop of horse divided into four squadrons positioned about the area.[157] The government was taking all precautions against the possibility of a demonstration in Russell's favor.[158] As the coach turned into the Fields, Russell, apparently recalling the excesses of his youth, remarked to Burnet, "This has been for me a place of sinning, and God now makes it a place of my judgment."[159] William walked around the black-draped scaffold four or five times and then said a few words to the sheriff, addressing him as "Gentleman," because he did not believe that he was truly sheriff. He satisfied himself that Captain Walcot had not incriminated him, disavowed

with some disingenuity any knowledge of a plot against the king's life or government, and called upon all Protestants to "love one another" so as not to encourage popery by their own dissensions. Russell gave Tillotson his ring and Burnet his watch, and adjured Burnet not to forget some messages that he wished delivered at Southampton House and Woburn. Characteristically showing his thoughtful nature, Russell included a word to one of Bedford's chaplains who adhered to the church's view of passive obedience.[160] He paid the executioner as Burnet had instructed him to do, so as to redeem his clothing and, after some moments of private prayer, removed his coat, waistcoat, and cravat, put on his nightcap, and placed his head on the block, all without any change of expression.[161] At the very end of his life, Russell adhered to a chivalric code, showing customary bravado by refusing to be blindfolded. Burnet had told him not to turn his head once it was on the block and not to give a signal. The ax fell as William raised his arms, all untrembling in a last prayer. But since his eyes were uncovered, he apparently saw the ax coming and flinched, so that the first stroke was too high and caught him in the shoulder. It was fastened there as his body rose against it, and it took two more blows before his head was severed.[162] Russell died, all observers agreed, in a noble and courageous manner. Some people dipped their handkerchiefs in his blood,[163] a gesture suggesting that his martyrdom was already well under way.

To forestall such a development, King Charles, who had gone to Windsor early in the morning, ordered Oxford University to burn the very day of Russell's execution certain books whose principles justified resistance theory. Among the books were those by George Buchanan, Hobbes, and two Dissenting ministers, both associated with Russell, Samuel Johnson and Richard Baxter.[164] In so doing the court reasserted the doctrine that unconditional obedience to a divinely appointed king was the duty of the subject and underscored the dangers of defying the government.

As was customary, Russell's head was held up for the crowd to see, and then his head and body were put in a hearse and taken to the marquess of Winchester's house, where they were sewn together before being taken to Southampton House.[165] The reception that the body received there must be imagined.

· 7 ·
Widowhood,
1683–1688

William's death was a shattering experience for Lady Russell. Lord Russell had feared that the "quickness of her spirit" would bring on a terrible reaction after he was gone, and he was right. Rachel suffered torrents of grief and "wild and raging" thoughts which seemed to increase rather than diminish for several years and brought her close to an emotional breakdown. Yet, even in the depths of her despair, she was not so distraught as to be incapable of conducting her affairs intelligently and effectively. Sustained by the counsel and comfort of clerics, family, and friends, by deepening religious piety and the very act of writing, and by the responsibilities of raising her young children, Rachel developed into an even stronger and more independent person than she had been before.

Despite her grief, she gave first priority to political and business matters. She was immediately drawn into a dispute with the government over William's scaffold speech. That speech had enraged the court. York fumed that there could not be a "greater libel on the government,"[1] and a swift, powerful, and well-orchestrated campaign against it followed. The court interrogated people suspected of assisting with the speech. The day after Russell's execution, July 22, 1683, the Privy Council, with the king and the duke present, examined Burnet, Johnson, Tillotson, and the printer John Darby to determine what part they had played in writing and publishing the speech.[2] The interview with Burnet further angered the court, because in the course of it Burnet won permission to read his journal of Russell's last days, and deeply offended the assembled company with a eulogy stressing William's piety, devotion to Protestantism, love of wife and family, and willingness to die for his beliefs.[3] Burnet was so alarmed by their displeasure that he went to the Continent for awhile. The next day the Privy Council, again with the king and the duke of York in attendance, ordered that Lady Russell should be interrogated about whether she had sent 2,500 copies of Russell's *Speech* into Bedfordshire.[4] Unfortunately, a record of the interrogation has not survived, but such an encounter with authorities

who had just executed her husband was surely a threatening experience.

The government also encouraged, if it did not originate, the rumor that Lord Russell was *not* the author of the speech that bore his name. It would have been in Lady Russell's interests to remain silent, but in conformity with her spirited nature, courage, and love of her husband, she escalated the dispute. A "few days" after the execution, she wrote a strong, indeed a bold, letter to the king.[5] Beginning preremptorily, "I find that my husband's enemies are not appeased by his blood, but still continue to misrepresent him," Rachel declared that it increased her grief "to hear your Majesty is prevailed upon to believe" that Russell's final speech was written by someone else. She averred that she was "ready in the solemnest manner to attest" that such a charge was untrue. Dismissing as "an argument of no great force" that some of the expressions in the paper had appeared in other pieces, she insisted that she and others who had visited him in prison had heard him say the things that appeared in the speech. Describing her husband as a man "who in all his life was observed to act with the greatest clearness and sincerity," Rachel begged the king to believe that William would not at his death "do so disingenuous and false a thing as to deliver for his own what was not properly and expressly so." Lady Russell also seized the opportunity to "avow" that the papers Burnet read to the council were "exactly true" and written at her request. She declared that Burnet himself had been a "tender and conscientious minister" to William and also a "loyal subject" to the king. Describing herself as incapable of consolation except to have Charles think better of her husband, she adverted to her "importunate" interview when she pleaded with the king to spare her husband and reminded him once more that she was the "daughter of a person who served your Majesty's father in his greatest extremities." She excused anything in the letter that might displease him as "coming from a woman amazed with grief." She used her sex to protect her. Nothing about this letter could have pleased Charles, neither its strident tone nor its bold affirmations, but no record has survived of his reaction. He did not think better of Russell nor moderate the government's public efforts to discredit him.

It is possible, however, that the evident distress the letter conveyed helped to soften Charles towards Rachel's private situation. He granted her request not to confiscate Lord Russell's private estate, legally forfeitable to the state. And, urged by Lord Halifax, he also agreed in early August to her request to be allowed to set up an escutcheon in William's honor. To place an escutcheon on the door of the deceased symbolized that a man of honor had died; to place an escutcheon on the door of a condemned traitor was unheard of, absolutely contrary to heraldic practice. An attainder voided a person's arms. In his careless

way Charles was clearly insensitive to the significance of what he had granted, but Lady Russell almost certainly was not. Nor were people at court, who made such a "stir" about the matter that Lord Halifax advised her in October to adopt a low profile.[6]

The court and its friends also took the case against Russell's *Speech* to the public, using the pulpit and printed and iconographic material. On July 28 Charles II ordered to be issued a *Declaration* that described the conspiracies, summarized the evidence, and justified the government's actions.[7] The *Declaration* was read in all churches on a day of Thanksgiving set for Sunday, September 9. Sermons accompanied the reading in many churches and reinforced its message.[8] Moreover, within five days of William's execution, two pamphlets appeared and by the end of the year approximately fifty procourt tracts were in circulation. Their style and approach were various, and thus they appealed to many different people. For example, one "C.P." offered a poem congratulating the king on escaping death, while another writer composed a dialogue between a Whig and a Tory and laced his title with sarcasm.[9] Someone arranged for a new edition of the *Eikon Basilike* to appear in 1684, clearly for the purpose of reviving memory of Charles I, with obvious lessons for contemporaries. A versifier composed a ballad titled "Lord Russels Farewel," to be sung to the tune of "Tender Hearts of London City." The musical score and three illustrations, one depicting the execution in grisly detail, adorned the broadside, whose essential message was that ambition had drawn Russell into a "base inhumane plot."[10] Even a medal was cast to convey the terrible danger to the state posed by Russell and his associates in treason. The medal showed Charles II as Hercules warding off Hydra, whose seven heads included those of Russell, Howard, Essex, and Sidney.[11]

Other writers focused on denigrating Russell and besmirching his former reputation. Sir Roger L'Estrange, licenser of the press, sneered that Russell's *Speech* was a ridiculous attempt to "draw the character of a seraphical resigning Christian from the copy of a stomachful, huffing Cavalier." Another author called William a "Protestant-Jesuit" because of the "equivocations, tricks, and evasions" that he found in the speech.[12] Further condemnation of Russell appeared in unlikely tracts, as in the misleadingly titled *A Vindication Of The Lord Russell's Speech and Paper, etc., From The Foul Imputation of Falshood*, which was, in reality, viciously anti-Russell.

Among the most effective tracts were those that dissected William's speech. Perhaps to assist pamphlet writers marshal a response, Francis North, the lord chancellor, prepared an eighty-point, nearly line-by-line critique of the speech, and probably another lengthy paper entitled "A Discourse of High Treason."[13] The substance of many of his

comments appeared in printed tracts. Of them the most powerful were *An Antidote Against Poison*, probably written by Sir Bartholomew Shower, and *Considerations upon a Printed Sheet*, written by Sir Roger L'Estrange.[14] Expressing doubt that Russell himself had written the speech, these authors insisted that the purpose of the paper was to embarrass the government by painting William as a victim, to protect Whigs by dismissing the conspiracy as nothing more than talk about "making some stirs," and to encourage Whigs to remain true to their principles. In fine, the speech was intended to "do the work of the conspiracy" and to arouse the "seditious rabble" to acts of "public vengeance."[15] William's language was deliberately evasive and misleading.[16] Further, procourt writers asserted that anyone who understood the law concurred that the evidence was incontrovertible. The author of *Antidote* emphasized that the actions to which Russell admitted in his speech were treason, not misprision of treason. Insisting that the trial had been conducted in an exemplary manner, L'Estrange ridiculed Russell's defense and denied emphatically that his prior political activity had influenced the proceedings.[17]

Finally, throughout the fall of 1683 the government continued to keep the public informed about its progress in dealing with the conspiracy by issuing accounts of the trials and executions, a report on the conspirators in *A List of all the Conspirators That have been Seiz'd, (and where Committed) since the Discovery of the Horrid and Bloody Plot*, and an "official" account of the plot under the lurid title *A History of the New Plot: Or, A Prospect of Conspirators, their Designs Damnable, Ends Miserable, Deaths Exemplary*. The striking pictures illustrating this tract must have excited interest. One shows a frog and a mouse "at variance which shall be king," while over them a kite prepares to swoop down and destroy both. An explicit moral was drawn: "So factious men conspiring do contend / But hasten their own ruin in the end."[18] In sum, these pamphlets presented a carefully reasoned, logical rebuttal to the points offered by Russell.

Lady Russell must have read many of these tracts, for she concluded that *An Antidote Against Poison* was the most damaging of them all and sought ways (without success) to counter it. Writing in great secrecy at the end of November 1684 to Sir Robert Atkyns, she asked him to send her his opinion respecting the "law part" of *An Antidote Against Poison* and promised to use it only privately and show it to others as he would approve. Presumably out of fear of being searched, she wrote, "I do engage, upon my honour, and all can bind a Christian, I will be secret," and she promised to transcribe any paper that he should send and either destroy or return the original, measures that would shield Atkyns' identification. She said that she had been so cautious that

Bedford did not know that she had written or meant to write him.[19] But Atkyns, who in July had expressed concern that his correspondence with Hugh Speke would endanger him,[20] did not, apparently, respond to this entreaty and certainly did not publish anything in the fall.

There really was very little that Rachel could do alone to combat effectively such an onslaught of the government and Russell's political friends were in no position to help her. Indeed, his friends confronted a disastrous situation in 1683. The Whig party was in near-total disarray, its leadership variously dead, in prison, in exile, or plea-bargaining with the state. The revelations of the conspiracies shocked many people and prompted an outpouring of devotion to the king.[21] Moreover, Charles II continued to harass persons who were associated with Russell's speech and/or expressed approval of Russell and Whig principles. For example, Darby, the printer, was summoned again before the Privy Council in September and in February 1684 was "tampered with" to name the author of a tract, *Julian the Apostate*, which he had printed. That pamphlet, written in fact by the Reverend Samuel Johnson, was a powerfully expressed affirmation of the right of resistance. The government fined Darby twenty marks and warned him to "take heed what he printed in future." He asked what rules he should follow and was told "not to print anything against the government."[22] Also in February Sir Samuel Barnardiston was brought to trial before Judge Jeffreys on a charge of seditious libel. The evidence was four printed letters which described the Rye House Plot as a "sham" and defended Russell and Sidney. Jeffreys, deploring that "such bloody miscreants, such caterpillars, such monsters of villainy" as Russell and Sidney should be regarded as martyrs, fined Barnardiston the enormous sum of £10,000.[23] Clearly, the dangers of criticizing the government were very real.

There were compelling reasons for memorializing William even if it meant risking the government's displeasure. Denying the reality of the plot and labelling Russell an innocent victim of Stuart despotism, as his *Speech* had implied, helped to preserve the integrity of the party, maintain interest in its principles, continue subtle criticism of the government, and imply the innocence of Whigs still present. Accordingly, Russell partisans nourished William's memory in private and in public. One anonymous admirer composed a Pindaric ode on William's death, which began with "Hush! And the dismal tidings shall be told," and wisely left it in manuscript.[24] Russell partisans managed also to take a few inconsequential public steps to counter the court's offensive. A paper found in the Guildhall as early as July 30 calumniated the government for entrapping and murdering the "eminent Protestants of England." L'Estrange received a "poison-pen" letter dated August 20 vilifying him for writing *Considerations upon a Printed Sheet*.[25]

Rumors circulated in Holland in August that the Rye House Plot was "invented" by the government.[26] And talk flourished for over a year in England and on the Continent of "projects" to revenge Russell's death.[27] In addition, printed tracts appeared. One was purportedly William's last "affectionate and pious exhortations" to his wife and children, with an illustration showing the family in an affecting pose.[28] Further, at least six unofficial accounts of his trial and execution were published, notwithstanding the government's order that none was to be printed without permission.[29] Such accounts nourished Russell's memory, but they could cut both ways. The court also published a record of the trial in the expectation, James said, that it would persuade all readers of William's guilt.[30] For the same reason, James, who became king in February 1685, ordered Bishop Thomas Sprat to compile and publish information and papers about the late "horrid conspiracy" against his brother.[31]

The most powerful pamphlet, however, remained Russell's *Speech*, and try as it might, the government was unable to deflate the pamphlet's wide popularity. Upon first appearance it sold "prodigiously" and continued to do so.[32] It had three editions in 1683 and was also printed in London in 1683 under three other slightly variant titles, each by a different printer. Twenty-five hundred copies of the original pamphlet appeared in Bedfordshire by July 22, sent there, it was suspected, by Lady Rachel.[33] There must have been at least 25,000 copies in circulation during the last five months of 1683.[34] Such a quantity virtually assures that the speech reached people in all social categories. No wonder the government was outraged.

Still further, Rachel kept in touch with William's former friends and helped them financially. She remained especially close to Gilbert Burnet, storing his books for him while he was in exile, corresponding with him, sending him money, relaying greetings through her sister, and perhaps responding positively to his earnest appeal to help Lady Argyle, said to be living in destitution in London.[35] Circumspection in the correspondence was necessary; it was only when Burnet was confident that the bearer of the letter was "sure" that he felt comfortable in writing freely.[36] Rachel also gave at least £40 to political friends in Holland and provided the Reverend Samuel Johnson with a pension of like amount, a bold gesture in view of the government's burning of his books. In fact, her support of Johnson became known.[37] Other friends also kept in touch with Rachel and suggested steps that might be taken. For example, a letter of November 29, 1683, from an anonymous correspondent, thought to be Sir Robert Atkyns, brought Lady Russell the rumor that the duke of Monmouth, restored to his father's good graces, had told Charles that he had lost in William the "best subject he had" and that the

court now repented the execution of Russell.[38] The correspondent recommended that if such an intimation were made directly to Rachel, she should ask the government for permission to publish a book about William. Rachel received no such intimation. However, a flattering polemical biographical sketch of William was printed in 1684. There is no evidence of the author or that Rachel was consulted, but presumably a friend of Russell's wrote the account.[39]

In truth, from 1683 to 1689, Lady Russell's life-style was more effective than anything else as a visible criticism of the government and a memorial to Lord Russell. As we shall see, she went into deep mourning, suffered loss of weight and a near emotional collapse, and engaged in voluminous correspondence devoted largely to her grief over her husband's death. That correspondence was so powerful as to provide the basis for renewing Russell's martyrdom at the end of the eighteenth century. But until the Glorious Revolution, the Stuart government triumphed over the unhappy Lady Russell and the remnant of the Whig party.

Financial and business affairs also laid claim on Lady Russell's attention, and despite the sharpness of her grief, she was able to conduct them effectively. Although she could have asked others to supervise her affairs, she gathered such matters into her own hands, and drawing upon her earlier experiences and the example of her father and father-in-law, she became a shrewd and careful manager throughout the rest of her life. Such a role was not new; from the time of her second marriage she had actively engaged in property management. But as a widow, her status at law was different from that of a married woman. No longer a *femme couverte*, Rachel needed no legal instrument to enjoy the same rights and powers over her property that men possessed. Lady Russell was not the only aristocratic woman to oversee her property; Anne, countess of Pembroke, is an example of another. But such women were a minority in late-seventeenth-century England, and Rachel Russell is not usually included among them. She should be.

A number of matters required attention after Lord Russell's execution. Whether or not the king would demand the forfeiture of William's personal estate, the legal penalty imposed on a convicted traitor, was an urgent question. The bulk of that personal estate was the Hampshire properties that Rachel had brought William at the time of their marriage. It was a lucky circumstance for Rachel and her children that, although Russell was heir to the Bedford properties, he obviously had not inherited them, for his father was still living. William had begged the king in his last letter to spare his wife and children the penalty of forfeiture, and Rachel had reinforced the request in a petition. Within "a very few days" of the execution, Charles sent Lady Russell

word that the personal estate would be hers, justifying the favor on the grounds of her father's former loyalty and services to the crown.[40] In this case, the evocation of her father's name had served Rachel well. The king's grant was of importance to her economic well-being. She would not have been destitute without it, for her marriage contract had reserved certain properties in trust to her, but the properties at issue were of value. In 1669 they had brought in about £1,000 per year, and they were almost certainly worth more than that in 1683.

The legal process transferring Lord Russell's personal properties to Lady Russell was completed by the end of September. Rachel's response, two months after the bold letter about William's speech that she had addressed to the king, is significant. It marks the first step that she took to ingratiate herself with the court, her ultimate purpose being the preservation of the Bedford title for her son. She wrote to Halifax and to Lord Russell's uncle, Colonel John Russell, asking for advice on the most appropriate way to thank the king and enclosing a letter that might be given him. She had also asked her brother-in-law from her first marriage, Lord Vaughan, to stand ready to assist and had availed herself of the services of an officer in the office of the secretary of state, where the seals of the grant were affixed, promising him "satisfaction" when she had the grant.[41] Halifax recommended that Colonel Russell deliver her compliments orally rather than in writing. He explained that some people about the king were still irritated over the permission given her to set up the escutcheon and were using that to weaken his (Halifax's) position, so the less said about the grant of the personal property, the better. Her handling of this little project demonstrates her energy in marshalling a number of people in her behalf at a time when she was distraught with grief and illustrates her sound reasoning, which Halifax remarked. Had she not solicited advice, but rather gone ahead with a letter to the king, she might have undermined later steps that she and others took on behalf of her son. Her handling also reveals Lady Russell's knowledge of the patronage system that existed and her skill in drawing upon personal and familial contacts that had been built up over the years.

Another matter of some urgency was to provide Lady Russell with cash. Steps were taken to draw upon the £2,000 a year due her by the terms of her marriage contract with William. On July 8 and 10, 1683, she received 100 guineas and later, in August, an advance in full of the moneys not due until Michelmas (September 29). On August 8, £100 was advanced her on £400 annual interest due on the loan of £8,000 made in 1682 from the earl of Bedford. It appears that the money was still intact, and Bedford now undertook to set it aside and pay Rachel at the rate of 5 percent per year.[42] Still further, Lady Russell had to make arrangements to pay off her husband's debts. In the absence of the

Russells' household papers, the total amount of the debt is unknown, but it was apparently substantial. The earl of Chesterfield (who had declined to testify on William's behalf) entered a claim of £3,000 on Lord Russell's estate and petitioned the Treasury lords that the money be paid before the estate was settled.[43] In August 1684 Lady Russell borrowed £2,500 from her brother and sister-in-law, Edward and Margaret, to pay a debt owed to another brother-in-law, Lord Alington.[44] There must have been other creditors, for later, in 1699, Rachel wrote of having "struggled through so great a debt" that William had left.[45]

Rachel also enlarged her power over her Middlesex properties. Just four days after William's execution, she signed a deed revoking the trusts that had been appointed for the manor of Bloomsbury and the hospital of St. Giles in the Fields and reserving henceforth the "use and behoofe" of the properties to herself, her heirs and assigns.[46] Further to settle her properties in her own and her son's interest, Sir John Maynard, the well-known Whiggish lawyer, was called in on July 28 and 31 and on August 1 to provide legal advice.[47]

Despite deepening grief, Rachel continued to devote time to business affairs, sometimes giving them priority in her correspondence.[48] Feeling that "some frugality" was advisable in her new circumstance, she reduced the number of officers in her household staff. She also replaced William's steward, Watkins, whom she suspected of an indiscretion and also a discourtesy to her husband. Still a sympathetic and considerate mistress, even as she had shown herself to be earlier, Rachel went to the trouble of finding Watkins other employment, but he rebuffed her assistance and secured a place on his own, which he kept a secret. Rachel generously insisted that she did not "take it ill from him," explaining away his behavior on the grounds that he was "not acquainted with the usual way of respectful proceeding in such cases."[49] The little incident reinforces understanding of an aspect of Rachel's personality and also provides a rare glimpse into "upstairs-downstairs" relations during the period.

Lady Russell also showed independence of her father-in-law. She opened her own account with Child and Rogers, goldsmith bankers with whom Bedford had dealt for some years.[50] And she appointed her own business manager to assist her in her affairs rather than depending upon Bedford's staff. The man she chose, in June 1684, was John Hoskins, Shaftesbury's relative and probably his former solicitor. She had met him some time before at the Shaftesburys' house and had formed a high opinion of him as a "very worthy and ingenious man." He admired her too, remarking that she would "require less help [in business matters] than most others."[51] The appointment of Hoskins was a gesture of defiance to the court, for he was known as a close associate of Shaftesbury's.

The government had denied him permission to visit Shaftesbury when Shaftesbury was imprisoned in the Tower in early 1677, but Hoskins had attended the earl in 1681 when he was again imprisoned.[52] Such a close link between Lady Russell and Hoskins reinforced other signals she sent of her continued commitment to Whiggish principles. The business relationship lasted until Hoskins' death, and a personal relationship developed between the two families when in 1718 Hoskins' daughter married Lady Russell's grandson, William, the marquess of Hartington, son of her elder daughter.[53]

So deeply involved did Rachel become in business matters that she wrote in the spring of 1684 that her "design" was "to converse with none but lawyers and accountants."[54] At this time she undertook the responsibility of settling the trust that her sister Elizabeth had vested in William to raise portions for Elizabeth's daughters out of the manors she had inherited from her father. Rachel was anxious to make the proper arrangements for her beloved sister's children, whose "least concerns," she wrote in her warmhearted way, "touch me to the quick." She was also eager to take the steps that she thought William would approve.[55] To facilitate the transaction, she made plans in May 1684 to visit Stratton, despite reluctance to be in the place where she had enjoyed so much happiness with William. In the event, her plans were cancelled "by the lawyers" and the death of her mother-in-law, but that does not diminish the strength of character she showed in her willingness to go forward with a step that she was sure would cause her acute distress. By the end of July the terms of the new trust were settled to her satisfaction, and the decree filed in the Court of Chancery.[56]

Rachel supervised her properties conscientiously. New trusts for both her Hampshire and Middlesex properties were created in May and June of 1685.[57] She continued to develop Bloomsbury Square, signing twenty-five more leases between 1683 and 1699. The rents ranged from twenty shillings per year for a term of thirty-two years for a stable, to a high of forty pounds per year for a term of twenty-one years for property on High Holborn. She raised ten pounds a year from a twenty-one-year lease of a horse pond adjoining her, specifying that she and succeeding occupiers of Southampton House would have the right to wash and water their horses there.[58]

The increasing prosperity that she achieved from the effective management of her estate not only allowed her to live in great comfort but also put her in a position from which she would negotiate favorable marriage settlements for her three children.

At the same time that Lady Russell was handling business and political matters, she was also suffering agonies of grief over Lord Russell's

death. It is testimony to the rationality in her nature that she was able to compartmentalize her emotions and function as well as she did. Rachel revealed the depth of her sorrow and her private struggle to master it in a voluminous correspondence that she carried on largely with male clerics, especially the Reverend John Fitzwilliam, her father's former chaplain. That she grieved was not, of course, unusual; other widows suffered deep sorrow when their husbands died and expressed their anguish in affecting terms.[59] Rachel's grief, however, is set apart by its intensity and duration. Accordingly, her letters and private papers and the letters and essays of her correspondents provide a rare picture of grief, its course, and, in twentieth-century language, its "management."

In keeping with her passionate, spirited personality, Lady Russell's grief was intense and prolonged. Rachel struggled to rein in her emotions, but as twentieth-century studies show us is common in mastering grief, she would achieve some command over them only to suffer a setback.[60] In the weeks immediately following the execution, Lady Russell described herself as "amazed"—meaning crazy—with grief, and her first letter about her suffering reveals the sharpness of her anguish. Dated September 30, 1683, it came from Woburn, where with her children and William's parents she had retired to mourn. Appealing to Dr. Fitzwilliam for sympathy, Lady Russell began, "You that knew us both, and how we lived, must allow I have just cause to bewail my loss. . . . I want him to talk with, to walk with, to eat and sleep with: all these things are irksome to me now; the day unwelcome and the night so too." Christian consolations about the merit of eternal life did not console her; the idea that her husband was in a better, happier place than this world she dismissed for lack of faith. Reason did not help. "My understanding is clouded, my faith weak, sense strong, and the devil busy," she admitted. Torturing herself with the thought that she was so "evil and unworthy" as to be unable to receive God's mercy, she wrote distractedly, "I most willingly forsake this world, this vexatious, troublesome world."[61] Blaming God for not answering her earnest prayers to spare William, she was "very strongly tempted" at this time to curtail her prayers and Bible reading.[62]

Outward signs of her grief, carried to extremes over the years, testified to her inward turmoil. In the first year of her widowhood she neglected her health, losing so much weight as to alarm her friends.[63] She went into mourning, of course. It was virtually obligatory for widows to wear black for a year, but Rachel continued to wear black for the rest of her life. All subsequent portraits of her, which she presumably approved, show her dressed in black. In a portrait by Sir Godfrey Kneller, reproduced here as the frontispiece, her black gown is relieved only by white lace at the cuffs and neckline, her expression is infinitely

sad, her large eyes heavy-lidded and downcast. Further, Southampton House was draped in black, black ribbons were affixed to the trousers of grooms and the bridles of horses, and liveried servants wore black, all customary marks of mourning.[64] But for the rest of her life, Rachel kept black crepe in her private rooms at Southampton House and at Stratton.[65]

Her private expressions of grief were intense and long-lived. She was in virtual seclusion at Woburn for at least a year, vowing, as already mentioned, to see none but lawyers and accountants. Three years later, in 1686, when she had brought herself to return to Southampton House, she refused a proposal that her half-sister and her family live at Southampton House with her for a time on the grounds of her "sad circumstances."[66] Although initially angry with God, she almost immediately returned to religion and thereafter led a life of piety far more rigorous than anything that she had followed before William's death. She rose at five o'clock in the morning and followed a regimen of thrice-daily prayers, meditation, and reading of religious texts. She regularly examined her sins and kept a meticulous record of them.[67] Praying, meditating, reading the Bible and religious works, and preparing for and, at the appropriate time, participating in the sacrament became central features of her life. One portrait of her as a widow shows her in a meditative pose, one hand supporting her head, the other holding a book, thus signaling her pious introspection.[68]

In the spring of 1684 Rachel's sorrow increased rather than abated. She was unable to escape the memory of and longing for her husband. "Where can I dwell," she cried, "that his figure is not present to me?"[69] Despite her determination to recover her equilibrium in the face of her son's illness in June, her condition worsened as the first anniversary approached of the three blackest days of her life—June 26, William's arrest; July 13, his trial; and July 21, his execution. On that first anniversary Lady Russell began a regimen that she followed, with few exceptions, for the rest of her life. She sanctified those days by prayer, reflection, and remembrance, aided by the rereading of Dr. Burnet's account of Lord Russell's imprisonment, and for several years saw no one but her children during this period and them late at night. Such a practice revived and sharpened her anguish every year at that time, as modern studies of grief confirm it naturally enough would do.[70]

For the next five years or so, Lady Russell made only faltering progress towards controlling her sorrow. To her embarrassment tears were at the ready whenever she thought of her "calamity," which was often.[71] When she compared the richness of her former life to her present misery, self-pity overwhelmed her. "All relish is now gone," she complained in 1685. Never again, she said, would she know happiness

on earth.[72] In 1686 she began to accept social engagements, but that same year she again expressed a longing for death, admitting, however, that if she really faced death, as in an illness, she would defer it if she could.[73] The separation from her husband was still "bitter" in 1687, but she felt that although "not cured," her grief was less overwhelming than before. In 1688 when she was negotiating a marriage settlement, she went out to dinner frequently, but only for her children's sake, not for any pleasure it gave her, so she said.[74] Clearly, her sorrow revealed a high degree of self-consciousness and, it must be said, selfishness. Its persistence tried the patience of some about her, even as it won their admiration and that of commentators later.

Multiple reasons explain why her grief was so inveterate. Her sorrow owed much to her passionate nature. Lord Russell's death deprived her of companionship and friendly conversation, as she said, and of sexual fulfillment, as she implied. With notable candor, Lady Russell admitted that she had lived so long by the senses that she found it nearly impossible to live by faith alone.[75] The romantic view of her husband that she had created and continued to perpetuate served to heighten her sense of loss. She looked back upon William as an "inestimable treasure," and upon her marriage as a time when she had known as "much happiness as the world...can give."[76] Social circumstances may have prolonged her grief. As a privileged, wealthy, aristocratic lady, there were few duties that she *had* to discharge and much time for reflection and self-indulgence. Her grief became a kind of companion which she found difficult to give up.[77] The changes occasioned by the menopause, to which she does not allude, but which coincided with the years of her most intense sorrow, may also have intensified her sense of loss.[78] Further, the suddenness and violence of Russell's death so appalled her as to suggest that she had heard of the butchery he endured on the scaffold. She tormented herself with the thought that if certain events, such as Essex's death, had not occurred, or if she had only managed things better, William would have been saved.

Moreover, Lord Russell's attainder put at risk the social, economic, and political position of herself and her children and destroyed whatever ambitions she had had for her husband and through him for herself. So long as the present Stuarts reigned, there was only the slightest chance of a change in that situation, although Rachel and others took steps prior to the Glorious Revolution to secure the right of her son to inherit Bedford's title. Furthermore, the public manifestations of her sorrow—the mourning clothes, wasted figure, isolation—were as effective as anything done prior to the Revolution to keep alive the memory of her husband and subtly foster the idea that he was a martyr to a despotic government. If he was martyr, she was mourner, a kind of saint

in her distress. Lady Russell was too sophisticated politically to be unaware of this. Her petition to display the escutcheon testifies to her sensitivity to the value of public symbols. Still further, grieving for her husband, as genuine as that grief was, must also have fed Rachel's sense of importance. In 1690 she admitted that "there was something so glorious in the object of my greatest sorrow, I believe *that* in some degree kept me from being...overwhelmed."[79] Had she "cured" herself of grief soon after William's death, she would have lost an emotional crutch, a reason for self-importance, and a way to participate in politics.

Yet, she needed comforting to combat the "fierce rages of grief" that she experienced.[80] Lady Russell's choice of Fitzwilliam as her major confidant sheds light on her personality and character. It might be expected that as a woman Rachel would have chosen a woman to confide in. But her beloved sister Elizabeth, whom she sorely missed, was dead. Her half-sister Elizabeth was in France, and although they corresponded, Rachel did not dwell on her grief, at least not in the surviving letters.[81] None of her women friends possessed her intellectual capacity or knowledge of religion. Her close friend, Lady Shaftesbury, could do no more than write letters of passionate condolences, full of pity and conventional advice, nor could her new friend, Lady Ranelagh. Men who had been friends and/or Lord Russell's political associates could do no more either.[82] She found companionship and sympathy in her father-in-law, and lived with him at Woburn for much of the time, but Bedford was aging and too grief-stricken himself by his son's death and by the death of his wife in May 1684 to offer Rachel the kind of assistance she needed.

Rachel wanted someone able to discuss authoritatively the nature of God's Providence, the meaning of man's suffering, the relationship of the secular to the eternal, the meaning of eternal life, and the nature of sin. Like many women before, after, and contemporary with her, she looked to the clergy for help.[83] Among the "many"[84] clergymen with whom she corresponded were the Anglican clerics Burnet, Tillotson, and Dr. Simon Patrick, and Dissenting ministers Dr. Bates and the Reverend John Griffith (chaplain to Lord Cavendish). Their letters and essays, she declared, were the only thing that brought "momentary refreshment" to her "wounded spirit."[85] The exchanges with these men were conducted on a near-equal basis. While the clerics instructed and comforted her, they also admired the sentiments she expressed. Patrick asked her to send him her thoughts on passages in some books that she had recommended to him and declared that he would value her comments as "misers do their treasure."[86] Burnet praised her highly for her style of writing, which he declared he could not "come up to," and for her other "talents...[that] distinguish[ed] her from most other women

in the world."[87] Such marks of approval gratified her, for she candidly admitted that she coveted the praise of good people and took comfort in finding herself "esteemed by worthy persons."[88] Her letters helped her to win such esteem and establish herself on an almost equal footing with male clerics. It was unusual for a woman to achieve such a relationship.

She found the greatest solace in corresponding with Fitzwilliam. His ties with her and her family were intimate and long-standing, and he had responded to her first anguished appeal with a letter full of sympathy and advice.[89] Thereafter, until his death in 1699, he regularly sent her letters, essays, prayers, and collects.[90] Not only was he genuinely fond of Rachel, but also, as he said at the outset, he hoped to publish his essays.[91] Social and educational differences obviously separated the mourning widow and the cleric, but Lady Russell sought to bridge the one,[92] and Fitzwilliam ignored the other. He, of course, knew more theology than Rachel, but was not more intelligent than she. He turned to her for advice about lawyers and investments.[93] In his letters about religion he addressed her as an intellectual equal. Drawing upon classical myths and philosophers, the Bible, religious thinkers, and tales of Christian martyrs, he presented his message in vivid, memorable language. Although he offered practical advice—that Rachel should count her blessings, adopt a charity, and devote herself to her children—Fitzwilliam's message was essentially religious. The basic themes remained the same throughout the long correspondence, but he tailored them to suit Lady Russell's emotional needs, as he perceived them. He offered comfort, acknowledging that she had every reason to lament her loss; encouragement, praising the signs of faint improvement in her attitude; and understanding. He sympathized, as no one else did, with her stubborn determination to visit her husband's tomb at Chenies.[94] From the beginning of their exchange, however, his counsel was stringent. Fitzwilliam maintained that in her passionate love for her husband Lady Russell had neglected God, that this was her "secret sin," and that Lord Russell's death in so dreadful a manner was her punishment. God's purpose was to teach her the vanity of loving secular things above Him. For her to question God's Providence was an offense, encouraged by the devil. God brought good out of evil: William's death would help to humble her before God, "wean" her from secular pleasures, and fix her affections on God and eternal life. She should thank God for it rather than complain. Her immoderate grief testified to the "sensuality" and "earthiness" of her love, increased the "sin which . . . brought on the punishment," and invited further punishment. She must happily accept God's will, and her comfort must be in the belief that she and her husband would be reunited in eternity. In the meantime, God would "cohabit" with her as husband, unless she obstinately refused.[95]

It was a struggle for Rachel to accept all these points. She resisted the idea that she should regard William's death as a blessing in disguise to effect her own salvation. She preferred William to God as husband. She insisted upon her belief that philosophers dissembled in saying they felt no turmoil at the death of a truly loved one. She was skeptical of the notion that everything that happened was ultimately for good and alarmed that her grief might bring on a further chastisement, perhaps in the form of the illness or death of her children. She candidly told Fitzwilliam that she might not "always comply" with his counsel.[96]

Yet, none of the discourses she received from others "more suited [her] humour" than his essays. "You deal with me," she wrote Fitzwilliam, "just as I would be dealt withall." Insisting that she wanted her spiritual wounds rigorously searched so that "they may not fester," she repeatedly dismissed his anxieties that his message might offend her.[97] She read and reread his letters, essays, and prayers. Sometimes she marked passages that she particularly liked, such as one about the confidence in eternal life that true Christians should feel. Fitzwilliam wrote that true Christians will "be renewed like Eagles, and like Eagles mount up. . .to meet the Lord coming in the clouds." Rachel thought that a "ravishing contemplation."[98] She also took comfort from Fitzwilliam's analogizing the death of a person to his "going out of a rotten, weather-beaten house, or putting off rags of flesh and blood, as a dismission from. . . attendance here, as the Emperor Antonine styles it." Rachel liked the phrase "dismission from attendance" and used it herself.[99] The assurance of life after death with God particularly comforted her. Gradually she embraced the main thrust of her friend's argument, agreeing that through God's grace she was learning to despise this world and long for His glory. In 1687 she wrote Fitzwilliam in terms that must have gratified him: "Tho' I walk sadly through the valley of death, I will fear no evil, humbling myself under the mighty hand of God, who will save me in the day of trouble: He knows my sorrows and the weakness of my person, I commit myself and mine to Him." She felt that she would have perished without Fitzwilliam's comfort and counsel in leading her to accept such a view.[100]

Equally important was the role Fitzwilliam played as a faithful correspondent. Lady Russell needed someone who looked forward to receiving her letters, took them seriously, and answered them in a timely way. This Fitzwilliam did, and for years never failed to send a special message and prayer to comfort Rachel during the three blackest days of her life. Prior to her husband's death, Rachel had loved to write; after 1683, writing became almost an obsession with her. She might write seven business letters one morning and, before turning to her "French" correspondence, dash off a letter to Fitzwilliam. It was not unusual for

her to be still writing personal or business letters at midnight or at one or two o'clock in the morning.[101] As before, she rarely used an amanuensis or made copies of any but the most important letters. But she kept a log of the dates and addresses of her correspondence.[102] She suited her style to some degree to the addressee, writing about politics and business matters in a businesslike manner, about domestic affairs, gossip, and the state of her emotions more openly. As before, she wrote with apparent ease, the words tumbling out on the page in a clear, legible script. She did not like to reread what she had written or correct any errors, and her unedited letters provide still further testimony to her intelligence and quickness.

Letters connected her with the wider world when she was living in retirement nursing her grief. Writing letters gave definition to her day, importance to herself, and a sense of being in command of her affairs. In writing to Fitzwilliam, Rachel made him a surrogate for her husband, in that she kept him informed about family affairs, political events, and the condition of her grief. After four years of an almost weekly exchange, she confessed that she was not "easy in [her] mind" until she had written Fitzwilliam once a week. Even when she was doubtful that her letter would reach him, she wrote anyway, saying that she could "willingly lose a sheet of paper of my scribbling." She also sent him her "own thoughts or exercises" on religion and, when he suffered the death of a close friend, her personal prayers, all of which won his praise.[103] Fitzwilliam's patience in the face of her persistent grief gave her confidence that he did not censure her weakness nor regard her as "tedious," and she wrote him with more freedom than she wrote to anyone else.[104]

Lady Russell was, of course, aware that she and Fitzwilliam, a High Church Anglican, held different opinions on Anglican church policy towards Dissent. Throughout their correspondence, even at the height of her grief, she was strong enough to preserve her independent judgment, but, at the same time, she contrived not to offend her confidant. Disagreement over her choice of a chaplain arose in January 1684 and moved her to write Fitzwilliam frankly. Assuring him that they could agree as to the "definition of a prudent person" and declaring that she regarded the Anglican church as "the best church, and best offices and services in it, upon the face of the earth that we know of," she affirmed her sympathy for Dissent. She insisted that she sought a man as chaplain who would be "so moderate, as not to be impatient and passionate against all such as can't think so too." She wanted a cleric, she said, "of such a temper as to be able to converse peaceably with such as may have freedom in my family, tho' not of it, without giving offence." She held to this view and ten months later selected a chaplain on a temporary basis who was "conforming enough...and willing to act that

prudent part" that she had outlined.[105] After the Revolution of 1689, certainly in the face of Fitzwilliam's disapproval, she reappointed the radical minister the Reverend Samuel Johnson, who had served her and William as chaplain from 1678 until the troubles of 1683. She also resisted Fitzwilliam's efforts to appoint his candidate as a tutor in French for her son, selecting instead a Huguenot refugee. In 1686 she decided on political grounds, after having agreed to the contrary, that she could not approve his design to publish the essays that he had written for her. She pointed out that his authorship and the occasion would become known and that the times were dangerous. "This is my highest objection, and what I will not too easily pass over."[106] As we shall see, at the time of the Revolution she tried unsuccessfully to persuade him to take the oaths and accept the government of King William and Queen Mary.

Lady Russell devoted herself to her three young children: Rachel nine and a half, Katherine six, and Wriothesley not quite three in the summer of 1683 (see the illustrations). Initially, the sight of them made her "heart shrink," provoking as it did memories of the delight she and her husband had shared in them.[107] But she loved them dearly, and the general supervision of their education and health was a powerful antidote to her sorrow. In early 1684 Lady Russell apparently undertook to instruct the girls herself, having turned aside a suggestion by Dr. Burnet that she employ a Frenchwoman, the sister of one of the ministers at Charenton. Parenthetically, Burnet's recommendation about this domestic matter holds larger interest in illustrating the close connection between the Huguenot community and the English political opposition. The woman's brother was a "great friend" of both Burnet and Hampden, and Hampden had intended to raise the matter with Rachel himself. Burnet approved of her decision to teach her daughters, saying that it would provide the "best diversion and cure" of her spirit.[108] How long Lady Russell served as "governess" for her children is unknown. Miss Berry thought that she did not at any time employ a governess for the girls. But that course seems unlikely, and the probability is that she called on John Thornton, Lord Russell's former tutor.[109] Thornton certainly prepared a catechism for young Rachel and with Hoskins and Burnet put questions to her at several times in 1685, when she was between ten and eleven years old. Her answers, written out in childish script and preserved, reveal how far she had come in handwriting, spelling, and understanding of Christian principles. For example, to the question "If there be a God, why may we not see him?" she answered, "Becose it is not his natur to be seen for he is a spiret."[110] Furthermore, the tutors that Lady Russell engaged to teach her son almost certainly instructed her daughters as well. In January 1686, when Wriothesley was six years old, Lady Russell had the idea of employing a Huguenot

refugee as a French master. She met with resistance from Bedford, who thought the child too young, and, as we have seen, from Fitzwilliam, who had his own candidate for the post. But she implemented her design and, before the month was out, wrote that she and her children were "all well, exercising our French. Master sung a French song yesterday with music, but the girls are all silent."[111]

Her children's health was also a matter of anxious concern to Lady Russell. In May and June 1684 Wriothesley was so ill with teething problems and, according to his grandfather, a "humour," that Rachel and Bedford feared for his life. The illness forced Lady Russell to realize that she had more to lose and caused her to fear that her discontent might provoke God to punish her by her son's death. She reaffirmed her resolve to dedicate herself to her children, as "their most tender and loving father" would have done.[112] Rearranging her plans, she took her son and elder daughter to Totteridge in Hertfordshire to be close to a London doctor, leaving Katherine with Bedford at Woburn. The boy improved, and putting aside her reluctance, Rachel planned to take him to Stratton to benefit from the country air. But the news that Charles II's court would be nearby at Winchester deterred her.[113] Although she regarded Woburn as the "most comfortable" place for herself, when a doctor said that London was best for Wriothesley, she decided to return to Southampton House for the first time since her husband's death for the winter of 1684–85.

That decision was an act of psychological courage, because she looked upon her London mansion as a "place of terrour," a "desolate habitation," and expected to be assaulted by "several passions."[114] With that visit her reluctance to live at Southampton House subsided. Plans to go to Stratton the summer of 1685 were cancelled because of her uncle's arrival from Paris and it was not until the summer of 1687 that she returned to the place where she had been so happy with William.[115] Thereafter Lady Russell fell into a pattern that lasted until old age of spending winters in London and the other months of the year at either Stratton or Woburn.

Public events in 1685 sharpened Lady Russell's emotional distress. In February the worst fears of former Whigs were realized when King Charles II died and the Catholic duke of York peacefully ascended the throne as King James II. Rachel expressed her dismay over James's accession and ensuing policies, writing in the fall that "the new scenes of each day" made her think that she was "devoid of temper and reason" to lament that William was dead.[116] The rebellion of the duke of Monmouth in June 1685, its failure, and the execution in July of the duke as a traitor were especially painful. Rachel wrote to Fitzwilliam, "These late confusions have afforded matter of tumultuous devouring

thoughts."[117] Her avowed tumult over the episode may have reflected her indecision over whether to provide money to unidentified conspirators, as they apparently hoped that she would do. Burnet reported that the conspirators blamed him for "prevail[ing] so effectually" with Rachel that she "resolved" not to have anything to do with them.[118] In the event, it was a wise decision. The identification of her husband with the rebellion caused her anxiety. Monmouth's *Declaration* justified the rebellion in part by the "murder" of that "loyal and excellent" Russell, thereby associating him with a treasonable enterprise that attracted limited support and was readily defeated. The *Declaration* also undermined the effort to paint Russell as a martyr to the tyranny of the Stuart court, a man who abjured the use of violence. In her letter to Fitzwilliam, Lady Russell sought to dissociate Lord Russell from the uprising, writing that she looked upon it as a "wild attempt" and as a "new project" unrelated to "any former design." Admitting that if William were alive, great suspicion would fall on him, she insisted that he would not have "thought well of the late actings" and "most probably" would not have participated in them.

Another probable reason that Rachel regretted the association of William with Monmouth's rebellion was its coincidence with her initial effort to remove the effect of William's attainder on their son. In May Lady Russell arranged for eight well-known lawyers—including Maynard, Pollexfen, Pemberton, Holt, and Williams—to consider the following proposition: "A is baron of England. B, his son, is attainted of treason and dies. C, B's son, lives. A dies. Shall C have the barony, despite B's attainder and the barony being entailed?" Several of the legal experts believed that C might inherit A's title and lands, because B was never seised of the title. The title of "Lord" that B had borne was a courtesy title only, with no legal significance. But others held that an act of Parliament would be necessary to restore C to the blood.[119] A draft petition to Parliament for such an act survives in Rachel's own hand, and, as we shall see, such a petition was submitted to Parliament in the spring of 1689, following the Glorious Revolution.

Another initiative to the same end was undertaken by Rachel's uncle, Henri de Ruvigny, who came to England in July 1685 for the express purpose of discussing the matter with King James II and his ministers. De Ruvigny met with the king; the lord treasurer, Laurence Hyde, earl of Rochester; and Sidney Godolphin, the chamberlain to the new queen. In arguing his case that the new government should favor Lady Russell and her children, de Ruvigny stressed her father's distinguished service to the Stuarts and urged repeatedly that she be regarded not as Russell's widow but as Southampton's daughter. He described

Rachel as a woman who, in the midst of her tears, well knew her duty, was "very reasonable," and possessed a "just and wise disposition." Restoring the right of Russell's son to inherit the family title would offer signal evidence of the government's clemency and "facilitate the design. . .to reestablish the memory of the count of Stafford." Everyone with whom de Ruvigny spoke expressed admiration for Lady Russell, James II himself saying that she was "a person whom he much esteemed." Godolphin, however, pointed out that the Bedford family were "great Presbyterians" who had long opposed the king and suggested that it would advance Rachel's cause if she sent her son to Oxford University. De Ruvigny rejoined that the boy was only four and a half years old and that Lady Russell professed belief in the Anglican church. The conclusion was that it was premature to act, but the court was sympathetic and would take steps at an appropriate time.[120]

Later, the earl of Rochester called on Lady Russell. In their conversation Rachel "positively affirmed" that she had not asked de Ruvigny to intercede for her, but at the same time she confessed that she wanted to do everything in her power to assure the well-being of her beloved husband's children. She expressed special concern that her son might not complain later that out of ignorance or negligence she had failed to secure the family title for him. She did not tell Rochester that she had obtained legal opinion on the matter.[121]

This rather curious episode came to nothing as events leading to the Glorious Revolution overtook whatever favor James's court might have shown Lady Russell. Presumably de Ruvigny made the petition with Rachel's approval, and her remarks to Rochester imply that she was willing to be reconciled to the new government. Had these things been known, Rachel would have surely suffered embarrassment with her Whig friends. Moreover, it is possible that William's brother, Edward, who was, theoretically at least, next in line to the Bedford title and fortune, would have objected. Rachel kept the matter secret.

During de Ruvigny's visit an event occurred that "hurried [Rachel] into new disorders" and also testified to her fondness for her uncle. De Ruvigny had brought his wife and niece with him to England, and they stayed with Lady Russell at Southampton House. Rachel remained in London to receive them rather than take her children, the eldest of whom was recovering from an illness, to the country as planned. Shortly after their arrival de Ruvigny's niece was stricken with smallpox, forcing an exodus of Rachel and her "little tribe" of children. The niece worsened and died. In her warmhearted way Rachel hastened back to London to condole with her eighty-year-old uncle, calling him "as kind a relation, and as zealous and tender a friend as anyone ever

had."[122] He returned to France in October 1685, Rachel bidding him, she thought likely, a last farewell. Events in France, however, were to bring de Ruvigny back to England within three months.

In October 1685 King Louis XIV issued the Revocation of the Edict of Nantes, a step that dismayed and angered Rachel. The edict, promulgated almost a hundred years before, in 1598, had afforded protection and provided rights to the Huguenot community in France. With its removal, Protestant churches were razed; one of the first was the Temple at Charenton, which was burned to the ground, destroying the original records of Lady Russell's mother's baptism, her parents' marriage, and the death of her brother, Henry. The Huguenot community was persecuted and dispersed, many French Protestants seeking refuge in England. Lady Russell followed events closely and with mounting horror. Referring to Louis XIV as "that savage man," she reported that no more than 10,000 Protestants out of a total of approximately 1,800,000 were left in France and that they would soon be converted to Catholicism or perish. Children were separated from their parents, wives sent to monasteries, and husbands to prison or the galleys. "'Tis enough to sink the strongest heart to read the relations [that] are sent over." Remonstrating with Fitzwilliam for his insistence that God's Providence eventuated in good, she exclaimed, "These are amazing Providences, Doctor! God out of infinite mercy strengthen weak believers."[123] Kept informed by her sister, French newspapers, and French relatives, Rachel knew more about the consequences of the Revocation and conditions in France than did most English people.

In January 1686, de Ruvigny returned to England with his family and servants.[124] The only Protestant nobleman to win permission from the French king to emigrate, he was well received at court by the king, queen, and dowager-queen.[125] De Ruvigny soon established himself in a house at Greenwich, and there, despite advanced years, became the leader of about a hundred French Huguenot refugees. He obtained the use of the parish church for them and assisted in conducting services.[126] The congregation was conformist—that is, members used the English liturgy translated into French. Later, de Ruvigny was responsible for building a separate Huguenot chapel on London Street in Greenwich.[127]

Rachel saw him regularly, journeying to Greenwich in March 1686 to be with him, thereby reinforcing her identity with Dissent.[128] The presence of de Ruvigny (until his death on August 9, 1689) must have sharpened Rachel's interest in the plight of the French refugees. Undoubtedly, through him she had access to privileged information about the English government's policy towards them. The law required that the permission of the king in council be secured before a subscrip-

tion could be raised for charitable purposes. Early in November, the Privy Council approved such permission, but with the provisos that the beneficiaries conform to the Church of England and that the two archbishops administer the fund.[129] Rachel followed closely the progress of this "brief," or order, and reported that Chancellor Jeffreys was responsible for delaying it in January. In April she learned that Jeffreys was so strict about the qualifications of those who could receive help that many left him with "sad hearts."[130] She took some steps towards assisting the French refugees. It is likely that she contributed money to the relief fund, but there is no positive proof. It is a reasonable assumption that she encouraged their settlement on Bedford's property at Thorney, although the number of individual communicants there did not grow.[131] Finally, despite opposition, as we have seen, from Bedford and Fitzwilliam she hired a French refugee as a tutor for Wriothesley, in part to help out. As she put it, "So shall I do a charity and profit the child also, who should learn French."[132]

The year 1686 also saw Rachel's participation in marriage negotiations involving members of her elder sister's family and of William's family. That people turned to her for advice and active assistance on such a personally and financially important matter underlines the reputation she had developed as a woman of uncommon intelligence and good sense. In February 1686 Lady Digby asked Rachel to act as intermediary in proposing a marriage between her son and Rachel's niece, the second daughter of Rachel's sister Elizabeth and Edward, now earl of Gainsborough. Protesting to Fitzwilliam that she was "unfitted for the management" of such things, Rachel undertook the task. She reported with evident satisfaction that the proposal was accepted and that her brother-in-law had provided well for his daughter.[133]

The following year the Dissenting minister John Howe asked Rachel for her candid opinion of Edward Russell, William's next younger brother. Howe was interested in promoting a marriage between Edward and a widow whom he knew, but before any steps could be taken, the woman wanted—preferably from Rachel, whom she admired— some testimony about Edward's character and religious convictions. Those things first, then the size of his estate, concerned her, Howe insisted.[134] Rachel's response was an enthusiastic endorsement of Edward (as a man of courage and good nature) and of the Bedford family (as the "easiest to converse or live with that ever I have known, or could observe"). In her practical way, she gave Howe the name of the person who could tell him about Edward's financial prospects and went so far as to vouch for Bedford's prompt discharge of all his obligations. She concluded by promising to take on any part of the negotiations in the future that properly fell to her and to keep Bedford informed.[135]

Howe's appeal provides early evidence of Rachel's emergence as the central figure among Bedford's children. After all, there were several other blood children—James, Diana, and Margaret, to name but three—who might have been seen as the person to whom a prospective marriage broker would turn. Further, Rachel's volunteering to keep the earl apprised of developments may suggest a closeness between them on such matters. The closeness was to deepen over time. To anticipate, early in 1688, when Rachel was in the middle of negotiations leading to the marriage of her elder daughter (discussed below), William Wentworth, earl of Strafford, sought the hand of Margaret Russell. Rachel was drawn into the affair from the start and wrote to Fitzwilliam of her desire to "do her duty" to her sister-in-law as "cordially as to [her] children."[136] Discussions between Strafford and Bedford dragged on for a year and came to nothing. Apparently Rachel had played a substantial (but unidentified) role in them. In her kind-hearted, warm way she wrote in March 1689 to ease Strafford's pain over his failure and to advise him to seek a bride in another quarter. He was full of admiration for all that she had done for him and expressed to a friend his particular obligation to her.[137] Such affairs as these gave Rachel experience prior to managing the marriage contracts of her own children. They also add evidence about the role a woman could play in arranging marriages.

Early in 1687 Lady Russell received a mark of respect from the prince and princess of Orange in the form of a visit from their envoy, Everhard van Weede, Heer van Dijkvelt, who was on a special mission to King James II's government.[138] Dijkvelt carried specific instructions to pay a call on Lady Russell, which he did on Thursday, March 24, 1687. Rachel recounted that Dijkvelt, speaking in French, conveyed the condolences of the prince and princess of Orange on her loss, asserted that they had lamented Lord Russell's execution as a "blow to the best interest of England [and] the Protestant religion," and recounted that Bevil Skelton, then the English ambassador to Holland, had remarked that the king "had taken the life of one man, but he had lost...thousands by it." Dijkvelt also stressed the prince and princess's desire, should the power ever lie in their hands, to grant whatever Rachel should ask. With regard to the question of "reestablishing" Wriothesley, Dijkvelt said he spoke not as a private person but as a "public minister" in asserting that what Rachel "should at any time see reason to ask, would be done in as full and ample manner as was possible."[139]

Dijkvelt's conversation with Rachel holds significance beyond his professed support for restoring Wriothesley to the Bedford title. The iterated expressions of the prince of Orange's respect for Russell may reveal a closer connection between William and the Dutch court in the early 1680s than the surviving evidence from those years shows. Be that

as it may, the interview indicates concern to establish a friendly contact with Lady Russell and shows that four years after her husband's death she was still regarded as a symbol of the former Whig opposition, whom it was advantageous to cultivate. Rachel's careful notes of the meeting suggest that she thought it important. In the spring of 1687 it was assumed on all sides that Mary, princess of Orange, the presumptive heir of James II, would one day inherit the English crown, and it must have given Lady Russell satisfaction and optimism for the future to hear in what esteem she and her family were held. Perhaps Dijkvelt's visit also contributed to a lessening of Lady Russell's grief. At any rate, she was able to report in June 1687 that although she was "not cured, [her] ill was less inveterate."[140]

Rachel took steps to forward this new relationship with the Dutch court. She had not met Princess Mary before, but she asked Dijkvelt to deliver a letter to her. The princess replied in a letter of July 12, 1687, excusing the delay on the need to send letters safely and entrusting this one to the wife of Arthur Herbert, later earl of Torrington. Repeating the esteem in which she and the prince held Lady Russell and sympathizing with her loss, Mary expressed the desire to do "any kindness" in their power to Rachel and the earl of Bedford. She concluded with the hope that Lady Russell "should be one of my friends."[141] Significantly, Rachel kept up the correspondence. In February 1688 Mary excused herself for not answering *three* letters from her. In May 1688 Rachel sent a letter with her kinsman Admiral Edward Russell, who made a secret visit to the Dutch court, and the princess entrusted him with her affectionate answer.[142]

This exchange between Lady Russell and the princess has important implications. It shows that Rachel knew that Admiral Russell was bound for a secret meeting with the prince of Orange, else she could not have given him a letter for the princess. How much more she knew is impossible to say. Her written comments on the deteriorating political scene in England in the spring of 1688—including James II's Declaration of Indulgence and the trial and acquittal of the seven bishops—are circumspect; and if Admiral Russell dropped any hint that he had secured the prince's agreement to participate in the English conspiracy against James II,[143] she was too sophisticated to record it. Further, the letters contributed towards the development of a friendship between Rachel and the princess and prince of Orange which continued after the Revolution of 1688–89.

Before that, Lady Russell became deeply preoccupied with a personal matter: the marriage settlement of her elder daughter. Her attitude towards the marriage was, paradoxically, in view of her romantic notions about love, almost entirely conventional. At a time when the trend in

noble families was to give major weight to the personal preferences of their children,[144] Rachel's major concern was to get the best possible financial and social alliance that she could. She was as serious about such matters as any conventional male head of family would have been. After that she took into account the personal inclination and character of the potential partners. Working out the marriage contract required the talents of a diplomat, lawyer, and accountant, and Rachel showed that she possessed a measure of each. She was so successful in the contracts for each of her children that she secured the social and financial position of their families for generations to come. Whether the unions also secured the emotional and psychological fulfillment of her children it is not possible to say.

Lord Devonshire, Russell's former best friend, proposed in the fall of 1687 that his son and heir, William, marry young Rachel.[145] The union would unite two families of like social status and political views, and such thoughts, as well as the affection Devonshire and Lady Russell bore each other, must have animated both parties. Five months of hard bargaining over the terms of the settlement ensued. Devonshire wrote her as an equal, and she responded in kind; their letters are the same in tone and reflect equal understanding of the law and the effect of the settlement on their properties.[146] Lady Russell prepared herself carefully for these negotiations, making notes herself on papers regarding Devonshire's holdings and on a lawyer's interpretation of his proposals.[147] Despite his "well-bred" manner and friendship, Lord Devonshire was "inflexible," Rachel said, "if the point [was] not to his advantage. Among the points on which he was inflexible was that the dowry should be £25,000, paid in a lump sum. Rachel said that that figure was more than she had intended and objected to a lump-sum payment. She reported that the lawyers put "hard difficulties" in her way and that she felt alone and sometimes "doubtful," but she declared that she was determined to go forward slowly so that she would understand every detail in the bargaining.[148] By the middle of March an agreement was reached. In essence, Devonshire undertook to provide the couple an income of £2,500 a year and a jointure of like sum. Lady Russell agreed to a dowry of £25,000; she put up £10,000 herself and persuaded Bedford to match that sum.[149] But she insisted that the remaining £5,000 be paid over a number of years, out of the income from her London properties, and Devonshire accepted that arrangement.[150] As an expression of his pleasure at the union of their two families, Devonshire presented Rachel a present of a pair of diamond pendants.[151]

Both children were underage, the bride fourteen years old and the groom fifteen, younger than the partners in most noble marriages.[152] There is no evidence that their personal preferences were considered. A

legal union would take place, after which the young people would complete their education, Rachel at home with her mother, and William Cavendish abroad. Young Rachel, who had suffered a severe eye infection in the fall, contracted measles at the end of March, and therefore the marriage ceremony had to be postponed. It was celebrated on June 21, 1688, in the chapel at Southampton House. Lord Devonshire had insisted on the date, probably forgetting that it was the anniversary of William's arrest. He had hurried the arrangements along because of plans to go to Bath, so it was said.[153] That may be, but political events may better explain the earl's haste. A fortnight before, on June 10, a boy had been born to King James II, thus assuring the perpetuation of a Catholic monarchy if steps were not taken to prevent it. A fortnight later, on June 30, a letter inviting the prince of Orange to come to England was signed by seven men, Devonshire among them. The letter was carried to Holland by Admiral Russell. This step forecast the landing of Prince William of Orange in England on November 5, 1688, the opening move in the Glorious Revolution.

Apart from her dismay over the date, the wedding of her elder daughter was a happy occasion for Lady Russell and marked a turning point in the mastery of her grief and in her self-image. To unite her daughter to the heir of the Devonshire title and fortune was, as she put it, a "glimmering of light I did not look for in my dark day." To achieve it she had engaged in many social activities which she professed to dislike but suffered for the sake of her child. Whatever her attitude, the fact remained that her social life was livelier. Further, Lady Russell was gratified by her success. "When I contemplate the fruits of the trial and labour of these last six months," she wrote to Fitzwilliam, "it brings some comfort to my mind, as an evidence that I do not live only to lament my misfortunes." She was confident that William would have approved, and pleased at the fulfillment of her belief that the children of the just are blessed. Reflecting her renewed sense of confidence, she candidly remarked that William was among the just, and "if my heart deceive me not, I intend the being so [too]." Such thoughts were a comfort, she said, especially "as the clouds seem to gather and threaten storms."[154] Her reference was to the deepening political tensions that had followed the acquittal of the seven bishops, the birth of a son to King James II, and the rippling rumor that the baby was a fraud.

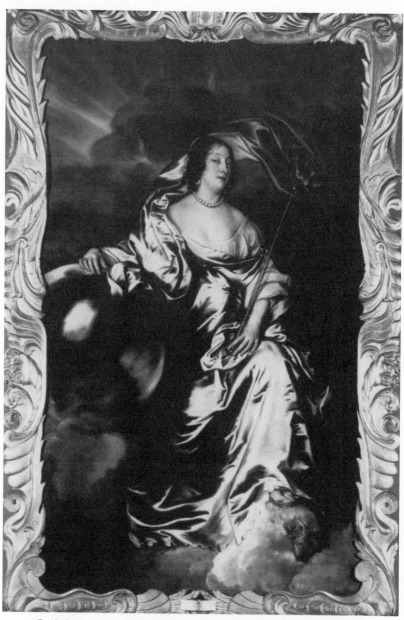

Rachel, countess of Southampton (1603–1640). By Anthony van Dyck.
Reproduced by permission of the Syndics of the Fitzwilliam Museum,
Cambridge, England.

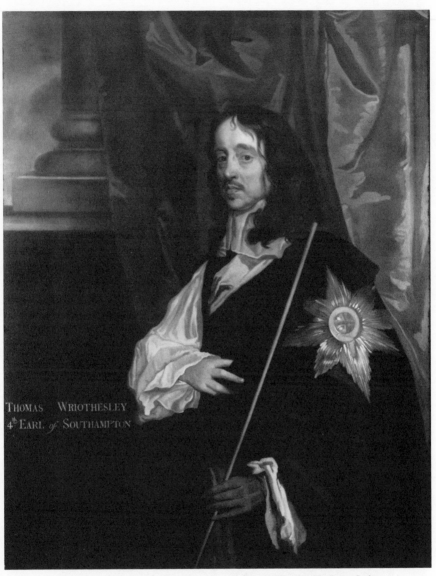

THOMAS WRIOTHESLEY
4ᵗʰ EARL of SOUTHAMPTON

Thomas, fourth earl of Southampton (1608–1667). By Sir Peter Lely.
Courtesy of Sotheby's.

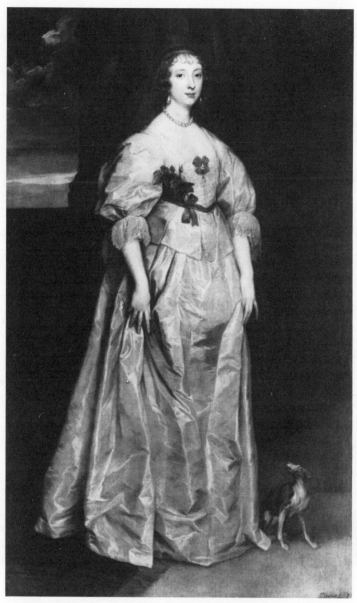

Anne, countess of Bedford (d. 1684). School of Anthony van Dyck.
By kind permission of the Marquess of Tavistock and the
Trustees of the Bedford Estates.

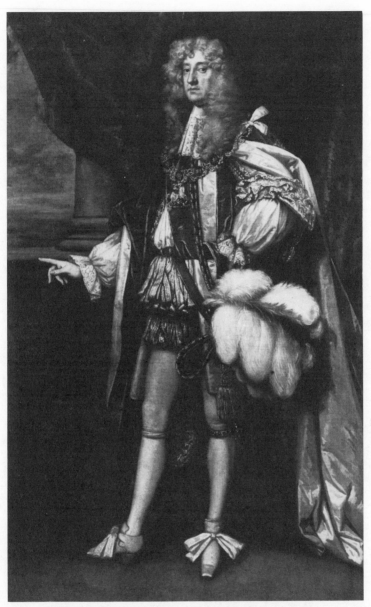

William, fifth earl and first duke of Bedford (1613–1700).
Attributed to Sir Godfrey Kneller.
By kind permission of the Marquess of Tavistock and the
Trustees of the Bedford Estates.

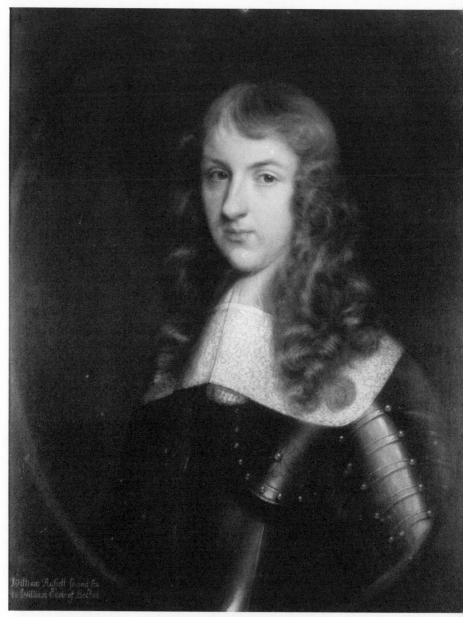

The Honorable William Russell (1639–1683), about 1659. By Claude Lefevre.
By kind permission of the Marquess of Tavistock and the
Trustees of the Bedford Estates.

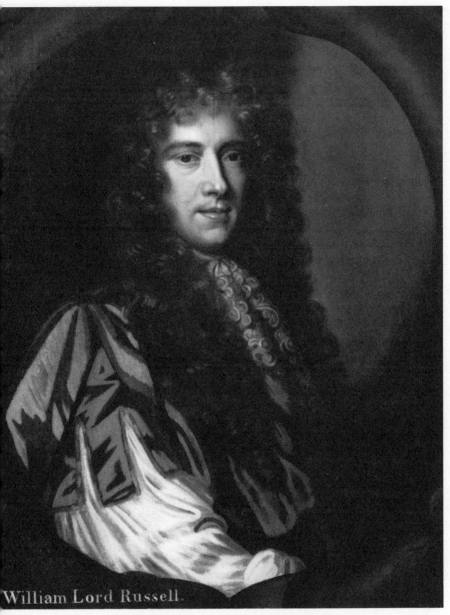

William Lord Russell.

Lord William Russell. Attributed to Mary Beale.
Present location unknown; photograph at National Portrait Gallery.
Courtesy of the National Portrait Gallery.

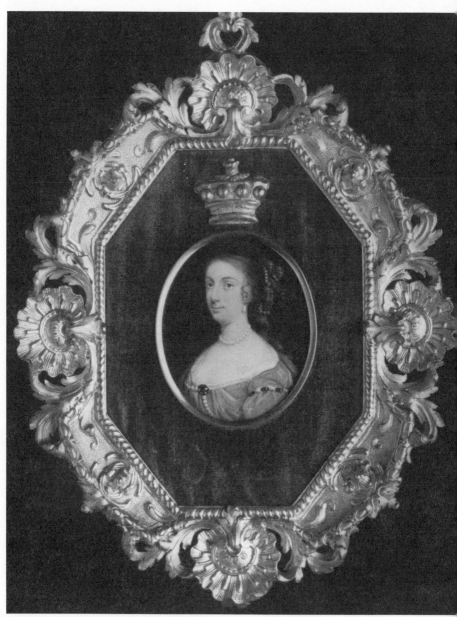

Miniature of Lady Rachel Vaughan. Drawn by W. Derby, 1829,
from an original by Samuel Cooper.
By kind permission of the Marquess of Tavistock and the Trustees of the Bedford Estates.

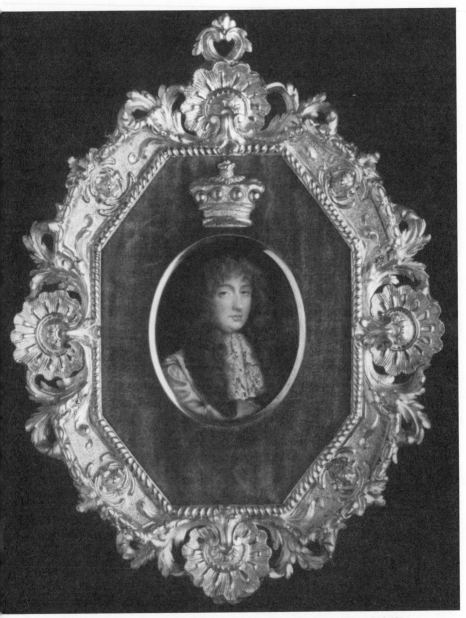

Miniature of the Honorable William Russell. Drawn by W. Derby, 1829 [?],
from an original by Samuel Cooper.
By kind permission of the Marquess of Tavistock and the Trustees of the Bedford Estates.

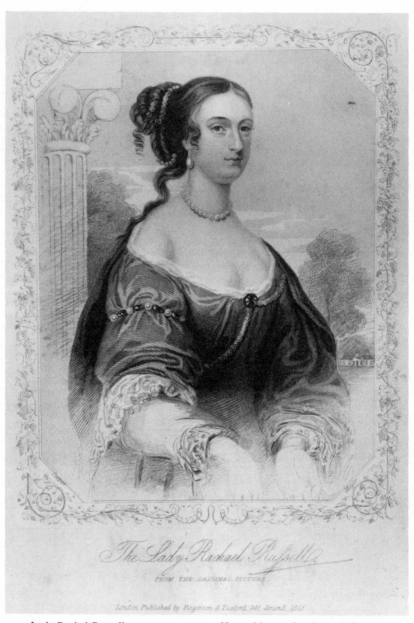

Lady Rachel Russell as a young matron. Henry Meyer after Samuel Cooper. Courtesy of the National Portrait Gallery.

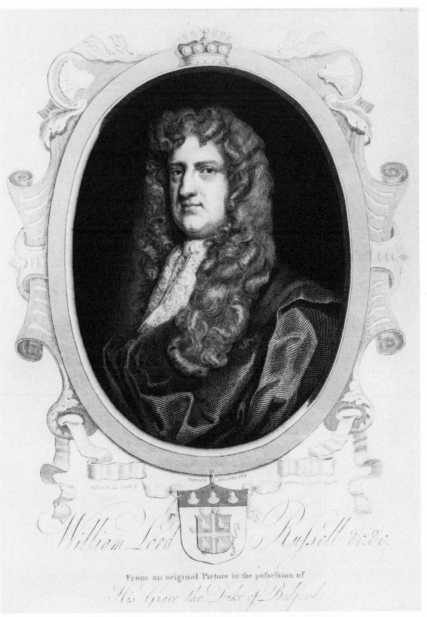

Lord William Russell in maturity. Engraving by James Fittler.
By kind permission of the Marquess of Tavistock and the
Trustees of the Bedford Estates.

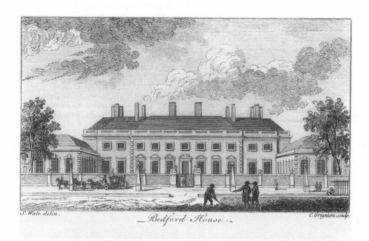

Bedford House, known as Southampton House when occupied by
Lady Russell and her family.
Located on the north side of Bloomsbury Square.
By permission of London Borough of Camden Local History Library.

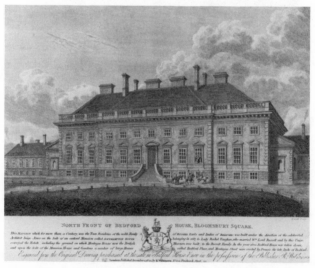

North front of Bedford House, Bloomsbury Square.
By permission of London Borough of Camden Local History Library.

Woburn Abbey, Bedfordshire, home of the earls and dukes of Bedford.
By kind permission of the Marquess of Tavistock and the Trustees of the Bedford Estates.

every new promisse of your
Duffells un utterable kindnesse is
a most unspeakable delight
to my thoughts, therfore I
need use no more words to
tel you how welcome your
letter was to me, but how
much welcomer monday will
be, I hope you do immagine
my father sent me ye jnclosed
but says withal yt ye newes
at court from france this
morning, *Afrora* was missind was retired
for wedings and deaths, & yt
sort of newes I know not ye
least, hur grace of cleauland
has set ye day for france
to be withing ten dayes, ye
duchesse of porthmouth is
malincolie as som persons will
have it, and with reason, you
will easiely conclude yr sister
Jhinton is so when I tel you
hur boy has ye ~~made~~ measles
he had a cough two or three

Mon: yᵉ 26th 1681 6

I suppose you received mine of Thurs:
I hope this will bee the last time for this
bout of troubling you in this kind, for on
Twesday God willing I intend to set
out to goe to my nearest Deare's
embraces wᶜʰ vpon my word I value
now as much as I did ten eleven, &
twelue yeares agoe, & more then any
the Towne can afford now you are
out of it: on Munday wee intend
to bee at Westminster to bee baile
for my Lord Shaftsbury in case it
bee demanded & I heare yᵉ Liut:
of yᵉ Tower has order to bring him
Lord Howard Willmore & Whitaker
soe that t'is concluded they will
bee all releas'd, allthough some talke
as if they would bring fresh matter
but I don't beleeue it: t'is thought
by some of your friends where wee
din'd together when you were in
Towne that the Faire man was
the person most troubled at Thursday

Letter of Lord Russell to Lady Russell, November 26, 1681.
Devonshire Collections. Courtesy of Trustees of Chatsworth Settlement.

Letter of Rachel, daughter of Lord and Lady Russell, to Lord Russell.
Devonshire Collections. Courtesy of Trustees of Chatsworth Settlement.

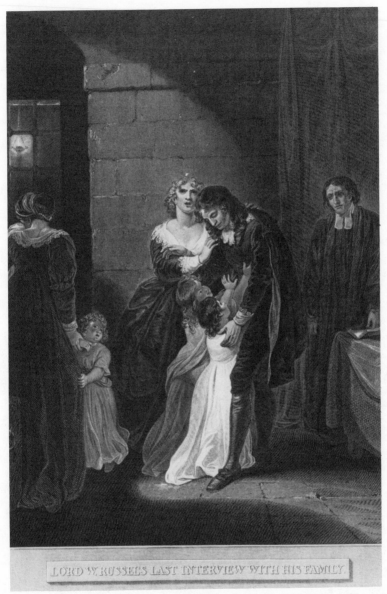

Lord Russell's last interview with his family, in the Tower, July 20, 1683.
Courtesy of the National Portrait Gallery.

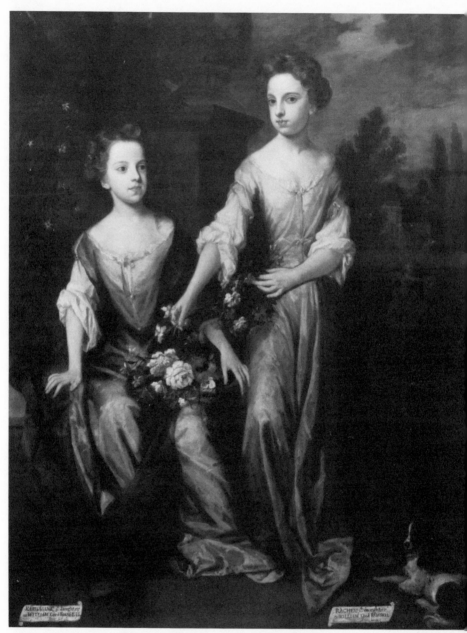

Rachel and Katherine Russell, daughters of Lord and Lady Russell. By Sir Godfrey Kneller.
By kind permission of the Marquess of Tavistock and the Trustees of the Bedford Estates.

Wriothesley, son of Lord and Lady Russell. By Sir Godfrey Kneller.
By kind permission of the Marquess of Tavistock and the Trustees of the Bedford Estates.

Chatsworth, Derbyshire, home of Lady Russell's daughter Rachel,
duchess of Devonshire.
Courtesy of Trustees of Chatsworth Settlement.

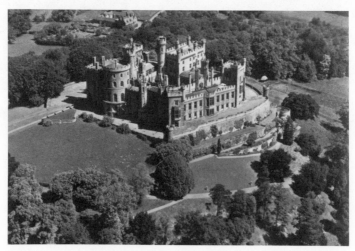

Belvoir Castle, Leicestershire, home of Lady Russell's daughter Katherine,
duchess of Rutland.
By kind permission of the Duke of Rutland.

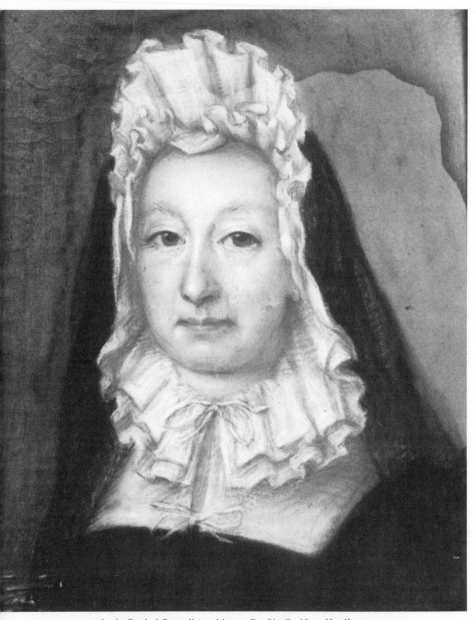

Lady Rachel Russell in old age. By Sir Godfrey Kneller.
Present location unknown; photograph at National Portrait Gallery.
Courtesy of the National Portrait Gallery.

· 8 ·
Prime Years,
1689–1702

The Revolution of 1688–89 renewed Lady Russell's social and political position. The flight of King James II, her husband's archenemy, cleared the way for the ascent of the prince and princess of Orange as king and queen of England and for the restoration, at least for a time, of the Whigs. In these national events Rachel played a discernible, although of course a minor, role. But with the reversal of Lord Russell's attainder in the spring of 1689 and the elevation in 1694 of his father to a dukedom, largely on the grounds of Lord Russell's suffering, Rachel assumed an assured and respected place as "Grand Dame" of the Whigs. Until about 1702, when she was sixty-five years old, she exercised personal influence in elections and in political and ecclesiastical appointments. She also maintained her role as head of her family, successfully negotiating favorable marriage settlements for her second daughter and her son, and overseeing their religious and secular education. All these activities she undertook despite failing eyesight.

Lady Russell spent most of the fall of 1688 at Woburn observing, reporting, and soliciting news of public events. Unidentified sources kept her fairly well informed. On a visit to London in early October she found everyone "in amaze, all talking of the same matter"—namely the weather, the wind, and when Prince William of Orange would set sail for England, which she reported could not take place before October 5. She also learned of meetings King James was holding with Anglican bishops a week before an account of the discussions was "leaked" to the press. She lacked confidence in the outcome of a possible invasion by Orange and expressed fear not for herself but for her children.[1] Prudently circumspect about committing herself publicly, she refused at the end of October to persuade Bedford to come up to London as his daughter Margaret (now married to Admiral Edward Russell) urged her to do.[2] The earl warily decided that if the prince of Orange landed in the north, he would move to Chenies, his estate in Buckinghamshire, and thus minimize the chances of being forced to declare himself.[3] Rachel indicated no dissent. A move to Chenies proved unnecessary, for the prince landed

at Torbay on November 5, 1688, and for the next three weeks was encamped in and about Exeter. During these days, Rachel, still cautious in the face of a yet unsettled and dangerous situation, and fearful of bloodshed, confessed to Fitzwilliam that "one is in prudence confined not to speak of matters one is strangely bent to be talking of."[4]

As the prince of Orange made his way east towards London, Rachel's confidence in his eventual success grew. She became increasingly impatient for news and for the opportunity to discuss unfolding events with a friend of like mind.[5] On December 8 she could contain herself no longer and wrote several letters designed to find out precisely what was happening and also to affirm her support of the prince. One letter addressed to Dr. Burnet, a member of the prince's party, she sent by messenger so that she might have a prompt reply. "I would see something of your hand writing upon English ground," she wrote, "and not read in print only, the labour of your brain." Praising Providence for the wonderful events that had occurred, Rachel expressed hope that a "happy success" would attend the prince's affairs. She wrote an even more impatient letter to an anonymous addressee. Complaining of the suspense she was under, she confessed, "I every day hoped that you would have found some way or other to let me hear from the quarters you are in, but I believe, a prudent caution has kept me ignorant." Affirming her best wishes for the success of the prince's enterprise, she declared, "If I could see how I could do more than wish or pray for it, I would readily make it appear how faithfully I would serve him and his interests." Lady Russell sent off still another letter to an anonymous addressee, almost certainly the Reverend Samuel Johnson, expressing unequivocal approval of and commitment to the changes underway. "I have had more mind to scribble a few lines to you than I ever had in my life," she declared. "My religion and my country are dear to me, and my own hard fate will ever be as a green wound. I need say no more to you. I have been but too impatient to say so much. I have fancied it a sort of guilt not to do it, and want of ingenuity not to find an opportunity; yet I met it not until now." Observing that some people think that recent events are only a dream, Rachel asserted that the changes were no dream, but rather "so amazing a reality of mercy as ought to melt and ravish our hearts" into thanks to God.

Rachel returned to London with the earl of Bedford perhaps in mid-December, certainly in time for the meetings of the Convention, the body elected to settle the government of the nation.[6] The Convention opened on January 22, and for the next three weeks Tory and Whig members engaged in strenuous debates in and between both Houses. Discussion focused on the state of the nation, the headship of the state, the justification of James II's removal, the grievances and rights of the

nation, and, once a decision was made to make Prince William and Princess Mary of Orange king and queen of England, the succession to the crown. It must have gratified Rachel that the memory of Lord Russell was evoked in these debates. In fact, she may have known that the way had been prepared for the Convention to cite as a grievance the proceedings in Lord Russell's trial, for on December 22, 1688, the earl of Devonshire and Henry Booth, baron Delamere, had announced their intention of investigating the trials of former Whig leaders, including Lord Russell's.[7] A tract from Windsor dated that same day, *A Letter To A Gentleman at Brussels, containing An Account of the Causes of The Peoples Revolt from The Crown*, directed the Parliament to take note of certain juries that deserved censure, among them Lord Russell's. The memory of Lord Russell's trial animated the committee of the House of Commons charged with drafting a statement of the grievances and rights of the nation. On that committee were several of William's former political colleagues, such as Capel, Sacheverell, and John Hampden, and his defense lawyers in 1683, Holt and Pollexfen.[8] It was charged that Russell's jury had been packed and that men who were not freeholders had served on it. These points appeared in the draft statement of the nation's grievances and rights that was sent up to the House of Lords, and thus, Bedford, who was present when that statement was debated, knew of them and surely apprised Lady Russell.[9] They were preserved in the final version of the Declaration of Rights as a grievance against King James II (no. 9) and as a right of the nation, article 11 reading: "That jurors ought to be duly impaneled and returned, and jurors which pass upon men in trials for high treason ought to be freeholders." Lady Russell mentioned none of this in her surviving letters, but one may presume that these initial steps in vindicating her husband pleased her.

The memory of Lord Russell figured in another way in the politics of the Convention. It will be recalled that Sir George Treby, recorder of London in 1683, had pronounced the dreadful sentence for treason against William and had signed the warrant for his execution. Treby's part in William's execution still rankled with Bedford and Devonshire, and to avenge Russell's death they blocked Treby's appointment as one of the legal counsel to the peers. It took intervention by Pollexfen (Russell's counsel in 1683)—who explained that Treby was only fulfilling his duties and had not signed the death warrant until reassured by Russell himself—to restore Treby to the good graces of the lords.[10] The episode provided a striking example of the restored political power of former Whigs. There is no evidence that Lady Russell was apprised of this incident.

During these weeks Rachel was among a handful of aristocratic women, both Whig and Tory, who had some influence on the course of

events.[11] Her most important role during the meetings of the Convention was to help persuade a reluctant Princess Anne, Princess Mary's younger Protestant sister, to accept a place after Prince William in the succession to the throne. It appears that Sarah Churchill, Princess Anne's close friend and adviser in 1688–89, sought the advice of "several persons of undisputed wisdom and integrity, and particularly. . .Lady Russell of Southampton House and Dr. Tillotson" as to the course the princess should follow in respect to that issue. Both urged the princess to give way to Prince William. Reluctantly Anne agreed. Her announced decision on February 6 to that effect moved the Convention along to a resolution. That Lady Churchill linked Lady Russell with Tillotson clearly indicates that Rachel was regarded as one of the most respected and influential Whigs in London.[12]

By February 12 a compromise agreement between Tory and Whigs had been reached which elevated Prince William and Princess Mary of Orange to the throne of England, declared the rights of the nation, and settled the succession to the throne to four removes, the whole set out in the Declaration of Rights. In a carefully contrived ceremony held in the Banqueting Hall on Wednesday, February 13, the Declaration was read and the crown of England offered to both William and Mary. Responding for himself and Mary, Prince William accepted the crown and acknowledged the statement of rights. That ceremony, followed by a party that evening at Whitehall, brought the most critical stage of the Revolution to an end.

Whether Lady Russell was among the crowds of people who witnessed the procession to the Banqueting Hall or attended the party that evening is unknown, but her elder daughter, Rachel—married, it should be remembered, to the son of the earl of Devonshire—was present and she left an account of both events. Following in the footsteps of her mother, young Rachel, now seventeen years old, reported in detail the settlement and the ceremony. She was "much pleased," she wrote, "to see Ormanzor and Phenixana [names she gave to the prince and princess of Orange] proclaimed king and queen of England, in the room of King James, my father's murderer." The mob's wonderful acclamations of joy also delighted and at the same time frightened her. That evening she kissed the hands of the new king and queen, describing him as "homely at first sight" but with "something in his face both wise and good" if one looked closely, and her as "altogether very handsome."[13] Young Rachel's presence at these splendid events testified to her father-in-law's role in the Revolution and to a change in the position of Lady Russell and her family.

Within three weeks of the settlement, on March 7, 1689, a bill to reverse the attainder of Lord Russell was introduced in the House of

Lords by the earl of Bedford and Lady Russell. Rachel played an active role in this effort. As we have seen, an undated draft petition to achieve the reversal survives in her hand. Perhaps as a result of the friendly relationship with the new monarchs that Rachel had been at pains to establish since 1687, someone showed the bill to King William III before it appeared in the House of Lords, and on the eleventh of March the Lords sent the bill reversing Russell's attainder to the House of Commons.[14] There, it received a warm welcome, provoking a debate full of encomia for Russell, near tears on Sir Robert Howard's part at the very mention of William's name, an explanation by Finch respecting his role in Russell's trial, and an assertion that the issue transcended the personal interests of the earl of Bedford and Lady Russell. "All the nation is concerned in it," asserted an M.P.[15] A second reading followed immediately, and the bill was sent to a committee that included Russell's former friends. Five days later, when the Lords sent down the engrossed bill, this committee offered an amendment to destroy all records relating to Russell's attainder so that "the same may not be visible in after-ages." In that way they hoped to do "right. . .to the memory of the deceased Lord Russell." With this amendment the reversal received the royal assent on March 16.[16]

The reversal of Lord Russell's attainder was promoted and defended in a quantity of tracts. As early as February 28 there appeared *A Defence Of the Late Lord Russel's Innocency*, a pamphlet which must have held special interest for Rachel. The author, Sir Robert Atkyns, described his "Defence" as letters that he had written in 1683 in response to a request for advice from William's friends and relations.[17] One may recall that despite Rachel's efforts Atkyns' advice in 1683 was minimal and that he declined to publish anything then. Another piece on the injustice of Russell's trial, available before March 11, was written by Lord Delamere, who felt a special sense of obligation to the Russell family. Two more pamphlets were printed by Sir John Hawles, a lawyer.[18] These tracts sought to prove that Russell's trial was a travesty of justice and, in contrast to those printed in 1683, focused on the absence of freeholders on the jury, the illegality of the king's guards, the need to have two witnesses to the *same* act of treason, and the inadmissibility of the testimony of "plea bargainers." Other printed material was also put into circulation. To reinforce the view that Russell was a victim of Stuart despotism, his *Speech* was reprinted in a collection of scaffold speeches of eminent Protestants who had suffered under the late-Stuart kings. The preface asserted that the Rye House Plot was a "mere sham-contrivance" concocted by papists "to bring an odium on Protestants."[19] Printed lists of the jurymen and the judges who were connected with the trials of the Whig martyrs sought further to persuade the

public that William had been unjustly condemned.[20] Finally, to make certain that people "all over the kingdom" should have no doubt about the legitimacy of the reversal of the attainder, an anonymous partisan published a broadside before April 9 justifying it.[21] Only Sir Bartholomew Shower, who had probably written *An Antidote Against Poison* in 1683, undertook a direct response to these defenses of William.[22] Rachel does not mention these tracts, but in view of her lifelong habit of reading polemical literature, she almost certainly was aware of them. And since Bedford purchased the pieces by Atkyns and Hawles, they at least were readily available for her perusal.[23]

No direct comment by Lady Russell on the reversal of her husband's attainder survives. Gratified she must have been, for the reversal opened the way for achieving a goal towards which she had worked for at least four years, namely the transfer of the Bedford title to her son. Still, a sober, even melancholy letter to Lady Essex written just three days after the reversal received royal assent on March 19 suggests that she felt no great sense of elation.[24] Probably the attention given the trial in Parliament and in the press over so many weeks had revived memories of her husband and his suffering and precipitated a return of active grieving.

During the early years of the new government, Rachel's position in public affairs underwent a transformation. The change owed much to the honors and high offices the men in her family received. Her father-in-law became a privy councillor and lord lieutenant of the counties of Bedford, Cambridge, and Middlesex, while the earl of Devonshire also became a privy councillor, lord lieutenant of Derbyshire, a knight of the garter, and lord steward of the King's Household. She must have taken satisfaction also from the fact that at the coronation of the new monarchs on April 11, 1689, Bedford bore the Queen's Scepter with the Dove and Devonshire acted as lord high steward of England. And even more satisfaction must have been hers in 1694 when both men were elevated to dukedoms, especially because Bedford's letters patent specifically justified his promotion on grounds that the earl was father to the Lord Russell, "the ornament of his age," who preferred "love to his country before that of his life."[25] As a result of Bedford's promotion, Rachel's son was given the courtesy title of Lord Tavistock, the first time that a courtesy title was used by a grandson.[26]

Lady Russell's new position also owed something to the strengths she herself possessed. She was on friendly terms with King William and Queen Mary. She had long since established a reputation for intelligence, courage, good sense, piety, and loyalty. From past experiences and lifelong observation of the political process, Lady Russell was well informed about how to win favor for one's family and friends in both

church and state. She liked being close to the center of power, as she candidly admitted. Above all, she became a surrogate for her husband, a symbol of the best of the former Whigs. As William became a Whig martyr, Rachel became a Whig saint, mourning her beloved husband. This role decisively strengthened the position given her by wealth and the political power of men in her family.

Concurrently Lady Russell's self-confidence and command of her grief over her husband's death grew. Using her influence in the complicated patronage network of late-seventeenth-century England on behalf of her family and friends to advance worthy Whigs contributed to her sense of responsibility, enlarged her social position, and fed her sense of self-importance. Her activities provide a glimpse of the strategies used by a woman to achieve some goal.

In view of her position and the influence she was thought to possess, it is not surprising that both men and women sought Rachel's favor. For example, on February 19, 1689, Lady Ranelagh implored her to help Lord Rochester escape the vengeance of the House of Commons, which she had heard intended to punish people who had served on James II's Ecclesiastical Commission. Lady Ranelagh, who had assisted Rachel in 1683, shrewdly remarked that the wheel of fortune had now reversed their roles. Reminding Rachel that she owed a debt to Lord and Lady Rochester for their efforts in 1683 to win a reprieve for William and to Lord Rochester later for supporting petitions respecting her husband's personal property and the title for her son, she asked Rachel to use her influence and to persuade Bedford to use his "with your friends in the House of Commons in my Lord Rochester's behalf."[27] In the event, the House investigated James's Ecclesiastical Commission and decided to spare Lord Rochester, but no record of Lady Russell's intervention survives.[28] Lady Sunderland also appealed to Rachel to intercede with the new government on behalf of her husband, who was in disgrace on the Continent. Rachel had earlier resisted overtures of friendship from Lady Sunderland, in part because Sunderland had done nothing to save Lord Russell in 1683 and in part because she simply did not like her.[29] After receiving several importuning letters from her, Lady Russell pointedly declined to help.[30] As it happened, Sunderland was condemned by the House of Commons for his part on the Ecclesiastical Commission, but by April 1690 King William had allowed Sunderland to return to England and thereafter depended upon his advice.[31]

Fitzwilliam, who disavowed the new government and refused to take the oaths imposed on the clergy, also turned to Lady Russell for assistance in securing a pass to go abroad. Temporizing on the pass, Rachel undertook to persuade Fitzwilliam to reconsider his position

respecting the oaths. Her letter has not survived, but judging from Fitzwilliam's admiring response, it advanced carefully reasoned arguments, based on history, the law of Henry VII, the meaning of the words "abdication and vacancy" (which had been used to justify the removal of James II), and a practical consideration that if Cromwell had become king, as Rachel said her father feared, then he, Fitzwilliam, would have been chaplain in a family that had accepted a de facto monarch.[32] The discussion about oaths continued through the spring, with Rachel hurting his feelings by saying that his boggling at one oath that clashed with another was an "unnecessary scruple."[33] Rachel tenaciously reopened the question in August. In a vigorous manner, she began, "I am very sorry the case stands with you as it does in reference to the oath; and still wonder (unless I could find kings of divine right) why it does so!" Continuing unsympathetically, she declared, "All this is the acceptation of a word which I never heard two declare the meaning of, but they differed in their sense of it. You say you could have taken it in the sense some worthy men have done. Why will you be more worthy than those men? 'Tis supererogation." Saying that when her wishes were "earnest" she "spoke without reserve," Rachel went on to predict, prophetically, that the refusal of able men to serve would weaken the church and the Protestant religion all over the world. She counselled him to admit that passive obedience "went too high" and to accept the new government.[34]

It was to no avail; Fitzwilliam refused to take the oaths. Displaying generosity of spirit and knowledge of church politics, Rachel continued to assist him. In 1691, for example, she discussed the possibility of an appointment for him, forthrightly advising him to be more circumspect, and pointing out that his identification with a high Tory bishop could not help him. "You should be a little more wary," she wrote. "One should be wise, tho' harmless as doves."[35] In 1696 Rachel acknowledged her defeat in the struggle over his conscience, saying that she could not "manage the argument" any longer but then adding, in ways that reveal her personality, that she might yet convince him if she "had the fight [she] once had."[36] Lady Russell's lifelong sympathy for Dissent, her rationalism, her pragmatism, and her approval of the Revolution left her incredulous that Fitzwilliam would not conform.

Rachel also used her influence to win the appointment to government posts of family members and friends, but only those, she insisted, who were well qualified. Some positions were of moderate importance. Thus, her first effort, in March 1689, was a petition for the appointment of a cousin by marriage to be clerk of the presentations.[37] Or again, in 1690, Lady Russell sought the assistance of Lady Ranelagh for help in placing one Sir Francis Wingate, a distant relative, in a post at the Prize Office, about to be vacated by the imminent death of the occupant. She

contrived for Lady Ranelagh to see Lord Devonshire and tell him that the request came from Bedford and, as Rachel put it, "on my own account." Then to reinforce the effort, she wrote Devonshire herself.[38]

Lady Russell also aimed much higher in influencing appointments. On April 15 she wrote Halifax, lord privy seal in the new government, to ask his help in securing the appointment as king's counsel of William Cowper, whose father had been closely associated with Shaftesbury. Cowper was a promising young lawyer of twenty-four only recently called to the bar, who had early declared himself for William of Orange. His youth, however, was an obstacle to his appointment. Explaining that Lady Shaftesbury had engaged her to help secure the appointment, Rachel reminded Halifax that in the past he had expressed willingness to oblige Lady Shaftesbury. She also told him that she had spoken to Pollexfen, now the attorney general, who had responded unenthusiastically. Halifax brought Rachel's request to King William, who granted it as a *favor* to Lady Russell and Lady Shaftesbury, signifying thereby that the appointment was irregular because of Cowper's youth. When the appointment was held up in the attorney general's office, Lady Russell wrote to Halifax again. Assuring him that she and Lady Shaftesbury were ready to accept the appointment as a "concession" from the king, she reported that "several eminent men of the law" whom she had consulted had assured her that many men as young as Cowper had served as king's counsel. She said flatly that there must be a deeper reason for objecting to the appointment. Rachel also wrote to Pollexfen. She told him frankly that she had William's promise, that she and Lady Shaftesbury had been too much trouble, and that she did not "love to be baulked." Peremptorily she asked him to keep her informed and announced that she would bring Cowper's mother to see him.[39] Cowper was appointed.

Halifax's willingness to assist Lady Russell at a time when many such requests were flowing into his office requires explanation. His cooperativeness was surely accountable not only to his admiration for and familial link with Rachel but also to his own political situation.[40] Halifax held high office and the confidence of the new king at this time, but he did not enjoy the favor of either Tories or Whigs. The Tories despised him for abandoning during the Convention debates a Regency proposal which would have preserved James II's title. They also disliked his championing the interests of the Dissenters. The Whigs hated him for defeating Exclusion. Debates in the House of Commons in March on the Rye House trials and in May and June on an indemnity bill revealed how vulnerable Halifax was.[41] His friendly interest in a request that came from two woman who symbolized the former Whig leaders could have helped his position with the vengeful Whigs in the Lower House. In July

1689 he acknowledged Rachel's favor and "the protection" of her good opinion.[42]

Reports of Lady Russell's favor helped to protect Halifax in the fall of 1689, when Lord Russell's trial again became the subject of investigation. Then the trial was even more deeply enmeshed in the partisan politics of revenge. On November 2 a motion was introduced in the House of Lords to consider "who were the advisers and prosecutors of the murders of Lord Russell, Colonel Sydney, Sir Thomas Armstrong and others." The underlying purpose of the move, it was widely recognized, was to destroy Halifax.[43] A committee of peers, referred to as the Murder Committee, examined the written record and called witnesses, among them Tillotson. Peers questioned him about the part Halifax had played respecting the letter Tillotson had written to Lord Russell in 1683 to urge him to disavow the doctrine of right of resistance. Tillotson was at pains to exonerate Halifax, declaring, in response to a question about the opinion of the Russell family, that Rachel, with whom he had mostly talked, had never said anything against him.[44] By the end of November it was doubtful that a case against Halifax could be made.

That fact makes all the more curious a petition to the Lords that Lady Russell submitted on December 6, 1689. She thanked them for the investigation and prayed that the "just inquisition of blood" might be pursued.[45] The petition is out of character for Rachel. There is no surviving comment to explain it. Presumably vengeful Whigs persuaded her to present it and regarded it as sanctioning the work they had done. Vengeance found further encouragement in London street theater that featured Lord Russell's trial. On December 18, the first anniversary of the arrival of the prince of Orange in London, a great bonfire was arranged in Fleet Street at Temple Gate, and the London "mob" came in "three pageants" carrying effigies of the three foremen of the three juries in the cases of Russell, Sidney, and Cornish. The mob held a mock trial of the foremen, found them guilty of high treason, hanged them on the gibbet, then burned them in the bonfire.[46] Two days later, on December 20, the Lords Committee presented its report condemning former ministers, including Halifax.

Apparently Rachel knew the contents of the report, for she wrote immediately to her half-sister regretting the steps her brother-in-law Montagu and others had taken against Halifax and expressing renewed grief (as had happened in the spring when Lord Russell's attainder was reversed) over her husband's death. Elizabeth impatiently replied that the punishment of men responsible for William's death should be a comfort to Rachel. In doing so she failed to take into account the friendly relationship between Rachel and Halifax.[47] In the event, the report died.

Lady Russell's influence was also felt in the filling of ecclesiasti-

cal offices. They too varied in importance. For example, in the spring of 1689 she interceded with Bedford for Fitzwilliam, who feared that the earl would appoint clergy sympathetic to Nonconformity. She assured her clerical friend that Bedford would make no changes in the personnel of the Bedfordshire clergy that would disappoint him.[48] Also in 1689 she championed the interest of the Reverend Samuel Johnson and secured him not a living, but a grant of money, a life pension for him and his son, and a place for his son.[49] In thus identifying herself with the radical cleric she reaffirmed her belief in the right of resistance, the principle Johnson had promoted for so long.

Still further, when the rectory of St. Paul's Covent Garden became vacant in September 1689, Tillotson wrote to Rachel that the king would not appoint a replacement until Bedford, the patron of the rectory, gave his approval. The dean asked if *she* and Bedford would favor one Dr. John More. Bedford apparently left the choice to Rachel, and she handled the correspondence. Lady Russell vetoed More for his lack of talent as a preacher. Tillotson invited Rachel's opinion of other candidates and shared with her his "free thoughts of them."[50] Tillotson's second choice won the appointment.

Also, in September 1689 Tillotson solicited Rachel's advice on whether he should accept the post of archbishop of Canterbury. With unusual frankness he expressed his misgivings about his abilities and his fears of jealousies of others. In 1690, with the issue unresolved, Tillotson appealed again to Lady Russell, writing in early October, "Madam, what shall I do? my thoughts were never in such a plunge. . .I hope that I shall have your prayers, and would be glad of your advice." In response, Rachel adverted (surely with secret pleasure) to his effort in 1683 to persuade her husband to accept the doctrine of nonresistance, asking him to "put anew in practice that submission you have so powerfully. . .instructed others to." She cited his duty to the king, talent for the position, and responsibility to the church as reasons why he should accept the appointment. "I see no way to escape it; you must take up the crosse, and bear it." Tillotson followed her advice. Thanking Rachel for her help, he expressed his "great regard and deference for [her] judgment and opinion" and also promised to assist her in whatever way she might command.[51] Lady Russell's relationship with the man who occupied the highest position in the Anglican church is a measure of the respect she commanded. Few other people, whether male or female, were on such friendly terms with the archbishop. Few would have had the knowledge, the self-confidence, or the respect to address church leaders as she did.

Tillotson's dependence on Rachel repays scrutiny. Just as Halifax had political reasons for assisting her, so too did Tillotson. In 1689

Tillotson's enemies, both Whigs and High Tories, sought to make capital of Tillotson's letter to Lord Russell urging him to disavow the doctrine of right of resistance. A High Tory partisan of James II printed a tract titled *A Letter formerly sent to Dr. Tillotson, and for want of an Answer made publick and now Reprinted* whose point was that Tillotson should practice in 1689 what he had preached in 1683 and assist others in restoring King James. Whig peers in the fall of 1689 questioned him closely about the letter, as we have just seen. The radical Whig, the Reverend Samuel Johnson, who had been furious with Tillotson over his 1683 letter and had written *Julian the Apostate* in answer to it, continued to upbraid him for his moderate principles. In September 1689, Tillotson told Rachel that Johnson's sharpness with him was tantamount to "railing."[52] In 1691 several more libels against Tillotson appeared. Citing damage to Lord Russell's reputation, Tillotson decided in June 1691 to appeal to Bedford to bring an action against the perpetrators of the tracts.[53] Under the circumstances it was in Tillotson's interests to have Lady Russell, Lord Russell's widow, as his ally and confidante, and it is impossible to think that he was not acting in part upon that consideration in turning to her for advice and in representing her interests.

Lady Russell's favor was also sought by Whigs in parliamentary elections. On October 9, 1691, Lord Devonshire wrote Rachel that interest was brewing in having his son, Cavendish (now returned from his travels), stand for the House of Commons in a by-election for the borough of Westminster. He said that he could not answer the principals without "first begging to know [Rachel's] opinion," for he was certain that his son had no hope of success unless Rachel and Bedford approved. With some extravagance Devonshire said that he would always submit his and his son's concerns to her "direction and advice."[54] Rachel made herself busy in this matter. She wrote on October 23 to Thomas Owen (c. 1637–1708), a possible candidate for the seat, in terms that show her firm knowledge of the political process and the identity and interests of possible candidates. Without mincing words she asked Owen to withdraw from the race. Candidly she said that the task of contacting him had fallen to her because she knew him better than "any of the Devonshire family." Presumably Rachel's contacts with Owen dated back to the reign of Charles II, when Owen, a member of an Independent congregation, had shown sympathy for the Dissenters.[55] Owen felt close enough to Rachel to have asked her earlier to speak to Bedford about supporting him in the election. She had done so and conveyed the earl's enthusiastic endorsement. But now that Bedford and others had shifted their support to Cavendish, Rachel frankly asked Owen how strong he reckoned his chances were. In her forceful and logical way Lady Russell itemized the strengths of her son-in-law's candidacy: the cordial endorsement of

Bedford, the withdrawal of some candidates (among them Sir Stephen Fox), the approval of many people of quality and of the king, and the memory of his father's role in the House when he was Lord Cavendish. Further, as she shrewdly put it, "It will not hurt his interest that he is married to my Lord Russell's daughter." Declaring that she "would fain have it come to a fair tryal of skill between the two partys, which it can't so well do if Lord Cavendish be not singly at the head of one of them, and that I reckon he will be if you desist," Lady Russell forthrightly asked Owen to "tell [her] ingenuously" his view of the situation and "if you please, [give] your reasons against my Lord's standing, and for your own."[56] Owen decided to remain in the race and was badly defeated in the election on November 9 by Sir Stephen Fox, who had reentered the contest. Although Rachel did not prevail in shaping the election as she wished, the episode shows how close she was to Whig party strategy and planning and how unabashed she was in using her influence in partisan politics.

That Rachel's public reputation had grown significantly is indicated by an honor she received in 1691. The Dissenting minister Dr. William Bates dedicated *The Last Four Things* to Rachel, prefacing the book with a flattering epistle dedicatory. It was not unusual for a woman to receive such a mark of respect. It was the first time Lady Russell had. The gesture reinforced her identification with Dissent.

Lady Russell also took advantage of the friendship with Queen Mary and King William that she had so carefully nurtured. She turned to the queen in 1691 to help her win the position of auditorship of Wales for Sir Richard Vaughan, a distant relative from her first marriage. Confessing to Tillotson that the award would "please me on several accounts," she asked him to deliver her petition directly to the queen, but then expressed some misgivings, writing, "I am not versed in the court ways, 'tis so lately since I have loved them. Therefore be free, and do as you think most fit." Not satisfied with those instructions, Rachel wrote Mary directly that same day. In response, Queen Mary promised to put the matter before the king and assured Rachel that if the place were not already filled, her petition would find favor with the king.[57]

Lady Russell did not abuse the favor that she enjoyed with the queen. In 1691 one Miss Mortimer, who was connected with one of Lady Russell's sisters, appealed to her to promote some concern with the queen. Lady Russell demurred. In 1692 she again denied Miss Mortimer's request for assistance.[58] By using such discretion, Rachel undoubtedly preserved her credit at court for more important matters.

Interestingly enough, Queen Mary also turned to Rachel for assistance. Mary acted as queen regnant during many months of the early years of the joint monarchy because of King William's absence

fighting against Louis XIV and James II. Lady Russell's cousin by marriage Admiral Edward Russell played a prominent role in the naval battles and became a national hero. Like Lord Russell, the admiral was an impetuous and headstrong man whom the queen found difficult. In one trying situation, Mary sought Rachel's help in persuading him to come to her and in a letter to the king credited her with doing so. She wrote, "To this hour [the Admiral] would not have asked to have spoke with me, had not I told Lady Russell one day I desired it."[59]

Mary's death in December 1694 deprived Lady Russell of a warm friend, and although no comment by her has survived, Rachel's sense of loss was surely acute. She would have taken satisfaction at the public acknowledgment of the friendship between her and the queen by John Howe's dedicating to her his *A Discourse Relating To the Much-lamented Death and Solemn Funeral, Of Our Incomparable and most Gracious Queen Mary*. This was the second book dedicated to her in four years and is further testimony to the high regard in which she was held.

These instances of Lady Russell's involvement in partisan politics and in patronage projects testify to the influence in politics that she possessed and illustrate the indirect political power an intelligent, well-placed woman might exercise in a society that denied females legal political rights. Rachel used the access to power that family members and friends gave her, appealing to Devonshire, Godolphin, Halifax, Tillotson, and Lady Derby and Lady Ranelagh. She capitalized also on the friendship she enjoyed with the queen. That her petitions were well received owed much to her wealth, contacts, and role as surrogate for her husband, the Whig martyr.

Lady Russell's strengthened self-confidence and sense of self also informed her private life. The passage of time, the comforts of religion, the marriage of her elder daughter, the success of the Revolution, her revived political role, business activities, and the responsibilities of her children combined to assuage her grief. It is true that a melancholy strain still appeared in her letters, especially in those to Fitzwilliam or about the death of a family member or friend; moreover, she continued to memorialize the three days of William's arrest, trial, and execution, and events, as we have seen, still had the power to revive her grief. But her mourning was less intense, and lapses into black despair were less frequent. By 1691 she was keeping "visiting days," playing cards, and, upon her own admission, losing too much money at it.[60] The change in her attitude found reflection in a letter written to Tillotson on July 14, 1691, a time heretofore marked by intense mourning. Significantly, the purpose of the letter was to seek his help in winning a government post for a friend, but in closing she declared that she had been quite revived recently by the "many public and signal mercies" the nation had

received and that despite the "black and dismal scenes which are constantly before me" she was trying to "raise my spirit all I can."[61] Moreover, she no longer imposed her grief on others or expected them to grieve also, as she had done as late as 1687.[62] Rather, in the summer of 1693 she expressed relief that July 13 fell on a fast day so she could retire to remember William without exciting comment and declared that she took care not "to affect" in doing so. And that summer she spent a holiday at Bath.[63]

Rachel, moreover, seems to have reconciled herself rationally to the passionate side of her nature and to have become more comfortable with her own interpretation of Christian grief. She ruefully wrote in 1692 that her warm friendships and passionate attachment to her husband were at the root of all her "joys and troubles." Yet, to live and not love would make life insipid, and moreover, the delight of love in this world prepared one to know the greater bliss of it in the next.[64] She also elaborated the point in a draft paper in which she rejected the thought that a true Christian should "pluck out the eye, and cut off the hand, [and] lay aside every thing that may be an impediment in running our Christian race." If one loves nothing but God and fears nothing but sin, there will be no sorrow in a person's life. But in her view "flesh and blood recoil" from such a prospect.[65] She was confident enough to tell Fitzwilliam candidly that she could not live by his rules and that she felt she might grieve without sinning.[66]

This more secure command over her emotions and confidence in God did not mean that she had lost the capacity to grieve. The deaths in 1690 of her half-sister Elizabeth; of her nephew, the son of her sister Elizabeth; and of her cousin, a son of her uncle de Ruvigny, left her distraught. In commenting on Elizabeth's death, she observed with a touch of bitterness that on earth whatever is the "object of our love will become the matter of our sorrow." The idea of her young nephew dying before her she found hard to bear. "It is harder to be borne than a bigger loss, where there has been spun out a longer thread of life. . . Me thinks 'tis a violence upon nature." But she felt a little time would restore her to her "settled state of mourning; for a mourner I must be all my days upon earth."[67]

Greater confidence in God's love helped Lady Russell confront the most serious physical affliction of her life—the appearance of cataracts on both eyes. Because she enjoyed reading and above all the physical act of writing, failing eyesight was an especially hard blow. She first alluded to the condition in the summer of 1688, but it was not until 1692, when she was fifty-five years old, that she felt severely impaired. "I can hardly see what I write, and my eyes won't endure to do it by a candle," Lady Russell confessed.[68] In August 1692 Katherine wrote in great

anxiety to her sister, Rachel, over the fact that their mother had lost so much sight in the past three or four weeks. Katherine shared Lady Russell's fears that she would go blind.[69] In September Rachel could read very little, but she persuaded herself that writing did not hurt her eyes, so she continued to do it, but correspondence in her own hand was severely curtailed.[70]

Rachel's reaction to this impairment illuminated her strong character. "I hope I do not repine," she wrote Fitzwilliam, "but on the contrary rejoice" that total blindness had not yet overtaken her.[71] Furthermore, she decided to undergo an operation—a decision that took great courage in the late seventeenth century, when procedures and anesthesia were primitive. The operation was not new to late-seventeenth-century England, since the procedure dated back to the twelfth century, but dramatic improvements in it did not come until the middle of the eighteenth century.[72] An operation was performed on Rachel's right eye in the summer of 1694 and on her left eye the next summer; both operations were successful.[73] No information has survived about her doctor(s), about where the operations were performed and the exact dates, nor about what anesthesia and other procedures were used. It is also unknown whether or not Lady Russell was fitted for glasses. A portrait of her in old age (see the illustrations) does not show her wearing them, but it would seem likely that she did, the more so because Bedford, whose eyes were poor, used spectacles himself.[74] Rachel appears to have made a rapid recovery from each operation. In August 1694 her sister-in-law wrote of her happiness in hearing how much Rachel's eyes had improved. In August 1695 Lady Russell wrote herself, "I venture to write this much with my first eye. My new one does not alter much though I think I do see better than at first, but there is something still before it."[75] The next month she was able to write a "letter upon business" without damage to her eyes and follow it with a lengthy letter to her daughter Katherine.[76] After the operations, her handwriting, which had deteriorated in the early 1690s, was restored to its previous legibility and strength, and although she used an amanuensis as necessary, she resumed writing many letters herself. Lady Russell's eyes were never strong again, but she suffered no further serious problems with them.

During the years when her eyesight was failing, Rachel not only attended to public matters, as we have seen, but also gave devoted attention to the interests of her three children. A woman of fifty-four in 1691 with children ranging in age from eleven to seventeen, Lady Russell was an older parent, certainly older than most aristocratic mothers. That biological fact plus her energy, intelligence, and sense of obligation to her husband's memory combined to create an overanxious, oversolicitous attitude towards her children, especially her son. As her children

grew into adolescence and beyond, Rachel continued to make herself actively involved in their lives, even to the point of intrusiveness.

Lady Russell was particularly concerned about the religious education of her children, and she took steps, as many contemporary fathers but few mothers did, to set out in writing advice on the subject. She would have known of Carbery's letters of advice to her first husband, for it is through her that they came into the Bedford family. Possibly they inspired her to the same exercise. In any case, when her children received the sacrament for the first time, Rachel presented to each of them a paper setting out "all the passages" of the child's life to that point in time, providing a record of his or her strengths and weaknesses.[77] A lengthy letter of general advice on the religious life and a paper of detailed instructions for taking the sacrament followed in 1691;[78] they were probably addressed especially to Wriothesley and Kate. Significantly, Lady Russell did not turn to Fitzwilliam or any of her other clerical friends to perform this service, but undertook to counsel her children herself. The letter and papers reveal a high degree of self-consciousness and self-confidence.

Rachel recommended to her children a rigorous religious regimen based upon her own daily habits. It included morning, afternoon, and evening prayer; reading; and written self-examination on a daily, weekly, and monthly basis. She explained how to keep such a record of one's sins.[79] She chose certain passages in the Bible for her children to memorize and supplied specific pages in devotional material written by Taylor, Patrick, and others for them to consult. She stressed the conscientious confession of their sins and offered her own failings as a model. Declaring that nothing (barring religion) touched her so deeply as their concerns, Rachel exhorted her children, "When I have the least jealousy that any of you have ill inclinations, or not so good as I would, gladly have them, or fear that you tread, tho' never so little out of the right path, O how it pierces my soul in fear and anguish for yours—if you love or bear any respect for the memory of your father, do not endanger a separation from him and me in the next life."[80]

Although Rachel wrote didactically, rather like a schoolmistress, and anxiously, much like Carbery, she was also a sympathetic guide. Recognizing that her regimen might seem difficult in the beginning, she reassured her children that practice would make it easier. But easy or hard, for people who mean to be "serious in religion" such a procedure was "hugely more satisfying to the mind, than a more careless, loose way of living, and no settled method."[81] Moreover, in conformity with her lifelong sympathy for Dissent, Lady Russell was at pains to soften the dogmatic strain in her writing. She insisted that her recommendations for religious texts were not intended to restrict her children's

choice, but rather were "the best" that she could offer as a help at first. No one, she declared, may prescribe for another. Nonetheless, the standards that she set forth in these written materials must have seemed rather rigid and unattainable to an adolescent. Clearly Rachel sought to be a powerful presence for religion and morality in the lives of her children.

A prominent feature of these papers is the repeated evocation of the memory of Lord Russell. Rachel seemed determined that her children should not forget their father. But significantly she made no reference whatsoever to the political principles for which he stood in either these or any other surviving papers. In adulthood, only her elder daughter seems to have shared her interest in public affairs. Her son, who, as second duke of Bedford, might have made a mark in politics, did not develop an interest in public affairs.

Lady Russell took steps to advance the worldly as well as the spiritual interests of each of her children. Young Rachel was now living with her husband (who had returned from his travels and whose interests we have already seen Lady Russell promoting), and through the influence of her father-in-law, Lord Devonshire, she was invited to become one of the queen's ladies-in-waiting. Lady Russell was fearful that harm might befall her daughter in this role, and accordingly she appealed to Lady Derby, Queen Mary's mistress of the robes, for help. Remarking that her daughter was inexperienced, having never been parted from "too fond a mother," Rachel explained that Lord Devonshire had introduced her to court life earlier than she would have wanted. Since the queen desired her presence, Rachel would make no objections, but only seek Lady Derby's protection.[82] Lady Russell's love, anxiety, busyness, and connection with court figures are all reflected in this letter. Whether Lady Cavendish knew about it is unknown.

For her second daughter, Katherine, Lady Russell bent her energies in 1692 and 1693 towards achieving a favorable marriage settlement. Rachel did not initiate this project. Rather, John Manners, the ninth earl of Rutland, approached her in early 1692 with a proposal of marriage between Katherine and his son, also John, styled Lord Roos. The two families enjoyed equal social status. The Rutlands had won great wealth, high honors, and much land in the sixteenth century, and although their fortune and lands were less large in 1692, they remained powerful in Midland counties and in Yorkshire. Their principal seat was Belvoir Castle in Leicestershire, and among other estates they held Haddon Hall in Derbyshire.[83] Their politics were compatible with those of Lady Russell too. Although not prominently involved, the earl had been a supporter of the Revolution, joining with Devonshire and others in raising troops for the prince of Orange and giving Princess

Anne refuge at Belvoir Castle when she fled London in 1688.[84] Rachel realized that from a social and economic point of view this match was highly desirable, but initially she was unenthusiastic. The reason was that in 1670 the earl, then known as John Lord Roos, had won a divorce in church courts from his first wife on grounds of adultery. An act of Parliament, which became a cause célèbre, disabled the children of this marriage from inheriting his lands and honors and gave him the right to marry again.[85] Rutland had proceeded to do that; his second wife died without issue; his third wife, Catharine, daughter of Baptist Noel, viscount Campden (and thus related by marriage to Rachel's sister Elizabeth), was the mother of the prospective bridegroom. Rachel finally satisfied herself that the divorce was "just, as agreeing with the word of God" and that her "religious scruples" were "imaginary." This conclusion persuaded her that the earl's present marriage was also just and, hence, legal, so that Lord Roos's inheritance was not threatened. With these religious and economic reservations settled and the young man's character approved by others, Lady Russell was willing to entertain the idea of the marriage, but only, as she put it confidently, if Rutland agreed to *her* terms.[86]

Lady Russell handled the negotiations respecting the property settlement herself, as she had done the marriage contract of young Rachel. Although the discussions lasted over a year and involved several meetings of the parties and their lawyers, the bargaining with Rutland was apparently less tough than it had been with Devonshire. Rutland was apparently eager for the match, perhaps in part because in 1692 he had provided his daughter with a £15,000 dowry and hoped to recoup the money by marrying his son.[87] Rachel displayed an intimate knowledge of the value of her properties, a sharper understanding than Rutland of the relative value of London and Hampshire holdings, and skill in presenting her case. Rutland's position was that he wanted the same contract that she and Devonshire had agreed to. On August 30 Rachel sent him an abstract of that settlement, and they seem to have worked from it.[88] Disagreement between them centered on the size of Katherine's dowry, the security for it, and the method of payment. Initially Rachel had offered a smaller dowry, "because it was too hard on me to do so much," but Rutland persuaded her to provide the same dowry of £25,000. Rutland preferred a lump-sum payment, but agreed finally to accept payment in installments. The security for the money was Lady Russell's ground rents from her London properties, whereas initially Rutland had asked for land in Hampshire. Insisting that she wanted to please Rutland in everything, without "extreme inconvenience" to herself, Lady Russell repeatedly argued that the ground rents were of greater value and better security, for they brought in £6,000 a year and would increase in

value when they expired.[89] When Rutland finally agreed, Rachel persisted in iterating that the arrangements were the best for both of them.[90] Lady Russell liked to win an argument, and her knowledge of her business affairs and her skill in writing enabled her to do so.

Lady Russell did not defer to her daughter's wishes in the marriage any more than she had done with young Rachel. She declared that she would not unite her child with a person of ill repute, no matter what his wealth, but given the candidate's moral integrity, his wealth and social position weighed heavily with her. She seems to have quieted her own conscience by insisting that the young couple meet several times at Woburn so that they might, as she put it, "at least guess at each other's humour before we venture to make them (as I hope they shall be) a happy couple," but these encounters took place while the property negotiations were in progress.[91]

Whatever Katherine's view of Lord Roos, Rachel found him to be a "pretty youth," "virtuously bred," and with "no disposition in him that is blameable." She recommended that he should go to university, where in her view, "our nobility should pass some of their time; it has been for many years neglected."[92] This opinion did not prevail in the case of Lord Roos, but it anticipated Lady Russell's decision to send her son to university. Lady Russell frankly wrote to Fitzwilliam that although she was "apt" to say that the wedding would not go forward unless the pair were happy in each other, she found a distinction between their "happiness" and God's approval. Confident of the latter, she concluded that the union was highly desirable. Candidly, she expressed satisfaction in the thought that she had joined her daughters to the "two best fortunes in England."[93] She was as mercenary in her view as any patriarch of a noble family.

The wedding took place at Woburn on August 17, 1693. No description of the celebration there has survived, but a lengthy account of the reception young Lord and Lady Roos received when they journeyed to Belvoir Castle, contained in a letter to Lady Russell, provides a rare glimpse of country social customs. The high sheriff of Leicestershire and all the country gentlemen greeted the couple when they first entered the county, and the following day "thousands" of people joined the gentlemen to pay their respects. The crowds increased as the party approached Belvoir Castle, with aldermen and corporations in attendance, as well as clergymen who presented congratulatory verses. A twentieth-century visitor to Belvoir Castle may readily visualize the progress of the cavalcade across the flat plain to the castle, which stands on a low hill, and the welcome at the gate by four and twenty fiddlers, trumpeters, and ladies, altogether seventy-two people who ushered in the pair with music. After an "exceeding magnificent supper," everyone, led by the

bride and bridegroom, went in procession to the great hall, where an enormous cistern provided sack-posset for the drinking of toasts, first in spoons, then in silver cups, and then, with the family on their knees, in brim-full tankards. All this lasted until past midnight.[94] The account must have vivified the scene for Lady Russell, who, because of her poor eyes, was not part of the party. She followed her daughter to Belvoir after two or three weeks and stayed there for about a fortnight.[95]

After the marriage Lady Russell remained a presence in the life of her daughter, writing her regularly, arranging for visits, and sending her advice and admonitions.[96] Lady Russell also advised her daughter on more serious matters. In 1695 something went awry in Kate's life, and she turned to her mother. In response Rachel, writing in her own hand, urged her to remember her "former promises" to accept God's providences cheerfully. She reminded her of her duty to her husband and baby and adjured her to "act your part and glory in it." If she were happy now, she might be less well prepared for eternity. Inevitably Lady Russell adverted to her own years of "bitter grief" and declared that life was a "continual labour checkered with care and pleasure." The difficulty, she assured Katherine, would pass in time. Presumably the sympathetic, warm, and wise tone of Rachel's letter comforted Lady Roos, perhaps the more so because of the contrast offered by her sister's postscript, which read, "I am so out of charity with you that I will not add one word to this, but leave you entirely to my mother's good council."[97] The postscript is worth noting, for it indicates what other letters demonstrate— that, in contrast to Lady Russell's lifelong loving relationship with her own two sisters, young Rachel and Katherine did not get on well.[98]

Lady Russell was also at pains to create a warm relationship with the Rutland family, just as she had done throughout her life with respect to every family to which she was allied. She sent Kate a portrait of her mother and received with pleasure her son-in-law's portrait.[99] She continued to write to Rutland (rather than to the countess) and, as we shall see, was actively involved in winning a dukedom for him.

Lady Russell gave particular attention to the rearing of her son. She evidently felt a special sense of responsibility for him. Thanks to her energy and skill and the effects of the Glorious Revolution, he was presumptive heir to the Bedford title and fortune. Undoubtedly she saw in Wriothesley a reflection of her beloved husband and the possible fulfillment of the aspirations they had shared. Up to his coming of age in 1701, she carefully supervised all aspects of his moral, social, and intellectual development. After that she continued to advise him. Without her skills and indulgent love, there is no doubt that his prospects would have faltered.

Wriothesley was a coveted match in English society, and as in the

instance of his sisters, Lady Russell received, rather than initiated, proposals of marriage with him. When he was still thirteen years old, in 1693, the Reverend John Howe, the Dissenting clergyman, brought a proposal from Sir Josiah Child, the wealthy merchant and officer of the East India Company, for a union between Wriothesley and Child's granddaughter, the Lady Henrietta Somerset, the daughter of Charles, marquess of Worcester. The young woman's fortune was enormous, but for unknown reasons Lady Russell rejected this suit. Indignant at the rebuff, Sir Josiah confided to Howe that he believed that either Lady Russell did not understand the "considerableness" of his proposal or had made other arrangements for her son. The excuse given—namely, that the two young people were still being educated—was no bar to discussing marriage when great fortunes were involved. Recognizing that both parties would inherit large wealth, Sir Josiah declared that he wanted the fortune of his granddaughter to come into the "best and most pious noble family" in the land.[100] Lady Russell reconsidered. Over the past six years she had encumbered her estate and also paid out large sums of money for the dowries of her two daughters. To win for her son a bride of great wealth, even though the family was not landed nobility, would go far towards recouping that money. Whatever the reasons, negotiations were reopened. By the summer of 1694 negotiations leading to the marriage of Wriothesley, now Lord Tavistock, to Elizabeth Howland, another granddaughter of Child, and the only daughter of John Howland and Elizabeth Child Howland of Streatham in Surrey, were far advanced. The prospective bride, aged fourteen, was a fine match from an economic point of view, for she stood to inherit from her grandfather, deceased father, and her mother, and was reputed to be worth upwards of £100,000.[101]

Once again, as in the case of her two daughters, Rachel managed the marriage settlement. No evidence has survived to show that the boy was consulted. As we have seen, Lady Russell placed high priority on the social and economic benefits that accompanied uniting her children with great families. In the case of her son she chose great money over ancient lineage.

Lady Russell and Mrs. Howland were the principals in settling the marriage contract, the negotiations for which took over a year to complete. In August 1694, in one of the first letters that she wrote following her cataract operation, Rachel discussed with Mrs. Howland the matter of some land in Cambridgeshire that would pass to Wriothesley. With customary shrewdness and attention to detail, Rachel sent her steward to ascertain the value of the property and arranged to employ Mrs. Howland's attorney, who was better known in the area than her own lawyer.[102] A portion of the marriage treaty was ready in November 1694.[103] So

much property was involved that a parliamentary act was required to settle matters, and the Tavistock Estate Act passed on April 22, 1695.[104] That achieved, the parties completed the final document, dated May 20 and 21, 1695. The essential feature was that Mrs. Howland paid Lady Russell the enormous sum of £50,000 as dowry for her daughter. For her part Lady Russell conveyed to trustees properties that would provide the couple an income of £2,500 per year until Bedford's death. The money was to be paid first at Christmas 1695, with £1,200 going to Elizabeth Howland until the couple cohabited. Then Elizabeth was to have £1,000 a year for her separate use, apparel, ornaments, and wages for two servants.[105] As part of the arrangements at the time of her son's marriage, Lady Russell mortgaged Southampton House to the earl of Rutland for £10,000 and also put some of her Middlesex property in trust to raise further sums, not to exceed £20,000, as needed.[106] At her death those arrangements were to play a part in the settlement of the estate.

Negotiating the marriage settlement brought Rachel and Mrs. Howland together and they remained friends thereafter. As she had done with her daughters, Lady Russell made friends with the family with which her son was united. Rachel and Mrs. Howland shared an interest not only in the education of their children[107] and later in their grandchildren but also in religion and in business affairs. A business letter of January 3, 1696, illustrates the easy relationship between them and Rachel's shrewd business sense. Referring to the payment of rent due her from Mrs. Howland's father on a London property, Rachel wrote, "I will put him in mind to pay his rent, for I think 'tis good to take men's money when they have it to give." One may imagine that Mrs. Howland read this comment, written by an aristocratic lady but reflecting a practical attitude towards money, with some amusement. Continuing the letter about some property in which the two women shared an interest and apparently desired to sell, Rachel declared that she would make no decision on an offer she had received until she heard from her friend. "I do hope you will consider if we are like to do better, and if not, my opinion is to close with him," she wrote.[108]

The wedding ceremony uniting Elizabeth and Wriothesley was conducted by Bishop Burnet in the chapel at Streatham on May 23, 1695. The event is notable for a charming, perhaps apocryphal, story about the two youngsters, who slipped away from the adult company to play. The consequence of their running and sliding was that Elizabeth ruined her costly gown, which "petrified" both of them. Tavistock reappeared among the adults affecting innocence, while Elizabeth sought haven in the straw in the barn.[109] After the wedding both youngsters returned to their mothers to complete their education. Elizabeth was tutored privately. It was intended that Tavistock, in conformity with the

advice his mother had offered Lord Roos, should enter Cambridge University, where his father had been educated.

But before that happened an opportunity developed for Tavistock to perform a service for the Whig party. On October 3, 1695, Lady Russell received a letter written by Sir James Forbes on behalf of the lord keeper, Sir John Somers, and the duke of Shrewsbury, importuning her to allow her son to stand for knight of the shire for Middlesex in an upcoming general election. These men insisted that Tavistock need not actually serve in the House of Commons, and thus his election would not interfere with his education nor his plans for travel. He would appear but once on the hustings, attended by several hundred gentlemen on horseback and for that day would be known as "Lord Russell," to evoke memory of his father. His running mate would be Sir John Wolstonholme, a man recommended by Somers, who had connections in Bedfordshire. Their election was regarded as a certainty and the only way to defeat "two notorious Tories." Even if Tavistock was not present in the House, the Whigs figured that they would have three extra votes, because they would keep out two Tories and bring in at least one Whig, Tavistock's running mate. Allowing Tavistock to stand for election, Forbes argued, was for the honor of the Bedford family.[110]

A flurry of letters ensued, aimed at persuading Rachel and Bedford of the wisdom of the proposal. One man asserted that several other underage sons of great men planned to run on the same terms as Wriothesley, and that Tavistock would look less out of place than they because he was taller![111] Plans were laid to canvass the views of voters.[112] Suggestions were aired as to how to deal with a man who was much offended that Bedford had withdrawn support from his candidacy, switching it to Tavistock. The solution proposed by Edward Russell, Rachel's brother-in-law, was for Bedford to excuse himself by shifting the blame to Lady Russell, saying that the importunity of great men prevailed with her.[113] The idea seems to have died, perhaps because Rachel persuaded Edward that it insulted her political integrity. Although for a time it looked as if Rachel and Bedford would agree, Lady Russell finally decided not to allow her son to stand. The announced reason was that such an election would interfere with his education and plans for travel. Another reason is suggested in a letter Rachel wrote to Edward. Showing shrewd political sense, she declared, "It is clear to me that my Lord Shrewsbury had no original thought in this business; nor, I verily believe, any further approbation than through compliment to his friends." Fearing defeat, she asserted that it was "very late for two persons of uncertain interest to set up against two that know theirs, and no doubt have been effectually labouring in it."[114] As it happened, Edward Russell decided to run with Wolstonholme, and both

were elected on November 14, 1695.[115] Some weeks later Lady Russell expressed mild regret that she had *not* allowed Tavistock to stand.[116] Probably the memory of her husband's political career in the 1670s and her ongoing interest in public affairs had created ambivalence in her attitude. But when it came to making a choice that might have resulted in embarrassment and surely in some disruption of plans, Lady Russell put the welfare of her son above political considerations.

Rachel had gone forward with plans to take Wriothesley to Cambridge, where she intended to rent a small house until he was settled in.[117] A "snag" occurred when she heard that smallpox had broken out in the town. Admitting to Mrs. Howland her fear that she was being "too fussy," she decided to cancel the arrangements. She learned that Oxford was free from the disease and, acting upon this assurance, enrolled her son there.[118] Thus it happened that Tavistock attended Oxford University rather than Cambridge.

Lady Russell accompanied Lord Tavistock and his tutor, John Hicks, to Oxford in April 1696 and stayed there for several months.[119] She thoroughly enjoyed herself. Friends and relations came through the town, and she entertained them and was entertained in return. People from the university, such as Dr. John Wallis, a well-known mathematician and writer on philosophical and theological subjects, called. She also saw her son, never failing, at both dinner and supper, and received gratifying reports of the progress he was making in his studies.[120] Moreover, the academic atmosphere reinforced her usual reflective attitude. One letter that she wrote to Thornton is of special interest because in discussing her son's studies she comes close to suggesting personal ambitions. Rachel declared, "Whatever further progress I make [towards virtue and knowledge]... must content my ambition, but on my son's it does not; I desire he may aspire higher."[121]

Enthusiastic accounts continued of Tavistock's attention to work, liking for logic, and independence and excellence of judgment.[122] But Rachel, who knew her son well, was skeptical. She warned Hicks that he might expect from Tavistock "great promises and small performances" followed by "a full blush and some soft words in excuse for non-performance of promise."[123] She was correct in her judgment. Tavistock was not really inclined towards scholarship. He resisted reading a book more than once, and when Hicks recommended a new and advanced text in logic, Wriothesley said that he had had enough of logic.[124] But he developed a reputation as a gambler, as Hicks reported to Lady Russell. Tavistock wrote in anxiety to his mother that he thought it hard that a "little gaming, such I mean as would not hurt one," should have harmed his reputation. He begged her not to worry about "my loving play," and

declared that he was "certain" that he would never be guilty of losing a lot of money.[125]

When Tavistock had completed a year of study, Rachel sent him abroad to travel. She made arrangements for the trip with great care. In October 1697 Rachel won Bedford's approval of her choice of Hicks as tutor and traveling companion. The duke wrote that he had admonished Wriothesley to follow Hicks's advice. He also urged that his grandson not stay abroad long nor visit Italy.[126] Rachel also engaged a Mr. Fazio to be part of the party. She secured letters of introduction from her cousin, Henri de Ruvigny, now earl of Galway. Almost certainly because of her connections at court, arrangements were made for the group to embark with the king's convoy going to Holland at the end of October 1697.[127]

Tavistock stayed in Europe for two years, covering much the same ground as his father had done forty years before: the Netherlands, the German courts, France, and, despite his grandfather's objections, the Italian courts and cities. But there was a difference: whereas William Russell had been a younger son of a family of no great distinction, Wriothesley was the acknowledged heir to a magnificent fortune and to the title of duke. He arrived on the Continent preceded by the reputation of his father; his uncle, Admiral Edward Russell; his cousin, the earl of Galway; and even of his mother, a copy of whose portrait was found in a collection in Italy.[128] Everywhere he stopped he was received with ceremony and welcomed into the highest ranks of society. His mother must have felt special pleasure in knowing that at his first stop, The Hague, he was presented to King William III, who was there on his way back to England, following the signing of the Peace of Ryswick.[129] This and many other marks of favor were a heady experience for a young man, and it is not to be wondered that he took pleasure in describing them.

The high society that he moved in offered the temptation to gamble, and Tavistock succumbed immediately at The Hague. He was overcome with remorse, especially because Rachel apparently indicated to him that the expense was an inconvenience. He promised not to play anymore—except for the little money he had on him, which he declared was "as good as not playing at all."[130] Perhaps Lady Russell blamed Fazio for this lapse; perhaps Hicks did too. Rachel dismissed Fazio and appointed in his stead one Mr. Sherard, whose responsibility was to manage finances and accommodations. Fazio retaliated by bringing back poor reports of his former charge.[131]

The place that Tavistock loved the most and stayed in the longest was Rome. He particularly liked riding about Rome at midnight in an open calash. The routine of his days included listening to music, fencing

(with the best master in Italy), going out to take the air, practicing Italian, and attending social events. He became friends with cardinals, especially Cardinal Ottoboni, the nephew of the preceding pope, Alexander VIII; with a Catholic priest, Father Coemus, who supplied him with further introductions; with the Imperial Ambassador and his wife; and with a host of other high-born Italians. This Roman Catholic community, because of the pope's dislike of Louis XIV, professed to applaud the Glorious Revolution and to admire the English, especially King William and Admiral Russell.[132] They were pleased to shower Tavistock with attention, inviting him to dinners, lunches, and the opera. News of his reception reached Lady Russell by diverse sources, including a private letter to her goldsmith. She was so proud of comments about what a fine, deserving gentleman Tavistock was that she wrote about his triumphs to Lady Roos.[133]

Tavistock's letters would have made it abundantly clear to Rachel that her advice set out in 1691 recommending a regimen of thrice-daily prayer, reflection, and reading of religious texts had fallen on deaf ears. Clearly, Wriothesley was exulting in the freedom from the dour atmosphere of Southampton House and his mother's high moral and religious standards. The trip helped him to find his own tastes and interests: music, opera, art, and collecting rare and beautiful objects. He spent money lavishly. Sherard estimated that Tavistock's expenses for the year would come to about £3,000 and noted that Wriothesley "did not care being denied anything that he has a fancy to."[134] Hicks believed that the only way to achieve retrenchment in expenses was for Lady Russell emphatically to command that it be done. "Orders from England are what we want, and nothing will go well without them," he advised.[135] No such order was given.

Wriothesley's unrestrained extravagance reveals how indulgent a mother Lady Russell was. Tavistock sought to justify himself on grounds that his expenditures were "absolutely necessary" to maintain his position and that of his family. The money was well spent because his experiences in Rome would "improve" him as nothing else could. He was confident that his mother would not "grudge" the money, but rather pay the bills.[136] She did. Tavistock once took financial matters in his own hands by secretly drawing a bill for £200 on his mother's account to pay for some presents and other things he "had a great mind to have." He explained that his brother-in-law, Lord Hartington, owed him £120 and that if Rachel would get that sum from him, she would be out of pocket only £80. But if Hartington would not pay her, Tavistock was sure that under the circumstances his mother would pay the entire bill. He begged her not to tell Sherard or Hicks about the matter. Two months later, perhaps in response to a reproving letter from Rachel, Tavistock

described himself as in such a state of grief over the matter that much more sorrow would hurt him. He declared that if Sherard found out what he had done, he would lie to him, saying that the money was his in England, from the debt owed him by Hartington. He promised on his word and honor that if his mother had to go into debt he would repay her when he returned, even if it meant living in the country for ten years. He wanted to return to England to be a comfort to her and, choosing his words carefully, to "follow in some things...the steps of my good father." He ended this contrite letter by telling her that he had spent £100 on two pairs of fancy embroidered stockings, one for her and one for Lady Tavistock.[137] Rachel paid.

An even more reprehensible weakness in Tavistock was his addiction to gambling. Repeatedly he lost money; repeatedly he wrote his mother contrite letters promising before God not to gamble again.[138] In September 1699 the matter reached a crisis when Rachel wrote him an apparently sharp letter saying that Galway had heard rumors that Tavistock had left Italy without paying Cardinal Bouillon the gambling debts he owed him.[139] In response Wriothesley confessed himself guilty of concealing several "misfortunes," but he maintained that it was "absolutely false" that he owed Bouillon anything. He closed by saying that his head hurt too much for him to write more. Four days later, having received a letter from Rachel suggesting that perhaps he had been cheated, Tavistock agreed that such was probably the case. He recounted the "facts how it was," namely that he had been able to pay only half of his gambling debt to Bouillon, and that a "monk" had said he would pay the other half, as he had done at other times, and that he had heard no more of the matter until the rumor surfaced. He recognized that the "monk" was a cunning fellow and the people at Cardinal Bouillon's "very sharp." With this realization firmly in mind, he begged his mother that she and Galway agree quickly what should be done.[140]

Tavistock's imminent arrival home was further marred by another rumor. In great agitation, Admiral Edward Russell relayed to Lady Russell on September 19, 1699, gossip that Tavistock had converted to Catholicism. Russell declared that Wriothesley could not live as duke of Bedford and be Catholic.[141] The rumor came as no surprise to Rachel; she had heard it before and been reassured by her son that it was nonsense.[142] In her level-headed and protective way, she apprised Thornton of the situation and advised that everyone remain quiet about it. To avoid speculation about who originated the gossip, she excised names in Tavistock's letters before showing the letters to anyone else.[143] Hicks confirmed Rachel's good judgment, describing the charge as a "downright falsehood" that would die of its own accord, which in the event proved correct.[144]

Tavistock's gambling debts, however, were another matter. Upon his arrival in England, it was revealed that he had lost more than £3,000 in Italy. Fortified by Galway's insistence that gambling was the least serious of sins to which a young man might succumb,[145] Rachel took steps towards arranging for repayment. On Friday, December 22, 1699, Lady Russell wrote Bedford a masterful letter about the situation. She told him how much money was involved, stressed Tavistock's grief, and stated the problem: how to repay the money secretly so that Wriothesley's reputation would suffer no further damage. Next, she outlined her proposal in a logical, straightforward manner showing her grasp of financial matters and her intelligence and integrity. She asked that Bedford stand surety for a bond for £3,000 for which she and Tavistock would be the principals. "I will find the money," she declared. Bedford would run no risk, for the rents of their estates would soon pay it off; if either one died, the result would be the same. The bond "can at no time come to be paid by you," she assured the duke. Only the family steward need know of the bond, and he need not be apprised of its purpose. Lady Russell declared that she felt obliged to help her son "this one time, and no more." She also recalled the "debt [his] excellent son" had left her and ended rhetorically, "Who should I apply to besides yourself?"[146] The duke complied, and with Galway orchestrating the project, the money was sent secretly to France.[147] For years thereafter interest on the debt was paid until the principal was repaid at Wriothesley's death in 1711. Thus Lady Russell rescued her wayward son and preserved his reputation. She was too shrewd not to perceive his weaknesses and too loving a mother not to assist him.

Rachel took other steps to advance Tavistock's interests. In early 1699 she and Galway discussed making him a naturalized French citizen (her own status, it may be remembered) so that he might inherit property in France from her and Galway.[148] Nothing came of this idea, but it is worth noting, for it shows that long before his death, Galway and Rachel were concerned over how claims on his property, which had been forfeited when he joined the prince of Orange in the Revolution of 1688–89, might be pursued. Later, as we shall see, after Galway's death in 1720, when she was eighty-three years old, Lady Russell sought to claim her family's French property. "Some days" after the duke of Bedford died on September 7, 1700, Rachel wrote to King William to announce the duke's death and to tell him that, as Bedford's executor, she had his "George" (meaning the insignia of the Order of the Garter) in her hands. Confessing ignorance of the proper procedure in such matters and begging the king to forgive a woman's troubling him, Rachel respectfully requested that he confer on her son, now the second duke of Bedford, his grandfather's Garter. "I know," she wrote, in terms that reflect her cen-

tral position in the Bedford family, "the whole family would always look upon it as a mark of your grace and favor to them and if anything could make them show greater zeal for your service than they do now it would be the honor you bestow on this young man."[149] On September 23 King William responded in a letter written in his own hand in French. He sent condolences on the death of the duke, assurances of favor to Bedford, and expressions of admiration for her, but he neither awarded nor promised to award the order to Wriothesley.[150] Nevertheless, Rachel's overture laid the groundwork for the subsequent award of the honor. The next year, when Bedford reached his majority, he won appointment as lord lieutenant of Middlesex and of the counties of Cambridge, Bedford, and Middlesex.[151] Young Bedford's title and honor he owed to his mother.

The fact that Bedford made Rachel executor of his will requires special remark. It testifies to the fond place she held in the duke's affections and to the respect she enjoyed as a woman who understood business affairs. Even before his death, as he aged, Bedford gradually relinquished to or shared with Rachel the responsibilities associated with being the head of a family. After his death she unquestionably occupied that position. Such a role did not just happen; there were several blood sons and daughters of the duke. That it did develop underscores Rachel's intelligence and integrity and reveals the love and respect that Bedford bore her.

Although preoccupied with Lord Tavistock's affairs during these years, Lady Russell continued to take an active part in business and public matters. She took seriously her responsibilities as patron of churches on her Hampshire estate, as a letter to Sir Robert Worsley written perhaps in 1696 demonstrates. Writing in a businesslike manner, she sought his opinion of a candidate, one Mr. Swayne, for the rectory at Kingsworthy and the vicarage at Micheldever. Displaying a sense of confidence and of personal status, she asked Worsley, whom she thought favored the candidate, to respond honestly about his qualifications out of regard to the "weight of the matter and to me who ask it from you." She set out the terms of the contract: the stipend (which Lord Russell had increased and whose increase she proposed to honor) and also the requirement of a bond to perform the conditions she specified. Without the bond, she explained, she would have no remedy. Lady Russell asked Worsley to "discourse Mr. Swayne" and then have an instrument drawn up "to the purposes I have signified."[152] At about this time the churchwardens at Micheldever church acknowledged Lady Russell's interest and her business acumen by placing in her hands the money raised for a bond to help the poor of the parish.[153] Her devotion to the church at Micheldever found expression in 1703, when she presented it with an

unusually large silver cup, perhaps as a thanks offering that her son and daughter-in-law had escaped injury in the violent storm that ravaged England in November 1703.[154]

Now that the sharpest sting of her grief for her husband had subsided, she seemed to enjoy Stratton once more and to take an interest in her tenants and in the condition of the estate. For example, in 1700 she asked Bedford to bestow a living on one of her Hampshire tenants. The man's family had been tenants of her father, and as she put it, "I would not deny them to do thus much on their behalf."[155] There is no indication that Lady Russell made improvements to Stratton House, but she did improve the estate by buying two "little" parcels of land in 1698 and by starting in 1699 on a small scale a herd of fallow deer, which grew in number and in value to £250 by 1730.[156] She dealt with the severe storm of 1703, which had thrown corn and hay up into the treetops and torn up fir trees by their roots, by immediately dispatching her steward to assess the damage and take steps towards repair.[157]

Other business matters show Rachel's persistent attention to details. She took steps to protect the value of her London property by entering a petition on March 20, 1701, to confirm the patent that Charles II had granted her father to hold markets in Bloomsbury.[158] She continued to deal directly with Rutland regarding the business affairs between them. In 1702 she wrote to apologize for a delay in his receiving information from her. "The error," she explained, "lay in speaking first to a servant, who did not so well remember my settlements as myself."[159] In 1707 she was still handling the correspondence herself, writing that her steward had not replied to a letter from Rutland's agent because she wanted to do it herself.[160]

Rachel's interest in political gossip and issues remained strong. Even before Fitzwilliam's death in 1669, and especially thereafter, she poured out news of events in letters to her daughter Katherine and to the earl of Rutland. For example, in August 1697 she regaled Katherine with a story of the barbarous eating habits of Czar Peter of Russia, who was visiting England as part of his famous journey to the west. He "spit often," Rachel reported; and when he finished his meal, he "whistled" for an attendant who swept up the room with a broom. Lady Russell also noted that Peter was an excellent carpenter.[161] She may also have written to her son about the czar, for in December of that year Tavistock, traveling through Holland, was at pains to tell her that Peter had become more "sociable" in polite society, while at the same time he was learning Dutch and working every day with common seamen.[162] Another example of Rachel's ongoing enthusiastic interest in public affairs may be found in a letter she wrote to Rutland five years later, in 1702. Lady Russell was so eager to report the actions of the House of Commons that

she waited until evening for the latest news, and because her eyes would not permit her to finish the letter by candlelight, she had her daughter do it for her.[163]

Lady Russell was more than a mere observer of public affairs. As she entered the sixth decade of her life, she continued to exercise her influence on appointments at the national level. Although some of the posts in which she was concerned were of little significance, they hold interest because they show that the major contact Rachel used was the duke of Devonshire.[164] Devonshire had been named one of the lord justices to whom the government was entrusted after the death of Queen Mary when the king was out of the country and, clearly, was a powerful friend. For his part, Devonshire used Lady Russell's influence in a case that claimed his interest, that of Donough Maccarty, the fourth earl of Clancarty, Sunderland's son-in-law. Clancarty, who held huge estates in Ireland, had converted to Catholicism during the reign of James II, fought with him, been captured, and had his estates confiscated. He fled to the Continent. After the Treaty of Ryswick he returned home to be united with his wife and to beg pardon from the king and permission to go into exile with his wife and to be forgiven. But Sunderland and his son, greedy for Clancarty's lands and despising his past politics, not only refused to champion him but also arranged for his arrest. Probably because of political infighting as much as sympathy for the couple, Devonshire and Bedford took up his cause. Rachel, moved, perhaps, by the romantic story, agreed to help. In January 1698 Lady Russell, accompanied by Lady Clancarty, delivered a petition directly to King William on behalf of the earl of Clancarty. As Macaulay tells the story, William so esteemed Rachel that he pardoned Clancarty and granted him a small pension on condition that he and his wife live in exile.[165]

In further exercise of her influence, Rachel, always concerned to promote the interests of her family, undertook to win a dukedom for the earl of Rutland. She probably initiated this project in 1701, for a draft letter to the king dated February 1702 thanked him for noticing that she had not yet formally presented her petition and announced that she had put it in the hands of Lady Derby to present to him.[166] She followed this with a letter "about the first of March" which was found in the king's pocket at his death. In it she thanked him for promising to honor Lord Rutland and his family, "in which," she wrote, "I am so much interested." The act would lay an obligation on the family, she assured the king. Then, assuming a role as spokesperson for the entire family, a most unusual part for a woman to play, Lady Russell asked to be allowed to "answer for all those I am related to" and pledged them to his service. Further, always eager to put forward her son, Rachel seized the opportunity to remind William of her hope that he would bestow the Order of the

Garter on her son. In so doing she reinforced the written record she had earlier created.[167] But William did not live long enough to respond. He died from complications following a hunting accident on March 8, 1702, without awarding Wriothesley the Garter or making Rutland a duke.

For Lady Russell the "prime" of her life in terms of her influence, authority, and achievement came rather late, when she was about fifty to sixty-five years old. During these years she conquered the raging grief over the death of her husband that had nearly incapacitated her and emerged as a public figure, the symbol of her martyred husband. This role, in addition to wealth, the powerful positions of the men of her extended family, and her friendship with the new monarchs, enabled her to exercise influence on public affairs and to participate in the patronage system in state and church. Her requests carried weight partly because those in a position to forward them saw advantage to themselves in doing so. Her activities during these years illustrate in striking fashion the public dimensions of family connections and the part that a woman might play in public affairs.

Lady Russell also assumed the role of matriarch of the Bedford family, taking precedence over her brothers- and sisters-in-law. It was Rachel rather than one of them whom the duke chose as his executor. Thanks to her business skills, she increased the value of her properties and used her holdings to negotiate favorable marriages for her children, linking the girls with landed families of wealth and standing and her son with one of the wealthiest commercial families in the nation. Despite her own romantic view of love and marriage, she arranged these unions with little or no consideration of the personal inclinations of the partners. Thanks also to her understanding of finance, she was able to rescue her son from potential embarrassment. As she entered the seventh decade of her life, Lady Russell could take satisfaction in her personal position and achievements.

· 9 ·
Declining Years and Death, 1702–1723

Old age came gradually to Lady Russell, and no specific year marks its onset. One may select 1702 as the beginning of her seniority; it was the year in which she turned sixty-five, King William III died, and Anne, Queen Mary's sister, succeeded to the throne. For the next several years Rachel suffered little diminution in vigor, keeping in close touch with her children and grandchildren, following public affairs, monitoring her business interests, devoting herself to piety, visiting and receiving friends. She did not show strong signs of declining powers until the end of 1711, the year in which her friend Rutland and her son and second daughter died, her children within six months of each other. Living thereafter mostly at Stratton, Rachel became even more introspective and reflective than before, and occupied herself in writing meditations and short essays. Age and imperfect eyesight did not dampen her enthusiasm for "scribbling." Her cousin, the earl of Galway, became her closest confidant, but in contrast to earlier periods in her life, she seemed to have more friends among women. During these years she achieved a serenity of spirit that testified to her success in reconciling herself to sorrow and in accepting God's providence. She virtually disappeared from the written record after 1718 and died at Southampton House five years later, in 1723, at the age of eighty-six.

Lady Russell's longevity requires comment. To live to age eighty-six is an achievement in any society, the more so in Stuart England, when life expectancy at birth, across the population, was thirty-two years. That rate, however, jumped significantly for individuals who were members of the rural elite and survived to age twenty-one; their average age at death was early sixties, except during the late seventeenth century.[1] The age at death of many of Rachel's family and friends conforms to this statistic and makes her long life seem remarkable rather than extraordinary. Several people in her blood and extended family lived beyond sixty—her paternal grandmother to eighty-one; de Ruvigny, her uncle, to eighty-six; Galway, her cousin, to seventy-two; Devonshire

to age sixty-eight; Rutland to seventy-three; and Bedford to eighty-seven. Some of her friends also lived to advanced age. For example, Fitzwilliam lived to sixty-one years of age, Lady Shaftesbury to sixty-six, and Lady Essex to eighty-one. If one looks more widely, one finds that of the 267 men listed in *Who's Who in History, 1603–1714*, 63 percent attained the age of sixty or over.[2] The group in which Lady Russell was probably an outstanding exception is women, and in particular noble women, but there are no studies to confirm that hypothesis.

Lady Russell's longevity may owe something to biological tendency among both her French and English ancestors. But even more important surely were the moderate level of her fertility, which shielded her from yearly pregnancies, and her obvious ability to withstand miscarriages and the experience of at least five childbirths. Still further, her recovery from measles and smallpox during her twenties provided immunity which protected her from those dread diseases. Moreover, her wealth and intelligence served her health. She herself noted that she was prompt to seek the best medical advice when illness struck members of her family or herself. In her view medicines should be prepared only by skilled hands. She admitted that she had been "timorous" in face of the plague in 1665 and had left London.[3] Furthermore, Rachel's longevity may have been promoted by her love of walking and her active, vigorous personality, which induced her to stay busy long after she had reached advanced years. She alluded to the need to stay occupied in one way or another in 1698, remarking that "so one is doing 'tis well enough."[4] Her attitude towards aging may also have encouraged long life. She does not seem to have thought of herself as "old" until she was nearly seventy. The first time she alluded to her old age was in 1706. Writing to her son she confessed, "I feel the decays that attend old age creep so fast on me, that, although I may yet get over some more years, however, I ought to make it my frequent meditation, that the day [of death] is near."[5] In fact, she continued to enjoy good health, suffering from only minor infirmities, such as shortness of breath in 1709, "a sort of rash" in 1714, and, in view of her dislike for cold weather, undoubtedly the common cold.[6] In about 1717, when she was eighty, she complained to her granddaughter of cold weather, writing in words that show that she had not lost her command of felicitous expression: "Cold winds make your old mama shrink."[7] In the same year, she commented upon her "easy health," saying that she was as free from infirmities as anyone her age could hope to be and possessed of enough memory to enjoy hearing stories of her family.[8] But the last few years brought significant changes—a tremor in her handwriting and then an absence of letters and memorabilia, testifying to further dimming of her sight and slowing of her mental faculties.

From 1702 to about 1707 Lady Russell maintained interest in and exercised modest influence on public affairs. Although the death of King William and the accession of Anne to the throne find no comment in Rachel's surviving correspondence, one may be sure that she regretted the passing of a monarch who had consistently favored her petitions and advanced the interests of members of her family. As a Whig matriarch Lady Russell approved the terms of the Act of Settlement and expressed impatience with anyone who did not drink to the late king, the princess of Hanover, and the queen.[9] If she was not on such friendly terms with the new queen as she had been with Queen Mary, still she had known Anne for years, and the relationship was apparently cordial. Although Anne preferred Tories to Whigs in the early months of her reign, she detested factionalism and was prepared to honor worthy Whigs.[10] Within six days of the change of monarchs, Anne showed Rachel the high regard in which she held Lady Russell's family by implementing the arrangements left by King William to create the young duke of Bedford a Knight of the Garter.[11] Rachel must have taken huge satisfaction in knowing that the initiative she had undertaken two years before was finally realized. Equal pleasure would have been hers when her son served as lord high constable of England in the coronation ceremonies on April 23, 1702, and was named a privy councillor.[12]

Emboldened perhaps by these marks of favor, Lady Russell lost no time in apprising the new monarch of another piece of leftover personal business, that of a dukedom for Rutland. On March 29 her daughter Katherine wrote regretfully to Rutland that everything "we knew to be so near a conclusion" was now stopped because of the king's death. Asking him to keep the letter private, she inquired if he would approve of her mother's plan to tell the queen that the king had promised the honor and beg her to make it good.[13] A fortnight later, on April 14, Rachel informed Rutland that she had taken the matter out of her daughter's hands "to save her trouble." Apparently Lady Russell had already approached the queen, for she reported that Anne was firmly determined not to promote anyone so as to avoid anger and disappointment among those not honored. Expressing confidence that Rutland would be among the first promotions when they came, Rachel assured her friend that she would continue to promote his interests. If she failed, it would not be "from negligence," for she had followed the best advice she could think of getting.[14] But the first honor Anne conferred, on December 2, 1702, went to the earl of Marlborough, who was raised to a duke.[15] Later in the month, Lady Russell had an audience with the queen but, showing her good judgment and restraint, refrained from reopening the matter of Rutland's promotion. Reassuringly, she explained to Rutland that Marlborough's elevation was designed to assist him in his dealings

with foreign states.[16] Within three months Rachel had won Anne over, and in March 1703 Rutland was created duke of Rutland and marquess of Granby. Thereafter, his son bore the title of Lord Granby and Katherine became Lady Granby. Deserving Rutland was, but he owed his new title in large measure to the efforts of Lady Russell.

Rutland's dukedom is the only example of her influence on a major appointment at the national level during Queen Anne's reign. There are hints, however, that Rachel still retained a reputation as a person of influence. In 1711 Lady Cowper (whose son Rachel had assisted in 1689) apparently asked her to facilitate a meeting between Lord Cowper and Rachel's son-in-law, the duke of Devonshire, which Lady Russell did.[17] In 1712 she assisted the dowager duchess of Bedford (her daughter-in-law) in getting a place for a man at East India House.[18] But, clearly, her role had declined from what it had been between 1689 and 1702. The ebb and flow of parties during the reign of Anne, the death of Devonshire in 1707, which removed the most powerful contact that she had at court, and perhaps her advancing years account for the fading of her role.

Her influence on appointments to local church offices, however, continued. She did not hesitate to address the first earl Cowper, who was in her debt for her promotion of his appointment as king's counsel in 1689. Accordingly, in April 1706 she appealed to him to favor a Mr. Bolton for a small living in Bedfordshire, declaring that his doing so would be a great obligation on "our family, particularly" herself.[19] In February 1715 she again wrote Cowper respecting a dispute over a parish in Leicestershire and pressed for the appointment of her candidate.[20]

In the meantime Lady Russell sought to persuade Rutland to accept the post of lord lieutenant of Leicestershire, a position he had held during the Restoration. Disarming him by saying that if what she wrote was displeasing it was because of her "zeal," Rachel declared in a letter of 1702 that his refusal was a secret and "kept very faithfully, yet I have got it." Protesting that she would not attempt to try to change his mind, she proceeded to do just that. "Upon my knowledge," she wrote, the queen had received solicitations for the post, but had chosen Rutland. If he declined, the opportunity would go out of his family, whereas if he accepted, it could be "lasting for generations." Rachel dismissed the reason for his pique (apparently he did not like it that the queen had named gentlemen on the commission without consulting him), saying that "you great men should bear with things you disapprove for the public good." She wanted him to permit her to discuss the matter with Devonshire, but promised that she would not approach Devonshire unless Rutland empowered her to do so.[21] Rutland rejected her importunities, but declared that he regarded her as a "faithful friend." In

response Rachel, true to her nature, expressed enthusiastic pleasure at his remark, averring that she would "make it my business all my life upon all occasions to show I am so indeed." But she did not like to lose the argument with him and iterated and reiterated her disappointment at his decision.[22] Rutland finally accepted the post in 1706, and at his death in 1711, it passed to Rachel's son-in-law. One cannot read the letters about this appointment without sensing how much Rachel fulfilled her own, perhaps subconscious, ambitions through the men in her family.

Lady Russell exploited her connection with Rutland in an effort to help Lord Hartington, her son-in-law, in his campaign in July 1702 for a parliamentary seat in Yorkshire. She took it upon herself to engage Rutland to support Hartington. Writing on the ninth of July, at a time when earlier she would have been in deep distress remembering the trial of Lord Russell, she apologized for Hartington's negligence in approaching Rutland himself and asked Rutland to forgive him. She stated that Kate had told her that Rutland had said Hartington could have his support for the asking. Writing in tones appropriate to a male head of family, she declared, "I dare answer for him that he will be careful never to forfeit that honor of friendship." Rutland did as she requested, and perhaps because of his influence, Hartington was elected.[23]

Advancing years and retreating influence did not diminish Rachel's deep interest in public affairs. "Sources" close to the center of events, newspaper accounts, and her own position served to keep her well informed. She relayed news of domestic and foreign affairs to Rutland and to Lady Granby, her most faithful correspondent during these years. For example, she followed the deterioration in the queen's health, reporting in November 1702 that Anne could not set foot on the ground and had had a special chair made to convey her into her coach; Lady Russell declared in 1703 that the queen, despite her infirmity, was determined to be present in the House of Lords.[24] Her notices of other national affairs were often elliptical; she referred to angry speeches against the queen in the House of Commons, predicted that the union with Scotland would be difficult to negotiate, and mentioned that in 1707 the House of Lords had not returned thanks for the queen's speech.[25] One looks in vain for mention of the fate of the bill against occasional conformity, an issue in which her interest may be presumed. High Tories introduced the bill to prevent Dissenters from attending Anglican services on the odd occasion only to qualify for office. It must have grieved her that her son voted for it in the House of Lords.[26]

The War of the Spanish Succession, diplomatic negotiations, and the progress of the Peninsula Campaign seem to have held special fascination for Lady Russell. For example, in 1703 she provided Katherine

with a lucid account of a discussion in council respecting whether Spain should declare war against Portugal immediately, and whether to lay waste the land.[27] In July 1707, when she was seventy years old, she wrote with what may be called a youthful intensity that "every post day" filled her with "an inexpressible curiosity," and that the consequences of a battle were so great that her "heart pound[ed] on the post comes." "I keep the post bag in my pocket," she said.[28]

Lady Russell directed a large portion of her still considerable energies towards keeping in touch with her three children and their growing families, who now lived apart from her. Until 1712 her residences were Southampton House and Stratton House, whereas her elder daughter, although often in London, lived at Chatsworth in Derbyshire, her second daughter resided either at Belvoir Castle in Leicestershire or Haddon Hall in Derbyshire, and her son, after about 1703, lived at Woburn or at Streatham Hall with Mrs. Howland. (Photographs of Chatsworth, Belvoir Castle, and Woburn Abbey are reproduced in the illustrations.) In various ways she tied her children to her—inviting Wriothesley and his wife to live with her in Southampton House for the first few years of their married life, lending Southampton House to her elder daughter and her family, encouraging their visits, being present at the births of her grandchildren, and, above all, writing by almost every post to one or the other of them. "I wrote last post to your brother, not to you. Now it is to you, and not to him," she explained to Katherine.[29] She was too intelligent not to be sensitive to the fact that her advice might be resented. Indeed, she was not above employing a stratagem to persuade her son and his wife not to visit Streatham, where she had heard that smallpox had been prevalent. Instead of writing him directly, she urged her daughter Rachel, whom she knew intended to visit her son, to open the matter with him. "Any caution from me," she explained, "may not take."[30] And to Katherine she disarmingly confessed that much of her advice "might be omitted, if I did not like so well to be scribbling when I am doing it."[31]

Diverse reasons explain why Rachel tried to bond her adult children to her. Those reasons further illuminate her personality. Her anxious surveillance of their affairs as adults simply continued her anxious care of their affairs as children. Her love for them as the offspring of her dear husband combined with a deeper sense of the importance of family. She took special pleasure in her grandchildren not only because they were attractive little people, but also because they were the link to successive generations. Moreover, in advising and importuning her children, Rachel avoided loneliness and created the feeling that she was being useful to people she held dear. The act of writing letters was as important to her during her advanced years as before. Finally, maintain-

ing these ties preserved her role as matriarch of the family and her sense of importance in it.

Lady Russell dearly loved each of her children, and no estrangement between her and them ever occurred. With her eldest child, Rachel, she seems to have exchanged few letters, probably because Lady Hartington lived part of the time in London, and the letters that were written have with few exceptions failed to survive. Rachel was not always as attentive as Lady Russell would have liked, and at least once answered her "very quick," but the relationship was apparently harmonious.[32] With her youngest child, Wriothesley, Lady Russell encountered disappointment. Although the second duke of Bedford was not dissolute, he did not come up to his mother's high standards of conduct. In 1703 she wrote of her dismay that he and her son-in-law, Lord Granby, had lost a "great deal" at Newmarket. She had hoped that he would go to the races "better resolved," but resignedly concluded that "what must be must be."[33] Not only did Bedford gamble, but he also was rumored in 1703 to have offered to settle £600 for life on the actress Anne Oldfield.[34] Rachel does not mention this gossip, but it is not unreasonable to think that it reached her ears, so well informed was she about London society.

Still further, despite his wealth Bedford found himself short of cash. He failed to pay his mother rents due her when he occupied Southampton House. And he borrowed money from her at least twice. In 1701 Rachel lent him £3,500, £1,500 of which remained unpaid at his death, and in May 1707 the hefty sum of £16,000. It was not until Bedford's untimely death that the financial matters between him and his mother were mostly settled. The rents due on Southampton House appeared as still unpaid at her own death.[35] Lady Russell does not mention these loans, but if they concealed her son's profligacy, they must have saddened her.

A further reason for disappointment may have been that she and her son did not share the same interests. As we have seen, Bedford developed a love of music and of collecting rare books and manuscripts, tastes for which Lady Russell showed no inclination. From 1702 he employed in his household at a salary of one hundred guineas a year two musicians, Nicola Cosimi and Nicola Haym, the latter a violoncello player and composer, who promoted Italian opera in England. Bedford's patronage was important to the development of musical tastes in England.[36] Lady Russell does not refer to the musical soirees at Southampton House nor to Bedford's underwriting performances at one of the theaters in London. At no time in her life did she seem to take pleasure in music. Bedford was also deeply interested in horticulture and in improving the landscape at Woburn, going to the trouble to import many rare plants, especially ranunculi from Crete, "never before seen in

England."[37] Rachel left no comment on these projects either.

The fact is that Bedford's interests did not extend to politics, the subject that absorbed Lady Russell. As we have seen, she had not made an effort in Wriothesley's youth to inculcate the political principles that had animated her and Lord Russell, and in the absence of a father who might have guided him, Bedford cultivated interests in a different direction. Despite the high offices that he held, Bedford was perfunctory in his attention to public affairs and not very faithful in his attendance at the House of Lords and the Privy Council.[38]

On the other hand, he took seriously his duties as patron of the borough of Tavistock. In 1702 the vicar of the church in Tavistock refused to submit to episcopal jurisdiction. Bedford, surely out of the same concern for the welfare of the Anglican church that had underlain his vote against occasional conformity, gave orders that the minister should be told that his actions were not the "way to please me."[39] This minor matter takes on significance because of Lady Russell's involvement in it. The vicar remained impenitent, and later, at an unspecified date, the bishop reopened the problem, this time writing directly to Lady Russell. In response she stated that she knew about the difficulty because just after the old duke's death his steward had come to *her* with a letter from the vicar. The vicar had charged then that the bishop was persecuting him and expressed alarm that the new duke would not support him as the old duke had done. Rachel recalled that her son was at Newmarket, and that, in his absence, she had replied, saying that Bedford would support him in all things that were just and reasonable. Following this exchange, Lady Russell, with her customary attention to detail, spoke to the bishop's chancellor about the matter in hopes of resolving it amicably. Her position was that the vicar should observe the rubric and the bishop's injunctions, but she also said that she and her family opposed punishing people for not conforming to the ritual of the Church of England. She emphatically objected to keeping up a "dissension, when the reason of it is ceased."[40] Not only did Lady Russell's actions in this little incident show that she still commanded a role in the affairs of the Bedford family, but also her views testify to her continuing sympathy for Dissent at a time (about 1708) when it was falling out of favor nationally.

In 1706, when the duke was twenty-six years old, his mother sent him a lengthy letter of exhortation and admonition. Writing from Stratton in July, a time of withdrawal and contemplation, Lady Russell veiled strong sentiments in imploring and loving language. She began, "My dear child, I pray, I beseech you, I conjure you, my loved son, consider what there is of felicity in this world, that can compensate the hazard of losing an everlasting easy being; and then deliberately weigh,

whether or not the delights and gratifications of a vicious or idle course of life are such, that a wise or thoughtful man would choose or submit to." Confirming her belief in eternal life and of the need to prepare for it while on earth, Rachel argued that there was no hardship in the virtuous life and that "when we have moderated our irregular habits and passions," subduing them to reason and religion, life on earth is pleasant. The result is the assurance of eternal life. "Remember," she warned, "that to forsake vice is the beginning of virtue; a virtuous man need have no fear of either this life or death."[41] There is no evidence of what prompted her to write in these terms, but the letter shows her deep concern for Bedford's spiritual and moral integrity.

In 1708 a problem arose whose nature is unknown but which probably concerned money. On August 3, Bedford wrote his mother from Woburn to ask for advice "what to do in this case." He said that he could not come to a resolution on a proposal made respecting his wife and Mrs. Howland, but that he had no intention of doing anything but what was just and good. Since the matter was urgent he was confident that he would be excused for troubling her. He ended by saying that he expected his elder sister and family to arrive from Chatsworth later in the month.[42] Whatever its nature, this problem deeply disturbed Lady Russell, for a fortnight later in a letter to her daughter Rachel, she lamented that there was but one subject to think or speak of, "one that is not to be cast off, nor yet digested. For my part, I can bring no serious, thinking, considering thought; but, turn it all ways...it is dismal." "I throw it away as often as I can," she continued, "since no result is so taken from my opinion."[43] The inference is that Bedford rejected the advice that he had requested and thereby offended his mother. But that he should have brought the problem to Lady Russell in the first place underscores the respect in which he continued to hold her.

As Bedford approached his thirtieth year, he seems to have modified his behavior. Edward Russell, the earl of Orford, spent a week at Woburn in 1708 and reported that the duke and duchess were practicing great economy and regularity in their domestic affairs. With great pleasure, augmented perhaps by the memory of his former doubts about the integrity of his nephew, he wrote Rachel that her son was deeply involved in improving the grounds of his estate. He was "business itself," so much so that Orford feared that he might grow covetous! Orford went so far as to advise him not to pay off his debts but to borrow more to complete the improvements that he had in mind. Rachel may not have approved of Orford's advice, but she must have delighted in his account of life at Woburn.[44]

Lady Russell would have taken further satisfaction in 1710 when Bedford identified himself with the Whigs and voted against Dr.

Sacheverell.[45] And she could hardly have failed to approve her son's contributing to the publication of Dr. Burnet's *History of My Own Times*, which appeared finally in 1724–34, long after Bedford's death. He also subscribed to John Strype's *The Life and Acts of Matthew Parker, the first Archbishop of Canterbury*, published in 1711.[46] These books were so far removed in character from those that Bedford usually purchased or promoted as to suggest that Lady Russell may have urged his sponsorship.

In the spring of 1711, ignoring earlier advice not to visit Streatham because of the prevalence of smallpox, Wriothesley and his family arrived at his mother-in-law's estate for a visit. In May he was stricken with smallpox. Dr. Hans Sloane was brought from London to treat the duke, but to no avail. Lady Russell, because of her immunity to the disease, was the only member of his close family who could safely stay with him. Aided by two "diligent waiters," John Hobson and Peter Bramston, and a nurse, Mary Sellwood, Lady Russell kept a vigil at his bedside.[47] Professing devotion to God and love of his wife, children, sisters, and mother, the duke died at the age of thirty on May 26, 1711.

"Alas! my dear Lord Galway," Rachel wrote distractedly, "my thoughts are yet all disorder, confusion, and amazement...I did not know the greatness of my love to his person, 'til I could see it no more." But with fortitude built up over twenty-five years, Lady Russell was able to command her grief and believe that once "nature, who will be mistress, has...with time relieved herself," God would, through His grace, help her to understand the wisdom of His providence.[48] She must have felt exquisite emotional pain at the death of her only son, on whom she had lavished so much care, for whose advancements she had worked so hard, and in whom she looked to find the embodiment of her husband.

Lady Russell seems to have felt special warmth for her middle child, Katherine. In all periods of her life, Rachel needed a faithful correspondent, and in this stage Kate seems to have filled that role. Rachel wrote so often to her daughter that she felt obliged to reassure her that it did not matter that she might receive two of her mother's letters before she had answered the first.[49] Katherine seems to have treasured her mother's letters, for she preserved many of them, including one or two to her children.

Rachel poured out a steady stream of letters to Lady Granby containing family and public news; comments on problems with the butler, the nursery maid, the wet nurse, and the laundrymaid; advice about illnesses and medicines; and admonitions to Kate not to ride horseback unless she was sure that she was not pregnant.[50] Rachel did not lose her ability to vivify a scene or tell a good story. For example, revealing her boundless curiosity, she reported that she had touched Lady Cartwright's tumor, which caused the lady to jump, and had asked her many ques-

tions about it.[51] Or she recounted the story about Lady Salisbury, who was "mightily frenchified in her dress." On her way to Hatfield in a party of two coaches and six horses, Lady Salisbury met a man on the road and, lifting up the curtain of her window, spoke in French to "ask how far 'twas to Hatfield."[52]

Lady Russell took special interest in the education of her grandchildren and for several months in 1707, when she was seventy years old, made a project of finding a French tutor for the Rutland children. She consulted Lord Halifax and Lord Sunderland, among others, on the matter and arranged to interview candidates so that she might ask them all the questions on her mind. She held firm views on the differences between English and French methods of instruction, which she explained in detail to her daughter. The French, she said, teach by rote, whereas the English establish a rule, so that if a student forgets something he will know where to go to find it. The French do not know as much Latin as the English. The French are not so harsh on their pupils as the English. Students trained in the French method often face remedial work when they enter university.[53] Sound advice, fussy interference, and loving concern characterize her letters to Lady Granby.

Lady Russell also corresponded with her grandchildren, and a few letters to the Rutland children survive. They show her ability at tailoring her remarks to fit the interests of a young person. To James, the eldest, she wrote a little sermon, expressing the hope that he would always "think of your old grandmama as a friend that wishes you all the good qualities [that] make one useful to his country and happy to himself and then he can't be only wise but a good man, too, which is true wisdom." She wished Thomas luck in answering all the hard questions put to him by his father. To Lady Frances she sent best wishes for success in the current lottery and hopes that her father's horse should win in an upcoming race.[54] She won their confidence and love, expressed later in the naming of their children after her or her family and by their asking her to stand as godmother for a great-grandchild.

In the fall of 1711 Katherine, now the duchess of Rutland following her father-in-law's death, was five months pregnant with her ninth child, when serious complications set in. Lady Russell was with her at Belvoir and in early October wrote frantically to Dr. Sloane in London to send Dr. Chamberlain or his son to Leicestershire. Rachel feared a miscarriage, and if not that, danger to her daughter's life. There had been no movement of the fetus for twelve days, and her daughter had suffered retching, but had eaten a boiled chicken each day to keep up her strength. A few days later, begging him to excuse her haste and illegible handwriting, Rachel again appealed to Dr. Sloane to send Chamberlain "as soon as possible. All of us here are full of fear. She is very dear to

us all."[55] Her anxious letters vivify the sense of helplessness that confronted women and those who loved them when something "went wrong" in pregnancy and the birth process.

What happened next is clouded, but Katherine apparently rallied, at least enough to make the journey to Southampton House, where the best medical attention was readily available. There she was delivered of a son and died on October 30, 1711.[56] Tradition has it that Lady Russell went from Katherine's bedside to that of her elder daughter, who was also about to give birth. Resolute in her determination not to tell the duchess of Devonshire about the duchess of Rutland's death, Lady Russell assumed a cheerful air and answered Rachel's inquiries about her sister by saying, "I have seen your sister out of bed today." Her remark was, strictly speaking, true, for she had seen Katherine placed in a coffin![57]

Lady Russell recorded but did not comment on this terrible further blow that she had to endure in the year 1711. One hopes that she took comfort from the high praise given her daughter by William Burscough, who preached the funeral sermon, and by others who celebrated the duchess's "sweet temper," "virtuous education," and "wit."[58] One must assume that Rachel was prostrate for a time with grief in the winter of 1711–12. In one year she had lost her friend Rutland, her only son, and her second daughter.

After the death of her daughter, Lady Russell changed her principal place of residence. From 1712 to 1719 she lived mostly at Stratton, with only occasional visits to London, to friends living elsewhere, to her daughter-in-law at Woburn, and undoubtedly to her daughter at Chatsworth. The reason for this change was an event that illuminates still further aspects of Rachel's character—generosity of spirit and practical business sense. Within less than a year of Katherine's death, the duke of Rutland decided to remarry. Rachel handled what could have been a difficult situation with tact and kindness. Charlton had brought her the rumor of Rutland's intentions and of his "anxieties" over how to tell her. Rachel *first* satisfied herself that he had provided well for each of his children, adding to every younger child's portion, and *then* concluded that his remarriage was "the most solid instance of his respect and love" for Katherine that he could give. She decided that it would be "wrong" for her to take offense and instructed Charlton to let him know that she would willingly receive him. The interview "put us both in some disorder," she reported, but on a friendly footing.[59] So friendly were they that on July 3, 1712, Lady Russell leased the "great part" of Southampton House to Rutland for seven years at a rent of £300 a year, plus taxes and the requirement to keep everything in good repair.[60] Rachel apparently retained some rooms in Southampton House for her own use and presumably occupied them

on her trips to London. There is no indication that the lease was renewed nor that Southampton House was again let during the last years of Rachel's life. Presumably she was in London more regularly and for longer periods of time after 1719. She was there at the time of her death.

An undated portrait painted at about this time reveals her appearance in old age (see the illustrations). It depicts a handsome woman with white hair, dressed in widow's weeds, her face showing faint lines about the mouth and eyes. The rounded face and full upper torso suggest that Rachel had gained weight. The most striking features of the portrait are the set of the firm mouth and the confidence of the large, dark eyes. The portrait is of an intelligent woman who has achieved serenity of spirit, knowledge of self, and peace with God and the world.

This impression finds confirmation in what is known of Lady Russell in the last decade or so of her life. Her interests and activities remained much the same: public and business affairs, religious contemplation, friends and family. Naturally, her command of and concern for politics and finance declined.

Yet, Rachel did not lose touch with local affairs. She took an interest in local politics in Hampshire and almost certainly contributed money to the 1712 election in Bedfordshire.[61] Further, in an act that showed her sense of fairness for her tenants in Hampshire and also surely her desire to protect her own interests, on January 6, 1712, she "ordered" her agent in Hampshire to hold a "court according to custom, for the manor of Micheldever." To do this presented problems, for the records of the estate had disappeared with the disappearance of one "Mr. Pitman." But there existed a "Survey Book, which was taken in the Year 1677," which could serve as a basis for the proceedings. Lady Russell also ordered the agent to hold "all other courts as are needful from time to time" until she directed to the contrary.[62] Thereafter, manorial courts, called in her name as the lady of the manor, were held each year until the end of Rachel's life.[63] It would be unlikely that Lady Russell ever appeared in such a court, but there is no evidence on the point. That the court was kept busy is suggested by the fact that the tenantry of the estate underwent change during the decade as people died or moved away and others took their place. Lady Russell signed a total of thirty-one leaseholds and/or copyholds during this period.[64]

In May 1712 Lady Russell, with the help, of course, of her lawyers, took a decisive step in resolving a situation with respect to her steward that had given her "many terrible waking hours."[65] The sequence of events is unclear, but it is known that John Spencer, who had served Rachel as "chief" agent for "diverse years," was suspected of having embezzled upwards of £10,000 of her money. He had been responsible for holding "very great sums of money" for her from her

rents and the profits of her securities. He also assisted her in her role as sole executrix of the first duke of Bedford's estate and served as chief agent for the second duke. Her lawyers suspected him of having stolen the money, but did not have iron-clad proof. Their fear was that if she filed suit in the Court of Chancery, Spencer might be able to hold up a settlement for years. An unidentified "great lawyer" whom she consulted beyond the four attorneys who were advising her implored her to settle out of court. Accordingly, Lady Russell and Spencer signed an instrument dated May 30. Spencer was required to submit an inventory of his estate in land, leases, debts, and so forth and convey the whole to Lady Russell. In return Lady Russell agreed to hand back sufficient property to provide subsistence income for Spencer, his wife, and his children. Spencer won protection from any lawsuits that might arise respecting his duties as chief agent, and Lady Russell got title to any debt owed to Spencer that might surface in the future.[66] The settlement of the matter was a great relief to Rachel. From then until her death, Thomas Sellwood was her devoted and admiring steward. Naturally enough, as she grew older, Rachel increasingly depended upon Sellwood to assist her in managing her affairs. In 1718 she wrote him with respect to some business matter, "I leave it to you to act as you find it proper."[67] She repaid Sellwood's skill and loyalty by leaving him a handsome legacy at her death.

Another matter that claimed Lady Russell's attention was the drawing up of a new will to supersede that of May 21, 1695, a step necessitated by Bedford's death.[68] Signed on March 12, 1712, the will named as executors men of her extended family, her sons-in-law William, duke of Devonshire, and John, duke of Rutland; a relative from her first marriage, Richard Vaughan; and John Charleton, an unidentified friend. It specified a number of legacies and bequests that testify to Lady Russell's thoughtful nature and continuing commitment to Dissent. Thus, she left money to the poor in Middlesex and to the Charity School there for teaching poor children to read. The parishes of Micheldever, East Stratton, and Chenies were to receive a legacy. She remembered the "poor French Protestants in this kingdom," her cousin Galway, her grandchildren, and relatives from her first marriage.

The heart of the document concerned her London properties. She had in 1704 transferred to Bedford the properties from which her portion was derived, reserving the income to herself for life, so they were not at issue.[69] The will provided that Lady Russell's Middlesex properties were to be placed in the hands of trustees and be used to raise money to repay the £10,000 mortgage on Southampton House due the duke of Rutland. It also ordered that at her death Southampton House, its gardens, appurtenances, and pastureland should be sold at the price of

£6,000, with right of refusal to be given to the eldest living son or other descendant of her daughter Katherine. If that person did not wish to purchase the property at that price, it was to be sold for the highest price possible and the money used to pay off debts. Her London properties then descended to the duke of Bedford, her grandson.

The residue of all the transactions mentioned in the will was to go to Rachel, duchess of Devonshire, "alone and without her husband." The language was unequivocal. It was Lady Russell's intention that the property "may always be and remain in her separate use and absolute power and disposition exclusive of her husband." Rachel's sensitivity to the restraints on a married woman's legal rights over property and her patent determination to use the law to nullify those restraints are found further in a clause of a codicil to the will, dated May 24, 1718, whereby she gave to her "cousin Green, one of the daughters of Sir Edward Vaughan, deceased" £100 "for her sole separate and personal use." The text declared that her husband was to be "excluded from any benefit thereof and the said sum be not subject to his debts and encumbrances."

That Rachel's role as matriarch of her extended family continued into her old age finds confirmation in an episode that occurred in 1713. In that year her niece Lady Elizabeth Norton (the daughter of her sister Elizabeth) and her husband, Richard Norton, Esq., separated on grounds of incompatibility of temper. Norton turned to Lady Russell to recommend the terms on which they would part. Writing in reply in strictest confidence—she said no one "upon earth knows any word of [this letter]"—Rachel asked him to "accept of my plain way of expressing my meaning" and proceeded to suggest a detailed property settlement which proved satisfactory to both parties. Norton expressed his deepest appreciation, and Lady "Betty" must have felt likewise, because she became a frequent visitor of Rachel's.[70] The services that Lady Russell performed for the couple required knowledge of her niece's fortune and settlements and of Norton's estate in terms of present and prospective value. Few women in early-eighteenth-century England would have been equipped to execute such a project. That she was able to do so testifies to her high intelligence, and that Norton sought her advice underscores her reputation for fairness and integrity.

Lady Russell became even more introspective and self-conscious in old age. In 1713 she noted that she had "looked in my other papers of each year before."[71] She clearly took pleasure in marking the subject matter on the outside of her essays and the name of the correspondent, the date, and the topic on the outside of letters. Undated essays, prayers, scattered reflections, notes on reading, and biographical fragments, written in a handwriting that grows increasingly tremulous, survive from these years.[72]

Lady Russell's self-consciousness was highly enough developed for her to undertake in two forms the beginning of an autobiography, but not so highly developed that she finished either project. Some autobiographical fragments are in the form of a diary. In these papers Rachel simply recorded the dates of her marriages, of the births and deaths of her children and her miscarriages, of the removes from one country house to another and to London, and the illnesses and deaths of members of her family. She made two attempts to set down such a skeleton outline of her life, one covering her life from about age fourteen to the marriage of her daughter Rachel in June 1688, the other starting at the same time and breaking off in 1714. In neither case did she provide comments. The second effort at autobiography took the form of an essay in which she reviewed her life up to her second marriage in terms of her own shortcomings. The paper begins, "Vanity cleaves to me, I fear, O Lord! in all I do. In all I suffer, proud, not enduring to slights or neglects, subject to envy the good parts of others, even as to worldly gifts." As in the case of her confessions Lady Russell faulted herself for such weaknesses as pride, enjoyment of worldly pleasures when she was a young woman, sharp temper, desire for recognition, failure to train her servants properly in religion, and loving her second husband too passionately at the expense of her awareness of God. By condemning herself for these "sins" she purged her conscience. Such self-abnegation was not unusual in the diaries and private papers of seventeenth-century women.[73]

Lady Russell's "paraphrases," as she described them, of books of history and religion show what a conscientious and intelligent reader she became. They shed light on Rachel's study habits and the seriousness of her inquiries. She diligently took notes on such books as Taylor's *Holy Living* and *Holy Dying* and copied out passages from an unidentified history book. Such notes also suggest the limited intellectual sophistication that she brought to the task, which, in view of her education, would be expected. She was not trained as a scholar nor as a student of religion or philosophy, and she did not possess a first-class creative intellect. Rather, she remained into old age a highly intelligent, deeply religious, and reflective woman who enjoyed reading and taking notes on what she had read. Although not unique, Rachel stands out among other educated, serious-minded aristocratic women of her age in exemplifying such characteristics.

Lady Russell's surviving essays are short pieces on such topics as charity, friendship, duty to brethren, affliction, and marriage. Often she related the topics to her own shortcomings. These essays are her own work, the fruit of many years' reflection. For example, in discussing the subject of "duty to brethren" she wrote that the "spiritual bond of reli-

gion should of all others the most closely unite our hearts; forgive me if my love to Christians as Christians is not such as it should [be]." Or again, with respect to friendship, she confessed that she had been negligent in admonishing those she loved, because she did not want to displease them.

The most carefully developed essay that has survived is titled "Instructions for Children." In it Rachel set out her views on how to teach a child to know and love God. Lady Russell's first recommendation was to lead a child to think of God as a spirit: without end, good, powerful, and merciful. Showing sound pedagogical understanding, she went on to suggest that this and other religious principles be illustrated from the Bible and given application in the child's life "as his or her capacity will bear." As her use of the feminine pronoun demonstrates, Rachel envisioned her recommendations as applying to both girls and boys. Revealing the impact of Calvinist-inspired Dissent on her thinking, Lady Russell stressed the corruption of human nature by sin and the need to "break children of their wills," to make them humble and willing to accept God's providences for themselves. But testifying to her commitment to Anglicanism, she made no reference to the idea of the Elect, and instead asserted that with God's grace and help, man may redeem himself from sin. Drawing upon her own experience, she cautioned against loving the secular pleasures of this world, including the things of the mind. "The great propensity we have to love the world and the creatures in it hinders the advances in religion," she asserted. Only when one loves God completely and accepts His will wholeheartedly may one find happiness on earth. Although she taught that reason was one way to know God, she insisted that one should form a child's heart before his mind. Piety, truthfulness (for a pure mind was essential to understanding), humility, gentleness to neighbors, acceptance of God's Providence—these were the characteristics in a child that Lady Russell commended. On them, God could build great things, she said. Man's understanding, as Rachel herself had discovered, "is extreme[ly] curious, active, light, exorbitant, apt to judge, precipitate in judging." "Take care [children] do not become idolaters of reason; it leads too many to atheism, but if you would have them comprehend things by reasoning, make them give a divine reason for things." She completed her essay with a kind of catechism, posing such questions as "Why had God created the world?" and supplying appropriate answers.

What use Lady Russell envisioned for this material, beyond her own satisfaction in writing down her thoughts, is unclear. In 1712 or 1713, the earl of Galway appears to have raised the question of giving "her writings" a wider audience. She responded to the notion with an uncharacteristically self-deprecating remark, declaring that her writings

"were not worth your reading nor the postage" and that no one other than himself and her niece (Lady Norton) would find them of interest. But she admitted that she "often" felt herself "willing to relieve my thoughts so apt to reflect upon times past."[74] Perhaps Galway's interest reinforced her own inclination to look over her papers in 1713 and to write down her thoughts on various subjects. The fragmentary nature of most of the material suggests that it was meant to be private, but the care with which she set out her ideas on instructing children to lead a religious life may indicate the hope that this essay would be read by others and perhaps would serve as a guide for instructing her grandchildren. She preserved even the fragments. They were in the "trunks of writings" and the "strong box" containing writings that were sent to Chatsworth after her death.[75] Who is to say that this woman who took such pleasure in writing and in the good opinion of people she admired did not believe that her essays would find favor with them?

All during her life Rachel enjoyed friendships with both men and women. Reflecting upon friendship in old age, she declared that her "biggest blessing" was "loving and being loved by those I loved and respected."[76] In her declining years she appears to have been more in the company of women than men. She refers to upwards of fifteen women in her circle of correspondents and/or visitors, including Lady Essex; Sarah, duchess of Marlborough; Lady Vaughan, her sister-in-law from her first marriage; two French ladies, Madame Chavernay and Madame de Cosne, perhaps distant relatives, who paid her a visit; her niece Elizabeth Norton; and her daughter, said in 1718 to be "often" with her.[77] She took pleasure in their company, in visiting, talking, and playing cards. She also delighted in the times when a grandchild found time to dine with her, as noted on February 13, 1718.[78]

But, as before, her closest confidant was a man. At this time, her cousin, the earl of Galway, filled that role. Galway and Lady Russell had much in common: a family connection, personal sorrow and suffering, and commitment to public affairs and to religion. They had kept in touch with each other over the years during his absence in the wars, when he had been severely wounded, losing an arm[79] and an eye. In 1704 he had purchased an estate, Rookley, in Hampshire, not far from Stratton, and lived there whenever he was in England. The cousins clearly admired and liked each other. Galway found in Rachel's letters more wisdom and comfort, he declared, than contained in one of Tillotson's sermons.[80] For her part, Rachel must have admired him for the same reasons as did a contemporary who described Galway as "a man of honour and honesty, without pride or affectation," one whose talents "fitted [him] for the cabinet as well as the camp."[81] Lady Russell wrote Galway with a freedom and confidence that testified to her fondness for him. In

August 1712 she confided that in writing him, the "amusement is more agreeable to myself, and I assure myself you will make it so to you." Two and a half years later, she began a letter to him, "There is no post-day I do not find myself readily disposed to take my pen, and dispose of it as I now do."[82] The two aging cousins exchanged visits as well as letters, and in 1720 on a visit to Stratton House, Galway died. The walk along which his coffin was carried to the church is still known today as "Coffon Walk." In testimony to the high regard and affection in which he held her, Galway left his entire estate to Rachel. With his death the circle of Rachel's immediate family narrowed to her daughter, Rachel, and her grandchildren.

Lady Russell becomes a shadowy figure in the last five or six years of her life. The glimpses that we have of her still show four aspects of her character—love of family, rationality, interest in politics, and sharp business acumen. The last letter in her hand to have survived was written on June 17, 1718, when she was eighty-one years old. It is to acknowledge the invitation of her grandson (Katherine's son) that she stand as godmother to her great-grandchild.[83] No account of the baptismal ceremony follows, but one may be certain that the event brought great joy to Lady Russell. Another glimpse of Rachel comes from a story preserved by her steward, Thomas Sellwood, that she had told him herself. Lady Russell had been reading in her "closet" at Southampton House, when the candle and candlestick jumped off the table, and a hissing fire ran across the room, leaving some papers in flames. She rose and kicked the papers into the fireplace and, unperturbed and without calling for help, settled down in the dark to consider what could have caused this unusual incident. The windows and the door were locked and the only opening to the room was through the chimney. "That something should come down there, and strike my candle off the table in that strange manner, I believed impossible," she told Sellwood. Unable to think of a rational explanation she called in her servant-in-waiting. In great embarrassment the man declared that by mistake he had given her a "mould candle with a gunpowder squib, designed for sport with other servants on a day of rejoicing." Unfazed by the possible danger to herself, she readily accepted his apology, saying that she had no interest in the matter other than to discover the cause.[84]

Rachel continued to take an active interest in politics and to enjoy the reputation of being a concerned and well-informed person. For example, in July 1717 John Hough, the bishop of Litchfield and Coventry, wrote her about the new king, George I, and of the continuing breach between the king and the prince. Acknowledging that Lady Russell was kept informed of the "most important" matters by well-placed people, he commended the public welfare to her prayers.[85] Five months later, in

December, in one of Rachel's few surviving letters about public matters from these years, Lady Russell wrote Galway of her grief over the divisions at court. Finally, in 1720 the duchess of Chandos noted with pleasure Rachel's support for a project in which her husband had an interest.[86] That the opinion of an eighty-three-year-old person should make any difference at all implies that high regard in which that person is held.

Business affairs still claimed Lady Russell's attention. From 1720 to 1723 she signed fifteen leaseholds and/or copyholds for her Hampshire estate, three of them dated August 1723.[87] Moreover, she lost no time after Galway's death in laying claim to the property in France that he had willed her. In 1720 Rachel petitioned King George I for help. She laid before him the details of her claim, declared that she intended to start legal proceedings in France, and asked him to order the English ambassador to "espouse" her interests. George I responded with a letter dated December 1, 1720, to the duc d'Orleans in which he introduced Rachel and asked for protection for her.[88] There is no evidence that Rachel journeyed to France to pursue the matter; a Mr. Robertson apparently represented her interests.[89] Rachel's claim rested upon Galway's will, her French lineage (which made her Galway's next of kin), and her naturalization papers, dated 1641 and confirmed in 1721, which made her a naturalized French citizen with a dispensation from living in France.[90] She confronted counterclaims from her distant French relatives, including the relatives of Marie Tallemant, Rachel's uncle's wife, and from others who declared that Louis XIV had given them her cousin's property when he entered the service of William of Orange.[91] At her death the complicated legal case was still moving through four different French courts, and in 1739 her descendants were still engaged in the litigation.[92] Lady Russell's energy, initiative, and interest in enlarging her estate in all possible ways are admirably displayed in this last major business venture that she undertook.

Lady Russell had prepared her affairs carefully in anticipation of death, adding two codicils to her will. One in 1718 dealt with further legacies to her servants. Thus, the two men and one woman who had nursed her son in his fatal illness received a sum of money. Rachel also decreed that her housekeeper, Frances Cooke, and other servants were to have the contents of the rooms they occupied as well as a portion of her silver plate. She also provided in this codicil for her cousin Green, mentioned above. Finally, her steward was well rewarded with money (£1,000), furniture, horses, and a lease on property in Bloomsbury Square. Another codicil was added to her will in 1720 simply to provide a legacy for Lucy Sellwood, who had become her housekeeper at the death of Cooke. Rachel also left instructions that she be buried at

Chenies next to her husband and that the funeral be carried out "without escutcheons or funeral pomp further than decency may require."[93]

Sometime in the third week in September 1723 while at Southampton House, Lady Russell apparently suffered a stroke. Her health must have declined precipitously in early September, for beginning at that time "sitters up" or "watchers" were employed. Her old friend Dr. Hans Sloane and "Mr. Brown," a surgeon, attended her in this last illness.[94] On September 26, 1723, her granddaughter, Lady Rachel Morgan, wrote from Chatsworth to her brother, who was touring Europe, that the "bad account we have received of Grandmamma Russell has put us into great disorder and hurry." Their mother had left immediately for London, hoping to reach Lady Russell before death claimed her. It would be a satisfaction to both of them, Lady Morgan felt, for she had heard that her grandmother had asked for her mother.[95] But the duchess of Devonshire was too late. Four servants, including Lucy Sellwood, were with Rachel during her last hours, and one Mrs. Morrell sat up with her through the night. Lady Russell died at five o'clock in the morning on Sunday, September 29, 1723, Michaelmas day.[96] As she wished, Lady Russell was buried at Chenies, probably on October 8. The funeral arrangements cost £154, with the obligatory mourning livery for approximately thirty servants an added £194, sums that suggest that the funeral was conducted without pomp, as she had requested.[97] It may be presumed that her daughter, daughter-in-law, and all of her grandchildren who were in the country attended the funeral services, as well as her servants and the few remaining people whose lives she had touched over her long life. It is only a guess that the service was held in the chapel at Southampton House.

Lady Russell died a wealthy woman, thanks to her skill in managing the property that she had inherited from her father. A different result was, of course, possible, and she deserves credit for shrewd and prudent oversight of her affairs. Her landed properties had substantially increased in value, with the Bloomsbury rentals bringing in close to £3,000 per year and the Hampshire rentals worth also about £3,000 per year.[98] Those sums represented an increase in value of about one-third for the Bloomsbury properties and of about two-thirds for the Hampshire estate. Moreover, Rachel left a personal estate of about £24,000, which included South Sea Stock and annuities, perhaps her only unsound investment.[99] It also included charges of £250 a year due from her grandson for the use of goods and furniture at Southampton House, a sum showing the continued practice of the Russell family to charge relatives who visited them. Although Rachel was not unique among aristocratic women who took an interest in business affairs and estate management, she is not usually named among them; she should be.

Lady Russell also left quantities of household goods and silver plate. The former provided legacies for her servants with the remainder being sold. The bulk of the silver went to her daughter and to the duke of Rutland, who sold his share. The diamond pendants—the gift of the earl of Devonshire in 1688, it will be recalled—are not mentioned, nor is any other jewelry. Also curiously missing from the inventory is a reference to books; only her "papers" are mentioned as being sent to Chatsworth. Yet, it is clear that she had a library of religious works which she read regularly. Probably she disposed of her jewels and books prior to her death.

Lady Russell's death excited little public notice. She had outlived the many family members and friends who had known and admired her as Russell's wife and widow, as loving mother, and as a woman of deep piety and sharp political sense. Neither Wriothesley nor Katherine, Bedford nor Devonshire, Galway nor Rutland, Burnet nor Fitzwilliam, were alive to mourn her passing and provide testimonials. Accordingly, only brief notices appeared in the *Weekly Journal, or British Gazetteer* on October 5, 1723, and in the *London Journal* on October 12, 1723. The former also carried a poem in her honor, calling her a "relict worthy" of him who "fell a martyr to his holy faith" and commended her for not remarrying but remaining devoted to her husband's memory, as he had remained unshaken in commitment to political and religious principles.[100] This poem is the only surviving comment that linked Rachel, even indirectly, to public affairs, and it did so by commending her for remaining a widow in honor of her martyred husband. No mention was made that she too had adhered for forty years to the political and religious principles that had earlier animated her and her husband. No reference appeared to evoke memory of her role as William's political "eyes" and confidante, her unprecedented presence at her husband's trial, her leading part in the deliberate creation of Russell as a "martyr," her role in the Glorious Revolution, and her position for many years as a Whig matriarch who exercised some influence in the patronage system of both church and state. Such roles well illustrate the limits of what a well-placed, well-regarded, intelligent aristocratic woman might achieve in public matters.

Rachel's only surviving daughter, the duchess of Devonshire, did not express deep distress at her mother's death. Writing to her son James, who with his brother Charles was touring the Continent, the duchess confirmed that her "good mother" had died and added, " 'Tis always hard to part from our friends, but her great age made me expect it, and after a life so well spent, 'tis surely for her a most happy change." She counselled him and his brother to go into mourning and left it up to him whether his servants should adopt mourning livery. In February

1724, she wrote again about observing the customary marks of mourning and advised him to follow the custom of the country he was in, but cautioned him not to spend too much money on it.[101] The duchess recognized that her mother was set apart by her goodness and her well-spent life, but she did not take steps to preserve her memory in any special way. There is no evidence, for example, that she read her mother's religious essays nor that Rachel's most carefully written "Instructions for Children" found its way into the hands of her grandchildren. It was not, apparently, until 1815 that anyone noticed the essays. It was then that Mary Berry, in the course of preparing for publication Rachel's personal letters to her husband, came across the essays and deemed them worthy of comment in the biographical sketch of Lady Russell that she wrote. Rachel has not been counted among seventeenth-century women who wrote essays and treatises on religious subjects, but she deserves a place among them.

Lady Russell's personal letters, thanks to Mary Berry, appeared in print in 1819, just about a hundred years after her death. Love letters to her husband, written during the years of deep marital fulfillment and happiness, they met with approval throughout the nineteenth century, as repeated editions prove. Today they give historians rare insight into aristocratic home life and the interpersonal relationships of wife and husband, parents and children, sister and sister, and other members of an extended family network, and friends, both male and female. Open sensuality, warm friendships, and indulgent, loving parenting characterize those relationships. The extent to which they represent the norm in late-seventeenth-century English life remains to be established.

It was left to Lady Russell's steward Sellwood to go through the "trunks" of Rachel's papers that were sent to Chatsworth from Stratton. Among those papers he found the letters that Rachel, as a grieving widow seeking solace and the comfort of religion, had written to Dr. Fitzwilliam. These Fitzwilliam had returned to Rachel in hopes that they would be printed for the "benefit of the public."[102] Also in the trunks were the letters Rachel had written to Galway, preserved by him as testimony to his affection and respect, and correspondence between Rachel and Burnet and Tillotson, which they too had kept. Twenty-five years later, in 1748, it was Sellwood who urged John, duke of Bedford, to publish the letters as a tribute to Rachel herself, a woman whose character Sellwood described as "great." For unknown reasons, nothing came of Sellwood's project then. But his ordering of her letters made it possible at short notice to put them in the service of her husband's reputation. Thus, in the absence of Russell's papers, Rachel's letters were printed in 1773 as a way of rebutting the damaging revelations of Dalrymple. That Rachel's letters played a part in rehabilitating the name

of her adored husband would have pleased her. It was, after all, an unusual role for a woman's letters to play.

In the meantime, in 1723, Sellwood composed a carefully thought-out encomium in the form of a long poem. He praised Rachel's "arts," "wisdom," and "brighter genius," noted her courage in public affairs, and stressed how well in both trouble and prosperity "her great soul acted." He remembered her for acts of "piety and charity, love, honour, friendship, [and] hospitality."[103] The tribute came close to evoking Rachel's strong, lively personality and to noticing the themes that had defined her long life—passion, politics, piety, and property. In working closely with her for twelve years Sellwood had perceived the richness of her character and personality. He, more than anyone else at the time of her death, would surely have concurred with Burnet's judgment that she was, indeed, "one of the best of women."

Appendix

•

The Family of
Lady Rachel Russell

THE FAMILY OF LADY RACHEL RUSSELL

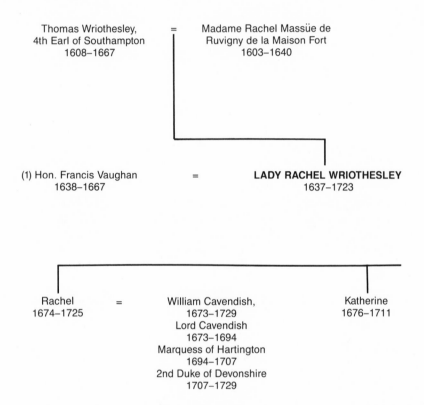

Thomas Wriothesley, = Madame Rachel Massüe de
4th Earl of Southampton Ruvigny de la Maison Fort
1608–1667 1603–1640

(1) Hon. Francis Vaughan = **LADY RACHEL WRIOTHESLEY**
1638–1667 1637–1723

Rachel = William Cavendish, Katherine
1674–1725 1673–1729 1676–1711
 Lord Cavendish
 1673–1694
 Marquess of Hartington
 1694–1707
 2nd Duke of Devonshire
 1707–1729

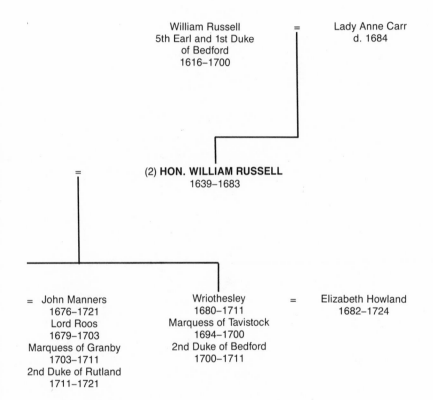

William Russell
5th Earl and 1st Duke
of Bedford
1616–1700

=

Lady Anne Carr
d. 1684

=

(2) **HON. WILLIAM RUSSELL**
1639–1683

= John Manners
1676–1721
Lord Roos
1679–1703
Marquess of Granby
1703–1711
2nd Duke of Rutland
1711–1721

Wriothesley
1680–1711
Marquess of Tavistock
1694–1700
2nd Duke of Bedford
1700–1711

=

Elizabeth Howland
1682–1724

Abbreviations
and Short Titles

 The following abbreviations are used for frequently cited locations and sources. The place of publication is London unless otherwise indicated.

Berry, *Some Account*	Mary Berry, *Some Account Of The Life Of Rachael Wriothesley Lady Russell . . .* (1819).
BIHR	*Bulletin of the Institute of Historical Research*
BL	British Library
Bodl.	Bodleian Library
BOL	Bedford Office, London
BROB	Bedfordshire Record Office, Bedford
Burnet, *HOT*	Bishop Gilbert Burnet, *History of His Own Time*, 6 vols. (Oxford, 1832).
Chatsworth	Chatsworth House
CJ	*Journals of the House of Commons*
Cobbett, *Trials*	Thomas B. Howell, ed., *Cobbett's Complete Collection of State Trials and Proceedings for High Treason*, 34 vols. (1809–28).
Complete Peerage	Vicary Gibbs et al., eds., *The Complete Peerage of England, Scotland, Ireland, Great Britain, and the United Kingdom*, 2d ed., 13 vols. (1910–40).
CSPD	*Calendar of State Papers*, Domestic Series
CSPD, 1683 [J-S]	*Calendar of State Papers, Domestic Series, July 1 to September 30, 1683.*
DNB	*Dictionary of National Biography*
Foxcroft, *Supplement to Burnet*	H. C. Foxcroft, ed., *A Supplement to Burnet's History of My Own Time* (Oxford, 1902).
FSL	Folger Shakespeare Library
Grey, *Debates*	Anchitell Grey, *Debates of the House of*

	Commons, from the Year 1667 to the Year 1694, 10 vols. (1763).
Hamp. RO	Hampshire County Record Office
Hert. RO	Hertfordshire County Record Office
HMC	Historical Manuscripts Commission
HOC	Basil Duke Henning, ed., *The History of Parliament: The House of Commons, 1660–1690,* 3 vols. (1983).
Letters of Lady Rachel Russell (1773)	*Letters of Lady Rachel Russell; From The Manuscript in the Library at Woburn Abbey* (1773).
Letters of Rachel Lady Russell (1854)	Lord John Russell, ed., *Letters of Rachel Lady Russell,* 2d ed. (Philadelphia, 1854).
LJ	*Journals of the House of Lords*
PRO	Public Record Office
Univ. Nott.	University of Nottingham Library
VCH	W. Page, H. A. Doubleday, et al., eds., *Victoria History of the Counties of England* (Westminster, 1900–).

Notes

• *Introduction* •

1. Univ. Nott., Ne C 22, Bishop Gilbert Burnet to Lady Rachel Russell, June 1, 1700.
2. Sir John Dalrymple, *Memoirs of Great Britain and Ireland*, 2 vols. (London and Edinburgh, 1771–73), 2:46.
3. Catherine Drinker Bowen, *Biography: The Craft and the Calling* (Boston, 1969).
4. Natalie Zemon Davis, " 'Women's History' in Transition: The European Case," *Feminist Studies*, nos. 3–4 (1976): 83–103; Joan Kelly, *Women, History, and Theory: The Essays of Joan Kelly* (Chicago, 1984); Hilda Smith, *Reason's Disciples: Seventeenth-Century English Feminists* (Urbana, 1982).
5. The term belongs to Natalie Zemon Davis, " 'Women's History,' " p. 86.
6. For example, Edward Gregg, *Queen Anne* (London, 1980), and Edith Hamilton, *William's Mary* (London, 1972). Recent biographies of late-seventeenth-century women are J. R. Brink, ed., *Female Scholars: A Tradition of Learned Women before 1800* (Montreal, 1980), a collection of biographical vignettes; Angeline Goreau, *Reconstructing Aphra: A Social Biography of Aphra Behn* (London, 1980); and Ruth Perry, *The Celebrated Mary Astell: An Early English Feminist* (Chicago, 1986).
7. Kelly, *Women, History, and Theory*, p. 51.
8. Robert H. Michel, "English Attitudes towards Women, 1640–1700," *Canadian Journal of History* 13 (1978): 35–60; Jerome Nadelhaft, "The English-woman's Sexual Civil War: Feminist Attitudes towards Men, Women, and Marriage, 1650–1740," *Journal of the History of Ideas* 43 (1982): 555–79.
9. Hilda Smith, "Feminism and the Methodology of Women's History," *Liberating Women's History*, ed. Berenice A. Carroll (Urbana, 1986), p. 370, argues that historians should view women as a "distinct sociological group" whose role, regardless of class, is defined by the same laws and prescriptions. Aristocratic women, however, escaped some of these constraints.
10. See, for example, Colin Murray Parkes, *Bereavement: Studies of Grief in Adult Life* (New York, 1973); Colin Murray Parkes and Robert S. Weiss, *Recovery from Bereavement* (New York, 1983); and Paul C. Rosenblatt, *Bitter, Bitter Tears: Nineteenth-Century Diarists and Twentieth-Century Grief Theories* (Minneapolis, 1983).
11. Work on widows has focused on women in middle and lower classes. See, for example, Charles Charlton, "The Widow's Tale: Male Myths and Female Reality in Sixteenth- and Seventeenth-Century England," *Albion* 10 (1978): 118–29, and Barbara J. Todd, "The Remarrying Widow: A Stereotype Re-

considered," in *Women in English Society, 1500–1800*, ed. Mary Prior (London, 1985), pp. 54–92.

12. Smith, *Reason's Disciples*.

13. *English Churchwomen of the Seventeenth Century* (Derby, 1845).

14. John Loftis, ed., *The Memoirs of Anne, Lady Halkett, and Ann, Lady Fanshawe* (Oxford, 1979).

15. For pioneering work on male sexuality see Lawrence Stone, *The Family, Sex, and Marriage in England, 1500–1800* (New York, 1977), chs. 11 and 12.

16. Ibid. See Lois G. Schwoerer, "Seventeenth-Century English Women Engraved in Stone?" *Albion* 16 (1984): 389–403.

17. Irene Q. Brown, "Domesticity, Feminism, and Friendship: Female Aristocratic Culture and Marriage in England, 1660–1760," *Journal of Family History*, Winter 1982, pp. 406–22.

18. The collected letters attracted admirers; in 1751, Horace Walpole wrote that he wanted "to persuade the Duke of Bedford" to print them. W. S. Lewis et al., *Horace Walpole's Correspondence*, 48 vols. (New Haven, 1937–83), 20:283.

19. Dalrymple, *Memoirs of Great Britain and Ireland*, 2:ix. The second volume appeared February 24, 1773: see Lewis et al., *Horace Walpole's Correspondence*, 28:66, n. 2.

20. The appearance in 1775 of *A History of Great Britain from the Restoration to the Accession of the House of Hannover*, by James McPherson, no admirer of Russell, did not help.

21. *Letters of Lady Rachel Russell* (1773). The letters are mentioned as appearing in May 1773: Lewis et al., *Horace Walpole's Correspondence*, 28:84–85.

22. Horace Walpole expressed surprise in 1773 that the duchess of Bedford should have allowed the publication. He noted that her late husband (the fourth duke) had regarded William Russell as "a very silly fellow." Lewis et al., *Horace Walpole's Correspondence*, 28:85.

23. William Hayley, *Plays of Three Acts: Written for a Private Theatre* (London, 1784), pp. 272–90 passim, 303, 310, 312–18, 331.

24. The Reverend Thomas Stratford, *Lord Russell: A Tragedy* (London, n.d.), pp. 21, 24, 46, 50, 66, 81, 88. The play was circulated in manuscript in 1782 and was printed in 1794. See Lewis et al., *Horace Walpole's Correspondence*, 29:223–25, for dates and comment.

25. I do not know why Berry spelled Rachel's name "Rachael." Lady Russell herself spelled her name without the second *a*.

26. Berry, *Some Account*, pp. iii–iv.

27. Ibid., p. c.

28. L. M. Francis (afterwards Child), *The Biographies of Lady Russell and Madame Guyon* (London, 1832); *The Life of Lady Russell*, Religious Tract Society publication (n.p., n.d.). An inscription on the flyleaf of the copy of *The Life of Lady Russell* at the BOL has led Marie Draper to speculate that the book was written by Lord Wriothesley Russell, son of the sixth duke of Bedford and rector of Chenies, and was published in 1857. However, an anonymous *The Life of Lady Russell* appears in the BL catalogue with the date 1847 in brackets; this book was destroyed during World War II. No book of such title bearing the date 1847 is at the Library of Congress.

29. It is a point of interest that Miss Berry refused to cooperate in this project. I am indebted to Paul Scherer for this information.

30. Lord John Russell, *The Life of William Lord Russell. With Some Account of the Times In Which He Lived*, 2d ed., 2 vols. (London, 1820), 2:134–37.

31. John Landseer, *A Brief Memorial, intended to accompany Mr. John Bromley's Engraving of William Lord Russell, from the celebrated picture painted by George Hayter* (London, 1828), pp. 9, 18.

32. François Guizot, *The Married Life of Rachel, Lady Russell*, trans. John Martin (London, 1855), p. 32n.

33. Lord John Russell, ed., *Letters of Rachel Lady Russell*, 2 vols. (London, 1853), preface, p. vii. Volume 2 carried an advertisement for *The Life of William Lord Russell*. A one-volume edition was published in 1854 in Philadelphia.

34. BOL, HMC 41, 41A, François Guizot to the duke of Bedford, August 27, 1854; also, Guizot, *The Married Life of Rachel, Lady Russell*, pp. 18, 24, 25, 77, 78.

35. One testimony to that enduring affection was the installation in 1889 of a memorial stained glass window in East Stratton Church in Hampshire, where Rachel and her family had worshipped two hundred years before. The window was dedicated to the memory of Lord and Lady Russell.

36. See Jacques Barzun, *Clio and the Doctors: Psycho-History, Quanto-History, and History* (Chicago, 1974), esp. pp. 7–9, 27–35, 112–114, and 147, for reasons why psychohistory *should* be dismissed.

37. Albert Bandura, *Social Learning Theory* (Englewood Cliffs, N.J., 1977).

• *Chapter 1* •
Background and Beginnings

1. Hamp. RO, PR 2, Titchfield Parish Register, 1634–78.

2. Ibid. See also La Société d'Etudes d'Histoire du Protestantisme, MS 66, "Notes estraites par Monsieur Eugène Haag des Registres de l'Etat-civil des Protestants qu'il trouva aux Archives du Palais de Justice et aux Archives de l'Hotel-de-ville de Paris, Archives qui on été encendiées dupuis, au mois de mai, 1871," p. 176, where the date of the marriage is erroneously given as September. I thank Didier Coupaye for making this search for me. The Registres de l'Etat-civil were destroyed in 1871 during the Paris Commune.

3. E. S. de Beer, ed., *The Diary of John Evelyn* (London, 1955), 2:115; Charles Read, "Le Temple de Charenton," *Bulletin de la Société de l'Histoire du Protestantisme Français* (Paris, 1854), pp. 427, 431, 435.

4. Edward, Earl of Clarendon, *The History of the Rebellion and Civil Wars in England Begun in the year 1641*, ed. W. Dunn Macray, 6 vols. (Oxford, 1888), 2:529. Hereafter, Macray, *Clarendon's History*.

5. W. Knowler, ed., *The Earl of Strafforde's Letters and Dispatches. With an Essay towards his Life by Sir George Radcliffe*, 2 vols. (London, 1734), 1:337–38.

6. See A. L. Rowse, "Thomas Wriothesley, First Earl of Southampton,"

Huntington Library Quarterly 28 (1965): 102–29, and A. L. Rowse, *Shakespeare's Southampton: Patron of Virginia* (London, 1965).

7. Rowse, *Shakespeare's Southampton*, p. 24, presented evidence of his Protestantism, but the general opinion is that he remained a Catholic.

8. *VCH, Hampshire*, 2:56, 181–86.

9. Ibid., 2:121; Lawrence Stone, *Family and Fortune: Studies in Aristocratic Finance in the Sixteenth and Seventeenth Centuries* (Oxford, 1973), pp. 209–12, 229; Gladys S. Thomson, *The Russells in Bloomsbury, 1669–1771* (London, 1940), p. 20.

10. Rowse, *Shakespeare's Southampton*, p. 12; *VCH, Hampshire*, 2:186.

11. G.P.V. Akrigg, *Shakespeare and the Earl of Southampton* (Cambridge, Mass., 1968), pt. 1, pp. 6–11, and Rowse, *Shakespeare's Southampton*, ch. 2.

12. Nikolaus Pevsner and David Lloyd, *The Buildings of England: Hampshire and the Isle of Wight* (London, 1967), pp. 624–25.

13. Akrigg, *Shakespeare and the Earl of Southampton*, pt. 2, chs. 2, 6–7.

14. Francis Wormald and C. E. Wright, eds., *The English Library before 1700* (London, 1958), p. 217. William Crashaw was the father of the poet Richard Crashaw.

15. Charlotte Carmichael Stopes, *The Life of Henry, Third Earl of Southampton, Shakespeare's Patron* (Cambridge, 1922), pp. 370–76.

16. M. R. James, *A Descriptive Catalogue of the Manuscripts in the Library of St. John's College, Cambridge* (Cambridge, 1913), pp. vi–vii.

17. His portraits confirm his good looks. At least fifteen portraits were painted, one of which hangs in the Great Hall at the Folger Library in Washington, D.C., a gift of the Mellon family.

18. Akrigg, *Shakespeare and the Earl of Southampton*, pt. 2, chs. 10–11 passim.

19. *VCH, Hampshire*, 3:389.

20. Stone, *Family and Fortune*, pp. 228–30.

21. Akrigg, *Shakespeare and the Earl of Southampton*, pp. 154–57. See Univ. Nott., letters to and from the earl of Southampton, Ne C 3, John Williams to the earl of Southampton, August 2, 1621, and Ne C 4, earl of Southampton to Salisbury(?), undated, but after July 18, 1621.

22. Stone, *Family and Fortune*, p. 230 and n. 2.

23. N. E. McClure, ed., *The Letters of John Chamberlain* (Philadelphia, 1939), 2:31; Macray, *Clarendon's History*, 2:530.

24. Hamp. RO, PR 1, Titchfield Parish Register, 1590–1634; *CSPD, 1625–1626*, 91:154n.

25. Stopes, *The Life of Henry, Third Earl of Southampton*, pp. 475–77.

26. For the dispute over the birthdate of Henri de Ruvigny, see the Rev. David C. A. Agnew, *Henri de Ruvigny, Earl of Galway: A Filial Memoir, with a Prefatory Life of His Father, Le Marquis de Ruvigny* (Edinburgh, 1864), pp. 3, 203, 204, and Agnew's *Protestant Exiles from France in the Reign of Louis XIV; or, The Huguenot Refugees and Their Descendants in Great Britain and Ireland* (London, 1874), 1:123. Also A. de Galtier de Laroque, *Le Marquis de Ruvigny: Député Général des Eglises Réformées auprès du roi et les protestants à la cour de Louis XIV (1643–1685)* (Paris, 1892), pp. 33, 34, n. 1 and Charles E. Lart, *Huguenot Pedigrees*, 2 vols. in 1 (Baltimore, 1967), 1:76, 78.

27. *CSPD, 1637*, p. 193 (June 5, 1637); PRO, Chancery Masters Deposits, C. 115, M 36, no. 8431, Edmund Rossingham to Viscount Scudamore, August 29, 1634 (I am indebted to Esther S. Cope for this reference).

28. Agnew, *Henri de Ruvigny*, p. 2.

29. Ibid. pp. 2–3.

30. *CSPD, 1633–1634*, p. 518; Knowler, *Strafforde's Letters*, 1:225.

31. Mme Saint-René Taillandier, "Une Ambassade de Sully à Londres, 1603," *Revue de Paris* 44 (1937): 631–32.

32. PRO, Chancery Masters Deposits, C. 115, M 36, no. 8429, Rossingham to Scudamore, August 18, 1634.

33. *CSPD, 1634–1635*, pp. 5, 28, 65, 166–67. A sermon preached on August 31, 1634, the Sunday after the couple's arrival, fixes the date. See BOL, HMC 41A.

34. Mario Roques, "Madame de la Maison-Fort et la Dédicace de *La Veuve*," *Revue d'Histoire Littéraire de la France*, 1951, p. 464, quoting Tallemant de Réaux.

35. Ibid., p. 461. Corneille's dedication may be evidence that Rachel de la Maison Fort took an interest in the theater.

36. Michael Jaffé, "Van Dyck Studies II: 'La belle & vertueuse Huguenotte,'" *Burlington Magazine* 126 (1984): 603–11, for Van Dyck portrait. See Belvoir Castle, Letters of Lady Rachel Russell, Add. 61, no. 31, Lady Russell to Lady Granby, June 3, 1700, for version given to Katherine. For further testaments to Rachel's mother's surpassing beauty, see PRO, Chancery Masters Deposits, C. 115, M 36, no. 8431, Rossingham to Scudamore, August 29, 1634.

37. Lawrence Stone, *Crisis of the Aristocracy, 1558–1641* (Oxford, 1965), p. 626.

38. *CSPD, 1623–25*, p. 422; *CSPD, 1625–26*, pp. 535, 562; Hamp. RO, Wriothesley Deeds, Personal, 124. See Stone, *Family and Fortune*, pp. 230–31.

39. At the back of the National Register of Archives 0570, C/CH/A, Cavendish Estate, there is a page headed "Archives Retained by Lord Chesham." Item 665 is the marriage contract. But efforts to locate it through the Buckinghamshire Record Office and the present Lord Chesham have been unavailing.

40. PRO, Chancery Masters Deposits, C. 115, M 36, nos. 8429 and 8431, Rossingham to Scudamore, August 18 and 29, 1634.

41. Roques, "Madame de la Maison-Fort," p. 463; R. Zuber to author, October 30, 1982. This Beaujeu family did not come from Perche, as stated in *Complete Peerage*.

42. Knowler, *Strafforde's Letters*, 1:338, 467; Stone, *Family and Fortune*, p. 232.

43. Knowler, *Strafforde's Letters*, 1:337.

44. Ibid., 1:435; Allen B. Hinds, ed., *Calendar of State Papers...in the Archives and Collections of Venice, 1632–1636* (London, 1921), 23:418.

45. Knowler, *Strafforde's Letters*, 1:467; Stone, *Family and Fortune*, pp. 232–33.

46. Hamp. RO, Wriothesley Deeds, Personal, 127.

47. Knowler, *Strafforde's Letters*, 2:57; *CSPD, 1640*, p. 91.

48. Stone, *Family and Fortune*, p. 233.

49. *Complete Peerage*, 12:132.

50. Pauline Gregg, *King Charles I* (London, 1981), p. 262.

51. Hamp. RO, Wriothesley Deeds, Personal, 237. The terms *denization* and *naturalization* were used interchangeably in the seventeenth century; the only difference was that the king conferred denization, while the Parliament granted naturalization. See W. A. Shaw, ed., *Letters of Denization and Acts of Naturalization*, Publications of the Huguenot Society of London, vol. 18 (London, 1911), pp. vi–ix, 57.

52. Stone, *Family and Fortune*, p. 234.

53. Macray, *Clarendon's History*, 2:530.

54. E. S. Cope and W. H. Coates, eds., *Proceedings of the Short Parliament of 1640*, Camden Fourth Series, 19 (London, 1977), pp. 76, 88–89. See also pp. 78, 79, and 229.

55. Chatsworth, Russell MSS, Uncat., box 2, Lady Russell's Confessions.

56. He served on at least twenty-seven committees. See *LJ*, 4:127–501 passim.

57. Macray, *Clarendon's History*, 2:530.

58. *The Life of Edward of Clarendon, Lord High Chancellor of England and Chancellor of the University of Oxford* (Oxford, 1759), p. 412; *LJ*, 4:128, 147, 174.

59. Burnet, *HOT*, 1:94.

60. C. V. Wedgwood, *The Trial of Charles I* (London, 1967), p. 173. The other three were the duke of Richmond, the marquess of Hertford, and the earl of Lindsey.

61. Ibid., p. 190.

62. It was on Southampton's watch that a muffled figure (allegedly Cromwell) passed by the bier and mumbled "cruel necessity." Wedgwood, in *The Trial of Charles I*, p. 229, doubts the story of the muffled figure.

63. *VCH, Hampshire*, 5:337–53; Stone, *Family and Fortune*, pp. 235–36.

64. Macray, *Clarendon's History*, 4:264; C. H. Firth, ed., *The Memoirs of Edmund Ludlow, Lieutenant-General of the Horse in the Army of the Commonwealth of England, 1625–1672*, 2 vols. (Oxford, 1894), 1:168–71.

65. Stone, *Family and Fortune*, pp. 235–36; BOL, Deeds, Southampton and Middlesex, General Evidences, vol. 5, bundle 2, nos. 25 and 28.

66. BOL, HMC 38, Lady Rachel Russell's Diaries, p. 10.

67. Macray, *Clarendon's History*, 5:211.

68. Berry, *Some Account*, p. x.

69. See Gladys S. Thomson, *Life in a Noble Household, 1641–1700* (London, 1937), pp. 72–78, 93–111.

70. Loftis, *The Memoirs of Lady Halkett and Lady Fanshawe*, pp. 10–11. Also *English Churchwomen of the Seventeenth Century* (Derby, 1845), which contains vignettes of about thirty women who were communicants of the Anglican church and known for piety equal to that of Puritan women.

71. See Norma McMullen, "The Education of English Gentlewomen, 1540–1640," *History of Education* 6 (1977): 87–102.

72. Rowse, *Shakespeare's Southampton*, pp. 8–9, 37; Stopes, *The Life of Henry, Third Earl of Southampton*, p. 518 (excerpts of the will referring to the books).

73. Rowse, *Shakespeare's Southampton*, pp. 104, 162, 170–73.

74. G. C. Moore Smith, *Henry Tubbe*, Oxford Historical and Literary Studies, vol. 5 (Oxford, 1915), pp. 12–14.

75. *Letters of Lady Rachel Russell* (1773), pp. 188, 210.

76. Berry, *Some Account*, p. xcviii.
77. Chatsworth, Russell MSS, Uncat., box 2, Lady Russell's notes on history.
78. Rowse, *Shakespeare's Southampton*, p. 29.
79. France, Archives nationales, TT 207, Papers of the de Ruvigny family, vol. IX, fol. 393, "Au suject de la Ruvigny Succession," 1721; fol. 397, Letters of naturalization for Wriothesley children, registered in the Chambre des Comptes, August 1641. Also, Lart, *Huguenot Pedigrees*, pp. 77, 79–83.
80. *Complete Peerage*, 12:134–35.
81. BOL, HMC 38, Lady Rachel Russell's Diaries, pp. 10, 17. Henry Tubbe's remark fixes her at Titchfield in 1648.
82. Solange Deyon, *Du loyalisme au refus: Les Protestants français et leur député général entre le Fronde et la Révocation* (Lille, 1976), pp. 57, 60.
83. Belvoir Castle, Letters of Lady Rachel Russell, Add. 61, no. 70, Lady Russell to Lady Granby, July 19, 1707.
84. Stone, *Crisis of the Aristocracy*, pp. 692–503, 793.
85. Chatsworth, Russell MSS, Uncat., box 2, Rachel Russell's Catechism, 1684/85.
86. Thomson, *Life in a Noble Household*, p. 74.
87. Berry, *Some Account*, p. xcviii; Chatsworth, Russell MSS, Uncat., box 2, essay beginning "Vanity Cleaves to me."
88. Chatsworth, Russell MSS, Uncat., box 2, Lady Russell's Confessions.
89. Thomson, *Life in a Noble Household*, p. 74.
90. *CSPD, 1651*, p. 520.
91. Macray, *Clarendon's History*, 2:533.
92. Berry, *Some Account*, p. xcviii.
93. Chatsworth, Russell MSS, Uncat., box 2, Lady Russell's Confessions.
94. *Letters of Lady Rachel Russell* (1773), p. 168. For step-parenthood, see Peter Laslett, "Parental Deprivation in the Past: A Note on Orphans and Step-parenthood in English History," in *Family Life and Illicit Love in Earlier Generations* (Cambridge, 1977), pp. 160–73.
95. *Letters of Lady Rachel Russell* (1773), p. 168.
96. BOL, HMC 38, Lady Rachel Russell's Diaries, p. 10; BOL, HMC 40B, fols. 18–19, Lady Russell to Lady Roos, December 8, 1695.

• *Chapter 2* •
First Marriage, 1654–1667

1. BOL, HMC 38, Lady Rachel Russell's Diaries, p. 10.
2. *DNB* and *Complete Peerage*, 3:7–8.
3. Major Francis Jones, "The Vaughans of Golden Grove," *Transactions of the Honourable Society of Cymmrodorion*, Session 1962, pp. 96–143. Major Jones kindly sent me details about the marriage settlement, which is *recited* in uncatalogued papers at Carmarthenshire Record Office, in a letter of October 4, 1982. I thank Basil B. Twigg for confirming that the marriage contract itself has disappeared. A fire at Golden Grove in 1729 destroyed many Carbery family papers, among them, presumably, Rachel's correspondence. For the dowry, see

Christopher Clay, "Property Settlements, Financial Provision for the Family, and Sale of Land by the Greater Landowners, 1660–1790," *Journal of British Studies* 21 (1981): 27.

4. He was born on March 14, 1638. *HOC*, 3:627; T. H. Hollingsworth, "A Demographic Study of the British Ducal Families," in *Population in History*, ed. D. V. Glass and D.E.C. Eversley (Chicago, 1965), p. 364, table 17; and Stone, *Family, Sex, and Marriage*, pp. 46–49.

5. Virgil B. Heltzel, ed., "Richard Earl of Carbery's Advice to His Son," *Huntington Library Bulletin*, no. 11 (April 1937): 92–95. The advice was in six letters dated from August 14 to September 30, 1651. The original letters were found among the Bedford papers, almost certainly because Rachel had preserved them in her own papers. Heltzel establishes that a version of the letters was printed as "Advice of William, Earl of Bedford, to His Son," in *Practical Wisdom* (London, 1824; rpt. 1901, 1907).

6. Heltzel, "Carbery's Advice to His Son," p. 102.

7. Chatsworth, MS Letters 15.0, Elizabeth Percy to Rachel Vaughan, December 5, 1665; Berry, *Some Account*, p. xvii.

8. BOL, HMC 40A, Letters of Lady Rachel Russell, fol. 3.

9. *Letters of Lady Rachel Russell* (1773), p. 205.

10. *Letters of Rachel Lady Russell* (1854), pp. 312–13

11. Berry, *Some Account*, p. xcviii.

12. BOL, HMC 38, Lady Rachel Russell's Diaries, p. 17 and passim. Also *CSPD, 1656–1657*, p. 587.

13. BOL, HMC 38, Lady Rachel Russell's Diaries, p. 17.

14. Heltzel, "Carbery's Advice to His Son," pp. 73–75, 79, 81, 86, 87, 89.

15. David Masson, *The Life of John Milton: Narrated in Connexion with the Political, Ecclesiastical, and Literary History of His Time*, rev. ed., 7 vols. (New York, 1946), 4:247n. The inscription is not in Milton's hand, as was thought earlier. See Douglas Bush, ed., *Complete Prose Works of John Milton* (New Haven, 1962), 3:336.

16. *HOC*, 3:631.

17. The Reverend Charles Page Eden, ed., *The Whole Works of the Right Rev. Jeremy Taylor, D.D., Lord Bishop of Down, Connor, and Dromore: With a Life of the Author, And a Critical Examination of His Writings, by the Right Rev. Reginald Heber, D.D., Late Lord Bishop of Calcutta*, 10 vols. (London, 1883), 2:307–8, 315–17; 4:79–80, 159–60; 5:248–79.

18. Jones, "Vaughans of Golden Grove," pp. 120–21; John Wilders, ed., *Samuel Butler: Hudibras* (Oxford, 1967), introd. In 1667 Carbery gave Butler protection from arrest, suggesting that a connection between the two men continued. See E. S. de Beer, "The Later Life of Samuel Butler," *Review of English Studies* 4 (1928): 161.

19. BOL, MS notes taken by M. Draper on the Account Book of Thomas Corderoy, receiver general for the fourth earl of Southampton, Nottingham County Record Office, Portland MSS. DD5/P/7, supplies proof that Taylor was Southampton's chaplain. (Hereafter Draper MS Notes, Corderoy's Account Book.)

20. *Letters of Rachel Lady Russell* (1854), pp. 280, 282.

21. *Complete Peerage*, 3:8. Carbery's first and second wives died in childbirth. The articles of the marriage between the earl and Alice Egerton are at Huntington Library, Bridgewater Collection—II, Deeds, 8193–8196.

22. Willa McClung Evans, *Henry Lawes: Musician and Friend of Poets* (New York, 1941), pp. 63, 66, 196.

23. Evans subscribes to the point (ibid., p. 191), but there is no proof.

24. George Saintsbury, ed., *Minor Poets of the Caroline Period*, 3 vols. (Oxford, 1905–21), 1:516–17. See Philip Webster Souers, *The Matchless Orinda* (Cambridge, Mass., 1931), pp. 73–74. I thank Elizabeth H. Hageman for allowing me to read her unpublished manuscript on Katherine Philips.

25. Saintsbury, *Minor Poets of the Caroline Period*, 1:518–19.

26. The essay was *A Discourse of the Nature, Offices, and Measures of Friendship, with Rules of Conducting It, in a Letter to the Most Ingenious and Excellent Mrs. Katherine Philips* (London, 1657). See Souers, *The Matchless Orinda*, pp. 74–77.

27. Jones, "Vaughans of Golden Grove," pp. 129–30.

28. *Complete Peerage*, 3:8; *HOC*, 3:630–31. Clarendon described John Vaughan in unflattering terms as ugly, ill-mannered, and lewd, but he was a prejudiced witness because of political differences between the two men.

29. Berry, *Some Account*, pp. 69–71.

30. BOL, HMC 40A, fol. 2. Francis Williams to Lady Vaughan, 1655. Williams knew both the Carbery and Southampton families. I have not been able to identify him.

31. Ibid., fol. 3.

32. Univ. Nott., miscellaneous letters of Lady Rachel Russell, Ne C 8, second earl of Carbery to Lady Rachel Vaughan, March 28, 1667.

33. See Brown, "Domesticity, Feminism, and Friendship," esp. pp. 420–22, for "heterosocial" relationships.

34. BOL, HMC 38, Lady Rachel Russell's Diaries, pp. 10, 17.

35. Ibid., p. 10, fixes the date of Elizabeth Leigh's death.

36. Ibid., pp. 10, 17.

37. Heltzel, "Carbery's Advice to His Son," p. 91.

38. *HOC*, 3:627.

39. *CSPD, 1660–1661*, pp. 172, 257, 504.

40. Burnet, *HOT*, 1:297, 316.

41. Ibid., 1:288–89.

42. Ibid., 1:323.

43. Clarendon, *Life*, pp. 247–49, 415–16.

44. Burnet, *HOT*, 1:163, 315–16.

45. Stephen B. Baxter, *The Development of the Treasury, 1660–1702* (London, 1957), pp. 9–11, 259–61.

46. *DNB*; Burnet, *HOT*, 1:457.

47. Clarendon, *Life*, pp. 411–12; Burnet, *HOT*, 1:173.

48. PRO, PRO 30/24/6A, printed memoir.

49. Edward Hawkins, comp., and Augustus W. Franks and Herbert A. Grueber, eds. *Medallic Illustrations of the History of Great Britain and Ireland to the*

Death of George II, 2 vols. (London, 1885), 1:502 nos. 137, 138.

50. BOL, Draper MS Notes, Corderoy's Account Book (Portland MSS. DD5/P/7/2 and 10).

51. Stone, *Family and Fortune*, p. 240.

52. BOL, Draper MS Notes, Corderoy's Account Book (Portland MSS. DD5/P/7/2).

53. Berry, *Some Account*, p. xcviii; BOL, HMC 38, Lady Rachel Russell's Diaries, p. 10.

54. BOL, HMC 38, Lady Rachel Russell's Diaries, pp. 11, 17; Sir Thomas Meyerne, the royal physician, testified in early 1637 that the earl "labours under grave obstructions." See Hamp. RO, Wriothesley Deeds, Personal, 125.

55. For the treatment used and for Southampton's death, see Burnet, *HOT*, 1:457. The autopsy is in BL, Sloane MSS. 1,116, fol. 46.

56. Clarendon, *Life*, p. 416.

57. BL, Add. MSS. 12, 514, fols. 315–17.

58. Foxcroft, *Supplement to Burnet*, p. 116.

• **Chapter 3** •
Second Marriage, 1669

1. The marriage license, permitting the ceremony to take place at Titchfield, is dated July 31, 1669; the parish record gives the date of the wedding as August 20. See *Complete Peerage*, 2:81, and Hamp. RO, PRO 2, Register (Titchfield Parish). The license cost £1 8s. See BOL, First Duke, Receivers General Accounts, George Collop's Accounts, 1669. For William's suit, see Gladys S. Thomson, *The Russells in Bloomsbury, 1669–1771* (London, 1940), p. 14. For a description of dress and entertainment at noble weddings, see Richards Greaves, *Society and Religion in Elizabethan England* (Minneapolis, 1981), pp. 185–87.

2. For Rachel's parents, see Chapter 1, above. William Russell, fifth earl of Bedford, William's father, married Anne Carr, the daughter of the disreputable Robert Carr, earl of Somerset, who with his wife was accused of poisoning Sir Thomas Overbury. The trial was one of the juiciest scandals of the early seventeenth century. The fourth earl opposed the marriage, but eventually gave way. See Knowler, *Strafforde's Letters*, 1:359 and 2:2, 86. The case of these two families lends support to Lawrence Stone's observation that marriages based on romantic attachment seem to run in families. Stone, *Crisis of the Aristocracy*, pp. 609–10.

3. Chatsworth, MS Letters 15.1, Elizabeth Percy, countess of Northumberland, to Lady Rachel Vaughan, June 29, 1667.

4. Ibid.

5. Thomson, *Life in a Noble Household*, pp. 373–74.

6. BOL, HMC 40A, p. 17, draft letter, William Russell to Lady Vaughan, n.d.

7. Chatsworth, Russell MSS, Uncat., box 1, draft letter, William Russell to Lady Vaughan, n.d.

8. BOL, HMC 39, pp. 34–35, William Russell to Lady Anne Russell, n.d. The contents of the letter identify the addressee.

9. BOL, HMC 40A, p. 12, Lady Vaughan to Lady Sidney, n.d., where the addressee is identified.

10. Ibid., p. 15.

11. Rachel's height is deduced from the measurement of her casket which is interred, along with William's, in the family vault at Chenies. I am indebted to Marie Draper for arranging for measurements of both caskets.

12. Foxcroft, *Supplement to Burnet*, p. 117.

13. *Letters of Lady Rachel Russell* (1773), dedication, p. lxvii.

14. Foxcroft, *Supplement to Burnet*, p. 117; Berry, *Some Account*, p. xcvii; Chatsworth, Russell MSS, Uncat., box 2, Lady Russell's essay, "On Choler."

15. Lou Taylor, *Mourning Dress: A Costume and Social History* (London, 1983), pp. 52, 54, 101–2. For advice to widows, see Margaret Lael Mikesell, "Catholic and Protestant Widows in the *Duchess of Malfi*," *Renaissance and Reformation* 19 (1983): 265–79.

16. BOL, HMC 38, Lady Rachel Russell's Diaries, pp. 11, 17.

17. Stone, *Crisis of the Aristocracy*, pp. 624–25.

18. *Letters of Rachel Lady Russell* (1854), pp. 13–15. Miss Berry identified the man as the Honorable Henry Sidney (1641–1704), younger brother of Algernon Sidney. Henry Sidney and Rachel were friends, as a letter to her of February 2, 1670, shows. See Berry, *Some Account*, p. 72.

19. Hamp. RO, Wriothesley Deeds, Personal, 160.

20. Hamp. RO, 5M 53/942, for Southampton's will.

21. Hamp. RO, 5M 53/1008, Agreement of partition of the estates of Thomas, fourth Earl [of Southampton], between his three daughters, 1668/69.

22. Hamp. RO, Wriothesley Deeds, Personal, 245.

23. BROB, Title Deeds of Estates, Southampton and Middlesex, A, bundle 2, p. 1/64, no. 34, January 18, 1668.

24. Thomson, *The Russells in Bloomsbury*, p. 17. The deed is in BOL, Deeds, Southampton, Middlesex, and Bloomsbury, vol. 2, A, bundle 2, no. 33.

25. Chatsworth, MS Letters, 28.116, Lady Vaughan's notes on her properties, n.d.

26. Thomson, *The Russells in Bloomsbury*, pp. 57–58; Stone, *Family and Fortune*, p. 240.

27. Diane Willen, *John Russell, First Earl of Bedford: One of the King's Men* (London, 1981), pp. 2–4.

28. Ibid., pp. 29n, 30, 62, 105–7, 110, 112–13.

29. *DNB*; Georgiana Blakiston, *Woburn and the Russells* (London, 1980), ch. 5.

30. Blakiston, *Woburn and the Russells*, ch. 6; F.H.W. Sheppard, gen. ed., *Survey of London*, vol. 36, *The Parish of St. Paul Covent Garden* (London, 1970), pp. 34–35.

31. See n. 11, above, for his height. For the portrait of William at seventeen years of age by Claude Lefevre at Woburn Abbey, see *Biographical Catalogue of Portraits at Woburn Abbey* (London, 1892), 2, pt. 1: between 60 and 61. The portrait by Sir Peter Lely is reproduced in Edmund Lodge, *Portraits of Illustrious Personages of Great Britain*, 12 vols. (London, 1835), 9:1. The miniature

painted at about the same time as the one of Rachel is at Woburn Abbey.

32. Burnet, *HOT*, 2:83, 365.

33. Thomson, *Life in a Noble Household*, p. 74. Also in BOL, HMC 8, 3:104, Richard Baxter to John Thornton, May 27, 1655.

34. See Gladys S. Thomson, *Family Background* (London, 1949), p. 177.

35. BOL, HMC 8, 3:7, 8, 18. Manton was a correspondent of Diana, William's sister. See also *DNB*.

36. John Venn and J. A. Venn, *Alumni Cantabrigiensis: A Biographical List of All Known Students, Graduates, and Holders of Office at the University of Cambridge, from the Earliest Times to 1900* (Cambridge, 1924).

37. V.H.H. Green, *Religion at Oxford and Cambridge* (London, 1964), p. 143.

38. BOL, HMC 8, 1:73.

39. Grey, *Debates*, 4:71.

40. BOL, HMC 40A, fols. 10–10v, William Russell to John Thornton, December 4, 1665.

41. Ibid., fols. 6–7, William Russell to Henry Capell, December 15, 1658; Chatsworth, Russell MSS, Uncat., box 1, William Russell to Sir John Reresby, December 25, 1658; *HOC*, 3:366, 449.

42. *DNB*; John Dunton, *The Hazard of a Death-Bed-Repentance, Fairly Argued* (London, 1708), p. 23.

43. BOL, HMC 38, William Russell's Travel Diaries, pp. 39, 42, 48, 51.

44. Chatsworth, Russell MSS, Uncat., box 1, William Russell to John Thornton, December 27, 1656.

45. Chatsworth, Russell MSS, Uncat., box 1, John Thornton to William Russell, May, 7, 1657.

46. Chatsworth, MS Letters, 10.2, John Thornton to William Russell, February 19, 1658/59; and ibid., 10.3, Thornton to Russell, March 18, 1658/59.

47. Bodl., Ashmolean 436.65a.

48. BOL, HMC 38, William Russell's Travel Diaries, p. 26.

49. Chatsworth, Russell MSS, Uncat., box 1, John Thornton to William Russell, May 7, 1657.

50. BOL, HMC 36, fol. 6, William Russell to John Thornton, March 11, 1657/58. Also Chatsworth, MS Letters, 10.1, John Thornton to William Russell, February 10, 1658/59.

51. Stone, *Crisis of the Aristocracy*, p. 794; Gladys S. Thomson, *Woburn and the Russells* (Derby, 1956), pp. 11–12; BOL, List of books of second, fourth, and fifth earls of Bedford in Woburn Abbey.

52. Chatsworth, MS Letters, 10.2, John Thornton to William Russell, February 19, 1658/59. The book William requested may have been *J. Cleaveland Revived: Poems, Orations, Epistles And other of his Genuine Incomparable Pieces, never before publisht. With Some other Exquisite Remains of the most eminent Wits of both the Universities that were his Contemporaries*, which appeared in 1659. See Lee A. Jacobus, *John Cleaveland* (Boston, 1975).

53. Chatsworth, MS Letters, 10.3, John Thornton to William Russell, March 18, 1658/59.

54. BOL, HMC 36, fol. 6, William Russell to John Thornton, March 11, 1657/58.

55. Chatsworth, Russell MSS, Uncat., box 2, William Russell to Francis Russell, December 5, 1659.
56. Chatsworth, MS Letters, 10.1 and 10.3, John Thornton to William Russell, February 10 and March 18, 1658/59.
57. BOL, HMC 8, 2:14, Francis Russell to John Thornton, January 7, 1659/60.
58. BOL, John Dawson's Accounts, March 19, 1660, and July 7, 1665.
59. Victoria and Albert Museum, Manuscripts, English, Haberdashery Bills, Russell, R.C.U. 20, pp. 2–5, 7, 8.
60. Chatsworth, Russell MSS, Uncat., box 2, William Cavendish to William Russell, April 7, 1669.
61. Thomson, *The Russells in Bloomsbury*, p. 14.
62. Victoria and Albert Museum, Manuscripts, English, Haberdashery Bills, Russell, R.C.K. 3, passim.
63. BOL, Collop's Accounts, 1660–69.
64. Chatsworth, Russell MSS, Uncat., box 1, William Russell to his father, July 2, 1663, and April 26, 1664.
65. BOL, HMC 36, fol. 9, William Russell to earl of Bedford, March 21, 1667. See also BOL, Collop's Accounts, 1668, which shows a payment of £112 18s. to M. Franqueoff.
66. BOL, Collop's Accounts, 1668.
67. Russell, *Life of William Lord Russell* (1819), 2:91.
68. Berry, *Some Account*, pp. 90–93, and below, Chapter 8.
69. Andrew Browning, ed., *The Memoirs of Sir John Reresby* (Glasgow, 1936), pp. 49–50. The rumored marriage treaty was with Gertrude Pierrepont, the third daughter of William Pierrepont, a parliamentary leader. She was a woman of great beauty but small dowry. In 1672 she became the second wife of the earl of Halifax.
70. Chatsworth, Russell MSS, Uncat., box 1, William Russell to his father, July 2, 1663, and April 26, 1664.
71. PRO, SP 29/116/83 and SP 44/23/37; also *CSPD, 1664–1665*, p. 281.
72. Thomson, *Woburn and the Russells*, p. 16; *HOC*, 3:365; BOL, Collop's Accounts, 1661.
73. BL, Harl. MSS. 6,846, fol. 123.
74. Andrew Browning, *Thomas Osborne, Earl of Danby and Duke of Leeds*, 3 vols. (Glasgow, 1944–51), 3:40; *HOC*, 3:365.
75. BOL, Collop's Accounts, 1669.
76. BOL, Deeds, vol. 2, Cantab., General Evidences, J, bundle 2, no. 41.
77. BOL, Collop's Accounts, 1670 [*sic*].
78. BOL, Deeds, vol. 2, Cantab., General Evidences, J, bundle 2, no. 42.
79. BROB, Title Deeds of Estates, Southampton and Middlesex, A, bundle 2, p. 1163, nos. 34, 38–43, January 18 and July 14, 16, and 17, 1669. Nos. 38, 39, and 43 show only the year 1669.
80. Ibid., no. 36, March 27, 1669.
81. BROB, R 2/144, "A Field Book, Belonging to several Plans of the Manours of Michel-Dever, East and West Stratton, Abbots Worthy, etc. . . . Survey'd & Delinated by Thomas Browne, Gent., Anno. Dom. 1730," p. 318.
82. *The Works of Sir William Temple, Bart.*, 4 vols. (London, 1757), 2:532.

• *Chapter 4* •
Domestic Life, 1669–1683

1. Berry, *Some Account*, p. 36.
2. BROB, R 4/6003, introductory remarks signed by Humphrey Smith and Joseph Willoughby, estate survey computed from a Court of Survey held at Stratton, November 16, 1730.
3. BROB, Title Deeds, Southampton and Middlesex, A, bundle 2, p. 1164, July 24, 1664.
4. Colin Campbell, *Vitruvius Brittannicus* (Paris, 1767 ed.), 4:52–55. I am indebted to Marie Draper for this reference.
5. Marie Draper, unpublished talk given to Kings Worthy Local History Group, October 1985.
6. BROB, R 4/6056, materials sold from Stratton in 1768, 1769, and 1770. For billiards, Thomson, *Life in a Noble Household*, p. 238.
7. BOL, HMC 38, Lady Rachel Russell's Diaries, p. 10. Barry Shurlock found references, but no details, to a manor house at Stratton in the sixteenth century in Hamp. RO, Wriothesley Deeds (Shurlock to the author, January 20, 1986).
8. Berry, *Some Account*, pp. 12, 26.
9. Ibid., pp. 16, 47.
10. BROB, R 4/6003, Introductory remarks, Smith and Willoughby Survey.
11. BROB, R 2/144, "A Field Book, Belonging to several Plans of the Manours of Michel-Dever, East and West Stratton, Abbots Worthy etc. . . . Survey'd & Delinated by Thos. Browne, Gent. Anno. Dom. 1730."
12. BROB, Introductory remarks, Smith and Willoughby Survey.
13. Ibid.
14. Alfred B. Milner, *History of Micheldever* (Paris, 1924), p. 129.
15. Draper, unpublished talk to Kings Worthy Local History Group.
16. BOL, HMC 36, fol. 12.
17. Berry, *Some Account*, pp. 60, 62.
18. BOL, SA 1, "An Accompt of the Whole Personal Estate of the Rt. Honble Rachel Lady Rusel as the same stood on 29th day of Septem: 1723 being the day of Her Ladyship Death." Also Thomson, *Life in a Noble Household*, pp. 256, 258.
19. Thomson, *Life in a Noble Household*, pp. 151–52.
20. BOL, SA 1, "An Accompt of the Whole Personal Estate of. . . Lady Rusel"; Berry, *Some Account*, p. 60.
21. BOL, HMC 36, fols. 12, 14.
22. BROB, R 2/144, "A Field Book. . . by Thos. Browne," p. 318.
23. *CSPD, 1683*, p. 83.
24. *VCH, Hampshire*, 3:389.
25. BOL, SA 1, "An Accompt of the Whole Personal Estate of. . . Lady Rusel"; BROB, R 2/144, "A Field Book. . . by Thos. Browne."
26. BROB, R 2/144, "A Field Book. . . by Thos. Browne."
27. *Letters of Rachel Lady Russell* (1854), pp. 318–19.
28. BROB, R 4/6000, Survey of Copyholds, 1677; BROB, Introductory remarks, Smith and Willoughby Survey. For Lady Russell's revival of the courts baron,

Barings Bank Archive, Northbrook Papers, N15, bk. 3, Records of Courts Baron.

29. BROB, General Evidences in Counties Southampton and Middlesex, p. 1209, bundle 1, October 1680.

30. *VCH, Hampshire*, 1:321, 3:390.

31. *Letters of Rachel Lady Russell* (1854), pp. 318–19.

32. Barry Shurlock to the author, January 20, 1986.

33. BOL, SA 1, "An Accompt of the Whole Personal Estate of . . . Lady Rusel."

34. *VCH, Hampshire*, 3:393.

35. In 1688 Robert Bristow bought property from the Russells. *Letters of Lady Rachel Russell* (1773), p. 93. The maps of Micheldever and East Stratton in BROB, R 1/609, show the location of Winchester's estate. See also Milner, *History of Micheldever*, pp. 58–59, 90–91, 137–38, 140.

36. BOL, HMC 38, Lady Rachel Russell's Diaries, pp. 11, 12, 18.

37. BROB, General Evidences, Southampton and Middlesex, bundle 1, pp. 1207–9, nos. 4, 9, 13–16, January 7, 1671, September 2, 1673, and April 4, 1682.

38. BOL, Title Deeds, vol. 5, Middlesex, St. George's, and St. Pancras, bundle 17, March 25 and 26, 1675. The house changed hands twice more in Rachel's lifetime. In 1680 Jones and his wife sold it to Sir John Brownlow for £5,000, the annual rent charge of £10 going to Lady Russell. In 1688 George, earl of Northampton, bought it.

39. Donald Olsen, *Town Planning in London: The Eighteenth and Nineteenth Centuries* (New Haven, 1964), plates 15–19.

40. John Evelyn, quoted in Thomson, *The Russells in Bloomsbury*, p. 34.

41. Thomson, *The Russells in Bloomsbury*, p. 56; BOL, Draper MS Notes, Corderoy's Account Book, Portland MSS. DD5/P/7.

42. Chatsworth, Russell MSS, Uncat., box 2, Lady Russell to Lord Russell, n.d. [1681?].

43. Berry, *Some Account*, p. 49.

44. Chatsworth, Russell MSS, Uncat., box 2, Lady Russell to Lord Russell, n.d. [1681?].

45. Berry, *Some Account*, p. 26.

46. Chatsworth, Russell MSS, Uncat., box 1, William Russell to Lady Vaughan, August 10, 1675.

47. Ibid., box 1, William Russell to Lady Vaughan, n.d. [1675?].

48. Berry, *Some Account*, p. 63.

49. Chatsworth, Russell MSS, Uncat., box 2, Lady Vaughan to William Russell, n.d. [1676?].

50. Ibid.; Berry, *Some Account*, p. 22.

51. BOL, Collop's Accounts, 1670.

52. Ibid., 1672.

53. Chatsworth, box 43, L/43/3, February 17, 1682.

54. BROB, Title Deeds, Southampton and Middlesex, pp. 1166–67, A, bundle 3, nos. 1–7. As a measure of area, a lugg was equivalent to a square pole or perch, about 30¼ square yards (*OED*).

55. BROB, General Evidences, Southampton and Middlesex, pp. 1210–11, bundle 2, no. 2.

56. *Letters of Lady Rachel Russell* (1773), pp. 1–2.
57. Chatsworth, MS Letters, 23.1.
58. BOL, Summary Analysis of Bloomsbury Leases.
59. Thomson, *The Russells in Bloomsbury*, pp. 64–65.
60. Chatsworth, MS Letters, 15.3. Russell opposed his sister-in-law's marriage to Montagu, which may account for the tension in the appeal. See HMC, *Manuscripts of the late Allan George Finch*, 4 vols. (London 1913–65), 2:38.
61. BOL, HMC 38, Lady Rachel Russell's Diaries, p. 11.
62. Berry, *Some Account*, pp. 1, 5–6, 9, 28, 39, 65.
63. BOL, HMC 36, fol. 68, Lady Rachel Russell to Mrs. Elizabeth Howland, August 29, 1695.
64. Roger North, *The Lives of the Right Hon. Francis North, Baron Guilford, the Hon. Sir Dudley North, and the Hon and Rev. Dr. John North*, ed. Augustus Jessopp, 3 vols. (London, 1890), 3:198.
65. Berry, *Some Account*, p. 62.
66. Ibid., p. 3.
67. Ibid., pp. 15, 35, 38, 56, 58.
68. Ibid., pp. 3, 5, 11, 13, 14, 15, 20, 26, 30, 66.
69. Ibid., pp. 12, 35, 48, 66.
70. Ibid., pp. 39, 60–61.
71. G. C. Moore Smith, ed., *The Letters of Dorothy Osborne to William Temple* (Oxford, 1968).
72. For familiarity in address see Keith Wrightson, *English Society, 1580–1680* (London, 1982), pp. 101–2; Stone, *Family, Sex, and Marriage*, pp. 329–30; and Samuel Sorbière, *A Journey to England. With Some Account of the Manners and Customs of that Nation. Written at the Command of a Nobleman in France. Made English* (London, 1700), p. 23. At least five editions of Sorbière's tract, two in French and with variants in the title, appeared between 1666 and 1709.
73. Only about five letters have survived. Rachel refers to others.
74. Chatsworth, Russell MSS, Uncat., box 1, William Russell to Lady Vaughan, n.d. [1675?].
75. The meeting was held at Basing, the estate of William's friend Charles Paulet, marquess of Winchester. See Berry, *Some Account*, p. 27n. The original is at Chatsworth, Russell MSS, Uncat., box 1.
76. Berry, *Some Account*, p. 64n.
77. BOL, HMC 38, Lady Rachel Russell's Diaries, p. 12.
78. See Dorothy McLaren, "Marital Fertility and Lactation, 1570–1720," in *Women in English Society, 1500–1800*, ed. Mary Prior (London, 1985), pp. 22–53.
79. BOL, HMC 38, Lady Rachel Russell's Diaries, pp. 8, 12, 13.
80. Ibid., p. 11.
81. The child died from eating berries she had picked in the park at Woburn Abbey. Thomson, *Life in a Noble Household*, p. 78.
82. BOL, Collop's Accounts, 1671.
83. BOL, HMC 38, Lady Rachel Russell's Diaries, p. 12; BOL, Extract from register at Chenies in Gladys Thomson's papers.

84. BOL, HMC 38, Lady Rachel Russell's Diaries, p. 12; BOL, Extract from register at St. Giles, Bloomsbury, in Gladys Thomson's papers.

85. HMC, *Manuscripts of the Marquess of Ormonde*, 8 vols. (London, 1902–20), 5:475. The earl of Bedford gave the messenger who brought news of the child's birth a pound. See BOL, Collop's Accounts, 1680.

86. BOL, Extract from register of St. Giles, Bloomsbury, in Gladys Thomson's papers.

87. Berry, *Some Account*, p. 41; *Letters of Lady Rachel Russell* (1773), pp. 3, 4.

88. BL, Sloane MSS. 4,060, fols. 218, 220, Lady Russell to Dr. Sloane, n.d. and October 5, 1711.

89. BOL, HMC 38, Lady Rachel Russell's Diaries, pp. 11, 12, 13.

90. Ibid., pp. 12, 13.

91. Berry, *Some Account*, pp. 22, 23, 47, 48, 53, 60, 63; BOL, HMC 40A, fol. 35; *Letters of Rachel Lady Russell* (1854), pp. 33–34.

92. Berry, *Some Account*, pp. 20, 56, 57–58, 65; Chatsworth, Russell MSS, Uncat., box 2, Lady Russell to Lord Russell, November 22, 1681, and one other undated letter [1681?].

93. Berry, *Some Account*, pp. 41, 48, 62; Chatsworth, Russell MSS, Uncat., box 1, Lady Rachel to her father, n.d.

94. Berry, *Some Account*, p. 38; Chatsworth, Russell MSS, Uncat., box 1, Lord Russell to Lady Russell, n.d. [1681?].

95. Wriothesley was ill in January 1682 and in May 1683 "had a fit." See BOL, HMC 38, Lady Rachel Russell's Diaries, p. 14; Chatsworth, Russell MSS, Uncat., box 2, Dr. Burnet's Relation of the late Lord Russell's behaviour after his Sentence and at his Execution.

96. Chatsworth, MS Letters, 15.4, 19.0; BOL, HMC 8, 3:112–14, 122; Berry, *Some Account*, p. 46; BOL, HMC 38, Lady Rachel Russell's Diaries, p. 14.

97. BOL, HMC 38, Lady Rachel Russell's Diaries, pp. 12, 13.

98. BOL, HMC 8, 3:108, Mr. Hurst (?) to John Thornton, November 24, 1676.

99. Chatsworth, MS Letters, 27.2, earl of Bedford to Lady Rachel Vaughan, undated.

100. BOL, Gladys Thomson's notes, the Privy Purse Account.

101. Berry, *Some Account*, p. 81.

102. Berry, *Some Account*, pp. 33, 60; BOL, HMC 36, fol. 14, William Russell to John Thornton, January 3, 1674(?); BOL, HMC 38, Lady Rachel Russell's Diaries, p. 14.

103. Berry, *Some Account*, p. 63.

104. *Letters of Rachel Lady Russell* (1854), p. 340; BOL, Collop's Accounts.

105. Berry, *Some Account*, pp. 20, 22, 23, 43, 45, 64n.

106. HMC, *Manuscripts of the late Allan George Finch*, 2:3–4.

107. Berry, *Some Account*, pp. 4, 63.

108. BOL, HMC 36, fol. 16, William Russell to John Thornton, June 4, 1674.

109. *Letters of Lady Rachel Russell* (1773), p. 43.

110. *Letters of Rachel Lady Russell* (1854), p. 313.

111. Berry, *Some Account*, pp. 14, 17, 29, 37, 42, 49.

112. BOL, HMC 36, fol. 17, William Russell to John Thornton, June 11, 1674.

113. Chatsworth, MS Letters, 10.1, 28.2.

114. Berry, *Some Account*, p. 13; cf. pp. 54 and 64.
115. Chatsworth, Russell MSS, Uncat., box 2, Dr. Burnet's Relation of the late Lord Russell's behaviour.
116. Cobbett, *Trials*, 9:624.
117. Samuel Johnson, *Remarks upon Dr. Sherlock's Book* (London, 1689), p. 51; *The Works Of the late Reverend Mr. Samuel Johnson, Sometime Chaplain to the Right Honourable William Lord Russell* (London, 1710), p. iv.
118. Deyon, *Du loyalisme au refus*, pp. 101, 105, 106, 110; Berry, *Some Account*, pp. 11, 55; BOL, HMC 38, Lady Rachel Russell's Diaries, p. 12; BOL, HMC 40A, fol. 55.
119. Robin Gwynn, "The Distribution of Huguenot Refugees in England," *Proceedings of the Huguenot Society of London* 21 (1965–70): 427–28. The congregation kept the French Calvinist, and hence Nonconformist, form of worship.
120. Berry, *Some Account*, p. 6.
121. Ibid., pp. 41, 46.
122. *Letters of Lady Rachel Russell* (1773), p. 4.
123. Chatsworth, Russell MSS, Uncat., box 2, Lady Russell's essay on marriage.
124. Berry, *Some Account*, p. 16, where the letter is misdated. The original at Chatsworth in Russell MSS, Uncat., box 2, reads "Monday, August 23rd" which fixes the year as 1675. Katherine was born on August 23, 1676.
125. BOL, HMC 40A, fol. 53; Berry, *Some Account*, pp. 57, 60, 61.
126. Berry, *Some Account*, p. 3.
127. BOL, HMC 40A, fol. 31, Colonel John Russell to Lady Vaughan, June 21, 1672.
128. Marie Catherine, Baronne D'Aulnoy, *Memoirs of the Court of England in 1675*, ed. George David Gilbert (London, 1927), pp. 42, 47, 51, 52, 54, 57–60, 63–64, 106–7, 164, 308.
129. Chatsworth, Russell MSS, Uncat., box 2, Lady Russell to Lord Russell, March, no year [1680?].
130. Berry, *Some Account*, pp. 36–37.
131. *Letters of Lady Rachel Russell* (1773), p. 32.

• *Chapter 5* •
Politics, 1673–1683

1. Frances Harris, "The Electioneering of Sarah, Duchess of Marlborough," *Parliamentary History* 2 (1983): 71–92.
2. The Right Honorable, the Lady Margaret Newcastle, *The Worlds Olio* [Olio = miscellanea] (London, 1655), sig. A.
3. J. H. Plumb, *The Growth of Political Stability in England, 1675–1725* (London, 1967), p. 112 and ch. 4 passim.
4. Chatsworth, Russell MSS, Uncat., box 2, Lady Russell's Confessions.
5. HMC, *Ormonde Manuscripts*, 5:473.
6. Chatsworth, Russell MSS, Uncat., box 2, Lady Russell's Confessions.
7. *CJ*, 9:163 and 165 illustrate his inconsequential role.
8. Berry, *Some Account*, pp. 1–12.

9. K.H.D. Haley, *The First Earl of Shaftesbury* (Oxford, 1968), p. 353; *HOC*, 3:366.
10. Haley, *First Earl of Shaftesbury*, pp. 336–37, 351–52.
11. For what follows, see ibid., chs. 14–18; David Ogg, *England in the Reign of Charles II*, 3d ed., 2 vols. (London, 1961), vol. 2, chs. 8–10; and John Miller, *Popery and Politics in England, 1660–1688* (Cambridge, 1973), ch. 6.
12. K.H.D. Haley, *William of Orange and the English Opposition, 1672–1674* (Oxford, 1953), discusses the propaganda campaign. The most important pamphlet was Pierre Du Moulin's *Englands Appeal from the Private Cabal at Whitehall to The Great Council of the Nation, The Lords and Commons in Parliament assembled* (London, 1673).
13. Grey, *Debates*, 2:198, 213–14.
14. Berry, *Some Account*, pp. 2–3, 4, and n. 1.
15. BOL, HMC 40A fols. 30–31.
16. *HOC*, 3:366.
17. Grey, *Debates*, 2:227, 232–33, 256, 265.
18. Ibid., 2:393.
19. Ibid., 2:399; *CJ*, 9:305.
20. Berry, *Some Account*, p. 13.
21. Ibid., pp. 22, 26, 29, 31, 35, 36, 41, 42, 45, 47, 49, 53, 57.
22. Chatsworth, Russell MSS, Uncat., box 2, William Russell to Lady Rachel Vaughan, August 10, 1675.
23. *CJ*, 9:315, 316, 323, 348, 365; Maurice F. Bond, ed., *The Diaries and Papers of Sir Edward Dering, Second Baronet, 1644 to 1684*, House of Lords Record Office Occasional Publications, no. 1 (London, 1976), pp. 59, 70; Grey, *Debates*, 3:40–41, 46. Also Browning, *Thomas Osborne*, 1:155, 160; Sir Richard Bulstrode, *The Collection of Autograph Letters and Historical Documents formed by Alfred Morrison*, 2d ser., vol. 1, *The Bulstrode Papers (1667–1675)* (London, 1897), pp. 286, 287.
24. Grey, *Debates*, 3:337, 419–20, and 4:8.
25. *CSPD, 1676–1677*, p. 287.
26. *HOC*, 3:366.
27. Haley, *First Earl of Shaftesbury*, pp. 204–5.
28. *HOC*, 3:365.
29. At that time Southampton redeemed a mortgage on some of his property that Margaret had taken out in 1650. See BOL, Deeds, vol. 2, Southampton, Middlesex, and Bloomsbury, A, bundle 2, no. 25, December 19, 1655.
30. *Calendar of the Clarendon State Papers Preserved in the Bodleian Library*, 5 vols. (Oxford, 1882–1970), 4:585; Haley, *First Earl of Shaftesbury*, pp. 125, 132, 143, 346.
31. In 1675 John Locke dedicated to Lady Shaftesbury his translations of essays by a French Jansenist, an indication of Locke's respect for her. Haley, *First Earl of Shaftesbury*, p. 91.
32. BOL, HMC 38, Lady Rachel Russell's Diaries, p. 17.
33. Berry, *Some Account*, pp. 13, 18, 29; BOL, HMC 38, Lady Rachel Russell's Diaries, p. 13.

34. Chatsworth, Russell MSS, Uncat., box 1, Margaret Shaftesbury to Rachel Russell, September 18, 1683.
35. Berry, *Some Account*, pp. 53–54; *Letters of Lady Rachel Russell* (1773), pp. 16–17, 24; BOL, HMC 38, Lady Rachel Russell's Diaries, p. 14.
36. Chatsworth, Russell MSS, Uncat., box 1, Margaret Shaftesbury to Rachel Russell, September 18, 1683.
37. Chatsworth, MS Letters, 50.0, Margaret Shaftesbury to Rachel Russell, August 18, 1688.
38. Berry, *Some Account*, pp. 18, 19, 37.
39. *Letters of Rachel Lady Russell* (1854), p. 114.
40. Mrs. Jameson, *Memoirs of the Beauties of the Court of Charles the Second, with Their Portraits* (New York, 1812), pp. 269–70; Maurice Cranston, *John Locke: A Biography* (London, 1957), pp. 28, 135, 138, 145, 173; E. S. de Beer, ed., *The Correspondence of John Locke*, 7 vols. (Oxford, 1976–82), 1:326, 338.
41. Cranston, *John Locke*, p. 196.
42. Berry, *Some Account*, p. 19.
43. Ibid., pp. 19–20.
44. Ibid., p. 17.
45. *CJ*, 9:382.
46. Grey, *Debates*, 4:64–72.
47. Ibid., 4:71.
48. Haley, *First Earl of Shaftesbury*, pp. 412–19 passim, where other reasons are given.
49. *CSPD, 1677–1678*, p. 267.
50. Agnew, *Henri de Ruvigny*, p. 17, quoting *Memoirs de St. Simon*.
51. Thomas Stringer, Shaftesbury's steward, told this story late in life, reinforcing its accuracy by saying that Lady Russell could "attest" to it. See W. D. Christie, *A Life of Anthony Ashley Cooper, First Earl of Shaftesbury, 1621–1683*, 2 vols. (London, 1871), 2:181.
52. Dalrymple, *Memoirs of Great Britain*, 2:129–30.
53. Browning, *Earl of Danby and Duke of Leeds*, 2:318–19, 325; R. Montagu to Danby, lord treasurer, January 1/11 and 8/18, 1678.
54. C. L. Grose, "Louis XIV's Financial Relations with Charles II and the English Parliament," *Journal of Modern History* 1 (1929): 177–204.
55. Browning, *Earl of Danby and Duke of Leeds*, vol. 1, ch. 12.
56. Ibid., 1:260.
57. William visited Shaftesbury in prison on January 1 and 12 and February 16, 1678. *CSPD, 1677–1678*, p. 269.
58. Dalrymple, *Memoirs of Great Britain*, 2:132–34, Barrillon to Louis XIV, March 4/14, 1678.
59. Ibid., p. 133.
60. Ibid., pp. 138–39, Barrillon to Louis XIV, April 1/11, 1678.
61. Grey, *Debates*, 6:359. The letter from Rachel's sister, mentioned by Lord Montagu in the House of Commons, has not survived.
62. Berry, *Some Account*, p. 30. Berry thought the letter alluded to the first Exclusion Bill.

63. PRO, PRO 31/3/138/142, Barrillon to Louis XIV, March 18/28, 1678.
64. Barrillon gives the names of Whigs who accepted bribes, but at no time includes Russell's name. See Dalrymple, *Memoirs*, 2:285, 314–19. Sometimes scholars fail to note that Russell is not mentioned. Haley, *First Earl of Shaftesbury*, pp. 444–45, wrote that Russell accepted bribe money but corrected himself in a letter to the author of July 2, 1986. The citations to the same point in Ashcraft, *Revolutionary Politics*, p. 129, n. 7, are incorrect.
65. Browning, *Earl of Danby and Duke of Leeds*, 2:318–19, 325.
66. HMC, *Manuscripts of the late Allan George Finch*, 2:38.
67. Ibid.
68. Haley, *First Earl of Shaftesbury*, p. 445. Browning, *Memoirs of Sir John Reresby*, p. 135, reports that both Danby and York got wind of a plan to discredit them in the House of Commons.
69. Grey, *Debates*, 5:224.
70. Ibid., pp. 225–47; Haley, *First Earl of Shaftesbury*, p. 443.
71. The note, written on a half-sheet of paper and folded over, is undated, but William wrote at the bottom, "March the——— 1677–8. While the House was sitting." Berry, *Some Account*, p. 21.
72. Haley, *First Earl of Shaftesbury*, p. 448.
73. *CSPD, 1678*, pp. 159–60; Grey, *Debates*, 5:334, 358; Haley, *First Earl of Shaftesbury*, pp. 448; Browning, *Earl of Danby and Duke of Leeds*, 1:276.
74. Haley, *First Earl of Shaftesbury*, p. 448.
75. *HOC*, 3:367.
76. Haley, *First Earl of Shaftesbury*, pp. 461–65.
77. *LJ*, 13:133; Haley, *First Earl of Shaftesbury*, pp. 471–72. It is worth noting that the not always reliable J. S. Clarke, ed., *Life of James II* (London, 1816), 1:524, says that Shaftesbury did not ask that the duke be exiled from the king and court.
78. H. C. Foxcroft, ed., *The Life and Letters of Sir George Savile, Bart. First Marquis of Halifax*, 2 vols. (London, 1898), 1:135; Browning, *Earl of Danby and Duke of Leeds*, 1:298; Grey, *Debates*, 6:133; *CJ*, 9:533.
79. The Speaker reprimanded one M.P. for using unparliamentary language in support of the motion (Grey, *Debates*, 6:144).
80. *LJ*, 13:345.
81. *CJ*, 9:536, 540, 542; Grey, *Debates*, 6:149.
82. Clarke, *Life of James II*, 1:530.
83. Browning, *Earl of Danby and Duke of Leeds*, 1:301–7; Haley, *First Earl of Shaftesbury*, pp. 487–90; Grey, *Debates*, 6:345.
84. Grey, *Debates*, 6:360.
85. Ibid., 6:363; Browning, *Memoirs of Sir John Reresby*, pp. 164–65.
86. Grey, *Debates*, 6:364.
87. Berry, *Some Account*, p. 25.
88. *HOC*, 3:365.
89. Berry, *Some Account*, pp. 23–24, 26–27, and n. 2. For an early analysis of the election, see M. Dorothy George, "Elections and Electioneering, 1679–1681," *English Historical Review* 45 (1930): 552–78. Lord Russell spent about £1,500 in the Bedfordshire election. See BL, Microfilm M 636/32, Edmund

Verney to Sir Ralph Verney, February 24, 1679. I thank Mark Kishlansky for calling my attention to this reference. For tracts in circulation at about this time, see B. Behrens, "The Whig Theory of the Constitution in the Reign of Charles II," *Cambridge Historical Journal* 7 (1941–43): 42–71, and O. W. Furley, "The Whig Exclusionists: Pamphlet Literature in the Exclusion Campaign, 1679–81," ibid. 12–13 (1956–57): 19–36.

90. George, "Elections and Electioneering," p. 554.
91. Ibid.
92. Berry, *Some Account*, p. 24. Also BL, Microfilm M 636/32, Edmund Verney to Sir Ralph Verney, February 24, 1679.
93. BL, Microfilm M 636/32, Edmund Verney to Sir Ralph Verney, February 24, 1679.
94. Berry, *Some Account*, p. 29.
95. Quotations in this paragraph and the next from ibid., pp. 23–31 passim.
96. Ibid., p. 30; *HOC*, 3:366.
97. Haley, *First Earl of Shaftesbury*, pp. 507–10.
98. *CJ*, 9:577. Cavendish, Hampden the younger, and William Sacheverell were also appointed.
99. Haley, *First Earl of Shaftesbury*, pp. 515–16.
100. Grey, *Debates*, 7:147–48.
101. J. R. Jones, *The First Whigs: The Politics of the Exclusion Crisis, 1678–1683* (London, 1961), p. 56, believes that the motion was a prelude to Exclusion, but there is no evidence that Russell saw it that way.
102. The summons is at BOL, HMC 40.
103. *CJ*, 9:599; Grey, *Debates*, 7:129 and n.; Burnet, *HOT*, 2:204.
104. HMC, *Ormonde Manuscripts*, 4:505; Jones, *First Whigs*, pp. 62–63. Rumor about such an appointment also reappeared later.
105. *CJ*, 9:605; Grey, *Debates*, 7:150, 151.
106. Grey, *Debates*, 7:237.
107. Haley, *First Earl of Shaftesbury*, p. 517; Grey, *Debates*, 7:247, 260; *CJ*, 9:620.
108. Andrew Browning and Doreen J. Milne, "An Exclusion Bill Division List," *BIHR* 23 (1950): 207. See Jones, *First Whigs*, pp. 71–72.
109. Haley, *First Earl of Shaftesbury*, p. 533; Jones, *First Whigs*, p. 77.
110. Roger North, *Examen; or, an Enquiry into the Credit and Veracity of a Pretended Complete History* (London, 1740), pp. 79–80. PRO, PC 2/68; Privy Council Register, shows that the council met on June 6, not June 7. I thank D. Crook for searching the register for me.
111. HMC, *Ormonde Manuscripts*, 5:137.
112. Foxcroft, *Life and Letters of Halifax*, 1:170; *CSPD, 1679–1680*, p. 195; HMC, *Ormonde Manuscripts*, 4:531; Haley, *First Earl of Shaftesbury*, p. 544.
113. Chatsworth, Russell MSS, Uncat., box 1, five Bedfordshire men to William Russell, August 31, 1679; Jones, *First Whigs*, p. 100; *HOC* 3:365.
114. Berry, *Some Account*, p. 31.
115. Jones, *First Whigs*, p. 100.
116. *CJ*, 9:633.
117. HMC, *Ormonde Manuscripts*, 5:238 and 4:559.

118. PRO, PC 2/68, Privy Council Register, November 1679–January 1680.
119. Haley, *First Earl of Shaftesbury*, p. 565, for Shaftesbury's letter urging resignation.
120. HMC, *Ormonde Manuscripts*, 5:270, 271.
121. Ibid., p. 274; Narcissus Luttrell, *Brief Historical Relation of State Affairs from September 1678 to April 1714*, 6 vols. (Oxford, 1857), 1:33.
122. Berry, *Some Account*, pp. 32–38 passim, 41, 44, 49. It is unknown which privy councillor would have told Rachel about council business. Probably it was Sir Thomas Chicheley, Knight, Master of Ordnance, her neighbor and a business associate of the Russells. The list of privy councillors is in White Kennett, *A Complete History of England*, 3 vols. (London, 1706), 3:374.
123. Berry, *Some Account*, pp. 39–40. North presented this evidence to the Privy Council (Dr. Williams' Library, Roger Morrice, "Entr'ing Book, Being an Historical Register of Occurrences from April, Anno. 1667 to April 1691," 4 vols., 1:273).
124. Berry, *Some Account*, p. 39.
125. Ibid., pp. 42, 46–47.
126. Browning, *Memoirs of Sir John Reresby*, p. 193.
127. Ford, Lord Grey of Werk, *The Secret History of the Rye-House Plot* (London, 1754), pp. 3–6; Haley, *First Earl of Shaftesbury*, pp. 576–77.
128. Haley, *First Earl of Shaftesbury*, p. 577.
129. Berry, *Some Account*, pp. 115, 129.
130. PRO, PRO 30/24/6 B. 420.
131. Haley, *First Earl of Shaftesbury*, p. 580.
132. Berry, *Some Account*, pp. 129, 132.
133. Grey, *Debates*, 7:357–58; *CJ*, 9:640; Haley, *First Earl of Shaftesbury*, p. 595 and pp. 554–55, 578, 581 for Dangerfield.
134. Haley, *First Earl of Shaftesbury*, p. 599, thinks that Russell was incapable of managing the bill, but by 1680 Russell had had considerable experience, and the timing and imperfections of the bill do not suggest that a mastermind was behind it.
135. Grey, *Debates*, 7:391, 395–413; *CJ*, 9:645. Morrice reported that "not 12" people were against the question. "Entr'ing Book," 1:274.
136. *CJ*, 9:646; Grey, *Debates*, 7:418–21.
137. Grey, *Debates*, 7:428.
138. Ibid., 7:425–30; *CJ*, 9:647.
139. Grey, *Debates*, 7:431–32; *CJ*, 9:648.
140. Grey, *Debates*, 7:451–59; *CJ* 9:651.
141. Haley, *First Earl of Shaftesbury*, pp. 598, 599.
142. PRO, PRO 31/3/147/379, Barrillon's dispatch of November 19/29, 1680.
143. HMC, *Ormonde Manuscripts*, 5:496; *CSPD, 1680–1681*, p. 86; Grey, *Debates*, 7:477; Morrice, "Entr'ing Book," 1:277.
144. Jones, *First Whigs*, p. 141.
145. Grey, *Debates*, 8:13. Another M.P. spoke of people defying the duke "with swords in their hands." Clarke, *Life of James II*, 1:621.
146. Grey, *Debates*, 8:4, 8, 10, 13; Haley, *First Earl of Shaftesbury*, p. 605; HMC, *Ormonde Manuscripts*, 5:561–62.

147. Louise Brown, *The First Earl of Shaftesbury*, (New York, 1933), p. 271. Thomas Pilkington, the radical London sheriff, favored the same measure: see Ogg, *England in the Reign of Charles II*, 2:588–89. An oblique reference to the idea appeared in Sir William Jones's speech on November 11. Grey, *Debates*, 7:451.

148. For Barrillon's dispatch, see Christie, *A Life of the First Earl of Shaftesbury*, 2:371.

149. Grey, *Debates*, 7:235, 261–62, 281, 285, 460–61, 470–71; 8:53–60, 67–71, 233–34, 237–50, 285–89.

150. Ibid., 8:21–31.

151. BL, Egerton MSS. 2,978, fol. 55.

152. Grey, *Debates*, 8:204, 209–10.

153. Haley, *First Earl of Shaftesbury*, p. 610, n. 2.

154. HMC, *Ormonde Manuscripts*, 5:467; R. W. Blencowe, ed., *Diary of the Times of Charles the Second by The Honourable Henry Sidney*, 2 vols. (London, 1843), 2:147–48.

155. HMC, *Ormonde Manuscripts*, 5:467; HMC, *Seventh Report* (London, 1879), pt. 1, app., p. 496b.

156. Berry, *Some Account*, pp. 42, 46.

157. Ibid., pp. 25, 40.

158. PRO, PRO 31/3/155/56, Barrillon's dispatch of June 28/July 8, 1683.

159. *A Seasonable Address to both Houses of Parliament* (London, 1680/81). See Foxcroft, *Life and Letters of Halifax*, 1:395, n. 2; Haley, *First Earl of Shaftesbury*, pp. 530, 538.

160. Chatsworth, Russell MSS, Uncat., box 1, the Reverend William Bates to William, Lord Russell, 1680. Bates had worked for comprehension and/or toleration during the Restoration. See *DNB*, s.v. "William Bates." The title of the book dedicated to Russell was *Vitae Selectorium Aliquot Qui Doctrina, Dignitate, aut Pietate Inclaruere* (London, 1681). Bates had another indirect connection with the Russell family: he wrote the dedicatory letter to the 1681 edition of sermons by Thomas Manton, who had served Bedford as chaplain. See BOL, HMC 8, 3:7, 8, 18.

161. Burnet, *HOT*, 2:83.

162. Berry, *Some Account*, pp. 50, 51. For this election, see Jones, *First Whigs*, pp. 167–73.

163. Berry, *Some Account*, p. 52.

164. Ibid., pp. 53–54.

165. Richard Ashcraft, *Revolutionary Politics and Locke's Two Treatises of Government* (Princeton, 1986), p. 342.

166. Grey, *Debates*, 8:303–9; *CJ*, 9:710.

167. Grey, *Debates*, 8:310, 332.

168. For what follows, see Ogg, *England in the Reign of Charles II*, 2:606–56; J. R. Western, *Monarch and Revolution: The English State in the 1680s* (London, 1972), esp. chs. 2 and 3.

169. Russell, *Life of William Lord Russell*, 2:1

170. Luttrell, *Brief Relation*, 1:80, 95.

171. Haley, *First Earl of Shaftesbury*, pp. 629–31, 634–37, 642–51.

172. HMC, *Ormonde Manuscripts*, 6:114–15; Foxcroft, *Life and Letters of Halifax*, 1:308; Clarke, *Life of James II*, 1:691–92.
173. BOL, HMC 39, Bedford's notes on conversation with Prince of Orange, pp. 19–21 (endorsed by Lady Russell).
174. Univ. of Nott., Ne C 9, p. 3, ? to William, August 1681, endorsed by Lady Russell "a letter written Aug. '81 while the prince of Orange was here."
175. *CSPD, 1680–1681*, p. 473.
176. Sir Edward Maunde Thompson, ed., *Correspondence of the Family of Hatton, being chiefly letters addressed to Christopher, first Viscount Hatton, 1601–1704*, 2 vols., Camden Society n.s., vol. 23 (London, 1878), 2:3; HMC, *Ormonde Manuscripts*, 6:95. Also Haley, *First Earl of Shaftesbury*, pp. 654–58.
177. Haley, *First Earl of Shaftesbury*, pp. 667–68.
178. Ibid., p. 669.
179. Chatsworth, Russell MSS. 31.0, Francis Charlton to William Russell, October 12, 1681.
180. Haley, *First Earl of Shaftesbury*, pp. 672–73.
181. Berry, *Some Account*, pp. 58, 60, 64.
182. Chatsworth, Russell MSS, Uncat., box 1, Lady Russell to Robert Spencer, November 24, 1681.
183. Luttrell, *Brief Relation*, 1:147; HMC, *Ormonde Manuscripts*, 6:242.
184. Berry, *Some Account*, p. 64.
185. *CSPD, 1682*, p. 303; *The Rights of the City Farther unfolded and The Manifold Miscarriages of My Lord Mayor, As well as the Punishments he hath rendered himself obnoxious unto, for his Misbehaviour in relation to the present Election of Sheriffs, Display'd and laid Open* (London, 1681).
186. *CPSD, 1682*, pp. 429–30; *HOC*, 1:544–45.
187. *CPSD, 1682*, pp. 430, 432, 447.
188. Ashcraft, *Revolutionary Politics*, pp. 351–59.
189. BOL, HMC 38, Diaries of Lady Rachel Russell, p. 14.
190. Haley, *First Earl of Shaftesbury*, pp. 705–25.
191. Ashcraft, *Revolutionary Politics*, ch. 8 for reality of the plot.
192. Sandbeck Park, Rotherham, York., MTD/A8/19, ? to Sir Robert Townsend, May 30, 1683.

• *Chapter 6* •
Trial and Execution of Lord Russell, July 1683

1. *The Speech Of the Late Lord Russel To the Sheriffs: Together with the Paper deliver'd by him to them, at the Place of Execution, on July 21, 1683* (London, 1683), p. 4. See also PRO, PRO 31/3/155/115, Barrillon's dispatch of August 16/26, 1683.
2. Paul de Rapin-Thoyras, *The History of England, As Well Ecclesiastical as Civil, Done into English from the French, by N. Tindal*, 15 vols. (London, 1728–31), 14:331; C. J. Fox, quoted in J. H. Wiffen, *Historical Memoirs of the House of Russell; From the Time of the Norman Conquest*, 2 vols. (London, 1833), 2:282; C. H. Firth, ed., *The History of England from the Accession of James the Second by Lord Macaulay*, 6 vols. (London, 1913–15), 1:256.

3. Lois G. Schwoerer, "William, Lord Russell: The Making of a Martyr, 1683–1983," *Journal of British Studies* 24 (January 1985): 41–71; David Ogg, *England in the Reign of Charles II*, 3d ed., 2 vols. (London, 1961), 2:647; Alfred Havinghurst, "The Judiciary and Politics in the Reign of Charles II," *Law Quarterly Review* 66 (1950): 245–46, 251; Sir James F. Stephen, *A History of the Criminal Law of England*, 3 vols. (London, 1883), 1:408–11. Ashcraft, *Revolutionary Politics*, passim, for reality of plot.

4. Thomas Sprat, Bishop of Rochester, *A True Account and Declaration of The Horrid Conspiracy Against the Late King, His Present Majesty and the Government: As it was Order'd to be Published by His Late Majesty* (London, 1685), p. 17; Bodl., MSS. Carte 219, fols. 472–73. An oilman was a manufacturer, seller, or dealer in oil (*OED*).

5. BL, Harleian MSS. 6,845, fols. 266–272v, Nathaniel Wade's confession, October 4, 1685.

6. Foxcroft, *Supplement to Burnet*, p. 115.

7. Bodl., MSS Carte 219, fol. 473.

8. Cobbett, *Trials*, 9:370.

9. *Copies of the Informations and Original Papers Relating to the Proof of The Horrid Conspiracy Against the Late King, His Present Majesty, and the Government* (London, 1685), p. 12.

10. Haley, *First Earl of Shaftsbury*, p. 717.

11. *Copies of the Informations*, p. 18.

12. Burnet, *HOT*, 2:358, 365–66.

13. *Speech Of the Late Lord Russel*, p. 4; *Letters of Lady Rachel Russell* (1773), p. 15.

14. Warrant addressed to the lieutenant of the Tower is in BOL, HMC 36, no. 37.

15. Burnet, *HOT*, 2:366; PRO, PRO 31/3/155/55v, Barrillon's dispatch of June 28/July 8, 1683; North, *Examen*, pp. 380–81. The official account of Russell's interrogation has not survived; perhaps it was expunged from the record when his attainder was reversed.

16. Bodl., MSS. Carte 219, fols. 476, 478; Thompson, *Hatton Correspondence*, 2:24.

17. Russell, *Life of William Lord Russell*, 2:25; *Letters of Lady Rachel Russell* (1773), p. 80.

18. Russell, *Life of William Lord Russell*, 2:25; Brian Bevan, *James Duke of Monmouth* (London, 1973), pp. 160–61.

19. See *Copies of the Informations*, pp. 6, 9, 10–11, 12, 22–23, 35, 37, 49, 52, 58.

20. *HOC*, 2:606.

21. David Ogg, no friend of the late-Stuart monarchy, states that "there is no proof that the Court prompted the confessions." *England in the Reign of Charles II*, 2:647.

22. Bodl., MSS. Carte 219, fols. 475, 482, 487; HMC, *Ormonde Manuscripts*, 7:74.

23. Foxcroft, *Supplement to Burnet's History*, p. 116.

24. J. H. Baker, "Criminal Courts and Procedure at Common Law, 1550–1800," in *Crime in England, 1550–1800*, ed. J. S. Cockburn (Princeton, 1977), pp. 39–40.

25. FSL, "The Newdigate Newsletters. Addressed to Sir Richard Newdigate, 1st Bart., and to 2nd Bart., 1673/74–1715," L.c. 1394. See also *CSPD, January 1 to June 30, 1683,* pp. 347–48.

26. Bodl., MSS. Carte 219, fols. 472–73; *CSPD, January 1 to June 30, 1683,* pp. 347–48.

27. Bodl., MSS. Carte 216, fol. 205; Bodl., MSS. Carte 219, fol. 474; HMC, *Seventh Report,* pt. 1, app., p. 363a; HMC, *Manuscripts of his Grace the Duke of Buccleuch and Queensberry, K.G., K.T., Preserved at Drumlanrig Castle,* 2 vols. (London, 1897–1903), 1:193; FSL, "Newdigate Newsletters," L.c. 1395.

28. PRO, SP 44, Entry Book 68, p. 301.

29. Ibid., pp. 293, 295–97, 300–303, 314–16, 332; Bodl., MSS. Carte 74, fols. 212, 217, 219; *CSPD, 1683* (J-S), p. 89.

30. PRO, SP 44, Entry Book 68, pp. 298, 299, 311.

31. Ibid., p. 323; also pp. 306–7; Bodl., MSS. Carte 74, fols. 210, 213.

32. The Reverend Thomas Stratford, *Lord Russell: A Tragedy* (London, [1784 according to the Folger Library catalogue]).

33. PRO, SP 29/427, pt. 1, p. 7; PRO, SP 44, Entry Book 66, p. 233; *CSPD, 1683* (J-S), pp. 5, 6, 17, 79, 83.

34. PRO, SP 29/427, pt. 1, p. 119; *CSPD, 1683* (J-S), pp. 25, 72.

35. Cobbett, *Trials,* 9:581.

36. *CSPD, 1683* (J-S), p. 108.

37. BOL, HMC 40, n.p. Also BL, Add. MSS. 8127, fols. 62–68. These two sets of notes, both in Russell's hand, do not vary materially from each other.

38. Russell, *The Speech of the Late Lord Russel,* p. 3.

39. William S. Holdsworth, *A History of English Law,* 3d ed., 13 vols. (London, 1922–52), 8:322–24.

40. Bodl., MSS. North 6.1, nos. 50, 68.

41. Cobbett, *Trials,* 9:584.

42. BOL, HMC 36, no. 17. A paper in Rachel's hand dated July 9 itemizes the same questions as in the official examination of June 28.

43. Burnet, *HOT,* 2:370.

44. Cobbett, *Trials,* 9:489.

45. See Chapter 4, above, at n. 55.

46. Russell, *Life of William Lord Russell,* 2:26.

47. Cobbett, *Trials,* 9:581.

48. Ibid. See ibid., pp. 488–89, for a record of the interview.

49. BL, Add. MSS. 34,526, fol. 16v, Rachel's notes on William's last days.

50. Chatsworth, Russell MSS, Uncat., box 1, William Harbord to Lady Rachel Russell, June 28, 1683; Foxcroft, *Supplement to Burnet,* p. 116; BOL, HMC 36, no. 19, two undated fragments in Rachel's hand about meeting with William's lawyers.

51. *CSPD, 1683* (J-S), pp. 109, 127; *DNB.*

52. BOL, HMC 36, no. 20.

53. *Letters of Philip [Stanhope], second Earl of Chesterfield, to several Celebrated Individuals* (London, 1829), pp. 39–43.

54. Luttrell, *Brief Relation,* 2:268; Baker, "Criminal Courts," p. 38.

55. James Wright, *A Compendious View of the late Tumults & Troubles in this*

Kingdom, by way of Annals for seven years (London, 1685), p. 176.

56. Bodl., Ashmolean MSS., 438, fol. 75; Cobbett, *Trials*, 9:594.
57. Cobbett, *Trials*, 9:594.
58. *LJ*, 14:381.
59. *Letters of Lady Rachel Russell* (1773), p. 61.
60. BOL, Collop's Accounts show nineteen instances of such counsel between 1669 and 1675.
61. Cobbett, *Trials*, 9:582; Baker, "Criminal Courts," p. 57.
62. Cobbett, *Trials*, 9:581, 582.
63. Ibid., p. 582.
64. Ibid., p. 618.
65. Ibid., pp. 629, 636.
66. Ibid., p. 582.
67. Ibid.
68. Ibid., p. 584.
69. Ibid., p. 585.
70. A list made by Gladys S. Thomson now in BOL, HMC 36, refers to depositions taken at the trial, some in Lady Russell's hand, but those papers have disappeared.
71. Cobbett, *Trials*, 9:591.
72. Ibid., pp. 590–91.
73. Ogg, *England in the Reign of Charles II*, 2:519; Stephen, *History of Criminal Law*, 1:412.
74. Cobbett, *Trials*, 9:594.
75. HMC, *The Manuscripts of the House of Lords, 1678–1693*, 4 vols. (London, 1887–94), 2:289; *LJ*, 14:393.
76. James C. Oldham, "The Origins of the Special Jury," *University of Chicago Law Review* 50 (1983): 154, n. 85; J. P. Kenyon, "The Acquittal of Sir George Wakeman: 18 July 1678," *Historical Journal* 14 (1971): 702.
77. Cobbett, *Trials*, 9:595, 602, 633.
78. North, *Examen*, p. 402; HMC, *Ormonde Manuscripts*, 7:73–74. A modern study of Arthur Capel, earl of Essex, would be useful.
79. *Letters of Lady Rachel Russell* (1773), p. 61.
80. Testimony of Rumsey, Shepherd, and Howard from Cobbett, *Trials*, 9:596–611.
81. Ibid., pp. 608, 612.
82. Ibid., pp. 613, 619.
83. Baker, "Criminal Courts," p. 39 and n. 139; also Stephen, *History of Criminal Law*, 2:409.
84. Cobbett, *Trials*, 9:614.
85. Ibid., p. 612.
86. Ibid., p. 613.
87. Russell's defense from ibid., pp. 614–24.
88. *CSPD, July 1 to September 30, 1683*, p. 148.
89. Cobbett, *Trials*, 9:616, 617, 618.
90. Baker, "Criminal Courts," p. 38; PRO, PRO 31/3/155/78v, Barrillon's dispatch of July 16/26, 1683.
91. Cobbett, *Trials*, 9:625.

92. Ibid., p. 628.
93. Ibid., p. 632.
94. L. M. Hill, "The Two-Witness Rule in English Treason Trials: Some Comments on the Emergence of Procedural Law," *American Journal of Legal History* 12 (1968): 95–111; James R. Phifer, "Law, Politics, and Violence: The Treason Trials Act of 1696," *Albion* 12 (1980): 244; Holdsworth, *History of English Law*, 9:207.
95. Cobbett, *Trials*, 9:628.
96. Stephen, *History of Criminal Law*, 2:263–68.
97. Cobbett, *Trials*, 9:636.
98. BL, Add. MSS. 34,526, fol. 16.
99. *LJ*, 14:393.
100. De Beer, *Diary of John Evelyn*, 4:329.
101. HMC, *Manuscripts of Lord Kenyon* (London, 1894), p. 166; cf. p. 162. See also Browning, *Memoirs of Sir John Reresby*, p. 311.
102. Thompson, *Hatton Correspondence*, 2:29–30.
103. PRO, PRO 31/3/155/78v, 85v, 86, Barrillon's dispatches of July 16/26 and July 24/August 2, 1683.
104. Foxcroft, *Supplement to Burnet*, pp. 116–17.
105. Russell, *Life of William Lord Russell*, 2:78–79; *CSPD, 1683* (J-S), p. 124.
106. Russell, *Life of William Lord Russell*, 2:74; *Letters of Lady Rachel Russell* (1773) p. xxxiv; Luttrell, *Brief Relation*, 1:269; Bond, *Diaries of Sir Edward Dering*, p. 145; *CSPD, 1683* (J-S), p. 91; PRO, PRO 31/3/155/85v, Barrillon's dispatch of July 24/August 2, 1683.
107. BOL, HMC 36, no. 52.
108. Ibid., no. 24.
109. Ibid.; *CSPD, 1683* (J-S), p. 140.
110. *Letters of Lady Rachel Russell* (1773), pp. xxxv, 6.
111. BOL, HMC 36, no. 23.
112. Ibid., no. 27; Chatsworth, Russell MSS, Uncat., box 2, Dr. Burnet's Relation of the late Lord Russell's behaviour after his sentence and at his Execution.
113. Bodl., MSS. Carte 216, fol. 309. Rachel's letter has not survived.
114. BOL, HMC 36, no. 23; PRO, PRO 31/3/155/79v, Barrillon's dispatch of July 16/26, 1683.
115. BOL, HMC 36, no. 22. The unsigned letter to Rachel is in Dr. Fitzwilliam's hand.
116. *CSPD, 1683* (J-S), p. 91; Bond, *Diaries of Sir Edward Dering*, p. 145; Luttrell, *Brief Relation*, 1:269.
117. PRO, PRO 31/3/155/84–84v, Barrillon's dispatch of July 19/29, 1683.
118. Dalrymple, *Memoirs*, 2:59–60.
119. BOL, HMC 36, no. 24; Burnet, *HOT*, 2:380.
120. *LJ*, 14:378; *Letters of Lady Rachel Russell* (1773), p. 138; Foxcroft, *Life and Letters of Halifax*, 1:392–93 and n. 4.
121. Chatsworth, Halifax Collection, Group A, 4:A.
122. PRO, PRO 31/3/155/115, Barrillon's dispatch of August 16/26, 1683; J. P. Kenyon, *Robert Spencer, Earl of Sunderland, 1641–1702* (London, 1958), p. 88.
123. Russell, *Life of William Lord Russell*, 2:74.

124. Burnet, *HOT*, 2:380; Bodl., MSS. Carte 216, fols. 307, 308.
125. *CSPD, 1683* (J-S), pp. 128, 170.
126. The original warrants respecting Russell are in Kent Archives, U 471 025, fols. 1–5, and U 471 021. See *CSPD, 1683* (J-S), p. 213, for the warrant ordering the heads of Walcot, Rouse, and Hone to be set up.
127. Russell, *Life of William Lord Russell*, 2:96.
128. Chatsworth, Russell MSS, Uncat., box 2, Dr. Burnet's Relation.
129. Ibid.; BL, Add. MSS. 34,526, Dr. Gilbert Burnet, Some Further Passages forgot in the former relation, fol 17v.
130. Chatsworth, Russell MSS, Uncat., box 2, Dr. Burnet's Relation.
131. BOL, HMC 38, sermon preached at Newgate on July 20, 1683.
132. Wriothesley had "a fit" in May 1683. BOL, HMC 38, Lady Rachel Russell's Diaries, p. 14.
133. BL, Add. MSS. 34,526, Burnet, Some Further Passages forgot in the former relation, fol. 17.
134. See Ashcraft, *Revolutionary Politics*, p. 390, for Russell's insistence earlier that the Council of Six publish a declaration of their aims.
135. Burnet, *HOT*, 2:382–83; *Letters of Lady Rachel Russell* (1773), p. 5; Chatsworth, Russell MSS, Uncat., box 2, Dr. Burnet's Relation; BL, Add. MSS. 34,526, Burnet, Some Further Passages forgot in the former relation, fol. 18. It was common practice for the condemned to exculpate themselves in a scaffold speech which was later printed. The word *slavery* was part of the "code language" of the Whigs. See Ashcraft, *Revolutionary Politics*, pp. 394–405.
136. Subsequent quotations from *Speech of the late Lord Russel*, pp. 2–4.
137. Mark Goldie, "The Roots of True Whiggism, 1668–94," *History of Political Thought* 1 (1980): 199, n. 16.
138. Ashcraft, *Revolutionary Politics*, p. 423, n. 64, for Russell's comment.
139. BOL, HMC 36, William Russell's scaffold speech written in his hand. An attached paper in Rachel's hand reads, "Given me to keep by my dear lord himself. Being the papers he ordered to be printed. These the original under his own hand."
140. John Tillotson, *A Letter Written to my Lord Russel in Newgate The Twentieth of July 1683*, referred to Russell's use of the word "invaded." Francis North mentioned "Whiggisms" in Russell's speech: Bodl., MSS. North 6.1, no. 24.
141. Chatsworth, Russell MSS, Uncat., box 2, William Russell's scaffold speech written in Rachel's hand, marked a "true copy" by Rachel and signed by William.
142. Chatsworth, Russell MSS, Uncat., box 2, Dr. Gilbert Burnet, An account of all that passed between the Late Lord Russell and me concerning his Last Speech and Paper.
143. Chatsworth, Halifax Collection, Group A, 4, note in Halifax's hand.
144. Bodl., Rawlinson MSS. C. 983, fol. 61. Written on the back of the letter is the paragraph that did not appear in the printed version of Russell's speech, perhaps to show Compton that Burnet and Tillotson had tried to persuade Russell to accept the doctrine of nonresistance.
145. Berry, *Some Account*, p. xxxvi.

146. The speech in William's hand in the Public Record Office is marked "the original." It is presumably the text William handed to the sheriff on the scaffold. PRO, SP 29/429, pt. 1, pp. 144–49.

147. HMC, *Manuscripts of His Grace the Duke of Buccleuch*, 1:194.

148. John Dunton, *The Life and Errors of John Dunton...written by himself in solitude...with the lives and characters of more than a thousand Contemporary Divines, and other persons of literary eminence* (1705), ed. J. B. Nichols, 2 vols. (London, 1818), 1:244; BL, Add. MSS. 34,526, Burnet, Some Further Passages forgot in the former relation, fol. 18; de Beer, *Diary of John Evelyn*, 4:332, n. 5. An anonymous author (Elkanah Settle according to the Folger Library catalogue) wrote that "the Zealous Lady Russell...set [the speech] to Printing a day before the Lord died." *Animadversions on the Last Speech and Confession of the late William Lord Russel* (London, 1683), p. 4.

149. BL, Add. MSS. 34,526, Burnet, Some Further Passages forgot in the former relation, fols. 17v, 18v.

150. Foxcroft, *Supplement to Burnet*, pp. 116–17.

151. BOL, HMC 36, no. 29; PRO, SP 29/429, pt. 1, pp. 65–66; PRO, PRO 31/3/155/90.

152. BL, Add. MSS. 34,526, Expressions of Lord Russell's, preserved by Lady Rachel Russell, fol. 16.

153. For Russell's last hours, see Chatsworth, Russell MSS, Uncat., box 2, Dr. Burnet's Relation.

154. *Letters of Lady Rachel Russell* (1773), p. 41.

155. Luttrell, *Brief Relation*, 1:271; Russell, *Life of William Lord Russell*, 2:99.

156. See Joan Parkes, *Travel in England in the Seventeenth Century* (London, 1925), p. 77.

157. Thompson, *Hatton Correspondence*, 2:32; Wright, *A Compendious View of the late Tumults*, p. 177.

158. PRO, SP 29/429, pt. 1, p. 21.

159. BL, Add. MSS. 34,526, Burnet, Some Further Passages forgot in the former relation, fol. 18.

160. Russell, *Life of William Lord Russell*, 2:106.

161. Chatsworth, Russell MSS, Uncat., box 2, Dr. Burnet's Relation.

162. HMC, *Seventh Report*, pt. 1, app., p. 374.

163. PRO, PRO 31/3/155/85v, Barrillon's dispatch of July 24/August 2, 1683.

164. BOL, HMC 36, Elizabeth, Lady Annesley, to earl of Rutland, July 21, 1683; Wright, *A Compendious View of the late Tumults*, p. 178.

165. BOL, HMC 36, Elizabeth, Lady Annesley, to earl of Rutland, July 21, 1683.

• *Chapter 7* •
Widowhood, 1683–1688

1. HMC, *Manuscripts of His Grace the Duke of Buccleuch*, 1:194; HMC, *Seventh Report*, p. 263 a.

2. *CSPD, 1683* (J-S), pp. 187, 190, 432; Luttrell, *Brief Relation*, 1:271.

3. Burnet, *HOT*, 2:389; Foxcroft, *The Life and Letters of Halifax*, 1:395.

4. *CSPD, 1683* (J–S), p. 190.

5. *Letters of Lady Rachel Russell* (1773), pp. 5–6.

6. BOL, HMC 36, no. 49, Lord Halifax to Lady Russell, August 6, 1683; Berry, *Some Account*, pp. xxxi–xxxiii (Lord Halifax to Lady Russell, October 16, 1683); A. C. Fox-Davies, *A Complete Guide to Heraldry* (London, 1909), p. 73.

7. *His Majesties Declaration to All His Loving Subjects, Concerning the Treasonable Conspiracy Against His Sacred Person and Government, Lately Discovered* (London, 1683), reprinted under slightly different title in 1684; *CSPD, 1683* (J–S), p. 216.

8. Bodl., MSS. Carte 216, fol. 317. Twelve sermons delivered on September 9 are in the Folger collection. See, for example, John Cave, *King David's Deliverance, and Thanksgiving. Applied to the Case of Our King and Nation*, and E. Foreness, *A Sermon Preached at Manchester Upon the 9th of September, Being the Day of Thanksgiving For our Deliverance from the Late Conspiracy.*

9. C.P., *A Congratulatory Pindaric Poem, For His Majesties Safe Deliverance from this Hellish and True Plot* (London, 1683); *The Whigs' Lamentation; or, The Tears of a true-blue Protestant Dropp'd for the loss of their unforfeitable Charter* (London, 1683).

10. *Lord Russels Farewel, Who was Beheaded for High-Treason, in Lincolns-Inn-Fields, July 21st, 1683*, from the Pepysian Collection of Ballads, reproduced in C. H. Firth, ed., *Lord Macaulay's History of England*, 6 vols. (London, 1913–15), 1:259.

11. Edward Hawkins, comp., and Augustus W. Franks and Herbert A. Grueber, eds., *Medallic Illustrations of the History of Great Britain and Ireland to the Death of George II*, 2 vols. (London, 1885), 1:593, no. 274.

12. Sir Roger L'Estrange, *Considerations upon a Printed Sheet entituled the Speech of the Late Lord Russell to the Sheriffs; together With the Paper delivered by Him to Them at the Place of Execution on July 21, 1683* (London, 1683), pp. 11–13 (misnumbered for 12); *Some Succinct Remarks on the Speech of the Late Lord Russell, To the Sheriffs: Together with the Paper deliver'd by him to them, at the Place of Execution, on July 21, 1683* (London, 1683), p. 2. Even John Ketch, the public executioner, published a tract to deny that he deliberately took three strokes to behead Russell. He blamed William for the butcherly job he had performed! *The Apologie of John Ketch, Esq. The Executioner of London, in Vindication Of himself as to the Execution of the Late Lord Russell* (London, 1683).

13. Bodl., MS. North 6.1; BL, Add. MSS. 32,518, fols. 121–124v (unsigned but identified as North's).

14. Sir Robert Atkyns, *Lord Russell's Innocency Further Defended* (London, licensed April 9, 1689), pp. 7, 11, identifies Shower as the author. The British Library assigns it to Heneage Finch. *An Antidote Against Poison* had four editions in 1683. Other pamphlets analyzing the speech include *Animadversions on the Last Speech and Confession of the late William Lord Russel*, assigned to Elkanah Settle; *Animadversions upon a paper entituled, The Speech of the*

late Lord Russell, assigned to John Nalson; and *Some Succinct Remarks on the Speech* (see n.12, above).

15. L'Estrange, *Considerations upon a Printed Sheet*, pp. 13, 16–17, 27, 28; *An Antidote Against Poison*, p. 1.

16. "Every line's a snare," complained L'Estrange, *Considerations upon a Printed Sheet*, p. 8.

17. *An Antidote Against Poison*, pp. 2, 3; L'Estrange, *Considerations upon a Printed Sheet*, pp. 26, 33.

18. In George deF. Lord, gen. ed., *Poems on Affairs of State: Augustan Satirical Verse, 1660–1714*, vol. 3, *1682–1685*, ed. Howard H. Schless (New Haven, 1968), between p. 462 and p. 463. The story of the battle between frogs and mice, attributed to Homer, was well known in England. It was printed in Greek in 1535, 1537, 1542, and 1587; in Latin in 1537, 1580, and 1629; in Italian in 1512 (described as an imitation), 1573, and 1642; and in English in 1603, 1616, 1624, and 1633. For the use of the term *frog* in political propaganda see Doris Adler, "Imaginary Toads in the Real Gardens," *English Literary Renaissance* 11 (1981): 235–60.

19. Berry, *Some Account*, p. 78. Portions of *A Defence Of the Late Lord Russel's Innocency. By way of Answer or Confutation of a Libellous Pamphlet, Intituled, An Antidote against Poyson*, printed in 1689, were Atkyns' response.

20. *CSPD, 1683* (J–S), p. 127.

21. For example, HMC, *Third Report* (London, 1872), p. 270a; Bond, *Diaries of Sir Edward Dering*, p. 145. Dering reported that his son had pledged his loyalty to the king, "which many other gentlemen had done."

22. BOL, HMC 41, 41A, newsletter dated February 5, 1683/84; *CSPD, 1683* (J–S), p. 432; *Letters of Lady Rachel Russell* (1773), p. 11.

23. See *DNB* and Cobbett, *Trials*, 9:1334–72 (p. 1354 for Jeffreys' remark). Barnardiston paid £6,000 and gave his bond for the rest of the fine; he was released from prison in June 1688.

24. Bodl., MSS. Don. C. 55., fols. 16v–18, "On the Death of the Lord Russell," dated July 21, 1683.

25. *CSPD, 1683* (J–S), pp. 308–9; PRO, SP 29/429, pt. 3, p. 199 for the paper.

26. PRO, PRO 31/3/155/115, Barrillon's dispatch of August 16/26, 1683.

27. *CSPD, October 1, 1683–April 30, 1684* (London, 1938), p. 11; HMC, *Seventh Report*, pp. 341b, 342a; *CSPD, May 1, 1684–February 5, 1685* (London, 1938), p. 188. It was reported that in order to embarrass the government, unidentified Whigs were advising a woman whose husband had been killed by the brother of the earl of Thanet in a melee the morning Russell was beheaded to press charges. See Chatsworth, Devonshire Collection, Group I, F, ? to Devonshire, August 28, 1683.

28. *The Last Legacy, Or Affectionate and Pious Exhortations and Admonitions Of the Late William Lord Russell, to his Vertuous Lady, and dear Children* (London, 1683). A second edition appeared in 1683 without a picture.

29. [L.A.], *An Impartial and full Account Of The Life and Death Of the late Unhappy William Lord Russell, Eldest Son and Heir of the Present Earl of Bedford, Who Was Executed for High Treason, July 21, 1683, in Lincoln's-*

Inn-Fields. Together with the Original and Rise Of The Earls of Bedford: Giving A brief Account of each of them (London, 1684). A picture of the execution enlivened *The Whole Tryal and Defence of William Lord Russel, Who Dyed a Martyr to the Romish Fury, in the Year 1683, with the Learned Arguments of the Council on both sides* (London, 1683).

30. HMC, *Seventh Report*, p. 263a.

31. Sprat, *A True Account and Declaration of the Horrid Conspiracy against the Late King*.

32. Luttrell, *Brief Relation*, 1:271; de Beer, *Diary of John Evelyn*, 4:332; Bodl., MSS. Carte 216, fol. 315. *The Last Speech and Behaviour of William Late Lord Russell*. . .was printed in London in 1683 by J. C. and F. C. for Thomas Fox, and reprinted in Dublin in 1683. *The Last Speech and Carriage Of The Lord Russel*, a variant title of the same tract, appeared first in London and was reprinted in Edinburgh in 1683. *The speech and Confession of William Lord Russell who was executed for high-treason* was also printed in London in 1683 for R. V. It was destroyed in World War II.

33. PRO, SP 29/429, pt. 2, p. 231; *CSPD, 1683* (J–S), p. 190. People in London sent copies to their friends in Dublin and Paris. See HMC, *Seventh Report*, p. 365b; Bodl., MSS. Carte 168, fols. 152–53; *CSPD, 1683* (J–S), p. 197. Cf. PRO, SP 29/429, pt. 2, p. 247, where the words describing Russell read "a brave Protestant," not "a born Protestant," as in the Calendar.

34. A conservative estimate. Darby alone admitted to printing 20,000 copies (*CSPD, 1683* [J–S], p. 432), and it is likely, given the public interest, that more than the average number of 1,000 copies per edition were printed.

35. Univ. Nott., Ne C 13, Dr. Gilbert Burnet to Lady Rachel Russell, May 7, 1686; Northamptonshire Record Office, Montagu MSS, vol. 1, fol. 105, Lady Rachel Russell to Lady Elizabeth Montagu, May 17, 1685; *Letters of Lady Rachel Russell* (1773), p. 139 (for books).

36. *Letters of Lady Rachel Russell* (1773), p. 10.

37. HMC, *Manuscripts of the Marquess of Downshire*, 2 vols. (London, 1924–36), 1, pt. 1:172.

38. Berry, *Some Account*, p. 76.

39. [L.A.], *An Impartial and full Account Of The Life and Death Of the late Unhappy William Lord Russell*. . .(London, 1684).

40. *CSPD, 1683* (J–S), p. 215; *Letters of Rachel Lady Russell* (1854), p. 85.

41. Chatsworth, Devonshire Collection, Group I, B, ? to Devonshire, September 22, 1683; *Letters of Rachel Lady Russell* (1854), pp. 86–87; Berry, *Some Account*, pp. xxxi–xxxiii.

42. BOL, First Duke, Receivers General Accounts, John Fox's Accounts, n.p.

43. William A. Shaw et al., eds., *Calendar of Treasury Books, 1660–1718*, 32 vols. (London, 1904–62), 7, pt. 2:867.

44. BOL, First Duke, Receivers General Accounts, John Fox's Accounts, Moneys Lent, 1684, n.p.

45. Berry, *Some Account*, p. 92.

46. BOL, Title Deeds, vol. 2., Southampton and Middlesex, General Evidences, bundle 2, no. 7, July 25, 1683.

47. BOL, First Duke, Receivers General Accounts, John Fox's Accounts, n.p.

48. *Letters of Lady Rachel Russell* (1773), pp. 16, 35, 49.

49. Berry, *Some Account*, pp. xxxvii–xxxviii; *Letters of Lady Rachel Russell* (1773), p. 25.

50. Thomson, *Life in a Noble Household*, p. 378.

51. *Letters of Rachel Lady Russell* (1854), p. 114; Berry, *Some Account*, p. xxxviii.

52. Haley, *First Earl of Shaftesbury*, pp. 430, 656; E. S. de Beer, ed., *Correspondence of John Locke*, 7 vols. (Oxford, 1976–82), 1:436, n. 9, and 2:154.

53. Berry, *Some Account*, p. xxxix.

54. *Letters of Lady Rachel Russell* (1773), p. 17.

55. Ibid., pp. 17, 37.

56. Ibid., pp. 18–19; *Letters of Rachel Lady Russell* (1854), pp. 110–12; BROB, General Evidences, Southampton and Middlesex, bundle 2, p. 1211, no. 9, July 30, 1684.

57. BROB, General Evidences, Southampton and Middlesex, bundle 2, pp. 1211–12, nos. 10 and 11, May 14 and 15, June 15, 1685.

58. BOL, Summary analysis of Bloomsbury leases.

59. Ralph A. Houlbrooke, *The English Family, 1450–1700* (London, 1984), pp. 206–7.

60. Rosenblatt, *Bitter, Bitter Tears*, pp. 20–24.

61. *Letters of Lady Rachel Russell* (1773), pp. 6–7.

62. *Letters of Rachel Lady Russell* (1854), p. 282.

63. Chatsworth, Russell MSS, Uncat., box 2, Lady Shaftesbury to Lady Russell, September 18, 1683; Berry, *Some Account*, p. xxxviii.

64. BOL, stable account book, 1683/84, n.p.

65. Barings Bank Archives, Northbrook Papers, N 15, book 6, "An Inventory of the Goods in Stratton House, 25th of May, 1724," notes in Lady Russell's room seven pieces of black and white crepe as hangings.

66. Northamptonshire Record Office, Montagu MSS, vol. 1, fol. 107, Lady Rachel Russell to Lady Elizabeth Montagu, September 4, 1686.

67. *Letters of Lady Rachel Russell* (1773), p. 102; *Letters of Rachel Lady Russell* (1854), pp. 275–84.

68. The portrait, attributed to Sir Godfrey Kneller, is in the duke of Bedford's collection at Woburn Abbey, no. 182.

69. *Letters of Lady Rachel Russell* (1773), p. 77.

70. Rosenblatt, *Bitter, Bitter Tears*, pp. 24–28, 30.

71. *Letters of Lady Rachel Russell* (1773), p. 77.

72. Ibid., pp. 40, 41, 43; BL, Add. MSS. 19,399, fol. 132.

73. Univ. Nott., Russell Papers, Ne C 15, Dr. Gilbert Burnet to Lady Russell, June 14, 1686; *Letters of Lady Rachel Russell* (1773), p. 60.

74. *Letters of Lady Rachel Russell* (1773), pp. 80, 92.

75. Ibid., pp. 16, 43.

76. Ibid., p. 32; *Letters of Rachel Lady Russell* (1854), pp. 85–86.

77. *Letters of Lady Rachel Russell* (1773), pp. 14, 61.

78. The average age at menopause in early modern Europe was forty. See Stone, *Family, Sex, and Marriage*, p. 63.

79. *Letters of Lady Rachel Russell* (1773), pp. 15, 32, 61.

80. Ibid., p. 36; cf. pp. 14, 60.

81. Northamptonshire Record Office, Montagu MSS, vol. 1, fols. 104–8, Letters of Lady Rachel Russell to Lady Elizabeth Montagu, 1685–86.
82. Chatsworth, Russell MSS, Uncat., boxes 1 and 2.
83. Richard Greaves, *Society and Religion in Elizabethan England* (Minneapolis, 1981), p. 308. For a discussion of the distinctions between Anglican and Puritan rhetoric regarding suffering, its use and cure, see J. Sears McGee, *The Godly Man in Stuart England: Anglicans, Puritans, and the Two Tables, 1620–1670* (New Haven, 1976), ch. 2.
84. *Letters of Lady Rachel Russell* (1773), p. 41.
85. BL, Add. MSS. 19,399, fol. 132, Rachel Russell to the Reverend John Griffith, February 4, 1684.
86. *Letters of Lady Rachel Russell* (1773), p. 22.
87. Ibid., p. 11. Burnet remarked that if Rachel had known "all the little rules of grammar her writing would be one of the perfectest things" he knew. Foxcroft, *Supplement to Burnet*, p. 117.
88. *Letters of Lady Rachel Russell* (1773), p. 64; BL, Add. MSS. 9,828, fol. 19, Lady Russell to [Sir Robert Atkyns?], April 30, 1684.
89. Ibid., pp. 8–10.
90. Approximately thirty-five essays and prayers are at Chatsworth, Russell MSS, Uncat., box 2.
91. *Letters of Lady Rachel Russell* (1773), p. 8.
92. Ibid., p. 70.
93. Ibid., pp. 103, 112, 119.
94. BOL, HMC 36, no. 75, the Reverend John Fitzwilliam to Lady Russell, n.d.
95. Univ. Nott., Ne C 11 Fitzwilliam to Lady Russell, July 11, 1687; *Letters of Lady Rachel Russell* (1773), pp. 8–10, 18–20, 27–28, 66.
96. *Letters of Lady Rachel Russell* (1773), p. 13.
97. Ibid., pp. 14, 70, 85.
98. Ibid., p. 60. For Fitzwilliam's essays, see Chatsworth, Russell MSS, Uncat., box 2.
99. *Letters of Lady Rachel Russell* (1773), p. 86.
100. Ibid., pp. 63, 85.
101. Ibid., pp. 49, 85, 88, 102.
102. Ibid., p. 110.
103. Ibid., pp. 64, 85, 100, 143.
104. Ibid., pp. 43, 60, 82, 85, 145.
105. Ibid., pp. 13, 30.
106. Ibid., p. 65.
107. Ibid., p. 7.
108. Chatsworth, Russell MSS, Uncat., box 1, Dr. Gilbert Burnet to Lady Russell, December 23, 1683; *Letters of Lady Rachel Russell* (1773), p. 11.
109. Berry, *Some Account*, p. x; Thomson, *Life in a Noble Household*, p. 387.
110. BOL, HMC 36, Rachel Russell catechism, 1684/85. To another query, "Whot Attributes do the scriptures set forth God?" came the reply, "His Incommunikble Attributes Almightyness, Unchangableness, Omnipresents, Eternety, Omniscence &c. his communikble Attributes Goodness, Justice, Marcy, Trurth, Faithfulness, Patience, Wisdome, Holyness, Glory, &c." Such an answer must have gratified both Thornton and Lady Russell.

111. *Letters of Rachel Lady Russell* (1854), p. 141.
112. Univ. Nott., Ne C 13, Dr. Gilbert Burnet to Lady Rachel Russell, May 19, 1686; *Letters of Rachel Lady Russell* (1854), pp. 112–16.
113. *Letters of Lady Rachel Russell* (1773), p. 26.
114. Ibid., pp. 30, 32.
115. Ibid., p. 79.
116. Ibid., p. 43; cf. pp. 34, 35.
117. Ibid., pp. 39–40.
118. Foxcroft, *Supplement to Burnet*, pp. 151–52.
119. BOL, HMC 40, law opinions regarding the consequences of Lord Russell's attainder on the family inheritance.
120. BOL, HMC 36, no. 56. Two sets of unpublished notes record the substance of these conversations, one written by de Ruvigny, the other by Lady Russell. Biographers of King James II do not mention the court's interest in rehabilitating Lord Stafford.
121. Berry, *Some Account*, p. xlviii.
122. *Letters of Lady Rachel Russell* (1773), pp. 37, 42.
123. Ibid., p. 53; cf. pp. 48, 50, 52.
124. France, Archives Nationales, O$^{1*}$, Registre du secretariat de la maison du Roi, vol. 30, fols. 39 and 66, passports for de Ruvigny and his family, allowing them to take a stage coach, seven horses, and some furniture and tableware to England without paying a tax, January 18 and 29, 1686.
125. *Letters of Rachel Lady Russell* (1854), p. 141.
126. Berry, *Some Account*, p. li.
127. Anthony Wagner, "The Teulon Ancestry in France," *Proceedings of the Huguenot Society* 21 (1965–70): 583.
128. *Letters of Lady Rachel Russell* (1773), p. 57.
129. Robin D. Gwynn, "James II in the Light of His Treatment of Huguenot Refugees in England, 1685–1686," *English Historical Review* 92 (1977): 820–33.
130. *Letters of Lady Rachel Russell* (1773), pp. 53, 55, 58.
131. Gwynn, "The Distribution of Huguenot Refugees in England," pp. 427–28.
132. *Letters of Lady Rachel Russell* (1773), p. 55.
133. Ibid., p. 56.
134. Berry, *Some Account*, pp. 79–80.
135. Ibid., pp. 81–82.
136. *Letters of Lady Rachel Russell* (1773), pp. 89, 94.
137. Ibid., p. 126; Chatsworth, MS Letters, 42.0, Earl of Strafford to Marquess of Halifax, March 12, 1687.
138. Stephen B. Baxter, *William III* (London, 1966), pp. 218–19.
139. BOL, HMC 36, fol. 60, Lady Russell's account of Dijkvelt's visit, March 24, 1687.
140. *Letters of Lady Rachel Russell* (1773), p. 80.
141. Ibid., pp. 81–82.
142. Ibid., pp. 91–92, 97. Lady Russell's letters to Princess Mary have not survived.
143. Baxter, *William III*, p. 231.
144. See Stone, *Family, Sex, and Marriage*, pp. 184–87, for stories of other arranged marriages among the aristocracy. For the trend towards marriages based on prior affection, see ibid., chs. 6–8 (to p. 336) and 13, and Lloyd

Bonfield, *Marriage Settlements, 1601–1740* (Cambridge, 1983).

145. BOL, HMC 38, Lady Rachel Russell's Diaries, p. 15.

146. Chatsworth, MS Letters, 18.1, 2, 3, 6, Lord Devonshire to Lady Russell, February 29, 1688 (including the proposals), Lady Russell to Lord Devonshire, March 2, 1688 (including her counterproposals).

147. Ibid., 18.5, 7, 8; BOL, HMC 38, Lady Russell's notes on the proposed marriage settlement, p. 6.

148. *Letters of Lady Rachel Russell* (1773), pp. 89, 92, 94.

149. BOL, First Duke, Receivers General Accounts, John Fox's Accounts, Extraordinary Payments, June 1688, n.p.

150. Chatsworth, Box 43, L 19/16, marriage contract between Lady Rachel Russell and earl of Devonshire.

151. *Letters of Lady Rachel Russell* (1773), p. 99.

152. See Stone, *Family, Sex, and Marriage*, p. 49, for chart showing average age of nobility at first marriage.

153. Chatsworth, MS Letters, 28.42A, Lady Russell to the Reverend John Fitzwilliam, September 26, 1687; *Letters of Lady Rachel Russell* (1773), pp. 95, 98, 99.

154. *Letters of Lady Rachel Russell* (1773), pp. 89, 102, 104.

• **Chapter 8** •
Prime Years, 1689–1702

1. *Letters of Lady Rachel Russell* (1773), pp. 107, 108. The meetings took place on September 28 and October 3, 8, 10, and 11. The Anglican bishops recommended eleven changes that were necessary to settle the crisis. See Lois G. Schwoerer, *The Declaration of Rights, 1689* (Baltimore, 1981), pp. 120–22.

2. Chatsworth, MS Letters, 53.0, Lady Margaret Russell to Lady Rachel Russell, October 21, 1688.

3. *Letters of Lady Rachel Russell* (1773), p. 110.

4. Ibid., pp. 112, 114.

5. Following discussion and quotations drawn from ibid., pp. 115–18.

6. Berry, *Some Account*, p. lxiii; *Letters of Lady Rachel Russell* (1773), pp. 118–19.

7. Dr. Williams' Library, Morrice, "Entr'ing Book," 2:372.

8. See Schwoerer, *Declaration of Rights*, pp. 302–5.

9. *LJ*, 14:3–124. Bedford was absent only on January 24.

10. Schwoerer, *Declaration of Rights*, p. 45.

11. Lois G. Schwoerer, "Women and the Glorious Revolution," *Albion* 18 (1986): 195–218.

12. William King, ed., *Memoirs of Sarah, Duchess of Marlborough* (London, 1930), pp. 16–17; Edward Gregg, *Queen Anne* (London, 1980), pp. 70–71. Lady Russell does not mention an interview with Lady Churchill.

13. Chatsworth, MS Letters, 30.2, Lady Rachel Cavendish to Lady Katherine Russell[?], February 1689; reprinted in part in Berry, *Some Account*, pp. lxiv–lxv.

14. *LJ*, 14:142, 144, 145; HMC, *Manuscripts of the House of Lords, 1689–90*, pp. 40–41.

15. Grey, *Debates*, 9:150–53.
16. *CJ*, 10:46, 50; *LJ*, 14:151.
17. Atkyns, *A Defence of the Late Lord Russel's Innocency*, advertised in the *London Gazette*, February 28–March 4, 1689, pp. 1–3. Atkyns also wrote *The Lord Russell's Innocency Further Defended; by way of Reply to an Answer, entituled, The Magistracy and Government of England* (licensed April 9, 1689).
18. Chatsworth, Russell MSS, Uncat., box 1, Henry Booth, Baron Delamere, to William, earl Russell, March 16, 1686/87; Henry Booth, Baron Delamere, *The late Lord Russel's Case with Observations upon it* (London, 1689), advertised in the *London Gazette*, March 11–14, 1689. Sir John Hawles, *A Reply To A Sheet of Paper Entituled The Magistracy and Government of England Vindicated* (London, 1689), and *Remarks upon the Tryals of Edward Fitzharris, Stephen Colledge, Count Coningsmark, The Lord Russel, Collonel Sidney, Henry Cornish, and Charles Bateman* (London, 1689), pp. 56–75, for Russell's trial.
19. *The Dying Speeches of Several Excellent Persons, Who Suffered for their Zeal against Popery, and Arbitrary Government* (London, 1689), pp. 10–17. A single sheet, *Brief Heads of the last Speech of Lord Russell, with some seasonable notes thereupon*, was printed without place or date, but its reference to the annulment of William's attainder places it in 1689, not 1683, as shown in the British Library catalogue.
20. *An Alphabetical Table of the Names of all those Jury-men that serv'd with the Cities of London and Westminster, upon the Lives, Liberties and Estates of several Patriots, etc., in the late Reigns* (a broadside, n.p., n.d.); and, for the judges, *The Ashes of the Just Smell Sweet, and Blossom in the Dust* (a broadside, n.p., n.d.).
21. *A Justification of the late Act of Parliament for Reversing the Judgment against the Lord Russel* (London, 1689). The date is fixed by the fact that the tract is mentioned in Atkyns, *The Lord Russell's Innocency Further Defended*, p. 11.
22. Sir Bartholomew Shower, *The Magistracy and Government of England Vindicated: Or, A Justification of the English Method of Proceedings against Criminals, by way of Answer to the Defence by Sir R. Atkyns of the late Lord Russell's Innocence* (London, 1689). Shower also wrote *A Second Vindication of the Magistracy and Government of England, by way of answer to the several replies* (London, 1689) and *The Third and last part of the Magistracy and Government of England, . . . with reasons for a general act of indemnity* (London, 1689).
23. BOL, First Duke, Receivers General Accounts, John Fox's Accounts, 1689, Necessary Expenses.
24. *Letters of Lady Rachel Russell* (1773), pp. 124–25.
25. Chatsworth, MS Letters, 27.4, an English translation of the patent.
26. *Complete Peerage*, 2:82.
27. BOL, HMC 40A, fol. 97, Lady Ranelagh to Lady Russell, February 19, 1689.
28. Grey, *Debates*, 9:383.
29. *Letters of Lady Rachel Russell* (1773), p. 82.
30. Ibid., p. 155. Lady Sunderland's letters to Rachel have not survived. See also Blencowe, *Sidney Diaries*, 2:305.
31. Grey, *Debates*, 9:379, 383; see Kenyon, *Sunderland*, pp. 228–300.

32. Bodl., Rawlinson MSS. D.1251, fol. 226, the Reverend John Fitzwilliam to Lady Rachel Russell, February 20, 1689.

33. *Letters of Lady Rachel Russell* (1773), pp. 119, 128.

34. Ibid., p. 135.

35. Ibid., pp. 143–45.

36. Ibid., p. 172.

37. Ibid., p. 200; cf. pp. 196, 198, 199.

38. Ibid., pp. 125, 127.

39. Ibid., pp. 165, 166.

40. Ibid., pp. 120, 122.

41. Foxcroft, *Life and Letters of Halifax*, 2:74–78.

42. Ibid., p. 87.

43. Ibid., p. 91; Henry Horwitz, *Parliament, Policy, and Politics in the Reign of William III* (Manchester, 1977), pp. 37–38.

44. Foxcroft, *Life and Letters of Halifax*, 2:93; *LJ*, 14:378; HMC, *Manuscripts of the House of Lords, 1689–90*, pp. 283, 286, 287, 289, 297, 309; *Letters of Lady Rachel Russell* (1773), pp. 154–55.

45. Foxcroft, *Life and Letters of Halifax*, 2:105 and n. 3; *LJ*, 14:363.

46. Schwoerer, *Declaration of Rights*, p. 279.

47. *Letters of Lady Rachel Russell* (1773), pp. 154–55.

48. Ibid., pp. 130, 133.

49. Ibid., pp. 146, 153, 154.

50. BL, Add. MSS. 37,728, fol. 184v; *Letters of Lady Rachel Russell* (1773), pp. 146, 150, 153.

51. *Letters of Lady Rachel Russell* (1773), pp. 146–52, 159–61, 164.

52. Ibid., pp. 147, 153.

53. Ibid., p. 173.

54. History of Parliament Trust, London, draft biography of Thomas Owen. I thank David Hayton for allowing me to use this typescript.

55. BOL, HMC 36C, Lord Devonshire to Lady Russell, October 9, 1691 (copy).

56. *Letters of Lady Rachel Russell* (1773), pp. 180–81. Original letter is in BL, Add. MSS. 37,728, fol. 182.

57. *Letters of Lady Rachel Russell* (1773), pp. 175, 176.

58. BOL, HMC 40A, fol. 67, Lady Russell to Miss Mortimer, October 22, 1692.

59. Agnes Strickland, *Lives of the Queens of England*, 8 vols. (London, 1860), 7:252.

60. Chatsworth, Russell MSS, Uncat., box 2, Lady Russell's Confession, 1691; *Letters of Lady Rachel Russell* (1773), p. 183.

61. *Letters of Lady Rachel Russell* (1773), p. 175.

62. Ibid., p. 79.

63. Ibid., p. 186; HMC, *Finch Manuscripts*, 4:461.

64. *Letters of Lady Rachel Russell* (1773), p. 188.

65. Chatsworth, MS Letters, 28.115, Lady Russell's draft paper, n.d.

66. *Letters of Lady Rachel Russell* (1773), pp. 185, 186.

67. Ibid., pp. 168, 169.

68. Ibid., p. 102; Berry, *Some Account*, p. 88.

69. Chatsworth, MS Letters, 66.0, Lady Roos to Lady Cavendish, August 14, 1692; Berry, *Some Account*, p. lxxii, assigns this undated letter to 1692.

70. *Letters of Lady Rachel Russell* (1773), p. 188.
71. Ibid., p. 193.
72. Fielding H. Garrison, *An Introduction to the History of Medicine* (Philadelphia, 1960), pp. 110, 201, 227, 349, 505.
73. BOL, HMC 38, Lady Rachel Russell's Diaries, p. 18.
74. Gladys S. Thomson, *Woburn and the Russells* (London, 1956), p. 20.
75. BOL, HMC 8, 6:28, Lady Letitia Russell to John Thornton, August 16, 1694; BOL, HMC 36, no. 72, Lady Russell to Mrs. Howland, August 13, 1695.
76. *Letters of Rachel Lady Russell* (1854), p. 312.
77. Ibid., p. 276. None of her children preserved these records.
78. Ibid., pp. 275-84; Chatsworth, Russell MSS, Uncat., box 2, Lady Russell's "Instructions to her child for taking the Sacrament," 1691.
79. Lady Russell's records have not survived.
80. *Letters of Rachel Lady Russell* (1854), p. 278.
81. Ibid., pp. 281-82.
82. *Letters of Lady Rachel Russell* (1773), pp. 182-83.
83. See Stone, *Family and Fortune*, pp. 165-208, for the history of the Rutland estate.
84. *DNB; Complete Peerage*, 11:265.
85. Haley, *First Earl of Shaftesbury*, pp. 276-80. The critics of King Charles II saw the divorce as a precedent for the king to divorce his queen, marry a Protestant, and solve the problem of the Catholic duke of York. The episode needs further study.
86. *Letters of Lady Rachel Russell* (1773), p. 189; Berry, *Some Account*, p. 88.
87. *DNB*.
88. Chatsworth, MS Letters, 18.9, Lady Russell to earl of Rutland, August 30, 1692, enclosing the abstract of Rachel Russell's marriage settlement.
89. Belvoir Castle, Letters of Lady Rachel Russell, Add. 61, no. 5, Lady Russell to earl of Rutland, March 6, 1693.
90. Ibid., no. 6, Lady Russell to Rutland, March 28, 1693.
91. Ibid.
92. *Letters of Lady Rachel Russell* (1773), pp. 189, 191.
93. Ibid., p. 189.
94. *Letters of Rachel Lady Russell* (1854), pp. 304-5. The account came from Sir James Forbes, who usually wrote Rachel about political matters.
95. BOL, HMC 38, Lady Rachel Russell's Diaries, p. 18; *Letters of Lady Rachel Russell* (1773), p. 196.
96. Belvoir Castle, Letters of Lady Rachel Russell, Add. 61, nos. 15, 16, 25, Lady Russell to Lady Roos, October 12, December 5, 1695, and May 7, 1698. Other letters from 1698 to 1707 are similar in nature—i.e., nos. 26, 45, 51, 67, 69, and 71.
97. *Letters of Rachel Lady Russell* (1854), pp. 312-13.
98. Chatsworth, MS Letters, 66.1-12, correspondence between Lady Russell's daughters, October 1693-September 1709.
99. Belvoir Castle, Letters of Lady Rachel Russell, Add. 61, no. 31, Lady Russell to Lady Roos, June 4, 1700; *Letters of Rachel Lady Russell* (1854), p. 309.
100. Berry, *Some Account*, pp. lxxvii-lxxviii. See William Letwin, *Sir Josiah*

Child: Merchant Economist (Boston, 1958), p. 23, n. 75. Howe had consulted Lady Russell in 1687 when he had acted as a marriage broker for James Russell, Rachel's brother-in-law. See above, Chapter 7.

101. *Complete Peerage*, 2:81, note D.

102. *Letters of Rachel Lady Russell* (1854), pp. 311–12.

103. BOL, Deeds, Southampton and Middlesex, General Evidences, vol. 3, p. 2, Marriage Settlement, November 2, 1694.

104. HMC, *Manuscripts of the House of Lords, 1693–1714*, n.s., 1:508–9.

105. BOL, Deeds, Southampton and Middlesex, General Evidences, vol. 3, p. 3, Marriage Settlement, May 20 and 21, 1695.

106. Chatsworth, Deeds and Conveyances, box 43, L 43/10, March 8, 1720, codicil to Lady Russell's will, which refers to these arrangements.

107. Berry, *Some Account*, p. lxxix, portion of an undated letter from Lady Russell to Mrs. Howland about the details of Elizabeth's education.

108. BOL, HMC 36, no. 71, Lady Rachel Russell to Mrs. Howland, January 3, 1696.

109. BOL, HMC 41 and 41A, Account of Wriothesley Russell's nuptials, found in Stoneleigh Abbey.

110. Chatsworth, MS Letters, 28.99, Sir James Forbes to Lady Russell, October 3, 1695; Berry, *Some Account*, pp. lxxx–lxxxi.

111. Chatsworth, MS Letters, 88.0, Charles Montagu to earl of Bedford, October 8, 1695.

112. Ibid., 89.0–89.1, Edward Russell to Lady Russell, October 8 and 10, 1695.

113. Ibid., 89.2, Edward Russell to Lady Russell, October 12, 1695.

114. Berry, *Some Account*, p. lxxxiv.

115. Great Britain, Parliament, *Return of the Names of Every Member. . .in each Parliament*, 2 vols. (London, 1878) 1:574.

116. Belvoir Castle, Letters of Lady Rachel Russell, Add. 61, no. 16, Lady Russell to Lady Roos, December 5, 1695.

117. Ibid., no. 15, Lady Russell to Lady Roos, October 12, 1695.

118. BOL, HMC 36, nos. 70, 73, Lady Russell to Mrs. Howland, November 20, 1695.

119. BOL, HMC 8, 5:111, Thomas Gregory to John Thornton, April 14, 1696; BOL, HMC 38, Lady Rachel Russell's Diaries, p. 19.

120. *Letters of Rachel Lady Russell* (1854), pp. 319–27, 345.

121. Ibid., p. 320.

122. Chatsworth, MS Letters, 10.4, 5, John Thornton to Lady Russell, May 13 and June 22, 1696, and 96.1, John Hicks to Lady Russell, November 8, 1696.

123. Berry, *Some Account*, p. lxxxv; *Letters of Lady Rachel Russell* (1773), p. 199; Chatsworth, MS Letters, 96.0, John Hicks to Lady Russell, September 3, 1696, referring to Rachel's warning.

124. Thomson, *Russells in Bloomsbury*, p. 81.

125. Chatsworth, MS Letters, 73.2, Lord Tavistock to Lady Russell, n.d. [spring 1697].

126. Ibid., 27.5, duke of Bedford to Lady Russell, October 16, 1697.

127. Ibid., 10.9, John Thornton to Lady Russell, October 22, 1697; *CSPD, 1697*, p. 445.

128. Chatsworth, MS Letters, 96.12, John Hicks to Lady Russell, May 12, 1699; ibid., 73.14, Lord Tavistock to Admiral Edward Russell, August 30, 1698.
129. Berry, *Some Account*, p. lxxxviii.
130. Chatsworth, MS Letters, 73.5, 6, 8, Tavistock to Lady Russell, December 7 and 13, 1697, and January 25, 1698.
131. Ibid., 73.9, Tavistock to Lady Russell, February 1, 1698.
132. Ibid., 73.14, Lord Tavistock to Admiral Edward Russell, August 30, 1698.
133. Belvoir Castle, Letters of Lady Rachel Russell, Add. 61, no. 27, Lady Russell to Lady Roos, September 3, 1698; *Letters of Rachel Lady Russell* (1854), p. 334.
134. Berry, *Some Account*, pp. xc-xci, quoting a letter from Sherard to Lady Russell, n.d.
135. Chatsworth, MS Letters, 96.12, John Hicks to Lady Russell, May 12, 1699.
136. Ibid., 73.12, 13, 23, Tavistock to Lady Russell, August 9 and 30, 1698, and April 25, 1699.
137. Ibid., 73.16, 18, 20, Tavistock to Lady Russell, October 4, November 8, and December (?), 1698.
138. Ibid., 73.18, 22, 25, 30, 31, Tavistock to Lady Russell, November 8, 1698, January 31, June 17, October 17 and 21, 1699.
139. Univ. Nott., Ne C 27, Lord Galway to Lady Russell, September 2, 1699. Lady Russell's letter to her son has not survived. Rachel received another report about Tavistock's indiscretions from her daughter: Chatsworth, MS Letters, 66.9, Lady Katherine Roos to Lady Russell, September 30, 1699.
140. Chatsworth, MS Letters, 73.30, 31, Tavistock to Lady Russell, October 17 and 19, 1699.
141. Ibid., 98.1, Admiral Edward Russell to Lady Russell, September 19, 1699.
142. Ibid., 73.18, Tavistock to Lady Russell, November 8, 1698.
143. *Letters of Rachel Lady Russell* (1854), pp. 337-38.
144. Chatsworth, MS Letters, 96.15, John Hicks to Lady Russell, October 17, 1699.
145. Univ. Nott., Ne C 27, Lord Galway to Lady Russell, September 2, 1699.
146. *Letters of Rachel Lady Russell* (1854), pp. 339-41.
147. Univ. Nott., Ne C 33, Galway to Lady Russell, January 11, 1700.
148. Ibid., Ne C 26, Galway to Lady Russell, March 24, 1699.
149. *Letters of Rachel Lady Russell* (1854), pp. 343-44.
150. BOL, HMC 40, King William III to Lady Russell, September 23, 1700.
151. *CSPD, 1700-1702*, p. 445.
152. *Letters of Lady Rachel Russell* (1773), pp. 202-3, places the letter in 1696. The original letter is undated. See BL, Add. MSS. 37,728, fol. 180v.
153. BOL, SA 1, "An Accompt of the Whole Personal Estate of...Lady Rusel."
154. Milner, *History of Micheldever*, pp. 127, 235.
155. BOL, HMC 36, no. 102, Lady Russell to duke of Bedford, August 16, 1700.
156. BROB, Title Deeds, Southampton and Middlesex, bundle 3, p. 1167, nos. 8 and 9; BROB, Smith and Willoughby Survey.
157. *Letters of Rachel Lady Russell* (1854), pp. 346-47; Belvoir Castle, Letters of Lady Rachel Russell, Add. 61, no. 54, Lady Russell to Lady Granby, December 9, 1703.

158. HMC, *Manuscripts of the House of Lords, 1693–1714*, n.s., 4:155, 158, 159.
159. Belvoir Castle, Letters of Lady Rachel Russell, Add. 61, no. 36, Lady Russell to earl of Rutland, February 26, 1702.
160. Ibid., no. 71, Lady Russell to Lady Granby, July 23, 1707.
161. Belvoir Castle, Letters of Lady Rachel Russell, Add. 61, no. 22, Lady Russell to Lady Roos, August 1697. Also *Letters of Rachel Lady Russell* (1854), p. 329, where the text erroneously intimates that Rachel stood behind the czar's chair.
162. Chatsworth, MS Letters, 73.6, Tavistock to Lady Russell, December 13, 1697.
163. Belvoir Castle, Letters of Lady Rachel Russell, Add. 61, no. 36, Lady Russell to earl of Rutland, February 26, 1702.
164. BL, Sloane MSS. 4,063, fol. 16, Lady Russell to ?, April 15, 1700, about her success in winning a "place at court" for a person, using the good offices of the duke of Devonshire.
165. *DNB*; Firth, *Lord Macaulay's History of England*, 6:2750–55; *CSPD, 1698*, p. 22.
166. Belvoir Castle, Letters of Lady Rachel Russell, Add. 61, no. 35, draft of Lady Russell's letter to King William III, February 1702.
167. *Letters of Lady Rachel Russell* (1773), pp. 203–4.

• Chapter 9 •
Declining Years and Death, 1702–1723

1. Stone, *Family, Sex and Marriage*, pp. 59, 68–72.
2. Steven R. Smith, "Growing Old in Early Stuart England," *Albion* 8 (1976): 126.
3. Chatsworth, MS Letters, 28.109, Lady Russell's paper, "Vanity cleaves to me" [1718?].
4. Belvoir Castle, Letters of Lady Rachel Russell, Add. 61, no. 26, Lady Russell to Lady Granby, May 22, 1698.
5. *Letters of Rachel Lady Russell* (1854), p. 347.
6. Chatsworth, MS Letters, 125.0, duchess of Bedford to duchess of Devonshire, March 13, 1709; BOL, HMC 38, Lady Rachel Russell's Diaries, p. 19.
7. Univ. Nott., Ne C 4, Lady Rachel Russell to Lady Rachel Manners, n.d.
8. *Letters of Rachel Lady Russell* (1854), p. 373.
9. Belvoir Castle, Letters of Lady Rachel Russell, Add. 61, no. 40, Lady Russell to Lady Roos, July 14, 1702.
10. Gregg, *Queen Anne*, pp. 133–34, 155, 159.
11. Blakiston, *Woburn and the Russells*, p. 81.
12. Berry, *Some Account*, p. xcii.
13. HMC, *Manuscripts of the Duke of Rutland*, 2:171.
14. Belvoir Castle, Letters of Lady Rachel Russell, Add. 61, no. 37, Lady Russell to earl of Rutland, April 14, 1702.
15. Gregg, *Queen Anne*, p. 166.
16. Belvoir Castle, Letters of Lady Rachel Russell, Add. 61, no. 42, Lady Russell to earl of Rutland, December 31, 1702.

17. Hert. RO, D/EP F 204, Lady Russell to Lady Cowper, January 14, 1711. I am indebted to Eveline Cruickshanks for this reference.
18. Chatsworth, MS Letters, 125.1, Elizabeth, duchess of Bedford, to Rachel, duchess of Devonshire, February 12, 1712.
19. Hert. RO, D/EP F 175, Lady Rachel Russell to first earl Cowper, April 19, 1706.
20. Ibid., D/EP F 176, Lady Rachel Russell to first earl Cowper, February 10, 1715.
21. Belvoir Castle, Letters of Lady Rachel Russell, Add. 61, no. 42, Lady Russell to earl of Rutland, December 31, 1702.
22. Ibid., no. 43, Lady Russell to Rutland, January 7, 1703.
23. Ibid., no. 39, Lady Russell to Rutland, July 9, 1702.
24. *Letters of Rachel Lady Russell* (1854), pp. 344–45.
25. Belvoir Castle, Letters of Lady Rachel Russell, Add. 61, nos. 55, 59, 64, 67, 83, Lady Russell to Lady Granby, December 25, 1703; March 1704; August 18 and November 23, 1706; November 15, 1707.
26. *Letters of Rachel Lady Russell* (1854), p. 359, n. 1.
27. Belvoir Castle, Letters of Lady Rachel Russell, Add. 61, no. 50, Lady Russell to Lady Granby, October 25, 1703.
28. Ibid., no. 72, Lady Russell to Lady Granby, July 30, 1707.
29. *Letters of Rachel Lady Russell* (1854), p. 329.
30. Ibid., p. 356.
31. Belvoir Castle, Letters of Lady Rachel Russell, Add. 61, no. 93, Lady Russell to Lady Granby, June 15, 1710.
32. Ibid., no. 40, Lady Russell to Lady Granby, May 22, 1698.
33. Ibid., no. 50, Lady Russell to Lady Granby, October 25, 1703.
34. William Cooke, *Memoirs of Charles Macklin* (London, 1804), pp. 24–25. I thank Joanne Lafler for this reference and for allowing me to read her manuscript paper, "Anne Oldfield: An Actress Arranges Her Private Life."
35. BOL, SA 1, "An Accompt of the Whole Personal Estate of...Lady Rusel"; and BOL, First Duke, "Account Book of Lady Russell's account with... Wriothesley, duke of Bedford."
36. Blakiston, *Woburn and the Russells*, pp. 83–84; M. Ede, *Art and Society in England under William and Mary* (London, 1979), pp. 20, 90.
37. *Letters of Rachel Lady Russell* (1854), p. 359, n. 1, quoting Wiffen, *Memoirs of the Russell Family*.
38. For example, Bedford attended 20 of the 39 meetings of the House of Lords in the last year of William III's reign, 23 of the 50 meetings in the first year of Anne's reign, 16 of the 98 meetings from November 1709 to April 1710, and 36 of the 106 meetings in the fall of 1710. *LJ*, 17:3–151; 18:163–323, 575–725.
39. Chatsworth, MS Letters, 73.32, Wriothesley, duke of Bedford, to bishop of Exeter, 1702.
40. *Letters of Rachel Lady Russell* (1854), pp. 356–59.
41. Ibid., pp. 347–51.
42. Chatsworth, MS Letters, 73.33, duke of Bedford to Lady Russell, August 3, 1708.

43. *Letters of Rachel Lady Russell* (1854), p. 355. That Lady Russell was referring to the problem raised in her son's letter of August 3 is strongly implied by the dates of the letters and by Rachel's remark about her daughter's intent to visit Bedford, news contained in Bedford's letter.

44. Ibid., pp. 353–54; Chatsworth, MS Letters, 98.2, the earl of Orford to Lady Russell, September 2, 1708.

45. *Letters of Rachel Lady Russell* (1854), p. 359, n. 1.

46. Thomson, *The Russells in Bloomsbury*, p. 146.

47. BOL, SA 1, "An Accompt of the Whole Personal Estate of. . .Lady Rusel."

48. *Letters of Rachel Lady Russell* (1854), p. 361.

49. Belvoir Castle, Letters of Lady Rachel Russell, Add. 61, no. 27, Lady Russell to Lady Roos, September 3, 1698.

50. For example, ibid., nos. 28, 29, 32, 66, 84, and 99, November 19, 1698; August 10, 1700; November 12, 1706 (Lady Roos now Lady Granby); November 18, 1707; n.d.

51. Ibid., no. 38, June 30, 1702.

52. Ibid., no. 45, July 20, 1703.

53. Ibid., nos. 73, 74, 78, 82, 83, September 6 and 9, October 8, November 4 and 15, 1707. A scholarly account of French methods of language instruction confirms Rachel's shrewd assessment. See Lambley, *Teaching and Cultivation of the French Language in England*, ch. 4.

54. Belvoir Castle, Letters of Lady Rachel Russell, Add. 61, nos. 86–89, Lady Russell to Master James Manners, to Master Thomas Manners, and to Lady Frances Manners, all August 3, 1710; BOL, 100[1], Dillon Collection, p. 9, Lady Russell to Lady Rachel Manners, November 20, 1712.

55. BL, Sloane MSS. 4,060, fols. 218, 220, Lady Russell to Dr. Sloane, n.d. and October 5, 1711. For a scholarly account of the subject see Audrey Eccles, *Obstetrics and Gynaecology in Tudor and Stuart England* (London, 1982).

56. BOL, HMC 38, Lady Rachel Russell's Diaries, p. 19. The baby died several months later.

57. Berry, *Some Account*, p. xciv.

58. *Complete Peerage*, 11:266, note c.

59. *Letters of Rachel Lady Russell* (1854), pp. 362–63, 363–64.

60. BOL, HMC 38, Lady Rachel Russell's Diaries, p. 19; BOL, Counterfeit Leases, nos. 18–27, Bloomsbury Square, Lease of July 3, 1712.

61. Chatsworth, box 43, L/43/9, settlement between John Spencer (Lady Russell's steward) and Lady Russell, May 30, 1712. The settlement revealed that Spencer had £22 "remaining in his hands after the last election." Belvoir Castle, Letters of Lady Rachel Russell, Add. 61, no. 94, Lady Russell to Lady Granby, July 25, 1710, about the 1710 election in Hampshire.

62. Barings Bank Archive, Northbrook Papers, N 15, book 3, court records, Thomas Sellwood to Mr. E. Wigmore, January 6, 1712.

63. BROB, Manorial Papers, R 4/6020, 6021.

64. BROB, R 2/144, "A Field Book. . .Survey'd by Browne."

65. *Letters of Rachel Lady Russell* (1854), p. 366.

66. Chatsworth, box 43, L/43/9, settlement between John Spencer and Lady Russell, May 30, 1712; *Letters of Rachel Lady Russell* (1854), pp. 364–66.

67. Chatsworth, Russell MSS, Uncat., box 2, Lady Russell to Thomas Sellwood, July 1718; MS Letters, 28.107, August 4, Lady Russell to Sellwood, 1713.

68. BOL, HMC 41–41A, a copy of the 1712 will, taken from the Registry of the Prerogative Court of Canterbury.

69. BOL, First Duke, Papers of Lady Rachel Russell, "Account Book of Lady Russell's account with...Wriothesley, duke of Bedford."

70. Berry, *Some Account*, p. xcvi; *Letters of Rachel Lady Russell* (1854), pp. 369–70, 371.

71. BOL, HMC 38, Lady Rachel Russell's Diaries, p. 19.

72. All the papers are at Chatsworth, Russell MSS, Uncat., box 2, and MS Letters, 28.109, "Vanity cleaves to me," [1718?].

73. Sara Heller Mendelson, "Stuart Women's Diaries and Occasional Memoirs," in Mary Prior, ed., *Women in English Society, 1500–1800* (London, 1985), pp. 181–210. A portion of Lady Russell's essay "Vanity cleaves to me" is printed in Berry, *Some Account*, pp. xcvii–xcix.

74. *Letters of Rachel Lady Russell* (1854), p. 368.

75. BOL, SA 1, "An Accompt of the Whole Personal Estate of...Lady Rusel."

76. *Letters of Rachel Lady Russell* (1854), p. 366.

77. Chatsworth, MS Letters, 97.16, earl of Galway to Lady Russell, November 29, 1718; *Letters of Rachel Lady Russell* (1854), pp. 368, 378; Belvoir Castle, Letters of Lady Rachel Russell, Add. 61, nos. 70, 81, Lady Russell to Lady Granby, July 19 and October 8, 1707.

78. *Letters of Rachel Lady Russell* (1854), p. 378.

79. A letter written with his left hand in printed script like that of a child survives as poignant evidence of Galway's suffering in the War of the Spanish Succession: Chatsworth, MS Letters, 97.7, earl of Galway to Lady Rachel Russell, May 22, 1706.

80. Chatsworth, MS Letters, 97.13, Galway to Lady Rachel Russell, February 6, 1711.

81. *DNB.*

82. *Letters of Rachel Lady Russell* (1854), pp. 363, 370.

83. Belvoir Castle, Letters of Lady Rachel Russell, Add. 61, no. 95, Lady Russell to Marquess Granby, June 17, 1718.

84. *Letters of Lady Rachel Russell* (1773), p. 216. The original account is in BOL, HMC 37, pp. 403–5.

85. *Letters of Rachel Lady Russell* (1854), p. 376.

86. Ibid.; Joan Johnson, *Excellent Cassandra: The Life and Times of the Duchess of Chandos* (London, 1981), p. 110, referring to the letter.

87. BOL, summary analysis of leases.

88. BOL, HMC 39, pp. 4–5, copy of petition of Lady Russell to King George I, 1720; BL, Add. MSS. 15,915, fol. 43, King George I to duc d'Orleans, December 1, 1720.

89. France, Archives Nationales, TT 207, Papers of the de Ruvigny family, vol. IX, fols. 348–51, brief regarding Rachel's claim, June 23, 1723.

90. Ibid., vol. IX, fols. 346–47, statement regarding Rachel's claim, n.d.; fol. 397, Letters of naturalization for Wriothesley children, registered in the Chambre des Comptes, August 1641.

91. Ibid., vol. V, fol. 88, claim of Sieur de Matthieu Carue, June 26, 1723; vol. IX, fols. 356 and 357–58, M. Desourderval to Lady Russell, January 7 and June 11, 1723.

92. Ibid., vol. IX, fols. 348–51, statement regarding Rachel's claim addressed to M. le Cardinal Polignac, June 26, 1723; fol. 368, statement regarding claim of duke of Devonshire, addressed to M. le Cardinal de Fleury, first minister, January 31, 1739.

93. BOL, HMC 41, 41A, copy of Lady Russell's will.

94. BOL, SA 1, "An Accompt of the Whole Personal Estate of. . .Lady Rusel."

95. *Letters of Rachel Lady Russell* (1854), p. 382.

96. BOL, Gladys Scott Thomson notes, William Lord Russell and Lady Rachel (personal), Edward Fawlkner to Robert Butcher? (chief agent to the fourth duke of Bedford), November 8, 1743, recounting an interview with Mrs. Morrell (originals now missing). The notice in the *Weekly Journal, or British Gazetteer* for October 5, 1723, specified the hour of death: *Letters of Rachel Lady Russell* (1854), p. 382, n. 3, reprints a portion of the announcement.

97. BOL, SA 1, "An Accompt of the Whole Personal Estate of. . .Lady Rusel," shows the costs and suggests the date of burial.

98. Stone, *Family and Fortune*, p. 242; BROB, R 4/6003, introduction, Smith and Willoughby Survey.

99. BOL, SA 1, "An Accompt of the Whole Personal Estate. . .of Lady Rusel," documents the details in this paragraph.

100. *Letters of Rachel Lady Russell* (1854), p. 333, where the lines are reprinted.

101. Chatsworth, MS Letters, 30.13, 14, duchess of Devonshire to the Honorable James Cavendish, November 11, 1723, and February 13, 1724.

102. *Letters of Lady Rachel Russell* (1773), pp. lxv–lxvii, dedication signed by Thomas Sellwood, 1748.

103. BOL, HMC 37, pp. 399–403, A Poem to the Memory of Lady Rachel Russell, born 14 September 1637 and died 29 September 1723.

Selected
Bibliography

(The place of publication is London unless otherwise indicated.)

• Manuscript Sources •

Barings Bank Archives

Northbrook Papers. N 15. Bundle 1. Papers regarding purchase of Stratton property
from Duke of Bedford by Thomas Baring, 1801.
Northbrook Papers. N 15. Book 3. Records of Courts Baron, 1711–30.
Northbrook Papers. N 15. Book 6. Inventory of the goods in Stratton House,
May 25, 1724, including Lady Russell's room.

Bedford Office, London

(Note that the numbers that appear in HMC, *Second Report* [London, 1871], appen-
dix, to designate boxes of material or volumes in the Bedford archives have been
retained at BOL and that HMC numbers which do not appear in the *Second Report*
have been added. Each box or volume contains more than one item; some of the
items are quite different from the description on the box or in the HMC list.)
Deeds. Vol. 2. Cantab[rigia], General Evidences. J. Bundle 2.
Deeds, Vols. 2, 3, and 5. Southampton and Middlesex, General Evidences. Bundle 2.
Deeds, Vol. 2. Southampton, Middlesex, and Bloomsbury. A. Bundle 2.
First Duke. Papers of Lady Rachel Russell. Account book of Lady Russell's account
with her son, Wriothesley, duke of Bedford, May 25, 1695–May 26, 1711.
First Duke. Receivers General Accounts. George Collop's Accounts.
First Duke. Receivers General Accounts. John Fox's Accounts.
HMC 8. Manuscript Letters. 1564–1770. 59 vols.
HMC 36. Manuscripts. Lord and Lady Russell. 1658–1701. Letters and papers,
including an "original" of Lord Russell's scaffold speech.
HMC 37. Letters of the Right Honourable Rachel Lady Russell (1679–1717).
Copied by Thomas Wellwood [*sic*] 1748 from originals.
HMC 38. Lady Rachel Russell's Diaries; William Russell's Travel Diaries and Let-
ters. Copied from manuscripts at Latimer House.
HMC 39. Miscellaneous manuscripts, including William Russell's letter about Lady
Vaughan. Copied from manuscripts at Latimer House.
HMC 40. Papers regarding Lord Russell's attainder and trial.

HMC 40A. Letters of Rachel, Lady Russell, 1656–1717, mostly to her daughter Katherine, when marchioness of Granby.

HMC 40B. Miscellaneous letters of Lady Rachel Russell.

HMC 41, 41A. Lady Rachel Russell's will, in a case. Miscellaneous papers, letters and newsletters.

MSS. List. Summary analysis of seventeenth-century leases of Bloomsbury Estate properties.

MSS. Notes taken by M. Draper on the Account Book of Thomas Corderoy, receiver general for fourth earl of Southampton, Nottingham County Record Office, Portland MSS. DD5/P/7/1–12.

MSS. SA 1. "An Accompt of the Whole Personal Estate of the Rt. Honble Rachel Lady Rusel as the same stood on 29th day of Septem: 1723 being the day of her Ladyship Death."

Bedfordshire Record Office, Bedford

General Evidences in Counties Southampton and Middlesex. 1669–1731. Pp. 1207–15.

Title Deeds of Estates in Counties Southampton and Middlesex. 1638–98. Pp. 1163–67.

R 1/609. Maps of Micheldever and East Stratton.

R 2/144. A Field Book, Belonging to several Plans of the Manours of Michel-Dever, East and West Stratton, Abbots Worthy etc. . . . Surveyed & Delinated by Thomas Browne, Gent., Anno. Dom. 1730.

R 4/6000. Records of a Court of Survey of Copyholders. 1677.

R 4/6003. Survey of Estate by Humphrey Smith and Joseph Willoughby, Stewards. 1730.

R 4/6056. Materials sold from Stratton in 1768, 1769, and 1770.

Belvoir Castle

Add. 61. Lady Rachel Russell's letters to the Rutland family, mostly her daughter, Katherine.

Bodleian Library

Ashmolean 436, fol. 65a. Astronomical Figures on William Russell's Nativity.

Ashmolean 438, fols. 1–104. Ashmolean Weather Diary. July 1677–December 1685.

Manuscripts Carte 40, 168, 216, 218, 219. Correspondence of the Marquess of Ormonde.

Manuscripts North 6.1, fols. 280–81. Notes of Francis North on Lord Russell's scaffold speech.

Manuscripts Rawlinson A.241, fol. 76. Creation of Duke of Bedford as baron Howland of Streatham, Surrey, with remainder to Wriothesley Russell.

Manuscripts Rawlinson C.983, fol. 61. Dr. Gilbert Burnet to Bishop Henry Compton regarding William Russell's scaffold speech, 1683

Manuscripts Rawlinson D.1247, fols. 62, 64. The Reverend John Fitzwilliam's prayers for Lady Russell.

Manuscripts Rawlinson D.1251, fol. 226. The Reverend John Fitzwilliam to Lady Rachel Russell, February 20, 1689.

British Library

Add. MSS. 8,127, fols. 62–68. William Russell's notes for his defense, with his speech at his trial, 1683.

Add. MSS. 19,399, fol. 132. Lady Rachel Russell to Mr. William Griffith, February 4, 1684.

Add. MSS. 21,406, fol. 22. An account of William Russell's execution, 1683.

Add. MSS. 32,518, fol. 12. Tract by Lord Guilford, said to be against Lord Russell's execution speech. [1685].

Add. MSS. 34,526, fols. 16–19v. Bishop Gilbert Burnet, Some Further Passages forgot in the former relation.

Add. MSS. 34,526, fol. 16. Expressions of Lord Russell's, preserved by Lady Rachel Russell, and copied from a manuscript at Woburn Abbey.

Add. MSS. 37,728, fols. 154–93. Collections for a life of Lady Rachel Russell by Mary Berry.

Harleian MSS. 6,845, fols. 266–72v. Nathaniel Wade on Rye House: Information. October 4, 1685.

Harleian MSS. 6,846, fol. 123. Case of William Russell's election as M.P. for Tavistock.

Sloane MSS. 4,039, fol. 34. Lady Rachel Russell to Sir Hans Sloane, 1702.

Sloane MSS. 4,060, fols. 218, 220. Lady Rachel Russell to Sir Hans Sloane, n.d.

Sloane MSS. 4,063, fol. 16. Sir Hans Sloane to Lady Russell, 1700.

Microfilm M 636/32. Edmund Verney to Sir Ralph Verney, February 24, 1679.

Cambridge University, Magdalene College, Pepys Library

Miscellanies VII, fols. 484–91. List of Green Ribbon Club, 1679–81.

Chatsworth House

Deeds and Conveyances. Box 43. L 43/3, 43/8, 43/9, 43/10, 43/11.

Manuscript Letters 10, 15, 18, 20, 22, 27, 28, 30, 41, 43, 49, 73, 89, 97, 98.

Russell Manuscripts, Uncatalogued. Box 1. Lady Russell's letters, 1672–81; the Reverend John Fitzwilliam's essays and prayers; William Russell's early letters.

Russell Manuscripts, Uncatalogued. Box 2. Dr. Burnet's Relation of the late Lord Russell's behaviour after his Sentence and at his Execution; Lady Russell's essays, papers, and miscellaneous letters; Rachel Russell's Catechism, 1684/85.

East Sussex Record Office

GLY 794/1–10. Letters of Algernon Sidney, n.d., written while in prison, 1683.

Folger Shakespeare Library

L.c. 1–3950. "The Newdigate Newsletters. Addressed to Sir Richard Newdigate, 1st Bart., and to the 2nd Bart. 1673/74–1715."

France, Archives Nationales

O$^{1*}$ Vols. 23, 30, 42, 43. Registres du secrétariat de la maison du Roi. TT 207. Vols. IV, V, IX. Papers of the de Ruvigny family.

Hampshire Record Office

5M 53/942. Will of Thomas Wriothesley, fourth earl of Southampton, July 11, 1666.
5M 53/1008. Agreement of partition of the estates of Thomas, fourth Earl [of Southampton], between his three daughters. 1668/69.
Wriothesley Deeds, Personal. Fols. 2, 60, 73, 160, 124–27, 237, 240, 245, 279, 290–92, 294, 310, 414, 513–14, 549, 585. [Deeds of Thomas Wriothesley, fourth earl of Southampton.]

Hertfordshire Record Office

D/EP F.204, D/EP F.175, D/EP F.176. Correspondence of Lady Rachel Russell.

Huntington Library

Ellesmere Collection. Part III. Personal. 4.D. Miscellaneous. A copy of "The Rt. Honble Richard [Vaughan] Earle of Carberry [*sic*] his Advise to his Soun." Six letters dated August 14 to September 30, 1651.

Kent County Record Office

U 471 021. Papers regarding the execution of William Lord Russell.

Northamptonshire Record Office

Montagu MSS., Vol. 1, fols. 104–8. Letters of Lady Rachel Russell to Lady Elizabeth Montagu, 1685–86.

Public Record Office

Chancery Masters Deposits. C.115 (Duchess of Norfolk Deeds) in M 36, fols. 8429–31. Newsletters from Edmund Rossingham to Viscount Scudamore, August 18 and 29, 1634.
PRO Baschet transcripts. Barrillon's dispatches. 31/3/138, 139, 141, 142, 147, 148, 155, 156, 1678, 1679, 1680–81, 1683.
PC 2/68. Privy Council Register, 1679–80.

Sandbeck Park, Rotherham, Yorkshire

MTD/A8/19. Anon. to Sir Robert Townsend, May 30, 1683.

University of Nottingham Library

Ne C 1–7. Letters to and from the earl of Southampton.
Ne C 8–25. Miscellaneous letters of Lady Rachel Russell.
Ne C 26–35. Letters from the earl of Galway to Lady Rachel Russell.

Victoria and Albert Museum

Manuscripts. English, Haberdashery Bills, R.C.U. 20, 21; R.C.K. 3. Bills for purchases by William Russell, his father, and his brothers.

Dr. Williams' Library

Roger Morrice, "Entr'ing Book, Being an Historical Register of Occurrences From April, Anno. 1677 to April 1691." 4 vols. I have used a photocopy (now in my possession) of the original from the library of the late Douglas R. Lacey.

• **Printed Primary Sources** •

Letters of Lady Rachel Russell

Almack, Richard Esq., F.S.A., ed. Letters relating to Lady Rachel Russell in a private collection of a descendant of the Manners family. *Proceedings of the Society of Antiquaries*, June 11, 1874, pp. 1–10.
Berry, Mary. *Some Account of The Life of Rachael Wriothesley Lady Russell By the Editor of Madame Du Deffand's Letters Followed By A Series Of Letters From Lady Russell To Her Husband, William Lord Russell, From 1672 To 1682; Together With Some Miscellaneous Letters To And From Lady Russell. To Which Are Added, Eleven Letters From Dorothy Sidney Countess Of Sunderland. To George Saville Marquis Of Hallifax. In The Year 1680.* 1819. 3 eds. by 1820.
Letters Of Lady Rachel Russell; From The Manuscript in the Library at Woburn Abbey. To Which is prefixed, An Introduction, Vindicating the Character of Lord Russell Against Sir John Dalrymple, &c. 1773. Further editions in 1773, 1774, 1774 (Dublin), 1775 (Dublin), 1793, 1801, 1809, 1820, 1821.
Russell, Lord John, ed. *Letters of Rachel Lady Russell*. 2 vols. 1853; 2d ed. in one vol., Philadelphia, 1854.

Printed Letters, Memoirs, and Histories

d'Aulnoy, Baronne Marie Catherine. *Memoirs of the Court of England in 1675*. Ed. George David Gilbert. 1927.

Blencowe, R. W., ed. *Diary of the Times of Charles the Second by The Honourable Henry Sidney (Afterwards Earl of Romney) Including His Correspondence with the Countess of Sunderland...To Which Are Added, Letters Illustrative of the Times of James II and William III.* 2 vols. 1843.

Bond, Maurice F., ed. *The Diaries and Papers of Sir Edward Dering, Second Baronet, 1644–1684.* House of Lords Record Office Occasional Publications, no. 1. 1976.

Bramston, Sir John. *Autobiography.* Ed. Lord Braybrooke. 1845.

Browning, Andrew, ed. *Memoirs of Sir John Reresby.* Glasgow, 1936.

Bulstrode, Sir Richard. *The Collection of Autograph Letters and Historical Documents formed by Alfred Morrison.* 2d ser., vol. 1, *The Bulstrode Papers (1667–1675).* 1897.

Burnet, Bishop Gilbert. *History of His Own Time: with Notes by the Earls of Dartmouth and Hardwicke, Speaker Onslow, and Dean Swift.* 6 vols. Oxford, 1833.

Calendar of the Clarendon State Papers Preserved in the Bodleian Library, 1660–1726. 5 vols. Oxford, 1882–1970. vols. 1, 4, 5.

Chamberlain, John. *Letters.* Ed. Norman E. McClure. 2 vols. Philadelphia, 1939.

Chesterfield, Philip Stanhope, second earl of. *Letters of Philip Stanhope, second earl of Chesterfield to several celebrated individuals.* 1829.

Clarendon, Edward, earl of. *The History of the Rebellion and Civil Wars in England Begun in the year 1641.* Ed. W. Dunn Macray. 6 vols. Oxford, 1888.

————. *The Life of Edward Earl of Clarendon, Lord High Chancellor of England and Chancellor of the University of Oxford. Containing I. An Account of the Chancellor's Life from his Birth to the Restoration in 1660 and II. A Continuation of the same, and of the History of the Grand Rebellion, from the Restoration to His Banishment in 1667. Written by Himself.* Oxford, 1759.

Clark, J. S., ed. *The Life of James II Collected of Memoirs Writ of His Own Hand.* 1816.

Copies of the Informations and Original Papers Relating to the Proof of The Horrid Conspiracy Against the Late King, His Present Majesty, and the Government. 1685.

Dalrymple, Sir John. *Memoirs of Great Britain and Ireland from The Dissolution of the last Parliament of Charles II until the Sea-Battle off La Hogue.* 2 vols. London and Edinburgh, 1771–73.

de Beer, E. S., ed. *The Diary of John Evelyn.* 6 vols. 1955.

Delamere, Lord. *The Works Of The Right Honourable Henry late L. Delamer, And Earl of Warrington: Containing His Lordships Advice to His Children, Several Speeches in Parliament, &c. With Many Other Occasional Discourses On the Affairs of the Two Last Reigns.* 1694

Foxcroft, H. C., ed. *Life and Letters of Sir George Savile, First Marquis of Halifax.* 2 vols. 1898.

————. *A Supplement to Burnet's History of My Own Time.* Oxford. 1902.

Historical Manuscripts Commission. *Manuscripts of his Grace the Duke of Buccleuch and Queensberry, K.G., K.T., preserved at Drumlanrig Castle.* 2 vols. 1897–1903. Vol. 1.

——. *Manuscripts of His Grace the Duke of Portland, preserved at Welbeck Abbey.* 10 vols. 1891–1931. Vols. 2, 3, 8.

——. *Manuscripts of His Grace the Duke of Rutland, preserved at Belvoir Castle.* 4 vols. 1888–1905. Vol. 2.

——. *Manuscripts of Lord Kenyon.* 1894.

——. *Manuscripts of Mrs. Frankland-Russell-Astley of Chequers Court, Bucks.* 1900.

——. *Manuscripts of S. H. Le Fleming, Esq., of Rydal Hall.* 1890.

——. *Manuscripts of the Duke of Beaufort, K.G., The Earl of Donoughmore, and Others.* 1891.

——. *Manuscripts of the House of Lords. 1678–1693.* 4 vols. 1887–94. Vol. 2.

——. *Manuscripts of the House of Lords, 1693–1714.* New series. 11 vols. 1900–1962. Vols. 1, 2, 4, 8, 9.

——. *Manuscripts of the late Allan George Finch, Esq., of Burley-on-the-Hill, Rutland.* 4 vols. 1913–65. Vols. 2, 4.

——. *Manuscripts of the late Reginald Rawdon Hastings, Esq., of the Manor House, Ashby De La Zouch.* 4 vols. 1928–47. Vol. 4

——. *Manuscripts of the Marquess of Bath, preserved at Longleat, Wiltshire.* 5 vols. 1904–80. Vol. 1.

——. *Manuscripts of the Marquess of Downshire, preserved at Easthampstead Park, Berks.* 2 vols. 1924–36. Vol. 1, pts. 1 and 2.

——. *Manuscripts of the Marquess of Ormonde, K.P., preserved at Kilkenny Castle.* New series. 8 vols. 1902–20. Vols. 4–7.

——. *Seventh Report.* 1879.

Josten, C. H., ed. *Elias Ashmole (1617–1692): His Autobiographical and Historical Notes, His Correspondence, and Other Contemporary Sources Relating to His Life and Work.* 5 vols. Oxford, 1966.

Knowler, William, ed. *The Earl of Strafforde's Letters and Dispatches with an Essay Towards His Life by Sir George Radcliffe.* 2 vols. 1734.

Lewis, W. S., et al., eds. *Horace Walpole's Correspondence.* 48 vols. New Haven, 1937–83. Vols. 2, 16, 20, 23, 28, 29.

Locke, John. *Correspondence of John Locke.* Ed. E. S. de Beer. 7 vols. Oxford, 1976–82.

Loftis, John, ed. *The Memoirs of Anne, Lady Halkett, and Ann, Lady Fanshawe.* Oxford, 1979.

Luttrell, Narcissus. *A Brief Historical Relation of State Affairs from September 1678 to April 1714.* 6 vols. Oxford, 1857.

North, Roger. *Examen; or, An Enquiry into the Credit and Veracity of a Pretended Complete History.* 1740.

Smith, G. C. Moore, ed. *The Letters of Dorothy Osborne to William Temple* (Oxford, 1968).

The Works of Sir William Temple, Bart. Complete in Four Volumes. 1757.

Thompson, Sir Edward Maunde, ed. *Correspondence of the Family of Hatton, being chiefly letters addressed to Christopher, first Viscount Hatton, 1601–1704.* 2 vols. Camden Society, n.s., vol. 23, 1878.

Contemporary Tracts and Sermons

An Account of the Sentance [sic]. . .passed upon William Ld. Russell, T. Walcot, J. Rouse, and W. Hone at the Sessions-House in the Old-Bayley. . . . 14th of. . .July 1683, for High-Treason. 1683.

An Account of the tryals of William Lord Russell, William Hone, John Rouse, and William Blake, who took their Tryals at the Old-Bayley, on the 13th of July, 1683, for High-Treason, in Conspiring the Death of the King, and raising Rebellion in the Land. 1683.

Animadversions on the Last Speech and Confession of the late William Lord Russel. [By Elkanah Settle?] 1683.

Animadversions upon a paper entituled, The Speech of the late Lord Russell. . . . [By John Nalson.] 1683.

A Dialogue between Lord R[ussell]'s Ghost and the D[ean] of C[anterbury], J. T[illotson]. 1683.

Eden, the Reverend Charles Page, ed. *The Whole Works of the Right Rev. Jeremy Taylor, D.D., Lord Bishop of Down, Connor, and Dromore: with a Life of the Author, and a Critical examination of His Writings, by the Right Rev. Reginald Heber, D.D., Late Lord Bishop of Calcutta.* 10 vols. 1883.

An Elegy on the death of William Lord Russell. 1683.

The Execution of William Lord Russel, who on the 21st of this Instant July was Beheaded in Lincolns-Inn-Fields, for Conspiring the Death of the King, to Leavy War, and Raise a Rebellion, together with his Behaviour and Speeches. 1683.

Grey, Ford, baron Grey of Werk. *The Secret History of the Rye-House Plot: and of Monmouth's Rebellion.* 1754.

His Majesties Declaration to All His Loving Subjects, Concerning the Treasonable Conspiracy Against His Sacred Person and Government, Lately Discovered. 1683.

A History of the New Plot; or, A Prospect of Conspirators, their Designs Damnable, Ends Miserable, Deaths Exemplary. 1683.

L'Estrange, Sir Roger. *Considerations upon a Printed Sheet entituled the Speech of the Late Lord Russell to the Sheriffs; together With the Paper delivered by Him to Them at the Place of Execution on July 21, 1683.* 1683.

A List of all the Conspirators That have been Seiz'd, (and where Committed) since the Discovery of the Horrid and Bloody Plot. . .To which is Annexed, The Names of the Three late Famous Ignoramus Juries, etc. 1683.

Lord Russels Farewel, Who was Beheaded for High-Treason, in Lincoln-Inn-Fields, July 21st, 1683. To the Tune of, Tender Hearts of London City. West-Smithfield, n.d.

P., C. *A Congratulatory Pindaric Poem, For His Majesties Safe Deliverance from this Hellish and True Plot.* 1683.

A Satyre, By way of Dialogue between Lucifer, and the Ghosts of Shaftsbury and Russell. 1683.

Shower, Sir Bartholomew. *An Antidote Against Poison: Composed of some Remarks upon the Paper printed by the direction of the Lady Russel, and mentioned to have been delivered by the Lord Russel to the Sheriffs at the place of his Execution.* 1683.

Some Succinct Remarks on the Speech of the Late Lord Russell, To the Sheriffs: Together with the Paper deliver'd by him to them, at the Place of Execution, on July 21, 1683. 1683.

The speech and Confession of William Lord Russell who was executed for high-treason. 1683.

The Speech Of the Late Lord Russel To the Sheriffs: Together with the Paper deliver'd by him to them, at the Place of Execution, on July 21, 1683. 1683.

Sprat, Thomas, Bishop of Rochester. *A True Account and Declaration of The Horrid Conspiracy Against the Late King, His Present Majesty, and the Government: As it was Order'd to be Published by His Late Majesty.* 1685.

Tillotson, J. *A Letter Written to my Lord Russel in Newgate The Twentieth of July, 1683.* 1683.

A Vindication of the Lord Russell's Speech and Innocence. 1683.

W., F.N. *An Historical Review Of the Late Horrid Phanatical Plot, in the Rise, Progress, and Discovery of the Same.* 1684.

The Whigs' Lamentation; or, The Tears of a True-Blue Protestant Dropp'd for the loss of their unforfeitable Charter. 1683.

The Whole Tryal and Defence of William Lord Russel, Who Dyed a Martyr to the Romish Fury, in the Year 1683, with the Learned Arguments of the Council on both sides. 1683.

The Works of the late Reverend Mr. Samuel Johnson, Sometime Chaplain to the Right Honourable William Lord Russell. 1710.

Wright, James. *A Compendious View of the late Tumults & Troubles in this Kingdom, by way of Annals for seven years.* 1685.

Early Biographies and Family Memoirs of Lord and Lady Russell

Berry, Mary. *Some Account Of The Life of Rachael Wriothesley Lady Russell.* 1819. [Full title under "Letters of Lady Rachel Russell," above.] The biographical sketch was reprinted in 1819, 1820, and 1844.

Bunsen, Frances, Baroness. *A Memoir of Baron Bunsen.* 1868.

Francis (afterwards Child), L. M. *The Biographies of Lady Russell and Madame Guyon.* 1832.

Guizot, F.P.G. *L'Amour dans le mariage: Etude historique, extrait de la Revue des Deux Mondes.* Paris, 1855. Translated by John Martin as *The Married Life of Rachel, Lady Russell.* 1855. Reprinted as *Love in Marriage: An Historical Study—Lady Rachel Russell.* New York, 1864. Reprinted again as *The Devoted Life of Rachel Lady Russell.* 1883.

The Life of Lady Russell. Religious Tract Society. N.p., n.d. [1847 or 1857].

Martin, John. *An Enquiry into the Authority for Echard's Statement in his History of England that Lord Russell interfered to Prevent the Mitigation of the Barbarous Part of the Punishment for High Treason, in the Case of Viscount Stafford, upon the presentation of the Petition of the Sheriffs Bethel and Cornish, to the House of Commons 23 December 1680.* 1852.

Russell, Lord John. *The Life of William Lord Russell. With Some Account of the Times In Which He Lived.* 1819; 1820; 1853.

Stepney, Catherine (Pollock) Manners, Lady. *Memoirs of Lady Russell and Lady Herbert, 1623–1723; comp. from original family documents.* 1898.

Thomson, Gladys Scott. *Family Background.* 1949.

――――. *Life in A Noble Household, 1641–1700.* 1937.

――――. *The Russells in Bloomsbury, 1669–1771.* 1940.

――――. *Woburn Abbey: An Illustrated Survey of the Bedfordshire Residence of the Russell Family.* Derby, 1955.

Wiffen, Jeremiah Holmes. *Historical Memoirs of the House Of Russell; From the Time of the Norman Conquest.* 2 vols. 1833.

――――. *Verses Written in the Portico of the Temple of Liberty at Woburn Abbey, on placing before it the statues of Locke and Erskine, in the summer of 1835.* 1836.

Plays

Hayley, William. *Plays of Three Acts; Written for a Private Theatre.* 1784.

Russell; or, The Rye-House Plot. A Tragedy. In Five Acts. 1839.

Saintsbury, George, ed. *Minor Poets of the Caroline Period.* 3 vols. Oxford, 1905–21.

Stratford, the Reverend Thomas. *Lord Russell: A Tragedy.* 1784.

Public Documents

Calendar of State Papers, Domestic Series

Grey, Anchitell. *Debates of the House of Commons, from the Year 1667 to the Year 1694.* 10 vols. 1763.

Howell, Thomas B., ed. *Cobbett's Complete Collection of State Trials and Proceedings for High Treason.* 34 vols. 1809–28.

Journals of the House of Commons.

Journals of the House of Lords.

Shaw, W. A., ed. *Letters of Denization and Acts of Naturalization for Aliens in England and Ireland, 1603–1700.* Publications of the Huguenot Society of London. Vol. 18. 1911.

• Secondary Works •

Agnew, the Reverend David C. A. *Henri de Ruvigny, Earl of Galway: A Filial Memoir, with a Prefatory Life of His Father, Le Marquis de Ruvigny.* Edinburgh, 1864.

――――. *Protestant Exiles from France in the Reign of Louis XIV; or, The Huguenot Refugees and Their Descendants in Great Britain and Ireland.* 1874.

Akrigg, G. P.V. *Shakespeare and the Earl of Southampton.* Cambridge, Mass., 1968.

Allen, David. "Political Clubs in Restoration England." *Historical Journal* 19 (1976): 561–80.

Ashcraft, Richard. *Revolutionary Politics and Locke's Two Treatises of Government.* Princeton, 1986.

Baker, J. H. "Criminal Courts and Procedure at Common Law, 1550–1800." In *Crime in England, 1550–1800*, ed. J. S. Cockburn, pp. 15–48. Princeton, 1977.

Barbiche, Bernard. *Sully.* Paris, 1978.

Bevan, Bryan. *James Duke of Monmouth.* 1973.

Birch, Thomas. *The Life of the Most Reverend Dr. John Tillotson, Lord Archbishop of Canterbury. Compiled chiefly from His Original Papers and Letters.* 1752.

Blakiston, Georgiana. *Woburn and the Russells.* 1980.

Bonfield, Lloyd. *Marriage Settlements, 1601–1740.* Cambridge, 1983.

Brink, J. R., ed. *Female Scholars: A Tradition of Learned Women before 1800.* Montreal, 1980.

Brown, Irene Q. "Domesticity, Feminism, and Friendship: Female Aristocratic Culture and Marriage in England, 1660–1760." *Journal of Family History,* Winter 1982, pp. 406–22.

Browning, Andrew. *Thomas Osborne, Earl of Danby and Duke of Leeds (1632–1712).* 3 vols. Glasgow, 1944–51.

Browning, Andrew, and Doreen J. Milne. "An Exclusion Bill Division List." *BIHR* 23 (1950): 205–25.

Cardigan, Earl of. *The Life and Loyalties of Thomas Bruce: A Biography of Thomas, Earl of Ailesbury and Elgin Gentleman of the Bedchamber to King Charles II and to King James II, 1656–1741.* 1951.

Castiglione, Arturo. *A History of Medicine.* New York, 1947.

Clay, Christopher. "Marriage, Inheritance, and the Rise of Large Estates in England, 1660–1815." *Economic History Review,* 2d ser., 21 (1968): 510–15.

———. "Property Settlements, Financial Provision for the Family, and Sale of Land by the Greater Landowners, 1660–1790." *Journal of British Studies* 21 (1981): 18–38.

Davis, Natalie Z. "Women's History in Transition: The European Case." *Feminist Studies,* nos. 3–4 (1976): 83–103.

Deyon, Solange. *Du loyalisme au refus: Les Protestants français et leur député général entre le Fronde et la Révocation.* Lille, 1976.

Draper, Marie. "The Russells of Bloomsbury." *Camden History Review,* no. 7 (1979): 21–24.

Eccles, Audrey. *Obstetrics and Gynaecology in Tudor and Stuart England.* Kent, Ohio, 1982.

Ede, M. *Art and Society in England under William and Mary.* 1979.

English Churchwomen of the Seventeenth Century. Derby, 1845.

Evans, Willa McClung. *Henry Lawes: Musician and Friend of Poets.* New York and London, 1941.

Ferguson, James. *Robert Ferguson, the Plotter; or, The Secret of the Rye-House Conspiracy and the Story of a Strange Career.* Edinburgh, 1887.

Fraser, Antonia. *A History of Toys.* New York, 1972.

———. *The Weaker Vessel: Women in Seventeenth-Century England.* New York, 1984.

Galtier de Laroque, A. de. *Le Marquis de Ruvigny, député général des églises réformées auprès du roi, et les protestants à la cour de Louis XIV, 1643–85.* Paris, 1892.

Gardiner, Dorothy. *English Girlhood at School: A Study of Women's Education through Twelve Centuries.* Oxford, 1929.

Gaskin, Katherine. "Age at First Marriage in Europe before 1850: A Summary of Family Reconstitution Data." *Journal of Family History* 11 (1978): 23–36.

George, M. Dorothy. "Elections and Electioneering, 1679–1681." *English Historical Review* 45 (1930): 552–78.

Gibbs, Vicary, et al., eds. *The Complete Peerage of England, Scotland, Ireland, Great Britain, and the United Kingdom.* 2d ed. 13 vols. 1910–40.

Glanz, Leonore M. "The Legal Position of English Women under the Early Stuart Kings and the Interregnum, 1603–1660." Ph.D. dissertation, Loyola University of Chicago, 1973.

Goldie, Mark. "The Roots of True Whiggism, 1688–94." *History of Political Thought* 1 (1980): 195–236.

Grant, Douglas. *Margaret the First.* Toronto, 1957.

Greater London Council. *Survey of London.* Vol. 36, *The Parish of St. Paul Covent Garden,* ed. F.H.W. Sheppard. 1970.

Green, Thomas A. *Verdict according to Conscience: Perspectives on the English Criminal Trial Jury, 1200–1800.* Chicago, 1985.

Green, V.H.H. *Religion at Oxford and Cambridge.* 1964.

Gregg, Edward. *Queen Anne.* 1980.

Gregg, Pauline. *King Charles I.* 1981.

Grose, C. L. "Louis XIV's Financial Relations with Charles II and the English Parliament." *Journal of Modern History* 1 (1929): 177–204.

Gwynn, Robin D. "The Arrival of Huguenot Refugees in England." *Proceedings of the Huguenot Society of London* 21 (1965–70): 366–73.

———. "The Distribution of Huguenot Refugees in England." Ibid., pp. 432–33.

———. "James II in the Light of His Treatment of Huguenot Refugees in England, 1685–1686." *English Historical Review* 92 (1977): 820–33.

Haley, K.H.D. *The First Earl of Shaftesbury.* Oxford, 1968.

———. *William of Orange and the English Opposition, 1672–1674.* Oxford, 1953.

Hamilton, Edith. *William's Mary.* 1972.

Hannay, Margaret P., ed. *Silent but for the Word: Tudor Women as Patrons, Translators, and Writers of Religious Works.* Kent, Ohio, 1985.

Heber, Richard. *The Life of the Right Rev. Jeremy Taylor, D.D., Lord Bishop of Down, Connor, and Dromore: with a critical Examination of his writings.* 2 vols. 1824.

Heltzel, Virgil B., ed. "Richard Earl of Carbery's Advice to His Son." *Huntington Library Bulletin,* no. 11 (April 1937): 59–105.

Henning, Basil Duke, ed. *The History of Parliament: The House of Commons, 1660–1690.* 3 vols. 1983.

Hill, L. M. "The Two-Witness Rule in English Treason Trials: Some Comments on the Emergence of Procedural Law." *American Journal of Legal History* 12 (1968): 95–111.

Hogrefe, Pearl. *Tudor Women.* Ames, Iowa, 1975.

Hollingsworth, T. H. "A Demographic Study of the British Ducal Families." In *Population in History,* ed. D. V. Glass and D.E.C. Eversley, pp. 354–78. Chicago, 1965.

Houlbrooke, Ralph A. *The English Family, 1450–1700.* 1984.

Jaffé, Michael. "Van Dyck Studies II: 'La belle & vertueuse Huguenotte.' " *Burlington Magazine* 126 (1984): 603–11.

Jones, J. R. "Court Dependents in 1664." *BIHR* 34 (1961): 81–91.

———. *The First Whigs: The Politics of the Exclusion Crisis, 1678–1683.* 1961.

———. "Shaftesbury's 'Worthy Men': A Whig View of the Parliament of 1679." *BIHR* 30 (1957): 232–41.

Jones, Major Francis. "The Vaughans of Golden Grove." *Transactions of the Honourable Society of Cymmrodorion,* Session 1962, pp. 96–143.

Kelly, Joan. *Women, History, and Theory: The Essays of Joan Kelly.* Chicago, 1984.

Kenyon, J. P. *Robert Spencer, Earl of Sunderland, 1641–1702.* 1958.

Kinnaird, Joan K. "Mary Astell and the Conservative Contribution to English Feminism." *Journal of British Studies* 19 (1979): 53–75.

Lambley, Kathleen. *The Teaching and Cultivation of the French Language in England during Tudor and Stuart Times.* Manchester, 1920.

Lart, Charles E. *Huguenot Pedigrees.* 2 vols. in 1. Baltimore, 1967.

Laslett, Peter. *Family Life and Illicit Love in Earlier Generations: Essays in Historical Sociology,* Cambridge, 1977.

——. *Household and Family in Past Time.* Cambridge, 1972.

Letwin, William. *Sir Josiah Child: Merchant Economist.* Boston, 1958.

Lipson, E. "Elections to the Exclusion Parliaments, 1679–1681." *English Historical Review* 28 (1913): 59–85.

Maitland, F. W., and Sir F. Pollock. *The History of English Law before the Time of Edward I.* Oxford, 1973.

McMullen, Norma. "The Education of English Gentlewomen, 1540–1640." *History of Education* 6 (1977): 87–102.

Michel, Robert H. "English Attitudes towards Women, 1640–1700." *Canadian Journal of History* 13 (1978): 35–60.

Mikesell, Margaret Lael. "Catholic and Protestant Widows in the *Duchess of Malfi.*" *Renaissance and Reformation* 19 (1983): 265–79.

Milner, Alfred B. *History of Micheldever.* Paris, 1924.

Nadelhaft, Jerome. "The Englishwoman's Sexual Civil War: Feminist Attitudes towards Men, Women, and Marriage, 1650–1740." *Journal of the History of Ideas* 43 (1982): 555–79.

Olsen, Donald J. *Town Planning in London: The Eighteenth and Nineteenth Centuries.* New Haven, Conn., 1964.

Page, W., H. A. Doubleday, et al., eds. *Victoria History of the Counties of England.* Westminster, 1900– .

Parkes, Colin Murray, *Bereavement: Studies of Grief in Adult Life.* New York, 1973.

Parkes, Colin Murray, and Robert S. Weiss. *Recovery from Bereavement.* New York, 1983.

Perry, Ruth. *The Celebrated Mary Astell: An Early English Feminist.* Chicago, 1986.

Phifer, James R. "Law, Politics, and Violence: The Treason Trials Act of 1696." *Albion* 12 (1980): 235–56.

Prior, Mary, ed. *Women in English Society, 1500–1800.* 1985.

Read, Charles. "Le Temple de Charenton." *Bulletin de la Société de l'Histoire du Protestantisme Français.* Paris, 1854.

Roques, Mario. "Madame de la Maison-Fort et la Dédicace de *La Veuve.*" *Revue d'Histoire Littéraire de la France,* 1951, pp. 461–67.

Rose, Mary Beth, ed. *Women in the Middle Ages and the Renaissance: Literary and Historical Perspectives.* Syracuse, 1986.

Rosenblatt, Paul C. *Bitter, Bitter Tears. Nineteenth-Century Diarists and Twentieth-Century Grief Theories.* Minneapolis, 1983.

Rowse, A. L. *Shakespeare's Southampton: Patron of Virginia.* 1965.

Schochet, Gordon J. *Patriarchalism in Political Thought: The Authoritarian Family and Political Speculation and Attitudes Especially in Seventeenth-Century England*. New York, 1975.

Schwoerer, Lois G. *The Declaration of Rights, 1689*. Baltimore, 1981.

———. *"No Standing Armies!" The Antiarmy Ideology in Seventeenth-Century England*. Baltimore, 1974.

———. "Seventeenth-Century English Women Engraved in Stone?" *Albion* 16 (1984): 389–403.

———. "William, Lord Russell: The Making of a Martyr, 1683–1983." *Journal of British Studies* 24 (1985): 41–71.

———. "Women and the Glorious Revolution." *Albion* 18 (1986): 195–218.

Seidel, Michael A. "Poulain de la Barre's *The Woman as Good as the Man*." *Journal of the History of Ideas* 35 (1974): 499–508.

Shanley, Mary Lyndon. "Marriage Contract and Social Contract in Seventeenth-Century English Political Thought." *Western Political Quarterly* 32 (1979): 79–91.

Slater, Miriam. *Family Life in the Seventeenth Century: The Verneys of Claydon House*. 1984.

Smith, D. S. "Parental Power and Marriage Patterns." *Journal of Marriage and the Family* 35 (1973): 419–28.

Smith, G. C. Moore. *Henry Tubbe*. Oxford Historical and Literary Studies, vol. 5. Oxford, 1915.

Smith, Hilda L. *Reason's Disciples: Seventeenth-Century English Feminists*. Urbana, 1982.

Smith, Steven R. "Growing Old in Early Stuart England." *Albion* 8 (1976): 125–41.

Souers, Philip Webster. *The Matchless Orinda*. Cambridge, Mass., 1931.

Spring, Eileen. "Law and the Theory of the Affective Family." *Albion* 16 (1984): 1–20.

Stone, Lawrence. *Crisis of the Aristocracy, 1558–1641*. Oxford, 1965.

———. *Family and Fortune: Studies in Aristocratic Finance in the Sixteenth and Seventeenth Centuries*. Oxford, 1973.

———. *The Family, Sex, and Marriage in England, 1500–1800*. New York, 1977.

———. "Marriage among the English Nobility in the Sixteenth and Seventeenth Centuries." *Comparative Studies in Society and History* 3 (1961): 182–206.

Stopes, Charlotte Carmichael. *The Life of Henry, Third Earl of Southampton, Shakespeare's Patron*. Cambridge, 1922.

Taillandier, Mme. Saint-René. "Une Ambassade de Sully à Londres, 1603." *Revue de Paris* 44 (1937): 622–53.

Taylor, Lou. *Mourning Dress: A Costume and Social History*. 1983.

Trumbach, Randolph. *The Rise of the Egalitarian Family: Aristocratic Kinship and Domestic Relations in Eighteenth-Century England*. 1978.

Willen, Diane. *John Russell, First Earl of Bedford: One of the King's Men*. Royal Historical Society Studies in History Series, no. 23. 1981.

Woodbridge, Linda. *Women and English Renaissance Literature and the Nature of Womankind, 1540–1620*. Urbana, 1984.

Wrightson, Keith. *English Society, 1580–1680*. 1982.

Index

Abbots Worthy manor, Hampshire, 46

aging, Rachel's, 217–40

 her attitude toward, 218

Ailly, Antoine d', seigneur de la Mairie et de Pierrepont, 6

Alington, William, third baron of Alington Killard, 75, 76, 78, 79, 89, 145

Altham, Frances, second countess of Carbery, 21

Anglicanism

 vs. Puritan influences, 9, 12

 Rachel and, 19, 29, 153, 157, 233

 Rachel's father and, 27, 29

 William and, 66, 96, 132

 Wriothesley family and, 2, 4

Anne, queen of Great Britain and Ireland (*formerly* Princess Anne), 187, 217, 219, 221

Annesley, Arthur, earl of Anglesey, 125

Antidote Against Poison, An, 140, 189

 Rachel and, 140–41

appearance (physical), Rachel's. *See also* Portraits of Rachel

 at age 32 (1669), 33

 her mother and, 9

 in old age, 229

Armstrong, Sir Thomas, 104

army, support for, 27, 73, 74, 75–76, 80

Atkyns, Sir Robert, 140–41, 142

autobiography, Rachel's, 232

baptism, Rachel's (1637), 1

Barnardiston, Sir Samuel, 141

Barrillon, Paul, marquis de Branges, 81, 93, 123, 127

Bates, Rev. William, 96, 150, 284

 dedicates *The Last Four Things* to Rachel, 196

Baxter, Rev. Richard, 136

 Dying Thoughts, 129

 Sincere Convert, 39

Bedford, countess of. *See* Carre, Ann

Bedford, earls and dukes of. *See* Russell

Belvoir Castle, Leicestershire, *182,* 201, 203–4, 222

Berry, Mary, *Some Account of the Life of Rachel Wriothesley. . . ,* xxv, 239

Bible

 Rachel and, 15, 17, 66

 William and, 39, 129

biography of women, xvii–xviii

 psychobiography, xxvii

 of Rachel, xxv–xxvii, 262–63

birth, Rachel's (1637), 3, 11

Bloomsbury manor and estate, London, 3, 5. *See also* Southampton House, Bloomsbury

 developed by Rachel, 55, 146

 developed by Southampton, 28–29

 income from, 36, 146, 237

 and marriage contract, 45, 46

 patent for markets at, 214

 Rachel inherits, 36

 trusts for, revoked by Rachel, 145

Booth, Henry, second baron Delamere, 186, 188

Bridgeman, Sir Orlando, 35

Bristow family, 52

Bromley, John, xxvi

Browne, Mary, second countess of Southampton, 15

Bruce, Thomas, Lord, 86

Buckingham, duke of. *See* Villiers, George

Burnet, Gilbert, bishop of Salisbury, 28, 206

 History of My Own Time, 226

 and Rachel, 125, 134; in her widowhood, 142, 150, 154, 185

THE JOHNS HOPKINS UNIVERSITY PRESS

———

Lady Rachel Russell
ONE OF THE BEST OF WOMEN

———

This book was composed in
Times Roman text and Caslon Antique display
by Rosedale Printing Company, Inc.,
from a design by Sheila Stoneham.
It was printed on 50-lb Sebago Eggshell Cream Offset paper
and bound in Joanna Arrestox A #14550
by the Maple Press Company.